1991

W9-BCE-186

3 0301 00084238 1

LIBRARY
College of ...
...

Announcing

Broadcast
Communicating
Today

Lewis B. O'Donnell
State University of New York at Oswego

Carl Hausman
New York University

Philip Benoit
Dickinson College

Second Edition

Wadsworth Publishing Company
Belmont, California
A Division of Wadsworth, Inc.

LIBRARY
College of St. Francis
JOLIET, ILLINOIS

Publisher: Rebecca Hayden
Editorial Assistant: Sharon Yablon
Production: Del Mar Associates
Text and Cover Designer: John Odam
Print Buyer: Martha Branch
Copy Editor: Linda Purrington
Technical Illustrator: Philip Li
Compositor: G & S Typesetters
Printer: Vail-Ballou Press

This book is printed on acid-free paper that meets Environmental Protection Agency standards for recycled paper.

© 1992 by Wadsworth, Inc. All rights reserved. No part of this book may be reproduced, stored in a retrieval system, or transcribed, in any form or by any means, without the prior written permission of the publisher, Wadsworth Publishing Company, Belmont, California 94002.

1 2 3 4 5 6 7 8 9 10—96 95 94 93 92

Library of Congress Cataloging-in-Publication Data
O'Donnell, Lewis B.
 Announcing : broadcast communicating today / Lewis B. O'Donnell, Carl Hausman, Philip Benoit. — 2nd ed.
 p. cm.
 Includes index.
 ISBN 0-534-14958-8
 1. Radio announcing. 2. Television announcing. I. Hausman, Carl, 1953- . II. Benoit, Philip, 1944- . III. Title.
PN1990.9.A54036 1991
791.44'3—dc20 91-2817
 CIP

Photo Credits: 1: © Bob Daemmrich/The Image Works; 67: © Ulrike Welsch/PhotoEdit; 99: ©1989 Robert Brenner/PhotoEdit; 157: © John `Coletti/Stock•Boston; 197: courtesy of WCVH; 217: © Alan Oddie/PhotoEdit; 235: © Tony Freeman/PhotoEdit; 259: © 1979 Jerry Berndt/Stock•Boston; 271: © Michael G. Edrington/The Image Works.

791.443
0263
2ep

About the Authors

Lewis B. O'Donnell is professor emeritus of communication studies at the State University of New York at Oswego. A former announcer and performer on radio and TV stations in Syracuse and Buffalo, he is now president of Cove Communications Inc. He was also a performer on the nation's longest-running children's show—*The Magic Toyshop.* In 1985 Dr. O'Donnell was awarded the Frank Stanton Fellowship by the International Radio and Television Society.

Carl Hausman is a prolific author and experienced communications educator who has experience as a performer in a variety of media. Dr. Hausman has been host of local TV news programs and talk shows; served as a TV and radio anchor, reporter, and editor; and has worked as on-camera or voiceover talent in many commercials and corporate video presentations. He is currently a Mellon Fellow in the Humanities and a member of the journalism faculty at New York University. He is the author or co-author of fourteen books, including seven in mass communications.

Philip Benoit is director of communications at Dickinson College in Carlisle, Pennsylvania. He is an author, consultant, and former communications faculty member. Formerly executive officer of the American Forces Network, Europe, and American Advisor to the Vietnamese Armed Forces Radio Network, Benoit has a broad background in broadcasting and public relations. His articles on marketing and communications have appeared in *The New York Times* and *The Chronicle of Higher Education.*

,42,041

Preface

Announcing: Broadcast Communicating Today, Second Edition, will introduce you to the fascinating *art* of broadcast announcing and to the equally fascinating *business* of broadcast announcing. This business has evolved, over its relatively short history, from being the almost exclusive province of men with baritone voices to a field that now includes many women and a wide variety of styles. Above all, you must be able to *communicate*! Today's announcer must be able to inform, entertain, persuade, and motivate.

Modern broadcasting also demands specialized skills. For example, a voiceover announcer must be able to time delivery to the second. A television field reporter must be able to assemble a professionally produced, accurate report of a news event on very little notice. Radio talk show or call-in hosts must be able to handle everyone from the most expert guest to the most loony of callers. Different formats and the demands of demographics require radio staff announcers to reach and entertain very different segments of the audience.

Announcing: Broadcast Communicating Today, Second Edition, is designed as an academic *and* practical guide to the announcer's role in today's broadcast media. It details both principles of good communication and specific announcing skills and techniques.

Chapter 1 briefly describes the evolving media and the changing role of the announcer. Chapter 2, which deals with improving the speaking voice, shows the broad scope of this book. In addition to explaining the standard advice "breathe from the diaphragm," we show in words and pictures exactly how to improve your voice and diction.

Communication is the goal of announcing. Chapters 3 and 4 outline the basic skills of understanding and communicating the message. In Chapter 5, we move on to detailed instruction in various announcing fields. Chapter 5 deals with radio staff announcing. Chapter 6 introduces broadcast news in general and then examines radio news announcing in detail. Television news announcing is the focus of Chapter 7.

Chapter 8 deals with interviewing skills, which are critical to any on-air broadcast communicator. Chapter 9 details television and radio specialties such as sports announcing, weather reporting, and narration. Commercial announcing is one of the most important on-air tasks, and Chapter 10 offers a complete and comprehensive treatment. Methods of self-improvement and guidance to career advancement are discussed in Chapters 11 and 12, respectively.

End-of-chapter summaries are followed by exercises that recreate the pressures of on-air work and prod the reader to think in new directions. Appendix A is a pronunciation chart to help you decode foreign words and names. And the drill material in Appendixes B and C is designed to challenge every aspect of your delivery and analytical skills.

The first edition of *Announcing* was used in classrooms across the nation.

Users recommended additions, so we have integrated substantial new material while keeping the basic organization. Specifically, we have

- Expanded the coverage of television news. We've included new sections on live, remote broadcasting, and field reporting. We've added material on the newswriting techniques used by on-air newspeople.
- We have added a section on the special demands that all-news formats make on radio performers.
- The section on ad-libbing has been greatly expanded. The section now includes discussion of specific techniques that improve ad-libbing in major radio formats and in various television performance situations.
- We've added more discussion of what you need to succeed in an on-air career in broadcasting. We've included tips by industry experts on how best to prepare for such careers in both radio and television.

The second edition has additional information on voice use and development, on-camera appearance, and the importance of being able to read to time.

Most of the drill material is new. We've updated wire service and local news copy, and provided extra voiceover and promo copy. We've added newer material that offers the opportunity to practice new styles of presentation in both radio and television.

So this second edition of *Announcing* retains the best features of the original text while adding considerable new material focused specifically on the needs of on-air performers.

We extend our sincere gratitude to the following reviewers, who made many valuable suggestions: Phil Blauer, Anchor/Producer, KESQ-TV (ABC), Palm Springs; Terry Draper, National Broadcasting School; Lincoln M. Furber, American University; Darrell E. Kitchell, Fullerton College; Thomas Mullin, Eastern Wyoming College, Wheatland Program; and Roosevelt Wright, Syracuse University.

Finally we'd like to thank our editor, Becky Hayden, who again supplied experience and expertise to ensure that the final product is as good as we can make it, and that it fully meets the needs of those who will use it.

We hope this text will serve as a lifelong reference and help lay the groundwork for future growth. One thing that's great about this art and business is that you *never* stop learning.

Lewis B. O'Donnell
Carl Hausman
Philip Benoit

Contents

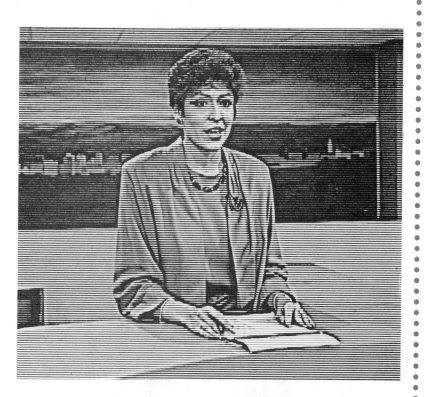

Power and magic attend the broadcast media. The mystique was there from the earliest days of broadcast history. Radio waves *could* be explained by science, but people were still fascinated by the idea that voices and music could somehow crystallize out of thin air. A cat whisker moving over a quartz crystal attached to primitive earphones could bring the distant sounds of concert music into the most remote prairie cabin. The simple "crystal set" quickly became a common feature in American homes. It became a popular pastime for families and individuals to don headsets and stare off into space while they used their imagination to picture the events they were hearing (Figure 1.1).

As radio developed and flourished, it became possible for virtually the entire nation to participate—in a weekly drama program, a comedy or variety show, a vivid description of a news event—at exactly the same moment. Never before had it been possible for the attention of such vast numbers of people to be focused on the same thing at the same time.

The power of this phenomenon was dramatically demonstrated by the famous Mercury Theater presentation of *War of the Worlds* on Halloween night, 1938. This dramatized invasion of "Martians" was mistaken for a real news event by millions of frightened listeners. Many people fled in panic from the supposed site of the invasion in New Jersey.

Only a short time later, a young journalist named Edward R. Murrow

Figure 1.1. The fascination with radio when it first began was focused on the novelty of being able to hear immediately the sounds of distant events. This photo shows two family members in 1921, listening to the first mass-produced receiver for home entertainment. (The Bettmann Archive)

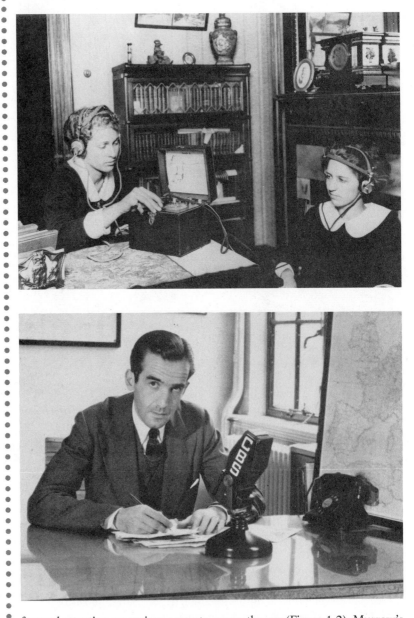

Figure 1.2. Edward R. Murrow broadcast reports from London during the German blitzkrieg at the outbreak of World War II. He is shown here at CBS headquarters in London. (UPI/ Bettmann)

focused attention on ominous events across the sea (Figure 1.2). Murrow's broadcasts from London during the summer of 1940 brought the sights and sounds of war to millions of Americans. They created among Americans a deep empathy with the plight of Londoners who lived with the constant threat of destruction as Hitler's bombs fell on them night after night during the troubling times that preceded World War II.

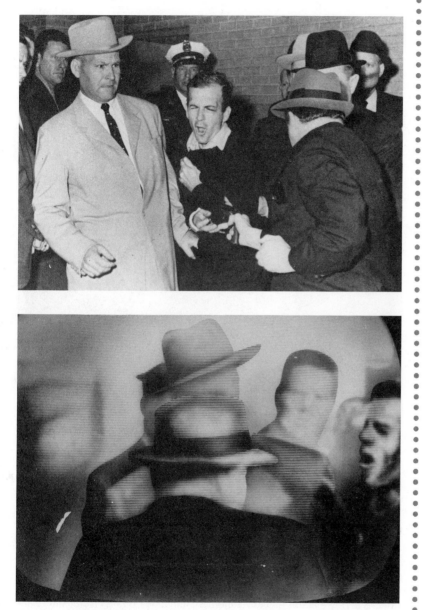

Figure 1.3. Jack Ruby (right) shoots Lee Harvey Oswald as he was being transferred from city to county jail in Dallas on November 24, 1963. (UPI/Bettmann)

Figure 1.4. This photo, taken from the NBC-TV screen, shows Lee Harvey Oswald (right), alleged assassin of President John Kennedy, gasping in shock as he is shot by Jack Ruby (in the foreground, wearing hat, back to camera). Millions of television viewers saw the event as depicted in this photo. (UPI/Bettmann)

Many more examples of the dramatic impact of the broadcast media can be cited. Live television pictures of the events surrounding the assassination of popular young President John F. Kennedy preceded the shooting of his alleged assassin on live television (Figures 1.3 and 1.4). TV coverage let millions of viewers watch as Neil Armstrong made the first human footprint on the moon's dusty surface (Figure 1.5). Sports coverage turned into a major

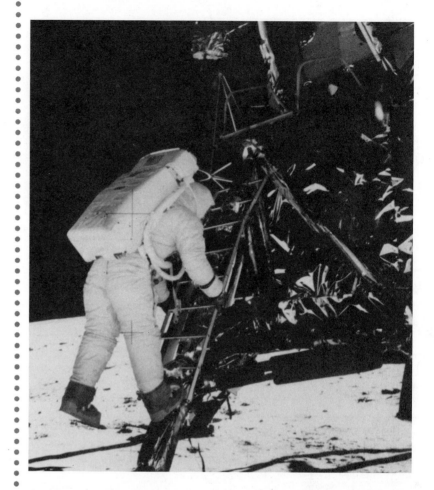

Figure 1.5. Astronaut Edwin E. Aldrin descends the steps of the lunar module ladder as he prepares to walk on the moon. Fellow astronaut Neil Armstrong took this photo of his colleague. (UPI/Bettmann)

news story as a devastating earthquake rocked San Francisco's Candlestick Park and much of California just as ABC began pregame broadcasting before the third game of the 1989 World Series. Live coverage showed people toppling the Berlin Wall, ending Soviet control of East Germany, and challenging it in Eastern Europe. And a succession of dramatic moments in the Persian Gulf War were depicted in live television sound and pictures of reporters and camera crews fumbling with gas masks as they described missile attacks taking place at that exact moment half a world away from Americans transfixed by the scenes they were witnessing (Figure 1.6; and Box 1.1). The list is long. Nearly everyone can relate personal experiences in their lives that were made dramatic and memorable by the power of broadcasting.

Today the "romance" is gone that once stirred the imaginations of people huddled over crystal sets, plucking distant sounds from the "ether." We now take for granted our ability to tune into events anywhere in the world. But

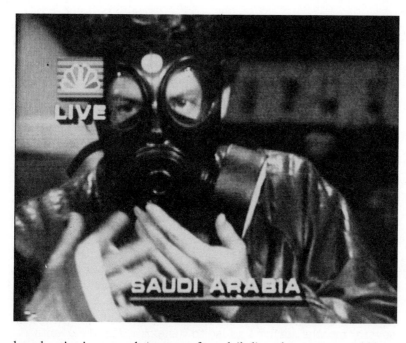

Figure 1.6. NBC correspondent Arthur Kent reporting live from Saudi Arabia during an air-raid alert at the beginning of the war in the Persian Gulf. Television viewers shared the drama and uncertainty reflected in the use of the gas mask by a correspondent uncertain of the level of danger involved in covering the event. (Photo courtesy NBC)

broadcasting is an even larger part of our daily lives than anyone could have imagined in its earliest days. Radio and television have become our eyes and ears on the world. We stay in touch as we drive, jog, and vacation. Cut off from this link with events, we feel deprived.

Given the amount of time we spend listening to and watching broadcast media, and given their influence on our lives, it's remarkable to realize how recent these developments are. And we do not yet fully understand how these developments have shrunk our globe and changed our prospects.

The discovery of electromagnetic waves by nineteenth-century German physicist Heinrich Hertz forms the basis of radio and television broadcasting. Guglielmo Marconi perfected the device that would allow the Hertzian waves to be put to such use. Working in Britain, the Italian inventor and businessman refined the technology, acquired patents, and set up an organizational structure to explore commercial applications for electromagnetic waves.

At the turn of the century, the closest thing to instant communication was the telegraph. Marconi's development of radio communication in the early 1900s was viewed simply as a way to remove the need for wires in telegraphy. So the term *wireless* was applied to Marconi's radio technology.

One outgrowth of Marconi's work was ship-to-shore communication. When Marconi expanded his operations from Britain to the United States, this application of his inventions held the major promise of commercial success for his firm.

A Historical Overview

B O X 1 . 1

Television in the Gulf War

On January 16, 1991, millions of people spent hours in front of their television sets watching a map. It was a map of Baghdad, and the audio portion of the program was coming through a telephone pickup of three CNN correspondents who were describing what they could see from the windows of their room in the Al Rashid Hotel. The fact that the visual portion of the program was nothing more than a map made no difference in the level of interest that viewers felt. It was the words of the eyewitnesses that kept viewers riveted to their television sets over the course of several hours.

What the CNN reporters were seeing and describing to viewers worldwide, was the outbreak of the air war against Saddam Hussein's Iraq. Saddam's annexation of Kuwait several months earlier had led to the extraordinary events now being described to a worldwide audience. Television was letting millions of viewers get some inkling of what it was like to be under attack by allied bombers.

As they crouched on the floor and held the mic out the open window to pick up the sounds of the bombs, these three reporters were also letting those who planned the attack know whether their plans were succeeding. This was made abundantly clear in a news conference that same evening when the Secretary of Defense responded to a question by stating that he was getting his information from CNN.

The experience was unique in human experience. For while the broadcast media have long been able to involve audiences in major events, never before had the event been the outbreak of war. CNN and to an extent the major broadcast networks had been heading for this kind of coverage. There were live reports from the Berlin Wall and Tienanmen Square. But the onset of the Gulf War was a precipitous moment in history whose precise outlines had been only vaguely outlined prior to the actual initiation of bombing. There had been uncertainty about when and if the allies would attack the Iraqis, and if so, how they would do it.

As the war unfolded, CNN and the broadcast networks

brought to their viewers a succession of reports that essentially changed the nature of news as it relates to the question of how the public becomes aware of events. Correspondents who came on the air in Riyadh, Saudi Arabia, or Tel Aviv, for example, to report on SCUD missile attacks were never sure of whether missiles were actually coming in, how many there might be, and whether or not they contained chemical warheads. Gas masks, if not actually donned, were handy. Often reporters and camera crews broke off coverage to take refuge in shelters. But what did this mean for viewers in terms of how the war was experienced?

It often meant that information came to us in raw form. The usual processes of television news reporting, in which information is gathered, evaluated, confirmed, and *then* reported, were absent during the live reports. Rumor and unconfirmed information were reported as soon as reporters learned of them. For example, it was reported at one point that chemical warheads had been used in some of the first SCUD missile attacks. Eventually it was learned that the missiles had conventional warheads. Once that was known, it was reported immediately. But some viewers received that information sooner than others, depending on which network they were tuned to. Some viewers likely turned off their sets before the networks learned the truth. They may well have been misinformed on this aspect of the SCUD attacks for quite some period of time.

So we have seen television take on a new role. The immediacy, which serves so well to involve us in events as they take place, means that we must be more sophisticated in how we use the information we receive through television. We need to assume a certain skepticism when we receive live news reports. There is a chance, indeed in some cases a likelihood, that what is reported may turn out to be false.

In making judgments about the significance of events thus reported, we are one step further removed than we have previously been from having solid information to work with. We must now make an extra effort to determine that the reports we have seen and heard are true before we accept what we have learned through broadcast news reports.

This newly learned skepticism about news broadcast reports can serve the public well if it also develops a tendency

(*continues*)

Box 1.1 (*continued*)

among citizens to take more responsibility in making sure of information before acting on it. In that sense, perhaps we can thank the technology that allows television journalists to let us experience events instantaneously, for necessitating and developing a new sophistication among news consumers that will raise the level of public discussion among television viewers worldwide.

For the broadcast performer, immediacy in news coverage simply means that in live reporting information will sometimes come to you at the very time you are on the air reporting on a story. There may be no immediate way to check on the accuracy of some of the reports you receive. In such circumstances it becomes necessary to exceed the normal journalistic requirement to provide complete information in a timely fashion. It becomes your additional task to fully inform viewers and/or listeners of the nature and quality of the information you report.

When the ocean liner *Titanic* sank in the Atlantic in 1914, the ship-to-shore wireless allowed the American public to read in their newspapers about the rescue efforts shortly after they occurred. A young wireless operator, David Sarnoff, sat for long hours at his telegraph key and relayed information from rescue ships to eager newspaper reporters.

When the firm called American Marconi later became RCA, and Sarnoff became its head, he predicted that radio would become a "music box" that would bring quality entertainment to people far from cultural centers.

Radio's development into Sarnoff's music box was spurred by an invention developed in 1912 by Lee de Forest. De Forest's Audion tube allowed radio to go beyond its role as a wireless telegraph. It was easy to impose on radio waves the simple on-off changes necessary to transmit the dots and dashes of telegraphy. But enabling the medium to carry and then reproduce voice and music was much more complex. De Forest's work made the breakthrough.

Extensive application of de Forest's invention began in the era immediately after World War I. The Roaring Twenties were on the horizon. The straitlaced Victorian era was fading, and the "jazz age" was dawning. Many radio sets were the playthings of technically skilled tinkerers, but radio equipment was being manufactured for the home, as well. Soon nearly every family could tune in to the sounds of this exciting era.

Schedules in those days were hit or miss, and programs always originated from a studio. Broadcasters took their role very seriously, and in fact it was common for performers to wear formal clothes when appearing before the microphone. Guest performers were brought in to fill up the broadcast hours. All programs were live. So that performers would not be intimidated

by the technology, studios were usually richly furnished to look like sitting rooms (Figure 1.7). The microphones were often concealed among large house plants, and the term "potted palm era" became a slang designation for this period.

This period gave birth to commercial radio. "Leasing" a radio station's airtime for delivery of a commercial message first took place in New York City on August 28, 1922. A talky spiel broadcast over WEAF promoted a real estate development in Jackson Heights.

While radio was developing, networks also evolved as distinct entities. By connecting stations and broadcasting the same programs simultaneously, networks could offer high-quality programming on a regular basis. From the stations'

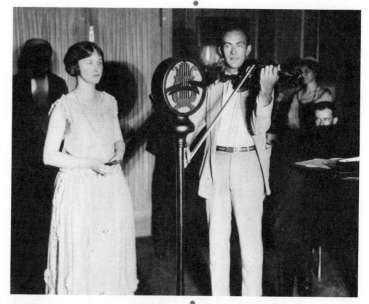

Figure 1.7. Old-style radio studio. (Photo courtesy of the National Broadcasting Company, Inc.)

standpoint, networks were what was needed to fill the long program hours that so quickly drained the resources of local operations.

Networks soon dominated radio programming. The first network, NBC, was developed in the 1920s and evolved into two separate arms, known as the Red and Blue networks. NBC Blue later split from NBC and became ABC. CBS started up in 1928. The networks occupied much of the attention of the U.S. radio listening audience for many years.

As radio developed through the 1930s and 1940s, its promise as a commercial medium ripened. Early advertising in radio used such devices as naming a performing group after the sponsor's product. Every time an announcer introduced the Cliquot Club Eskimos, the sponsor was mentioned. This soft-sell tactic was much favored over the less dignified direct product pitch. But there were sometimes gross advertising excesses. Bizarre items such as Dr. Brinkley's Famous Goat Gland Medicine and other products were extolled in terms reminiscent of snake oil pitches.

Since then, advertising has dominated the broadcast media. Advertisers associated with stars, and products became known through catchy musical jingles. During radio's heyday in the 1940s and early 1950s, the distinction between program production and advertising was blurred. Advertising agencies actually *produced* much of the programming, which was then delivered through the facilities of the stations. And advertising developed the one type of program most closely associated with this era of radio broadcasting. The soap opera still bears the name of its advertising connection.

Soap operas efficiently solved a major problem confronting the broadcast media, namely, the need to fill hour after hour of program schedules with entertainment that would attract audiences. The soap opera let writers work

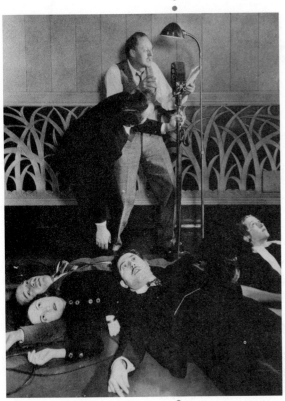

Figure 1.8. (Left) Radio drama enacted in NBC radio studio with the aid of a sound effects man and groaning victims (on floor) on "Lights Out." (The Bettmann Archive)

(Right) William Conrad, who went on to television fame in "Cannon" and "Jake and the Fat Man," starred on the radio version of "Gunsmoke," which aired on CBS radio. (The Bettmann Archive)

with a basic formula in which a situation was established and developed daily. All that was required was to introduce plot changes in the lives of the characters and to write dialogue that told the story. The extraordinary audience appeal of these imaginary everyday people made the soap opera a staple that has expanded to daytime television and now is a mainstay of evening television as well.

Radio programs of the 1930s and 1940s consisted of the various program types that we see today in modern television. Comedies like *My Friend Irma,* drama like *Lights Out* and *The Goldbergs,* and westerns like *Gunsmoke* (Figure 1.8) made up much of the evening programming schedules of the major radio networks.

Many of the most popular programs were sponsored by a single advertiser whose product became associated with the program. Many of the top radio programs were produced by the advertising agencies that handled the advertising of the sponsors. In time the networks had very little control over the programming they supplied to their affiliated stations.

The close association of advertiser and program production and the lack of supervision by broadcasters led to a crisis in the 1950s. The public found out that some ad agency-produced TV quiz programs were rigged by sponsors, producers, and agencies that wanted to inject more drama and excitement into the shows. When the quiz scandal was uncovered, the advertising community lost much of its control over the programming function of broadcasting. And the broadcast industry became more involved in the content of its programs.

Radio journalism initially met resistance from newspapers. Publishers

feared that if people could listen to news on radio, they would stop buying newspapers. Although that situation never developed, radio news did take on great impact in the uneasy days before and during World War II. The ability to transport the listener to the scene of an event and to hear the voices of newsmakers "shrank" the globe and led to a growing awareness that *nations cannot live in isolation from one another.* This revolution in thinking led to the development of the modern broadcast media.

The people who filled the airwaves with their talents created a tradition in early broadcasting. They developed a specialty that had roots in show business.

The announcer was part salesperson, part master of ceremony, part sophisticated worldly interpreter. Early radio announcers performed a wide variety of tasks. The announcer had to read commercial and news copy, pronounce foreign names, be conversant with classical music, and be knowledgeable about current performers and musical trends.

The announcer was expected to be witty and sophisticated, and was perceived as performing, rather than talking, when doing his job. By the mid-1930s radio broadcasting had become the era of the golden-voiced announcer. A deep male voice was considered essential for success in radio.

Delivery was stylized and emphatic. Announcers used a distinctive and instantly recognized style of speaking *that was heard nowhere else but in radio.* Anyone who talked like an announcer in normal conversation would have been considered rather strange, to say the least. Yet this style was expected and demanded on the air.

▼

The ability to transport the listener to the scene of an event and to hear the voices of news-makers "shrank" the globe and led to a grow-ing awareness that *nations* cannot live in isolation from one another.

The First Announcers

How the Modern Media Evolved

By the end of World War II, broadcasting had begun to change dramatically. The emergence of television directly led to developments that characterize contemporary broadcasting.

Television, which became a major force in the early 1950s, turned out to be much more than radio with pictures. It was a revolution in the lives of Americans everywhere. While radio engaged our imaginations and provided stimulus for the theater of the mind, television allowed us to react with less involvement. It filled empty hours effortlessly. By merely turning a knob, one could be in direct visual touch with arresting activity that occupies the senses.

And what about radio after television captured the U.S. psyche? Many observers felt the radio was on its deathbed. They argued that sound alone could not compete with sound and pictures. The program forms that had been the bread and butter of radio were being usurped by television.

But radio found a new role, a new application of Sarnoff's music box theory. By specializing on the modern availability and popularity of recorded music, and making this music available to the public day and night, radio emerged as a healthy new entity. At the same time, radio news evolved into a short format. News was given in brief doses at frequent intervals so that listeners could tune in and quickly hear about developments. The public, meanwhile, found that radio could go anywhere, and the medium became a constant companion, keeping the listener company during driving, picnicking, or studying.

As radio flexed its muscles in this new role, it learned to appeal to advertisers more effectively by targeting specific audience segments. The music selected for programming could attract one segment of the mass audience, which could then be delivered efficiently to advertisers who wanted to reach this group with a specific message.

Developments in Announcing

Announcers of this era began to break away from the stilted formality that had characterized the medium in the 1930s and 1940s. The disc jockeys of the 1950s took their lead from radio personalities like Cleveland's Alan Freed and Philadelphia's Dick Clark. The style was fast paced. The D.J. became one of the many sound elements that made up a steady stream of sound that came to be widely known as Top-40 radio.

The energy of the style captured the imaginations of American youth and became a focal point of a national youth culture. Rhythm and blues music merged with "hillbilly" music to form rock and roll.

And the role of the radio announcer changed. The D.J. became an architect of fun. It was his job (the field was very much male dominated) to inject energy. Rather than merely inform listeners about program elements, it became the announcer's task to fill the spaces between records with zany patter and a fast-paced delivery of time, temperature, and weather interspersed with information about the music and performers that dominated the airways of Top-40 stations.

The traditional announcer-host remained a fixture of many stations until the early 1970s. The style of this type of on-air personality was much the same as the announcer of the 1930s and 1940s. As the youth culture came to dominate broadcasting, however, the traditional announcer became rare. Today the only vestige of the sophisticated man-about-town style is in the nostalgia sound, typified by the "Music of Your Life" format.

The imprint of the early rock D.J.'s has carried forward into the style heard on modern stations that program the contemporary hit radio (CHR) format.

Meanwhile, television became the mass entertainer, offering something to everyone. At both the local and national levels, news has developed as an entertaining and money-making product appealing to a broad audience. Situation comedy, adventures, and other kinds of entertainment rivet vast audiences, and families today gather around an electronic hearth, which one astute social observer has termed "the cool fire."

Current Trends

Today's technology promises to improve the media and the number and variety of program forms that exist. The emergence of the videocassette recorder and the increasing abundance offered by cable and satellite technology provide an array of choices.

It seems safe to predict that modern developments and technology will reinforce certain trends that have emerged:

1. *More program choices, and increased specialization of the programs themselves.* Business reporting, for example, has developed into a distinct specialty, and certain cable and broadcast outlets offer extensive segments devoted to it.
2. *An increase in the importance of one-to-one contact between announcer and audience, especially in the supersegmented radio markets.* With this development comes the continued decline in the use of the stylized "announcer voice."
3. *The ongoing regulatory debate that seeks to define the range of expression permissible on broadcast media.* The questions of what constitutes indecency and whether or not such regulatory agencies as the Federal Communications Commission (FCC) can establish standards that don't trample on constitutional guarantees of free expression can affect the program content of both radio and television. Broadcasting that pushes the limits of such expression is likely to experience increasing pressure from the FCC and Congress to conform more closely with the standards of decency shared by the American mainstream.
4. *The ever-increasing importance of news, especially live news.* Technological advances, including portable transmitting units and compact audio and video gear, make further inroads into on-the-spot news coverage more likely and place additional demands on announcers' ad-libbing skills.

These and other trends have a strong impact on all segments of the broadcast industry, but they relate specifically in a number of ways to the on-air performer.

The Era of the Communicator

This book focuses on the communicator in the broadcast media. We use the term *announcer,* because it remains in common usage and still serves in industry job descriptions.

Eventually this outdated term will be replaced. A modern on-air performer does not simply announce. He or she entertains, converses, informs, and provides companionship, but very rarely proclaims a program element in the formal, stylized way of the old-era announcer.

The Communicator's Role

Today's on-air broadcaster is a *communicator,* a catalyst for a message. Whether the message is news, commercial copy, an interview segment, or a game show, the task of the communicator is to serve as a conduit for communication between the originator of the message and the audience.

The traditional announcer with the stylized delivery is no longer the backbone of the industry. He has been replaced by professionals who can convey greater intimacy, the image of a real person rather than a disembodied voice or a talking head.

A program director of one major market station, for example, wants air personalities to come across as "next-door neighbors." Another broadcast executive disdains the type of performer who speaks, as if from a pulpit, "to everyone out there in radio-land." One television news director specifies that staff members must show credibility and generate trust.

The communicator in the modern media must use more than good diction and appearance, although these qualities are undeniably important. He or she must also use qualities of personality and physical presence in the job. In addition to being adept at conveying the facts, a news reporter must show that he or she understands the story and is a trustworthy source of news, while communicating the story in a way that holds audience attention.

A communicator-announcer doing a radio commercial can no longer get by with the stylized, rhythmic affectations of the announcers of radio's golden age. Most announcers today are asked by producers of commercials, for example, to sound natural. That means that the delivery, as such, should not be noticeable. The ideas are what are important, and the announcer's job is to *interpret* and *communicate* them, not *announce* them to all those people in radio-land.

On-air jobs today frequently call for specialized knowledge and skills. In the radio of the 1930s and 1940s, the same announcer was sometimes expected to host an interview show, do a classical music program, deliver commercials, introduce various types of programs, and read the weather report. Today's broadcast communicator usually is assigned a much more narrow range of tasks.

For example, if an early-era announcer had to introduce classical music pieces during a short segment of his shift, he was expected to pronounce properly the names of the works, the composers, and the artists. But a modern radio announcer rarely encounters a brief segment of classical music. If classical music is played, it is generally within the entire format of the station, and the announcer has been hired partly because of his or her in-depth knowledge of the music, its history, and the styles of particular artists. Mere knowledge of pronunciation is not enough. Duties of a modern radio announcer do vary widely, especially in a smaller station, but the tasks are confined to a more focused area. Television on-air duties are typically even more sharply defined than in radio.

This is not to imply that you can succeed by becoming a specialist in one area and learning nothing else. A generalized background is important, for reasons that are pointed out throughout this text.

Jobs may overlap, especially in smaller stations where a radio staff announcer may double as a TV weather anchor. As you advance in market size, your duties will generally become more specific. Primarily, though, most on-air jobs fall into six basic categories (see Box 1.2).

A communicator has a great deal of responsibility, both to the employer and to the audience. Much has been made of the potential of broadcasting to be manipulative. A variety of industry standards and government regulations address this issue.

Responsibilities and Ethics

Like professionals in most fields, the broadcaster must follow principles and standards that guard against misuse or abuse of the power and influence of the media. Considerations of accuracy, fairness, honesty, and integrity apply not only to broadcast journalism, where they are paramount, but to all on-air operations as well. These considerations are discussed as they apply, throughout the book.

Preparing for a career as an on-air performer begins with an honest appraisal of talents, qualities, and abilities. Strengths and weaknesses must be examined honestly; this is no time for rationalization and excuse making. Make a sincere effort to discover whether you have what is needed to succeed as a broadcast communicator.

A Career Self-Appraisal

It is no disgrace to decide early in life, after a candid look at yourself, that on-air work is not for you. The broadcast announcing course in which you are now enrolled will be the first indicator. If your performance is excellent to outstanding, you stand a chance in this highly competitive field. Keep evaluating yourself as you work through the course and through this text.

Do You Have What It Takes?

Physical Requirements Experience and critique will tell whether you have the physical tools necessary to succeed. For example, although a deep

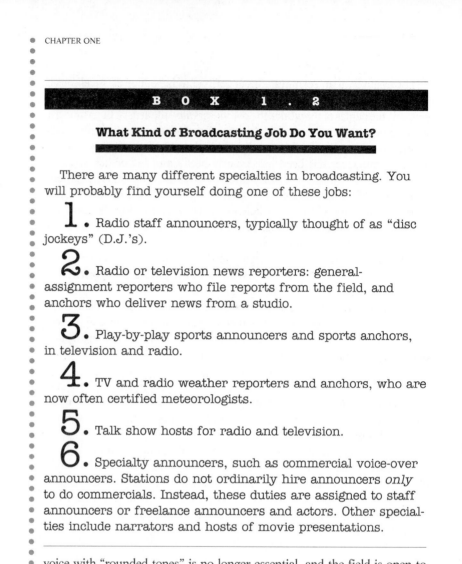

B O X 1 . 2

What Kind of Broadcasting Job Do You Want?

There are many different specialties in broadcasting. You will probably find yourself doing one of these jobs:

1. Radio staff announcers, typically thought of as "disc jockeys" (D.J.'s).

2. Radio or television news reporters: general-assignment reporters who file reports from the field, and anchors who deliver news from a studio.

3. Play-by-play sports announcers and sports anchors, in television and radio.

4. TV and radio weather reporters and anchors, who are now often certified meteorologists.

5. Talk show hosts for radio and television.

6. Specialty announcers, such as commercial voice-over announcers. Stations do not ordinarily hire announcers *only* to do commercials. Instead, these duties are assigned to staff announcers or freelance announcers and actors. Other specialties include narrators and hosts of movie presentations.

voice with "rounded tones" is no longer essential, and the field is open to women as well as men, an announcer does need a certain amount of vocal strength and a versatile voice with a pleasing quality. Severe speech impediments or voice problems must be evaluated realistically. If uncorrected or uncorrectable, they will limit your chances of success.

Poor appearance—to which obesity, bad teeth, and skin problems contribute—will certainly interfere with advancement in television. Overall poor health is a detriment on the air because the work is physically taxing and the hours demanding.

Educational Requirements An area to evaluate as soon as possible is your educational preparation. Most broadcasters who hire talent advise that it's important to be broadly educated. Some people who aspire to broadcasting careers make the mistake of concentrating on narrow, vocational courses.

But to be an effective communicator, you need to be able to discuss and recognize concepts from a variety of disciplines. The news reporter who is ignorant of political science and history will sooner or later misunderstand a story element and blunder badly on air. A radio announcer who doesn't know how to pronounce and use words will often appear foolish. *Both these flaws will hinder careers,* as will any on-air betrayal of a lack of education.

Whether gained through formal training or through reading and life experience, education is the best tool for success in this industry.

Also, the ability to write well—an outgrowth of the total educational process—is essential for almost all broadcasters.

Emotional Requirements Whether you are meeting a deadline for a news story or coming up with a funny ad-lib during a music program, you're sure to find stress in broadcasting. For one thing, your job will typically be performed before thousands of people, and that creates stress. Second, "time is money" in broadcasting. Tasks must be performed quickly and accurately to avoid retakes. Broadcasting is a constant race against the clock, and the clock never loses. An announcement slated for 5:59:30 P.M. must be made *precisely* at 5:59:30, and in most cases it had better be finished exactly at 6:00:00 because that is *precisely* when the news is fed from the network.

The ability to handle stress of this magnitude is critical, because for some people stress problems can become emotionally crippling.

It is also important to look honestly at the broadcast industry as a career field, a field that has been described variously as a golden path of opportunity and as a virtual snake pit.

Nature of the Business By its very nature, commercial broadcasting is a money-oriented industry. Depending on the level at which you work, you may be paid very well or very poorly. Job security is not particularly good in the industry in general, and it is especially poor for on-air performers. Except for noncommercial radio and television, ratings are money. (Ratings and market studies are also becoming increasingly important to public broadcasting programmers and fund-raisers.) As an on-air performer, you must produce ratings, and you will be looking for work if those ratings don't materialize. To add to the problem, consider that the situation is not always fair: a performer with good on-air abilities may be poorly rated because of inept station programming or an unfavorable time slot. Or you may come to work one day and find that the station has been sold to new owners who plan a new format, or that budget cuts have eliminated your job. We have talked with several young television newspeople who were ready to get out of broadcasting because of the uncertainty and insecurity of the field. One news producer had just been hired as part of a "new commitment to news" at a medium-market television station. Three weeks after leaving his former job in another part of

Is Broadcasting for You?

the country, he was called in by his new employers and told that his job had been eliminated because of budget cuts.

Careers can take off quickly and rise steadily. You may also, however, find yourself waiting for that big break for years, traveling from station to station. Sometimes that big break comes. Sometimes it doesn't.

Benefits and Drawbacks On the plus side of broadcasting as a career is the sense of importance and the degree of celebrity status that accrue even at lower levels of the business. It is also a job that gives a lot of personal satisfaction, a job that many people do for free.

In the highest levels of broadcasting the money is excellent, and it is not uncommon to make a good living at the medium-market level. As large corporations increase their involvement in the broadcasting industry, fringe benefits and salaries have been improving at all levels. It is not as common as it once was for radio stations to be staffed entirely by those willing to work at minimum wage, but minimum salaries do exist in small markets nevertheless.

Those who make good salaries have climbed a vast and heartless pyramid. For every announcer in Boston or Chicago, hundreds or thousands of announcers work for poor salaries in small markets while waiting hungrily for an opportunity to move into the big time.

A Realistic Evaluation Any on-air person knows that there's no greater feeling of accomplishment than that generated by those good days, those magic moments. But there are lows for most of the highs. Hard work may or may not be rewarded. The excitement of the business may make every day a new challenge, but stress may take a serious toll.

So how do you make a choice? There is no pat answer, but we sincerely hope this book will help you decide. When you have finished the chapters and exercises, you should have a realistic picture of what is required and where your particular strengths and weaknesses lie.

If you decide to pursue the profession of on-air broadcasting and performance, you will be entering a field that offers tough standards but wonderful rewards. You, too, will feel the unparalleled excitement of participation in important and significant moments.

The world of broadcasting, in fact, is a great succession of moments, like the ones Edward R. Murrow transmitted in the dark days of the Battle of Britain, and in the social drama reflected in television images of women reservists leaving husbands and children for military duty in the Persian Gulf. Those moments have been captured by a system of modern media that is stunning in its capabilities: we can be anywhere on the globe in an instant, and never be out of touch with entertainment, companionship, or news.

2

Improving Your Speaking Voice

▼

Most good broadcast voices are made, not born.

Most good broadcast voices are made, not born. True, many announcers have an extra share of native talent, but most of us learn effective vocal skills by practice.

This chapter lays a foundation on which you can build a clear, powerful, and professional-sounding speaking voice. After you have learned mechanics of posture, projection, and diction, you'll be able to practice those fundamentals not only during classroom sessions, but lifelong, on the job.

These mechanics are important, because a good-quality voice is an entry-level qualification for almost any on-air position. In broadcasting, voice quality is one of the first points on which people judge you. In radio, it is just about the only one. Your voice is what you *are* to the listener. This text steers clear of the "rounded tones and golden throat" approach to broadcasting, but having a pleasing voice *is* important. Remember that the emphasis is on a *pleasing* voice, not necessarily a deep, booming, overpowering voice.

Talent coach Bill Slatter points out that "with very few exceptions, the successful broadcaster has learned, one way or another, to speak well. His or her speech is usually free of marked regional accent, and his articulation is clipped and understandable."[1] Slatter notes that top network anchors and

[1]"By Their Speech You Shall Know Them," *Communicator,* April 1989, p. 51.

reporters have refined their speech over a period of years, by conscious effort and practice.

This chapter suggests ways to make the most of your voice, to use it as effectively as possible. We also discuss ways to eliminate problems that could disqualify you from on-air employment, such as diction problems, poor voice quality, and regionalism.

And we explain how to protect your voice from abuse by relaxing the mechanism. This technique also improves voice quality.

Voice instruction is worthwhile for anyone who speaks for a living, and it is of prime importance to an announcer. Often, voice and diction receive cursory treatment in broadcast performance courses. One reason, perhaps, is the feeling that the only way to deal with speech and voice problems is to get the help of a professional therapist. And it's true no broadcasting text could possibly cure stuttering or a severe speech impediment. For such disorders, consult a speech pathologist.

However, many problems broadcasters face are simply the result of bad habits, and this is where a full treatment of the subject can be beneficial. You *can* improve the quality of your voice by practicing some easy exercises. You *can* make your diction more crisp by acquiring an awareness of common problems and by practicing with a tape recorder. Many of the solutions are simple.

How Your Voice Works

The vocal mechanism is a marvelous device and has certainly come a long way from the early days of human evolution, when the apparatus was primarily a sphincter that could be manipulated to form a grunt. We can still grunt, but we can also use the vocal apparatus to form an incredible range of sounds.

When you are working on exercises to develop your voice, it helps to know the structure you are using. For instance, tightness in the throat can be more easily overcome if you understand the musculature of the region. In diaphragmatic breathing, it's important to understand just where the diaphragm is and what it does.

There is no need to memorize all the structures of the breathing and vocal apparatus, so we show only the basics. For further information, investigate the classes in basic speech production, almost certainly available in your institution. In addition to classes in normal speech production, you will benefit from exposure to singing instruction, even if you entertain no ambitions as a singer and have no talent for singing.

The Vocal Anatomy

The mechanism that produces your voice is tied to your respiratory system (Figure 2.1). This is important to know for a number of reasons, not the least of which is the action of your diaphragm. Your lungs extract oxygen from the air, but they don't suck air in or propel it out. That function is performed primarily by your diaphragm, a muscle that extends across the base of your chest. It is connected by fibers and tendons to your sternum (breastbone) in

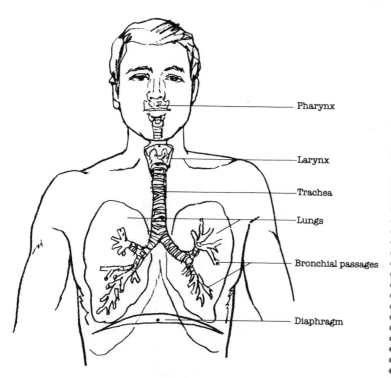

Figure 2.1 How you breathe.

Pharynx

Larynx

Trachea

Lungs

Bronchial passages

Diaphragm

front, to your ribs at the sides, and to your vertebrae in back. When you inhale, your diaphragm contracts, pushing your intestines down and out. That is why your abdomen should expand when you breathe in. When you exhale during speech, your diaphragm relaxes and is pushed upward by your abdominal muscles. Air in your chest cavity is compressed and forced out through your *trachea.*

The trachea is the airway leading from your chest to your *larynx.* The trachea is the point at which a number of airway tubes, including the bronchial tubes, are joined together. Bronchitis is an inflammation of the bronchial tubes, and through experience with this common malady, most people are keenly aware of the location of the bronchial tubes.

The larynx (Figure 2.2a) is often called the "voice box." The larynx is cartilage, a tough, somewhat flexible and gristly material. Several different cartilages make up the larynx. The most important are the *thyroid* cartilage, which protrudes from the neck and forms what we call the "Adam's apple" (larger in men), and the *cricoid* cartilage, which connects to the thyroid cartilage. These cartilages form a roughly tubular structure in which the vocal cords are suspended.

The vocal cords—more properly called vocal folds, since they're not really cords—are membranes that come together across the cavity of the larynx. There are two folds, and during the process of producing voice, known as

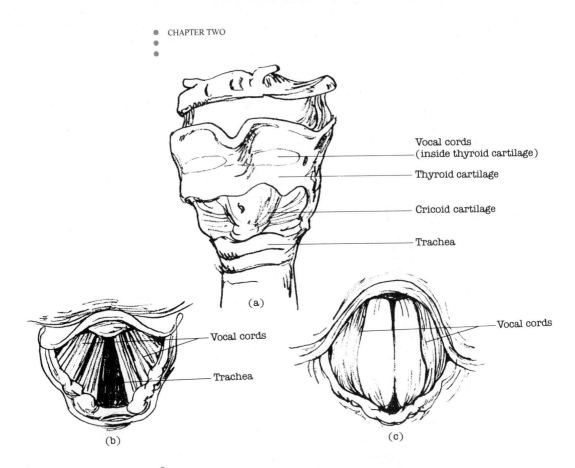

(a)

(b)

(c)

Figure 2.2.
(a) The larynx. In this roughly tube-shaped structure, vocal cords are suspended across the tube.
(b) Vocal cords open during quiet breathing. This is the view you would have looking directly down someone's throat.
(c) Vocal cords closed during phonation.

How Voice Is Produced

phonation, they stretch across the cavity. The easiest way to visualize the vocal cords is to see them as if you were looking down someone's throat, as shown in Figure 2.2b.

A number of muscles contribute to speech. The *intrinsic* muscles of the larynx are entirely contained within the larynx. The *extrinsic* muscles are outside the larynx and serve in speech, singing, and swallowing.

Above the larynx is the *pharynx,* the part of the vocal tract that exits into the mouth and the back of the nasal passages. Constricting muscles in the pharynx can close off the respiratory tract above the back of the throat. The pharynx connects with nasal passages above the back of the throat, the part of the throat you would see if you stuck out your tongue and looked in a mirror.

During normal breathing, the vocal cords are relaxed and are some distance apart, as pictured in Figure 2.2b. But during phonation, the folds meet and actually impede the flow of air through the larynx (Figure 2.2c). Air escapes through the folds in short bursts only hundredths or thousandths of a second in duration. These bursts cause vibrations in the air. Combinations of tension and air pressure on the vocal cords produce various pitches and loudness.

Each small vibration is amplified to produce voice in the same way a brass

instrument amplifies the sound from the mouthpiece. If you took the mouthpiece off a trombone and blew through it, it would produce only a weak, high-pitched squawk, the direct vibration of your lips. But when the mouthpiece is attached to the trombone, the acoustics of the instrument's piping cause an entire column of air to vibrate. Because of this effect, the musical note is heard, full of resonance and power. Likewise, a violin string just produces a scratchy noise when vibrated all by itself. The sounding board and the internal resonance cavities of the violin augment the sound of the string to produce a full, rich tone.

Roughly the same effect occurs in the human voice. The mouth and nasal cavities act as resonators, enhancing some of the harmonics (overtones) of the voice. Even the sinuses and the bones of the skull act as resonators.

Resonation in the nasal cavities is most apparent during the pronunciation of so-called nasal sounds, such as *m, n,* and *ng.* This becomes apparent when you close your mouth and hum; where does the air escape? The buzzing sensation of humming shows that you are producing resonance in the nasal passages.

You don't pass air into the nasal passages all the time. But nasal cavity resonance while saying *m, n,* and *ng* can enhance your voice. Resonance along the entire vocal tract enhances the quality of your voice.

Methods of developing resonance and other qualities of a pleasing voice are discussed later in the chapter.

It is worthwhile to make a clear distinction between voice and speech. Basically, *voice* is the vibration that emerges from the vocal cords and from resonance along the vocal and nasal tracts. *Speech* is how that sound is shaped and arranged within the mouth. The term *speaking voice* applies to the whole effect of voice and speech.

Making an honest evaluation of your voice and speech is one of the most productive things you can do in your career. Any voice or speech deviation is a handicap. Some performers have succeeded in spite of such deviations, but that is rare.

Evaluate your voice and speech with a tape recorder and, ideally, with a knowledgeable instructor, speech–language pathologist, or vocal coach. You can start with Box 2.1, the Self-Evaluation Checklist at the end of this section. It is difficult to critique yourself. You hear your own voice through bone conduction or vibration, whereas others hear your voice after it has traveled through the air. Remember the first time you heard yourself on tape? The difference between *your* perception of your voice and the actual playback was probably startling.

But tape playback also has its limitations, because we don't discriminate our own speech sounds with precision. Even people with severe lisps sometimes cannot tell they have a problem unless they are trained to listen critically to a taped playback.

Take advantage of critique from instructors and colleagues to identify

Evaluating Your Voice and Speech

▼

Making an honest evaluation of your voice and speech is one of the most productive things you can do in your career.

problem areas, and listen critically to your tapes in an effort to develop self-critiquing skills.

Voice

A pleasing voice is helpful to a broadcaster, but an offensive voice is a real handicap. Voices that "turn off" listeners may result from problems in *quality, delivery,* and *breathing.*

Problems with Voice Quality Have your ever developed a negative image of someone on the other end of a phone conversation, someone you've never met but have pictured because of his or her voice? Gravelly voices, for example, are not pleasant to listen to and certainly are a detriment for most broadcasters. Here are some of the most common negative voice qualities, possible causes, and suggestions for improvement.

HOARSENESS: A raspy sound in the voice, often categorized as a voice that "sounds like it's hurting," is called hoarseness. This vocal sound may be a symptom of a pathological condition and should, if persistent, be checked by a physician. Most hoarseness results from overuse and improper use of the voice, such as cheering at a sports event, and can be compounded by too much tension in the vocal apparatus.

"THIN" VOICE: When a "thin," weak voice is the result of the way the vocal mechanism is formed, not a lot can be done about it other than to enhance the thin voice as best one can through good vocal habits. Often, though, a thin quality is the result of a lack of resonance. The two keys to increasing resonance are proper air support, including good posture, and relaxation. Also, chronic inflammation and swelling of the nasal passages can cut off resonance. (Try pinching your nose and talking; note how "weak" the voice appears.)

GRAVELLY VOICE: Whereas a hoarse voice typically has a strident "breaking" quality to it, the gravelly voice is usually low pitched, does not project, and is not melodic.

Gravelly voices sometimes result from a simple lack of projection. Note how gravel-voiced people often slouch and speak with the chin on the chest. Gravelly voices often result from speaking in a pitch that is too low. Better breath support, a higher pitch, and better projection can often ease this problem.

Problems in Vocal Delivery Even when the vocal and breathing apparatus is working properly, a voice can fail to be pleasing because of poor delivery. We'll define five typical problems and give possible solutions.

MONOTONE: Failure to change pitch results in a monotone delivery. *Pitch* is the listener's perception of the frequency of a sound (its relative highness or

lowness), as in the pitch of a note on a musical scale. A monotone can be extremely unpleasant to listen to, and conveys the impression that the speaker is bored and/or boring. Speaking in a monotone can also irritate the vocal cords. A speaker with a monotone should pay more attention to the nuances of the pitch rising and falling.

POOR PITCH: Some people try to talk out of their range, too high or, as is sometimes the case with male news reporters, too low. One effect on the voice is an unnatural quality. Speaking at an unnatural pitch opens the door for vocal abuse, and a problem that would-be basses don't consider is that constantly talking at the bottom end of their range limits the expressiveness of the voice. When you are at the bottom of the range, you can only go up. Finding a more comfortable and natural pitch often clears up the problem.

SINGSONG: A singsong delivery is characterized by a rhythm that rises and falls; it's a predictable voice pattern showing artificially wide and pronounced pitch swings—the "disc jockey voice." The problem isn't hard to eliminate once it has been recognized. Adopting a normal speech melody solves the problem.

ENDING PATTERN: Many people end each phrase or sentence on the same pitch or series of pitches. A voice pattern that becomes predictable is boring and can be distracting.

WHININESS: A whiny sound is often caused by speaking at a pitch that is too high and elongating vowels. "I toooooold you this would happen . . . look at the mess you've gotten us into noooooowwwwww." Awareness of whiny delivery is the first step in eliminating it, along with assuming a better pitch and shortening vowels. Whininess is also sometimes associated with an overly nasal delivery (too much air being diverted into the nose during speech).

Problems in Breathing Poor breath control and the related problem of poor posture are often at the root of an unpleasant voice. Even though breathing is an automatic function, there is some technique involved in breathing properly for voice production. The old gym class concept of "throwing your chest out" when you breathe is incorrect and counterproductive. It is the abdomen, and not the chest, that must expand significantly during inhalation for proper speech.

Here are some typical problems and suggestions for alleviating them.

BREATHY VOICE: The "Marilyn Monroe" or "breathy starlet" voice may be either a physical or a breathing problem. It can be caused by failure to bring the vocal folds together closely enough during phonation, so that air escapes while you are speaking. A common and more easily corrected cause of a breathy voice, however, is not having sufficient air reserves, so that the speaker "runs out of breath." More attention to proper phonation, proper

,42,041

LIBRARY
College of St. Francis
JOLIET, ILLINOIS

vocal tension, and possibly professional therapy are indicated, along with better posture and breath support.

VOICE WITH NO "CARRYING POWER": Often the result of inadequate support from the abdominal muscles, lack of carrying power is compounded by lack of projection. Projection is simply the process of sending vocal sounds out of your mouth. Breathe diaphragmatically, and pay attention to posture.

Speech

There are different ways to categorize speech problems, and our categorization is not the same as a trained speech pathologist would use. Instead, speech problems are discussed in terms of their occurrence and importance to the on-air talent.

The most common categories of sounds produced within the mouth and vocal apparatus are vowels and consonants. Among the consonants, different parts of the vocal apparatus are used to produce various sounds, including the following.

FRICATIVES: The source of these sounds is the gradual escape of air through a constriction in the mouth or vocal tract. Major English fricatives are *f, v, th, s, z, sh, zh,* and *h.*

PLOSIVES AND STOPS: An explosion of air (*t* and *d* at the beginning of a word) or suddenly stopping air flow (*t* and *d* at the end of a word) will produce these sounds. Major English plosives are *p, b, t, d, k,* and *g.*

FRICTIONLESS CONSONANTS: Included are semivowels, nasals, and laterals. Semivowels, *w, r,* and *y,* have a continuous, vowel-like quality in their pronunciation. An *l* sound is similar but is known as a *lateral,* because the breath exits from the side of the mouth. Another related type of sound is the nasal category: *m, n,* and *ng.*

When the sounds just described are omitted, distorted, added, or substituted for one another, speech problems occur. Here are examples of four typical deviations:

- *Omissions:* Dropping the *k* in "asked" so it sounds like "ast" instead of "askt."
- *Distortions:* Altering the *s* sound so that it comes out more like a *th* (lisp). Vowel distortions are also common, such as saying "pin" for "pen" or "min" for "men." Vowel distortions sometimes are traceable to a regional accent.
- *Additions:* Putting an *r* where it does not belong: saying "soar" instead of "saw."
- *Substitutions:* Saying *d* for *th,* as in "dese" and "dose" for "these" and

"those"; or *n* for *ng,* as "bringin.'" This is sometimes called "dropping the *g,*" an error that also shares some characteristics of an omission.

Difficulties in sequencing sounds constitute yet another type of deviation, defined as follows.

- *Fluency problems (stuttering and cluttering):* Stuttering is a problem of rate and rhythm that is best addressed by a professional therapist. Cluttering, as an informal definition, involves telescoping sounds together, saying "vejble" for "vegetable."

Omissions, distortions, additions, substitutions, and fluency problems are terms used to identify specific speech deviations. How do they relate to broadcast announcing? Specific speech deviations are components of these overall problems: sloppy diction, regionalism, and cluttering and rate problems.

Sloppy Diction Simple failure to pronounce sounds clearly is sloppy diction. Faults of this type include omissions, such as dropping the final *-ing,* which is a typical transgression. While "lookin'" might be acceptable in conversational speech, it is not usually acceptable on the air. Sometimes substitutions are simply the result of social or cultural diction habits, such as saying "dis" and "dat" instead of "this" and "that." Substitutions, though, often require professional therapy. A lack of knowledge about the language can lead to additions, too, although this is not strictly a diction problem. For example, the adjective form of "disaster" is "disastrous," not "disasterous." The proper word is "nuclear," not "noo-cue-lahr."

Poor diction is a habit. "Lip laziness" accounts for many cases of sloppy diction, and failure to move the lips and tongue enough for crisp diction is a habit that must be overcome.

Here are some guidelines to help you tighten up sloppy diction.

1. *Self-evaluate.* Listen carefully: do you say "pitcher" for "picture"? Practice correct pronunciations.
2. *Do not "drop" final endings.* Be sure to pronounce *-ing* with an *ng,* not *n.*
3. *Practice giving full measure to all sounds within words.* The word "beasts" has three distinct sounds at the end. Say "beasts," not "beese."
4. *Watch contractions.* Unless you articulate clearly, the negative form of a contraction may sound like the positive form. If the announcer doesn't clearly pronounce the *t* at the end of "can't," the statement "The mayor said he can't remember being told the funds were missing" could be understood as meaning the opposite of the way it is written.

Regionalism Regional speech is almost always a handicap to on-air talent. Yes, there are successful news reporters with New England accents, and radio personalities with southern drawls, but they *are the exceptions,* not the rule. A regional accent may even disqualify you from broadcast work in your hometown. In a city on the other side of the country, you may literally be laughed at.

The discussion of regionalisms and ways to eliminate regional pronunciation is continued in the section titled "Language and the Broadcaster."

Cluttering and Rate Problems Cluttering, or telescoping sounds, is different from sloppy diction because cluttering typically involves a problem with rate of speech and sometimes a lack of attention to communicating the message. The clutterer often jams words and sounds together because he or she is speaking too quickly. Many otherwise intelligible people become practically incoherent when they read aloud and rattle off the words at breakneck pace, with no phrasing. A clutterer who reads over the air frequently compounds the problem by just reading, not communicating. In other words, proper stress is not given to the words and phrases, so the reading comes out as a mashed-up jumble.

These deviations reflect problems in *articulation,* meaning the joining and juxtaposition of sounds and words, rather than simple *diction,* which usually refers to the formation of individual sounds.

Cluttering and rate problems are common for people beginning air work. They are most effectively handled by

1. Slowing down the rate of reading
2. Marking copy for effective understanding and delivery (shown in the next chapter)
3. Speaking clearly in an effort to communicate ideas, not just read words.

Fluency Limitations and the Broadcaster On-air performers who have fluency difficulties will have difficulty communicating effectively. If words are delivered at break-neck speed and articulation is poor, the effect is like hearing the music from a Broadway musical without the lyrics. The music may not sound too bad, but it is easy to miss the full meaning of the message that the writer intended to convey.

The broadcast announcer has a number of tools that can be used to help convey the full meaning of the words being read. If the rate is too fast or if articulation is poor, however, those tools don't get a chance to perform the functions they should. The effectiveness of *speech melody,* or *inflection,* is totally wasted if it flies by the listener too rapidly. Nuances of meaning are lost and the intended effect of the copy is diminished or eliminated.

An uneven rate of delivery can also cause inaccurate and inconsistent timing. When a television news anchor reads copy that leads into a taped news package, people in the control room need to be able to depend on a consistent

rate of delivery. To come up to the proper speed, tape must be started several seconds before the anchor completes the lead-in. So an anchor who slows down at that point will "step on" the opening of the taped segment.

In radio, the increased use of satellite automation means that timing must be more precise than ever before. On many stations in the past, a five-minute newscast could run over or under time by several seconds or more without anyone noticing. But if you know that the satellite programming will start exactly when the minute hand of the clock hits 12, you also know that five minutes is all you have. Anything less than that will create dead air. That tight limit also applies to reading commercial copy and items like station IDs, promos, and weather forecasts.

Similar requirements limit people who do narration and voice-over assignments. Timing must be an element of your delivery that you can control. You must often adjust your rate so that you convey meaning even when conditions force you to vary from your usual rate.

The bottom line is that if you want to be effective as on-air talent in almost any type of assignment, you must know how to read copy precisely to time. Some top professionals can take a piece of copy, ask the producer how much time he or she wants filled, and read the copy in one take so that it hits the time limit exactly. But most of us need some rehearsal first. You must find ways to practice timing so that you can hone your skills.

One effective exercise to improve timing is to divide a piece of broadcast copy into sections, to be read in a stated amount of time. Read the copy over and over until you are able to read through to the end in the designated amount of time. Here's how to set up the exercise.

Typed copy has about ten words per line, on the average. Sixteen lines of copy would be about a minute's worth at a reading rate of 160 words per minute—a generally good rate for broadcast announcers.

Take a piece of copy with at least sixteen lines, and mark the midpoint— eight lines down—with a mark that is easy to see. Place another mark at the end of the copy—sixteen lines down. Using a timing device that lets you easily see the number of seconds that have elapsed, read the copy through. See how close you can come to reaching the midpoint at 30 seconds. Did you complete the sixteen lines in 60 seconds? Practice this over and over with various pieces of copy. (You can use the copy in Appendix B of this text.) With practice, you'll find that you will develop an awareness of how to read the copy at the proper rate to make it fit the proper time frame.

The point we're making is simple. Don't assume that you can simply ignore speech problems in rate and timing. Your problems may not be severe enough to require professional attention, but even relatively minor difficulties can severely hinder your ability to interpret copy effectively. The exercises at the end of this chapter can help you identify any problem areas you may have. For more help, consult a speech therapist or one of the many books on voice improvement.

One of the most comprehensive books is Utterback's *Broadcast Voice*

Handbook.[2] Utterback has a wide background in voice and diction and has helped many professional broadcasters improve their vocal delivery.

Language and the Broadcaster

Using language well is obviously of paramount importance to the broadcaster. Unfortunately, there are no simple and all-inclusive guidelines for proper pronunciation and usage, and categorizing standards and definitions is very difficult. Scholars have debated the issues of dialects and standardized language for centuries without producing a completely definitive standard.

For example, what defines a dialect? In most basic terms, it is a variety of a language, but from what exactly does it differ? Is a certain dialect substandard? What is standard?

It is useful to look at the language issue in the most basic terms, the terms most directly related to on-air broadcasters. This discussion includes pronunciation, which is obviously germane to a chapter on speech and voice. Also important, and included in this chapter to complete the discussion of language, is an examination of usage.

Two common terms encountered in on-air broadcasting are *standard English* and *general American speech.* Although these descriptions are sometimes used interchangeably, "standard English" is generally taken to mean the English language as it is written or spoken by literate people in both formal and informal usage, whereas "general American speech" can be defined as pronunciation of American English using few or no regional peculiarities. From the standpoint of pronunciation, deviations from general American speech are dialects resulting from regionalism or social circumstances.

Regional Dialects Linguists identify dialects in terms of local and regional peculiarities in pronunciation. There are said to be four main regional dialects in the United States: Northern, North Midland, South Midland, and Southern. There are many distinct variations within these categories.

The exact scope of general American speech has always been elusive, but it has come to be used for all speech except that of New England and the coastal south.[3] Perhaps a better basis for judgment would be *network standard,* the unaccented speech of most newscasters and actors delivering commercials.

[2]Ann S. Utterback, *Broadcast Voice Handbook* (Chicago: Bonus Books and Radio and Television News Directors Association, 1990).

[3]David Blair McClosky and Barbara McClosky, *Voice in Song and Speech* (Boston: Boston Music Company, 1984).

An unaccented form of American speech was thought to be spoken in Chicago, although clearly some speakers in Chicago do use regional speech. In the early days of broadcasting, some organizations sent announcers to Chicago in an effort to eliminate regional accents.

Eliminating regionalisms in any manner is not easy. We're so used to hearing our own regionalisms (primarily vowel distortions) that we find it hard to distinguish regional speech from the unaccented speech used by most network newscasters.

An effort must be made to correct regionalisms, though. Vowel distortions due to regional dialects can be distracting to a listener who, for example, expects to hear "boy," but hears instead "bo-ih" from a southern speaker. And many people find substitutions even more intrusive. The New England trait of adding *r*'s where they don't belong ("pizzer," "bananer") and dropping them where they do belong ("cah," "watah") can irritate listeners unaccustomed to the dialect.

As we noted earlier, you may not be able to distinguish your own regional dialect. If your instructors or colleagues tell you that you have a distracting regionalism, they're probably right. And if you can't identify and correct the regional distortion or substitution on your own, by all means ask a speech professional or coach for help in getting rid of it.

Social Dialects Certain differences in pronunciation are apparent among groups that differ in educational levels or cultural practices. Since standard speech is arbitrarily assumed to reflect the highly educated members of a society, a similarly arbitrary definition pegs lower social dialects as substandard.

George Bernard Shaw satirized the rigid British class system by reflecting its cultural differences in speech patterns. In *Pygmalion,* Shaw made the point that more attention was given to the packaging of the words than to their substance.

Still, it is important for a broadcaster to reflect the social dialect looked on as standard. You must use educated pronunciations and usages. Saying "dese" instead of "these" can reflect a substandard social dialect, as can loose pronunciation. "Whatcha gonna do?" is not acceptable speech for a newscaster. The appropriateness of loose pronunciations, however, clearly varies with the situation. You don't commonly intone every sound when asking a friend, "What are you going to do?" In informal situations, some loosening of pronunciation is acceptable.

Usage The choice and use of words must be considered in evaluating standard language. Standard English, remember, is pegged to the educated speaker or writer. Use of double negatives, such as "haven't got none" is obviously substandard.

B O X 2 . 1

Self-Evaluation Checklist

A speech or voice deviation or a significant deviation from standard English or general American speech can slow the advancement of even the most intelligent broadcaster. It is important to keep an open mind to critiques and evaluations of voice, speech, and language. Although it is often difficult to perceive deviations in your own voice and speech, by constant monitoring with a tape recorder you can train yourself to be your own best critic.

Read through two or three pages of copy or a newspaper article. Then play back the tape and ask yourself,

1. Do I slur any words and sounds together?

2. Are my consonants crisp and clear?

3. Are my *s* sounds too harsh? Do my plosives (*p*'s and *b*'s) cause the mic to pop?

There is a more subtle point to be considered here, however. Although it is assumed that anyone contemplating a career in the broadcast media has the knowledge and ability to avoid such obvious blunders as "haven't got none," other lapses in grammar and usage can seriously detract from your image as an educated, standard English-speaking broadcaster. What is your impression of an announcer who speaks about a "heart-rendering" movie? The usage is comically incorrect. (If you're in doubt, look up "rendering.")

A lack of knowledge of the language also can mislead. One news reporter, for example, spoke of a city official's "fulsome" praise for a retiring teacher. "Fulsome" is a word that is used as a synonym for "abundant," so much that its original meaning, namely, "offensive or disgusting," is rapidly becoming lost. Similar fates seem to be in store for "presently," "disinterested," and "infer." Use words correctly. Never guess in an on-air situation.

Self-Evaluation It is important to be aware of any speech or voice problems you may have. Self-evaluation can help you assess your own speech so you can more easily identify and deal with problems that will hinder your progress toward achieving a more professional on-air delivery. Use the checklist in Box 2.1 to get started.

4. Are there any regionalisms or colloquialisms in my speech? Do I say "soar" for "saw," or "youse" for "you"?

5. Do I "drop" endings?

6. Do I read too quickly? Do my words telescope together?

7. Do I have a distracting voice pattern? Do I sound like a bad disc jockey?

8. Is my voice hoarse, harsh?

9. Am I speaking in a pitch range that is too high or too low?

10. Can I *hear* tension in my voice? Does it sound constricted, tight?

Note: Although self-evaluation is helpful, the difficulty of hearing your own mistakes cannot be overemphasized. If at all possible, have an individual analysis of your voice and articulation problems.

Making Your Speaking Voice More Pleasing

The next step is to concentrate on some positive steps you can take for self-improvement. Of primary importance to improving voice quality is posture. Another critical aspect of a pleasant voice is relaxation of the vocal apparatus, which also plays the major role in preventing vocal abuse. Relaxation techniques are discussed in the section titled "Maintaining Your Voice."

The first step in improving your speaking voice is to learn correct posture and breathing.

Diaphragmatic Breathing

The suggestion to "speak from the diaphragm," which is a good one, doesn't make any sense unless the process is explained and understood. Using posture and breathing techniques will require forming good habits and breaking bad habits.

The first habit to cultivate is proper posture. "Posture is the most important element in voice," contends David Blair McClosky, an author and voice therapist who has coached presidents Kennedy and Johnson, broadcaster Curt Gowdy, and actor Al Pacino.[4]

[4]McClosky and McClosky.

McClosky recommends a posture in which your feet are spread comfortably apart and your weight is slightly toward the balls of your feet. The key to the proper posture is to get rid of an exaggerated curve in your back. Keep your back straight and tuck your hips in, as shown in Figure 2.3. This posture allows for proper breathing. Virtually all voice coaches point out that it is the abdomen that must expand during breathing, not the chest. Although you may have been taught in elementary school to "throw out your chest" when you breathe, that's not good technique. It doesn't let your abdominal muscles and therefore your diaphragm to provide adequate support for the column of air in your vocal tract. If you are unclear on this, please take a moment to review the sections on vocal anatomy and physiology.

"Diaphragmatic breathing" is something of a misnomer, because we have to use the diaphragm to breathe regardless of what scrunched-up posture we may assume. However, proper diaphragmatic breathing is accomplished when the contraction of the abdominal muscles pushes the diaphragm in and supports the column of air. This can be accomplished only if the abdomen is allowed to expand when the diaphragm pulls down into the abdominal cavity during inhalation.

Proper breathing compels us to abandon some of the typical vanities imposed by current culture, including the notions that we should be wasp-waisted and that men should have a swelling chest. In order for us to breathe properly, the abdomen must expand. Note the action in Figure 2.4 (a and b).

When the abdomen and the diaphragm have expanded, natural exhalation from that position, involving a contracting of the abdominal muscles, will produce the proper effect. Be certain you have used your diaphragm properly. One way to check on diaphragmatic breathing is to stand against a wall and have someone press his or her fist against your abdomen. Proper inhalation will drive that fist away (Figure 2.4c).

Here is one final test to see if you are breathing properly. Assume the correct posture and place your hands on your lower ribs (Figure 2.4d). Inhale. If your ribs move you are expanding your chest instead of your diaphragm.

This breathing posture works just as well in a seated position. All that will change is the position of your legs. Keep your back straight and your hips tucked in. Practice minimizing rib motion.

Exaggerated Diction

We've all heard the unnatural, affected delivery of the speaker whose diction is just *too* precise. This issue is raised because some people try to clear up imprecision in diction by swinging to the other extreme, which is probably a marginal improvement at best. Remember, English-speaking people do not pounce on every single sound in a sentence.

The best way to identify too-precise diction is, of course, to listen to a tape. It also helps to watch your mouth as you speak into a mirror. Exaggerated mouth and lip movements are often indicative of exaggerated diction.

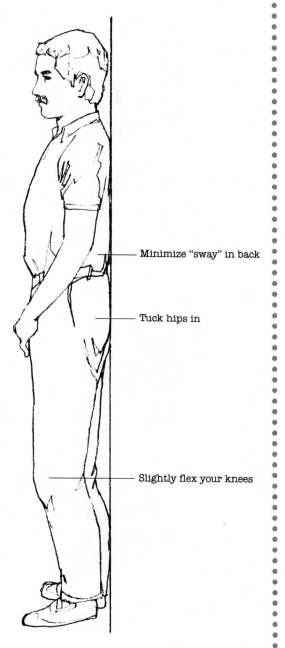

Figure 2.3. A good posture for speaking. The goal is to minimize back sway and give your diaphragm and abdomen plenty of room for expansion.

Minimize "sway" in back

Tuck hips in

Slightly flex your knees

Figure 2.4.
(a) The telltale way to determine whether you're breathing diaphragmatically: before inhaling, place your hand a couple of inches below your breastbone.

(b) When you inhale, you should feel and see an expansion of your abdomen. This demonstrates the action of the diaphragm.

(c) A good test of whether your diaphragm is being used in breathing is to stand against a wall and have a partner press with his or her fist as shown; inhale and try to push the fist away.

(d) If you can detect rib motion, you are breathing from your chest rather than from your diaphragm.

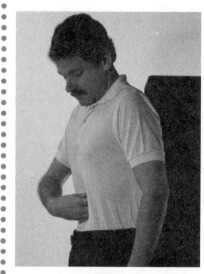

(a)

(b)

(c)

(d)

Special Considerations for Broadcast Work

Even normal-sounding *p*'s and *b*'s can cause a microphone to pop; that is, to vibrate with an explosive noise because a blast of air has hit the mic element. Sometimes, simple awareness of the problem and practice in controlling the force of plosives is enough. Speaking across the mic, rather than into it, can help. Or you might choose a mic that is less susceptible to popping. All options are discussed in Chapter 4.

Women doing on-air work sometimes encounter resistance from listeners who claim their voices are harder to understand. For some people, especially

older listeners with age-related hearing losses, this is true. For reasons dealing with acoustics and the functioning of the hearing mechanism, the impaired ear hears lower-pitched voices better than higher-pitched voices. A reasonable lowering of pitch can sometimes overcome this. Good projection and resonance can also resolve much of the problem.

Finally, be aware that many on-air diction problems can be solved by careful attention to copy interpretation. "Read for meaning," advises Ann Madsen Dailey, an author, consultant, and speech–language pathologist. "Use pauses where appropriate, stress key words, and use natural expression. Very often this can clear up the problems caused by poor habits developed by just 'reading out loud.'"

Broadcasters, like teachers and salespeople, often must contend with hoarseness, irritation, or just plain tiredness in the vocal apparatus. Even if the abuse is not serious enough to cause harm, no performer can communicate effectively when his or her voice is reaching the point of failure.

Good health and nutrition are important to on-air performers. They help you improve effectiveness the same way proper physical conditioning contributes to the performance of an athlete. Like athletes, announcers are called on to perform at a specific time and place. That means you must perform well *then* — not just at those rare times when your voice sounds perfect. If you have to produce a quality vocal performance on a regular basis, you should try to be as fit as possible at all times. Eating sensibly, exercising moderately, and avoiding behaviors that harm your health will help you make sure your vocal tools are always ready to use to their best effect (see Box 2.2).

Relaxation is the key to maintaining your voice. Proper relaxation also helps produce a pleasant, resonant voice. The exercises recommended in Box 2.3 really do work! Try them, practice them, and make them into a daily regimen.

"Vocal abuse" is any excess strain on the vocal apparatus, most notably on the vocal cords, that produces irritation. Symptoms of vocal abuse include hoarseness, a change in character of the voice, fatigue or discomfort in the region of the larynx and throat, and a change in the basic pitch of the voice.

Vocal abuse can be chronic or acute. Chronic abuse develops gradually from improper vocal habits and excessive stress in the vocal mechanism. The results of acute abuse come on suddenly, usually from screaming or a very hard period of speaking or singing.

Such abuse can result in a number of physical problems, including

- Formation of vocal cord nodules and polyps
- Excessive "bowing" (taking on a misshapen appearance) of the vocal cords
- Chronic irritation

Maintaining Your Voice

▼

Relaxation is the key to maintaining your voice.

Vocal Abuse

B O X 2 . 2

Tips on Diet and Health

To get the most from your voice, follow a healthy lifestyle. The vocal mechanisms are physical, after all. Good health practices and proper diet help strengthen the vocal mechanisms and provide the energy that helps you develop an effective vocal delivery. Here are some basic tips that will help you keep fit and avoid the consequences of poor general health:

- *Get plenty of rest.* When your body is tired, that will show up in your voice. A tired voice is usually higher pitched and lacks strength. Announcers who try to perform with a tired voice may wonder if they can even finish the shift. Attempts to "clear" the voice — frequent throat clearing and straining to lower the pitch — just aggravate the problem. The only effective remedy is to get some rest. Better yet, get enough sleep in the first place, and try to find some time for relaxation before starting assignments that require heavy use of your voice.
- *Exercise.* In addition to exercises that work the vocal mechanisms, engage in some form of regular, strenuous physical activity that works the major muscles of the body. This will strengthen your heart and lungs and give you endurance and overall energy. Your vocal delivery will

One cause of vocal abuse is an abnormally low pitch. McClosky notes that when he was a university choirmaster and singing teacher in the 1950s and 1960s, the heyday of the big-voiced announcer, a surprising number of students who reported voice problems to him were enrolled in the college's broadcasting school. They were trying to lower their pitch to the male ideal of those days.

Preventing Vocal Abuse

There are several ways to protect your voice from abuse in addition to speaking in a natural tone of voice. Neri Holzer, M.D., a Connecticut ear, nose, and throat specialist, offers these suggestions:

1. Listen to what your larynx and throat are trying to tell you. The body has several defense mechanisms, including pain and hoarseness. If these symptoms are chronic, reevaluate your speech patterns.

reflect the general condition of the rest of your body. You'll be able to go longer with less strain and the extra energy will give you a more forceful delivery when you need it. Of course, it is always wise to have a physical examination by a qualified physician before starting a strenuous exercise program—especially if you have been leading a rather sedentary life.

- *Watch what you eat.* A diet high in fat and low in nutrition contributes to fatigue and susceptibility to illness. The carbohydrates in whole grains and fruit, combined with adequate protein from various sources, will provide energy and help you maintain health. Don't eat too much fat, and pay attention to the nutritional values of the food you eat. If you are overweight, start a weight reduction program that helps you lose pounds over a reasonable length of time. Fad diets can endanger your health, and they usually don't work.

- *Don't smoke.* The constant irritation of heavy smoking can damage the vocal mechanism and greatly impair vocal delivery. Aside from the well-known risks to general health, smoking continually irritates the vocal cords. General irritation of the throat can result in excessive mucus production and the development of a "smoker's cough" that further strains the vocal mechanism. Over time, the general quality of the voice can change as the result of permanent damage to the vocal folds. Eventual lung damage can impair effective breath control and reduce the force of your vocal delivery.

2. Warm up. Do some light vocalizing (humming, singing, etc.) before an extended on-air period or other time of vocal stress.
3. Keep well hydrated. When tissues lose moisture, they're more susceptible to damage. Have a glass of water on hand.
4. Use amplification when possible instead of raising your voice. A radio announcer, for example, can reduce strain on his or her voice by turning up the volume on the mic channel instead of shouting.
5. Don't smoke. Tobacco smoke directly irritates the vocal cords. Smoke indirectly irritates the cords by stimulating coughing.
6. Avoid extensive use of the voice when you have a cold. Using your voice then makes you more susceptible to vocal irritation. Also, avoid habitually clearing your throat.
7. Look at your whole body for signs of tension. Stress in other parts of the body can cause a reaction in the voice. Similarly, posture has an important role in keeping the vocal mechanism relaxed and working freely.

B O X 2 . 3

Some Exercises to Relax Your Body and Throat

Many of these are performed regularly by professional singers and speakers.

1. Roll your head: forward, to the left, backward, to the right, and forward again. Repeat several times in each direction. This helps relax shoulders and neck.

2. Massage the muscles of your face. Work down from your hairline, and let your jaw go slack.

3. Thrust out your tongue several times, then let it hang limply over the bottom lip. Relaxing your tongue is important because the back of your tongue goes right down your throat. Tension here can interfere with vocalization.

4. Massage the area under your chin (Figure 2.5a) until there is no rigidity apparent. Learn to relax these muscles "on cue."

5. Grasp your lower jaw between thumb and forefinger and work it up and down until you overcome any muscular resistance (Figure 2.5b). When you get good at this, you can bounce your jaw up and down with your forefinger.

6. *Gently* massage the larynx from side to side (Figure 2.5c) until you eliminate rigidity and any "clicking" sensation.

Vocal Relaxation Techniques

Dr. Holzer's last point is important: having a relaxed body and vocal apparatus relieves much of the strain on the voice mechanism and allows the voice to function better. Voice therapist McClosky contends that relaxation is the precursor to any progress in voice development. Unless you can relax the muscles in your face, tongue, jaw, throat, and neck that interfere with the muscles controlling the vocal cords themselves, he says "your singing and speaking will be muscle-bound" (see Box 2.3).

Make these relaxation techniques a daily routine, and remember that relaxation exercises can be done at any time. Doing this routine during a break in a tiring recording session, for example, will help your voice immensely.

Figure 2.5a. Massaging under the chin.

Figure 2.5b. Working the jaw.

Figure 2.5c. Massaging the larynx eliminates rigidity.

7. Vocalize the word "hah" gently, using the *ah* sound as in "arm." Start vocalization high in pitch and then slide down the range of pitch. Initiate the vocalization as gradually and gently as you can.

Summary

Broadcasters need not force their voices into an abnormally low pitch range. A pleasant voice, rather than a deep voice, is the hallmark of today's professional announcer. An artificially low-pitched voice is unattractive and can actually damage the vocal cords.

A basic knowledge of the vocal mechanism lets you identify the function of various parts of the apparatus when doing exercises to improve its function. Vocal cords are suspended in a chamber of cartilage and allow air to escape in short bursts. Those short bursts create a vibration, which is amplified by the vocal tract and nasal passages.

Evaluation of voice and speech is valuable for all on-air performers.

Typical voice problems involve poor quality, delivery, and breathing. Typical speech problems are sloppy diction, regionalism, and cluttering.

It is also important for on-air personnel to be familiar with standard American English and general American speech and to avoid significant deviations from these standards.

An inappropriate rate of delivery and poor articulation can detract from the effectiveness of your vocal communication. Proper control of delivery rate also helps the announcer read to time limits—an important skill.

The broad task of making the speaking voice more pleasing begins with self-evaluation and isolation of specific problems. Continued work for crisp diction is important, but diction should not be overemphasized. It is also important to be aware of special considerations for broadcast work, such as using microphones properly.

Learning diaphragmatic breathing is the first major step in the long-term process of improving your speaking voice. Learning to relax is the second major step. In addition to preventing vocal abuse (a common problem of on-air broadcasters), relaxation increases resonance and improves the overall tone of the voice. Exercises can relax the vocal apparatus. A program of diet and fitness can help to ensure overall good health, which contributes to your ability to use your voice effectively at all times.

E x e r c i s e s

In addition to regularly practicing the techniques described in this chapter, you can benefit by doing these exercises.

1. Pronounce the following pairs of words; record them if possible. Is there a distinguishable difference in your pronunciation? There should be.

picture/pitcher	saw/soar
wear/where	best/Bess
park/pock	peas/please
adapt/adept	aunt/ant
bowl/bold	pin/pen
can/kin	ensure/insure
kin/king	bad/bed

An interesting variation of this exercise is to have a colleague or instructor check your pronunciation. An even more useful variation is to use each pair of words in a sentence. See if the distinction between the two similar words is still as clear during conversational speech as when the words are spoken in isolation.

2. Read through a line of poetry or other work and enunciate *every* sound in the sentence. Exaggerate to the point of silliness, but be sure to hit every consonant and vowel precisely. If you don't have poetry on hand, try this: "Speak distinctly, and rise above the babble of the crowd." The point of this exercise is to discover all the "hidden" sounds and variations of sounds we often gloss over.

3. Another type of diction practice is the tongue twister, which can be fun and interesting but probably not of extraordinary value. There was, however, a time when tongue twisters were popular material for radio announcer auditions, perhaps reflecting an overemphasis on mechanics, as opposed to communication. Tongue twisters can bring about a healthy awareness of the accuracy of diction, however, so try these:

Betty Botter bought some butter. But, she said, the butter's bitter and if I put it in my batter it will make my batter bitter. So Betty Botter bought some better butter and put it in her batter and the batter wasn't bitter so she opened a tin of sardines.

4. A variation on tongue twisters is a passage containing seminonsense words that must be read for *meaning*. Read the following paragraph so that the meaning is clear to a listener who has not heard it before. It is a very good exercise for showing how control of rate, pause, and inflection conveys meaning.

Bill Bell builds bells. The bells Bill Bell builds bang and bong on Beele Boulevard. Bill builds bells with brass bell balls. Bell's bell balls build big bells. Bill Bell built brass ball-built bells for the Beal's bull, Buell. Buell's Bell-built brass bell banged when Buell bellowed on Beele and bore Bell's bells bong abroad. Bill Bell's bells, brass-ball-built for Beal's Beele-based bull Buell biased brass bell builders toward Bell brass ball-built bells. Boy![5]

[5]Douglas Ehninger, Bruce E. Gronbeck, Ray E. McKerrow, and Alan H. Monroe, *Principles and Types of Speech Communication*, 10th ed. (New York: Scott, Foresman, 1986), p. 398.

3

Understanding the Message

The whole point of putting an announcer in a studio with a script to read is to convey a message to a listener or viewer. Whether that message is delivered solely by sound, as in radio or with the added use of visual elements as in television, the objective is to translate what the copywriter had in mind, so that the listener ends up with the same idea. The broadcast communicator is responsible for using all the skills and talents he or she can bring to bear, to make sure the message is as effective as possible. This chapter addresses the basic responsibility of the broadcast communicator to understand the meaning of the message, and outlines techniques to improve its delivery. We will discuss (1) finding key words; (2) determining the mood, the pace, and the purpose of the copy; and (3) understanding that the goal is communicating, not merely reading. We'll also explore ways to mark copy for pronunciation, interpretation, and phrasing.

The "message" is far more than just words. You must consider a variety of emotions and reactions when you look at words on paper, words that must be conveyed with meaning to each member of the audience. To compound the challenge, you must be sure that a faulty reading doesn't mar or blunt the meaning of the message.

Getting the Meaning

Figure 3.1. Bill St. James, one of the industry's top freelance communicators.

An announcer conveys meaning by giving the copy an *interpretation* that communicates, through inflection and emphasis, something beyond the literal reproduction of the words on paper. Perhaps the words must be charged with emotion, or give a sense of excitement. You communicate these ideas *by first getting a clear and precise understanding of the message.* To do so, you must

1. Carefully analyze the meaning and purpose of the copy (the topic of this chapter)
2. Communicate the words and phrases in such a way that the message has meaning and impact (the topic of Chapter 4)

Although years of experience can result in these two practices "coming naturally," the top professionals in the business never forget the need for understanding and communicating. "The most important ability an announcer can have is to interpret copy correctly," says Bill St. James, former air personality on WYNY, New York, and now one of the industry's best-known freelance commercial voices. (Figure 3.1) "You have to be able to read it as the guy who wrote it had it pictured in his head. And the other thing is that, when you get to this level, you have to do more than just read copy. You're expected to breathe life into it, to make it believable and human."

▼

"The most important ability an announcer can have is to interpret copy correctly."—Bill St. James.

The point is often driven home rather vividly to beginners. Consider, for instance, this businessman's response to hearing a tape of a proposed commercial: "The announcer doesn't know what he's talking about . . . don't you people know anything about my business?"

One prospective news reporter lost a job he wanted very badly. The news director explained why when the audition tape was played back. "Listen to how you read right through this line: '. . . relative calm except for rioting in a black township north of Soweto. . . .' What the hell is this story about? It's about rioting in a *BLACK* township."

Both performers were ineffective because they failed to understand the message.

To understand and communicate the message, you must identify *key words,* identify *pace and purpose,* and *communicate*—rather than just read—the copy.

Finding Key Words

The example we just gave of the news story shows what happens when the performer misses a key word. Finding those key words is the first step in analyzing the thrust of the copy.

Too often performers try to find key words by simply underlining every word that looks relevant. That approach is better than nothing, but if too many words are emphasized they are no longer key words. Striking a balance is the goal.

One way to get to the heart of a piece of copy is to read it through and identify *three* words that summarize the thrust. This approach can give a surprisingly accurate reflection of which words are most important.

Theater set designers, who must come up with simple structures to convey complex messages, often play the mental game of distilling a play into a paragraph, then a sentence, and then a word. The set is designed around this word. This approach is oversimplified, but does force you to think about the most basic meanings behind a play or any other form of communication. Key words *are those that accurately convey the meaning of the copy.* So changing key words can change the meaning of the copy.

For example, "Kim won the 10-kilometer run" is a simple statement. If you're looking for key words in that statement, you have to understand the context of the sentence. Is it an expression of amazement at athletic power? Turn it into a question-and-answer form to show it in a framework of a complete thought:

- "*KIM* won the 10-kilometer run? She hasn't trained in months!"

Changing the key word, then, can alter the perceived meaning. Let's complete three more question-and-answer pairs and show how context affects meaning.

- "Kim *WON* the 10-kilometer run? I thought she came in *third.*"
- "Kim won the 10-*KILOMETER* run? She said it was a 10-*mile* run."
- "Kim won the 10-kilometer *RUN?* I thought it was a *walk*athon."

Obviously, finding the key words may mean going through the original copy several times to clarify for yourself what the author had in mind. This is not a mechanical process, although mediocre announcers make it so. For example, in most commercial copy the performer can rightly assume that words such as "bargain," "inexpensive," "free," "new," "natural," and "modern" are key words, words that are intrinsic to the message and that deserve stress. But those powerful-looking words are not *always* the key words, and a performer can mangle the message by not understanding it in context. How important is the word "new" in the following piece of copy?

The new line of Smith Shoes will give you a step up as you swing into spring. . . . Look great and feel great in . . .

The most important words here are probably "Smith Shoes," "look great," and "feel great"; "new" is really not important. Also of secondary importance are the words relating to spring. The word "new" is almost redundant, since few shoe stores offer old shoes as their spring line. The purpose of this copy

is not to communicate the idea that Smith Shoes are new. The purpose is to communicate the idea that Smith Shoes will make you look and feel great, and will let you "swing into spring" in an upbeat way.

But let's take another example:

The new line of Smith Personal Computers, designed with the latest in digital technology . . .

Here, the word "new" assumes paramount importance. After all, a *new* personal computer, in these days of technological one-upmanship, is inherently more valuable than one of an older design.

The point is to avoid a mechanical approach to finding key words. Never assume that the most obvious choices are the words that convey the message.

Much the same caution applies to news copy. In news, there's really no stronger verb than "died." It conveys the most urgent event in our society, the loss of a life. But although there's no question that "four children *died* in a fire at . . ." is the correct interpretation of copy, the word *died* isn't always the most important word in a message. For example,

The families of the four children who died in Tuesday's tenement fire are suing the owner of the building . . .

Is "died" the key word here? Not really. The most important words are "families," "suing," and "owner." Putting too much stress on the concept of death:

The families of the four children who *died* in Tuesday's tenement fire are suing the owner of the building . . .

makes the listener think that the communicator is calling attention to a contrast between the families of those who died and those who didn't. According to this reading, the sentence ought to be completed with

. . . but the families of burn victims who did *not* die are not suing.

To sum up, finding key words is not a simple or mechanical process. It involves a thorough analysis of the copy. Marking key words in the copy helps the performer accurately communicate the thrust of the message.

Mood

Understanding the mood the copywriter wants to project helps you to give an accurate interpretation. By contrast, not understanding the mood can detract from the communication. Projecting an inappropriate mood or making an inappropriate change of mood can baffle the audience. For example, in one familiar situation comedy routine the newscaster mixes up his copy and

blunders into a tragic plane crash story with the smile and upbeat tone reserved for the final "light side" piece.

Misreading the mood is seldom that obvious, but it can happen, and it can mar your delivery. So carefully determine the mood. It could be, for instance, any one of the following:

- *Carefree.* "Swing into spring with Smith Shoes . . ."
- *Sincere.* "Are you concerned about your health insurance?"
- *Romantic.* "Dinner by candlelight at the Copper Bottom Restaurant will be one of the most . . ."
- *Somber.* "Twenty-three miners were killed this afternoon in a cave-in north of the city of . . ."
- *Excited.* "Bob Smith Oldsmobile has 30 cars ready to go at *below wholesale!*"
- *Humorous.* "A bank customer using an automatic teller machine in Los Angeles got more than he bargained for today when the machine spit out ten thousand . . ."

The relatively straightforward task of evaluating the copy for mood is done not so much to determine what mood the particular piece reflects as to find out where *changes* in mood must be expressed. A common problem for inexperienced or ineffective newscasters is not being able to *spot the points in copy where the mood must change.* When mood changes are not spotted in advance, the interpretation becomes inappropriate. At best, the announcer slides through the copy with an overall lack of mood, At worst, he or she catches the error and tries to change the mood at an inappropriate point, losing the real mood and sense of the copy.

Pace

Pace is the rapidity of words, the overall rate of reading, and the rate of reading within phrases. You can make the most effective use of pace after you have acquired an understanding of when and why to vary it. In general, a speeded-up pace conveys a sense of excitement. Sometimes, that excitement can be panicky, harried:

> Time is running out. Yes, you've heard all the talk about business phone systems. . . . All the commercials . . . all the hype. But it's your decision and you've got to make it soon! And you better make it *right.*

But note that a change of pace is needed in the second part of the commercial:

> . . . you'd better make it *right.*

At Telephone World Business Systems, we've been helping people like you make the right decisions for over twenty years. We've got the facts—not hype—and we can sit down with you and tailor-make a system that will do the job right.

We know it's a big decision, and . . .

Where would you vary the pace, and why? The first part of the commercial conveys a sense of time running out. That is as urgent a message as you can get. The pace, of course, is very rapid, almost breathless.

But the second part of the spot calls for a slower, more deliberate reading. "At Telephone World Business Systems, we've been helping people like you . . ." signals a change to a slower, deliberate, purposeful pace.

Get into the mind of the writer. What is he or she trying to get across? At this point, it's simply *you can stop panicking and come to Telephone World Business Systems, where we help people in the same situation every day, so calm down!*

An announcer who used the same pace throughout would mutilate this spot and lose much of its impact.

Purpose

What is the copy intended to do? Why was it composed in the first place? When you have answered these questions, you know the copy's purpose. Copy can persuade, inform, entertain, even anger. The communicator must understand the purpose in order to transmit the message accurately.

To understand the purpose, you have to understand more than what's on the paper. The more you know about the context for the copy, and the broader your range of knowledge, the better you can interpret the message.

For example, consider the intense advertising campaigns that competing phone systems have engaged in since deregulation opened the door to competition. To help interpret our imaginary Telephone World Business Systems spot, the announcer should be aware that the employee responsible for choosing a new phone system is under a great deal of pressure to make the right decision amid an intense advertising barrage. A valid interpretation must appeal to this theme.

Experience professionals can lend an important sound to such copy through accumulated skills of emphasis and inflection. Understanding copy, though, will *always* help *anyone's* interpretation.

In addition, the announcer should understand the purpose of individual phrases in relation to the context. What would you perceive to be the purpose of the question "Why did this happen?" Standing on its own, it means little. It assumes varied significance when read in relation to the context. For example,

- "Economists said interest rates fell sharply in the wake of the

> ▼
>
> The more you know about the context for the copy, and the broader your range of knowledge, the better you can interpret the message.

presidential election. Why did this happen?" Here, "Why did this happen?" is an expression of simple curiosity.

- "Scientists found that the orbit of Pluto varied last year by hundreds of millions of miles. Why did this happen?" Now the question expresses wonderment.

- "Speculation about whether the birds would fly north or south was ended today when they flew west. Why did this happen?" Why did it happen this way, and not the other ways?

- "Ten people died in yesterday's apartment house fire. There were no smoke detectors in the building, which had passed a recent code inspection. Why did this happen?" The question now expresses outrage.

To sum up, understanding the purpose is essential. The next stage of the broadcast performance process— communicating the message— cannot be done effectively unless you know why the copy, sentence, phrase, or word is there in the first place.

Communicating Versus Merely Reading

Perhaps the ultimate example of reading instead of communicating was provided by an announcer with a fine voice but a lazy and mechanical approach to his work. The copy was designed to relate the sponsor's product to the weather, and the announcer was supposed to open the spot with *one* of the following *three* options:

- "What a beautiful, sunny day. . . ."
- "Look at all that rain. . . ."
- "We've had more than our share of snow. . . ."

But he read all three, and he failed to understand at first why the program director and the sponsor were so upset with his delivery.

That example is *not* too far-fetched. Similar mess-ups happen every day. Poor on-air performers can make hash out of commercial and news copy because they simply do not take the time to understand the message they want to communicate.

This is the sum of what we discussed in the previous section. A good broadcaster must incorporate key words, mood, pace, and purpose to communicate, rather than just read.

Most of us have heard "announcers" who have decided in their own minds "what announcers sound like." They deliver each message in a mechanical singsong. That is *reading.*

A *communicator* knows how the copy should be read and can get across the intent of the author. He or she does not follow a preset formula but instead approaches each reading with an open mind, looking for the thrust of the

material. In most cases, the better performer is not necessarily the one with the better voice, but the one who makes the copy genuine, natural, believable, and true to the intent of the author.

After many years of practice, this ability can become second nature. Good performers develop that second nature by marking copy to indicate key words, pace, pauses, and in some cases mood and purpose. They also include methods of indicating pronunciations of difficult words. Learning to mark copy is one of the most important steps you can take toward improving your performance skills.

Marking Copy

To many, marking copy is more a learning process than a practical tool. Many performers don't mark copy. They rely on experience and ability to carry the situation.

Many announcers do not have the opportunity to mark copy. Commercials are kept in a copybook that is used by all staff announcers and would soon be obliterated if each staffer put individual marks on the copy. Newscasters must often read copy that is prepared by others and that is not assigned to a particular newscaster until moments before airtime. Marking such copy is not practical.

What experienced announcers do, in effect, is to mark copy mentally. Beginners should mark as much copy as possible directly on the paper, because the ability to do it mentally takes extensive practice.

However, all on-air people mark unfamiliar pronunciations, and such markings frequently are written right into the typed copy or wire service text. Marking copy for pronunciation is an integral part of understanding the message.

Phonetic Spelling

How do you show how to pronounce an unfamiliar word? Basically, you must come up with notations that will let you or another reader look at the agreed-on code and know how to pronounce the word. Such a system is known as *phonetic spelling.*

There are a variety of phonetic systems, and some are very accurate but very complex. The International Phonetic Alphabet (IPA), for example, uses symbols not found in the English alphabet to indicate elements of pronunciation. The International Phonetic Alphabet is a valuable tool for linguists and other scholars, but its value for broadcast performers is limited for two reasons:

1. It is not understood by all broadcasters. The IPA can help someone who knows it to reproduce pronunciations with great accuracy, but most broadcast copy is not written by people who will read it over the air. Even in newsrooms where broadcasters do write the majority of the news department's copy, much of that copy is read by other newspeople.
2. Many of the symbols in the International Phonetic Alphabet are not

B O X 3 . 1

The Associated Press Pronunciation Guide

Vowel Sounds

a	bat, apple	**oh**	go, oval	
ah	father, arm	**oo**	food, two	
aw	raw, board	**ow**	scout, crowd	
ay	fate, ace	**oy**	boy, join	
e, eh	bed	**u**	curl, foot	
ee	feet, tea	**uh**	puff	
i, ih	pin, middle	**yoo**	fume, few	
y, eye	ice, time, guide			

Consonants

g	got, beg
j	job, gem
k	keep, cap
ch	chair, butcher
sh	shut, fashion
zh	vision, mirage
th	thin, path
kh	gutteral "k"

Source: James R. Hood and Brad Kalbfedd, compilers/editors, *AP Broadcast News Handbook* (New York: Associated Press, 1982), p. 230.

reproducible by standard typewriters, teletype machines, or computerized word processing equipment.

The second problem also rules out the use of diacritical marks, such as those found in the dictionary. Standard typewriters, teletype devices, and word processors can't reproduce markings such as ă and ĭ.

The best alternative seems to be the phonetic spellings used by the Associated Press Radio Network. The AP uses a simple phonetic spelling system to convey how a name or other word sounds. It "goes along with the commonly accepted principles of English usage as to how vowels and consonants are sounded."

When an accent is indicated, the AP places a teletype apostrophe over the letter or letter group that should be accented. As an example, in the style of the *AP Broadcast News Handbook,*[1] the name Juan Martinez spelled phoneti-cally would appear as *Wahn Mahr-tee'-ness.*

When you are constructing or interpreting a "pronouncer," as it is called, use standard English usage and the guide shown in Box 3.1, from the *AP Broadcast News Handbook.*

Pronouncers are shown in all wire service copy destined for broadcast use. If you are doubtful about a word and don't have a pronouncer, two very

[1]James R. Hood and Brad Kalbfedd, compilers/editors, *AP Broadcast News Handbook* (New York: Associated Press, 1982), p. 230.

helpful works are the pronunciation guides prepared by the National Broadcasting Company (NBC) and the British Broadcasting Company (BBC). Newspeople are responsible for determining the pronunciation of names of local newsmakers, a process that often involves making telephone calls to individuals, their families, or business associates.

Marking and Decoding Unfamiliar Words

To be able to approximate unfamiliar English words and words in foreign languages, it is worthwhile to get some exposure to foreign pronunciations. For one thing, some pronunciations can't be approximated by phonetic spelling because the sounds are not commonly used in English. Also, sooner or later you will come across a foreign word and have no way to check it out.

The English-speaking announcer faces some additional problems, other than simply deciphering pronunciations.

Problem Many foreign words have been anglicized as a matter of convention. In English, we speak of Munich, Germany; to speakers of German, the city is named *München*. Naples, to an Italian, is *Napoli*. Even when the spellings are the same, American pronunciations can differ from those of the original language. Paris, to a Frenchman, is *Pah-ree'*. How does an announcer decide?

Recommendation Ideally, you must know the convention. Use pronunciation guides, the dictionary, wire service pronouncers, and the pronunciations you have heard from network newscasters. Be aware that the network standard in foreign pronunciation is not always infallible, and often those at the very top levels of the networks cannot come up with a definitive pronunciation, either. Coverage of the Iranian hostage crisis involved widely different pronunciations of names for a period of months until conventions were established. Use the convention favored by the most authoritative source you have.

Problem Assuming you know the convention to use, is the word or phrase (not a proper name or place name) pronounced with foreign inflection? If so, how much?

Recommendation Attempting to pronounce foreign words and phrases with the inflection used by a native speaker of that country can sound affected in many circumstances. For example, an announcer reading a commercial for a Mexican fast-food restaurant would appear affected if he or she trilled the r's in *burrito,* unless that announcer were adopting a character role. On the other side of the issue, American announcers do not have the flexibility to anglicize pronunciations as severely as the British, who pronounce Quixote as *Kwiks'-oht*. The American announcer must come up with compromises depending on the situation.

1. Most foreign pronunciations sound natural, unaffected, and acceptable

when rules of foreign pronunciation are followed. However, the word is pronounced *as an educated native English speaker would say it,* not as a native would say the word. An American speaker, for example, knows that the *au* configuration in German is pronounced *ow,* and would use that pronunciation. The speaker would not, though, try to reproduce a German accent precisely. Likewise, the speaker following this rule would not trill *r*'s in Spanish words and would not make the *n*'s in French words too nasal.

2. The most notable exception is in classical music programs, for here the announcer is expected to be an expert. Typically, the classical music announcer should give full inflection to the words, using native pronunciation.

Problem What about proper names and place names?

Recommendation Follow convention, use American pronunciations for names of well-known people or places according to these guidelines:

1. The names of major cities and countries are spoken according to American convention (e.g., Munich, not München). In most cases, an American-flavored pronunciation, rather than an imitation of native inflection, is best. The final *ch* in Munich, then, would be pronounced like an American *k,* not gutturalized, as in German.

2. Proper names of newsmakers are usually pronounced without foreign inflection. However, it is always correct to pronounce a person's name the way he or she says it, whether that person is foreign or American. Many names in classical music are by custom pronounced with foreign pronunciation and full inflection.

3. It is good form to pronounce names of people and places with foreign inflection if those people or places are not famous. A story about a small wine-producing town in France, for example, could be read with native French inflections given to the words.

It is difficult to decipher foreign pronunciations from tables of vowels and consonants. Moreover, a table is not always available, so it is worthwhile to memorize the *general characteristics* of the major languages. It is also worthwhile to listen to recordings of foreign speakers. A table of letters and sounds and their pronunciation in major languages is provided in Appendix A.

French At the end of a French word, the letter *e,* without an accent, is not pronounced (étoil*e*). This is also the case for final *es* (étoil*es*) and for the *ent* ending on verbs (ils parl*ent*).

Most final consonants are not pronounced. A phonetic approximation of *"Parlez-vous français?"* ("Do you speak French?"), for example, is *"Pahr-lay voo frahn-say'?"*

Most of the consonants are pronounced like English consonants. Some vowels before *n* and *m* are nasalized (*enfant, sont, fin, enchanter, un americain*. In short, a vowel or diphthong is nasalized when it is followed by *n* or *m* in the same syllable; *en*/fant, *em*/ployer, *am*/bu/lance.

J is pronounced *zh*, like the sound in *beige*. Accents usually fall on the last syllable: ba*taille*, termi*née*. Otherwise syllables receive about equal stress: *in-té-res-sant, Mon-a-co*.

German There are few if any silent letters in German. Some sounds are not approximated in English, such as the *ö* (the mark above the letter is an umlaut). This vowel can be either short or long, in the same sense that the English *a* is long in "lake" but short in "bat." The long *ö* can be approximated by rounding the lips as though you were going to say "oh" but saying "ay" as in "say" instead. To shorten the vowel, don't say "ay" as in "say" but rather "eh" as in "bed."

Two main indicators of a long vowel are that it is before only one consonant (much the same as in English) or that it is at the end of a word.

Other major facets of German vowel pronunciation are that *au* is pronounced *ow; eu* is pronounced *oy; ei* is pronounced like the word "eye"; and *ie* is pronounced *ee*.

Common consonant pronunciations: *d* is pronounced as *t* when occurring at the end of a word. Another common word ending substitution is *p* for *b*. The letter *j* is pronounced as a *y; s* is pronounced as *z; w* is pronounced as *f*. Native German speakers will pronounce a beginning *s* as *sh* when words start with an *st* or *sp* cluster; *ch* is pronounced as *kh,* a guttural *k*.

"Sprechen sie Deutsch?" ("Do you speak German?") would be approximated as *"Shprekh-en zee Doytch?"*

Accents in German are most commonly on the first syllable. It is also helpful to know that all nouns are capitalized in written German.

Spanish Spanish is very regular in its pronunciations, and you can figure out many Spanish words and names by remembering that *i* is pronounced *ee*, and *e* is pronounced *ay*. Typically, *a* is pronounced *ah* as in "father" rather than *a* as in "apple" (a convention that applies to many languages).

For consonants, remember that *ll* is pronounced as a *y*.

Caballero ("gentleman") is pronounced *cahb-ah-yay'-row*.

In Spanish, the *r* is trilled, but in most cases you will not try to approximate this in English pronunciation. *J* is pronounced like an English *h*. Accents usually fall on the last or next-to-last syllable; occasionally accent marks tell you what syllable to stress.

Italian Italian words are pronounced much as they are spelled. Unlike English, double consonants are pronounced as in ca*pp*ello (hat) and ca*rr*o (cart) in contrast to ca*p*ello (hair) and ca*r*o (dear).

Be aware that Italian *ci* and *ce* take on a *ch* sound, as in *ci*bo (food) and *ce*na (supper). Also, as often in English, Italian *gi* and *ge* take on a *j* sound (*Gi*ovanni, *ge*lato). The letter *h* is silent and is mainly used to change *ci, ce, gi, ge* sequences from *ch* and *j* sounds to *k* and *g* sounds (Cec*ch*etti, *Gh*ia).

The letter combinations *gn* and *gl* are pronounced something like the first *n* in onion (og*n*i, meaning "every") and the *ll* in *bi*lliards (fi*gl*io, meaning "son").

Keep in mind that *i* is pronounced *ee* but that *e* can be *ay* (m*e*no) or *e* (*E*lena) and that *o* can be *oh* (s*o*le) or *aw* as in English *law* (f*o*rte).

The letters *i* and *u* before and after another vowel (with the exception of the *ci, ce, gi, ge* sequences) are generally pronounced *y*, as in *yes* (ch*i*amo), and *w*, as in *wet* (b*u*ono).

Next-to-last syllables frequently receive stress in Italian words, but there are many words with stress on other syllables.

Russian Russian language copy written in the Cyrillic alphabet is transliterated for English speakers. This means that in a broadcast situation, the words have been converted to English equivalents, although the pronunciations still are somewhat irregular. The *ev* in Gorbachev, for example, is usually pronounced *off* by American speakers who transliterate.

A General Strategy Obviously, the introduction just given is not all-inclusive, and if a list *could* be made all-inclusive, it would be cumbersome and defy memorization. Committing these guidelines to memory, though, can provide a good start in decoding foreign pronunciations. The best strategy is to combine knowledge of pronunciation rules with a good set of reference books, a broad education, and an observant personality. Suppose you need to say,

Our next selection is by Richard Wagner: the prelude to *Das Rheingold*.

Wagner is one of the names that is customarily pronounced with full inflection and adherence to native pronunciation. Most names in classical music follow this custom. Therefore, the *ch* in "Richard" is pronounced as a *k*. The *a*, as is typical of most foreign pronunciation, is close to the *a* in the American word "arm." The *w* takes the Germanic *v* sound. The title of the music needs little decoding except for the *ei* configuration, which is pronounced like the word "eye." Thus we have *Rih-kart' Vahg'-ner, dahs Ryn'-golt.*

Similar analysis can be applied to the following examples or to the copy in the drill section in Appendixes B and C:

The Spanish region of Castile was originally divided into the provinces of New Castile and Old Castile, known as *Castilla la Nueva* and *Castilla la Vieja.*

Note in this example that you would use different inflections when reading the English and Spanish designations of the same regions.

Although not known as the most intellectual of Italian composers, Giacomo Puccini is one of the best known.

To begin your analysis, check the difference in pronunciation between the single *c* in Giacomo and the double *c* in Puccini.

Although this chapter centers on marking and understanding copy, some suggestions on delivering copy involving foreign words and phrases are appropriate to conclude the discussion:

1. *Try never to be caught unaware.* Check copy thoroughly and phoneticize words. Be aware that foreign words can arise in almost any on-air work, not just classical music, international news, or sports. Check proper names with the people named, if possible, because even a common name such as *Gentile* can be and is pronounced "*Jen-teel'-ee*" by some people in certain locations. With some words, there may be little to go on in terms of the word's origin or pronunciation, and it is wise to flag the word and check with an authoritative source, such as the radio station news director.

 As announcer Norm Howard of KQED-FM in San Francisco put it in one of his broadcasts: "In the course of our work we often have to pronounce unfamiliar and foreign words—the names of opera singers, composers, places and names in the news, words from different ethnic and cultural groups, from alphabets other than Roman. This is all by way of saying that a few minutes ago I mispronounced the name of the polar bear Pike, and I want you to know that it is '*Peek-uh,*' not 'pike.' Such are the hazards . . ."

2. *Do not hesitate before saying the word.* If you hesitate, listeners may think you are wrong *even if you are right.*

3. Bluffing sometimes is necessary, but don't get carried away. One announcer, for example, recalls the time he was reading "cold" a list of boxing title holders, who in the lower weight classes were mostly Latin Americans. He did rather well except for his highly accented rendition of what he thought was the name of the featherweight champion, "*Teet'-lay Vah-caht'-ate,*" which turned out to mean "Title vacated."

Remember that although learning the basic pronunciation rules can help in many situations, there are exceptions to many of the rules. True competence

in foreign pronunciation is best achieved by having some familiarity with the actual languages. Several semesters of foreign language courses will be of great benefit in cultivating pronunciation skills.

English words should also be marked and phoneticized. In fact, English is a very irregular language, and a simple set of rules to govern all English pronunciations cannot be devised.

Most lexicographers (writers and compilers of dictionaries) define "acceptable pronunciation" simply as a pronunciation agreed on by convention among educated people. Pay attention to the way knowledgeable speakers pronounce words, and when in doubt about a word, *look it up in a reference book.*

Some pronunciations are especially deceptive, and incorrect pronunciations have worked their way into common usage. See Box 3.2 for examples.

▼

When in doubt, *look it up in a reference book.*

B O X 3 . 2

Examples of Frequently Mispronounced Words

Some really common words are also very commonly mispronounced. Here are some examples:

- *nuclear.* it's *noo'-clee-yahr,* not *noo'-cue-lahr.*
- *status. stayt-us* is more widely accepted than *stat'-us.*
- *data. dayt'-uh* is more widely accepted than *daht'-uh.*
- *Greenwich.* Say *"Gren'-ich"* to designate Greenwich, England, and Greenwich Village in New York City. Some small communities pronounce the same word *"Green'-wich,"* however, which points up the need for checking local usages.

If these words took you by surprise, consult a dictionary or other reference book and check out the following words and place names. Be sure you are pronouncing them correctly and not adding additional sounds. For example, *"ath'-ah-leet"* is a common mispronunciation.

accessory	infamous	radiator	length
impotent	Moscow	Delhi	Yosemite
Spokane	La Jolla	Canaan	Cannes

Marking copy with correct pronunciations is one of the first things you need to do when evaluating material. The next consideration is marking it for proper interpretation, for correct *phrasing*.

Using Symbols to Aid Interpretation

The dictionary defines "phrasing" as a grouping together of words into a unit forming a single thought. Perhaps a more interesting definition from the broadcaster's point of view is the musical concept of phrasing, where many of the passages that combine to form a larger piece can also stand alone, each such passage, or phrase, expressing a more or less complete thought.

Musicians and composers use a variety of symbols to aid interpretation, such as a crescendo (◁), indicating a gradual increase in volume, or a "retard" (anglicized contraction of *ritardando*), meaning a slowing of the tempo.

A broadcaster can do the same. Figure 3.2 shows some useful symbols for marking copy. The next section shows how these symbols can help you communicate the message by phrasing it properly.

Phrasing

Notice how the symbols in Figures 3.3 and 3.4 add to both the understanding and impact of the copy. Key words are identified and their relative strengths indicated. The unfamiliar street name is flagged, and the pronunciation indicated phonetically.

Figure 3.2. Symbols for aiding interpretation.

Symbol	Meaning
<u>word</u>	underline for emphasis
<u>word</u> (double)	underline twice for heavy emphasis
word/word	slash for pause
word (flagged)	to flag unfamiliar word or pronunciation
[one complete phrase]	brackets identify complete phrase
phrase or sentence (jagged line)	jagged line means speed up
phrase or sentence (dotted)	dots mean slow down
word / word (jingle)	cue note for production element or time cue
Excited! (circled)	marginal note for interpretation

Two people are <u>dead</u>, <u>four</u> injured, in the wake of a violent explosion this morning at 443 Marseilles St. The <u>names</u> of the <u>victims</u> are being <u>withheld</u> pending notification of next of kin.

[The explosion and resulting fire] <u>leveled</u> the two-story house. <u>Investigators</u> are currently on the scene. One <u>fire</u> <u>official</u> [who does not want to be identified] told Eyewitness News that <u>arson</u> is a possibility.

Figure 3.3. A marked news story.

Figure 3.4. A marked news story.

["From <u>ghoulies</u> and <u>ghosties</u> and long-leggity <u>beasties</u>, and things that go bump in the night .] . . Dear Lord protect us." / So goes an old Irish kitchen prayer.

It's that last item that concerned two <u>local</u> residents late last evening.

[The bump in the <u>night</u>] [turned out to be an 18-wheel, semi-tractor-trailer] that crashed through the north wall of the kitchen in the home of John and Marsha Redbone, of 255 Mulberry Street at about 11:00 p.m. last night, while the Redbones watched television in their living room.

Hearing the loud "bump," John Redbone went to investigate. What he found was the front of a <u>large</u> <u>truck</u> protruding through the kitchen wall, with the front tire resting atop the overturned refrigerator.

The truck's driver, Ted Jarvis of Murfreesboro, Tennessee, was not injured.

State Police say the truck failed to make it around a sharp bend in the road at the Mulberry Street residence.

The location of that [bend in the road] has caused problems <u>before</u> for the Redbones. Two years ago a truck overturned in the side yard of the residence, dumping its entire cargo of <u>chickens</u> into the nearby <u>swimming pool</u>.

[The Redbones have <u>rejected</u> the idea of placing a <u>guard rail</u> along the edge of the property,] but say they <u>might</u> consider / a sturdy <u>fence</u>.

One part of the first sentence in the second paragraph has the potential of being confusing if not read as a unit: "the explosion and resulting fire" is bracketed as a grouping.

The examples in Figures 3.4, 3.5, 3.6, and 3.7 take the marking process further and add some pauses and nuances. Observe how the jagged line in Figure 3.5 indicates a speeded-up tempo. You want to create a fast, harried mood for the first section. But when the copy must be slowed down, the change is indicated by the series of dots. The performer who marked up this copy realized that the second portion must be read in *deliberate* fashion. Note how in the final phrasing, pauses are used for emphasis: "That's a fixed-rate mortgage (pause), at 11 percent (pause), and no points."

The performer who marked up this copy also used a cue for a jingle at this

Figure 3.5. Marked copy for a commercial.

Figure 3.6. Marked copy for a commercial.

A fine Italian restaurant is hard enough to find today [in this world of fast food] [and grab it and run.] And if you want to take time to enjoy the quiet elegance of beautiful surroundings while you dine, you may have given up hope.

Montinareeos

But wait./There's Montinerio's Casa Italiano, where fine dining is still considered a necessity of life. [The finest northern Italian cuisine] [expertly prepared by a master chef,] is presented to you/in an atmosphere of quiet Victorian elegance. [Your food is served with the attention to detail that reflects the Old World grace and style] of the finest European restaurants.

So forget the hurry-up world for a while. Put some style back into your life. Come to Montinerio's Casa Italiano and see what life can be like in the slow lane.

Figure 3.7. Marked copy for a commercial.

point. He or she might also elect to use that cue mark for timing. The performer could indicate that the remaining copy must be read in a given time period.

Phrasing and Interpretation

Consider how the examples presented show the ways in which phrasing can affect interpretation. The bank commercial was affected because the pace conveyed two very different moods.

Ineffective readers typically do not blend and match all the phrasing elements in a piece of copy. This frequently results in what might be called "mixed signals," for example, someone on television who is smiling but is clenching his or her fists.

You have to get your signals straight. There is some latitude in phrasing, but slow, deliberate phrasing would be inappropriate for most soft drink commercials, and quick, frenetic phrasing wouldn't work well for an insurance spot.

Rhythm and Inflection

The example of "Kim won the 10-kilometer run" in the section headed "Finding Key Words," illustrates the impact of inflection. Rhythm is also a powerful tool in conveying a message. The pause can create emphasis and, to an extent, suspense. Paul Harvey is an acknowledged master of the long, long pause, which virtually makes the audience beg for the punch line of his news story.

Rhythm incorporates change of pace, which is also a component of understanding and communicating a message.

The Melody of Speech

In many cases it is not difficult at all to visualize the copy as a piece of music. Variations in rhythm, different inflections and emphases, and variations in loudness, intensity, and pitch, all combine to provide a total effect.

Good writers know this, which is why they "write for the ear." Effective communicators recognize the melodic and dramatic features of what is written, and often compose their own words and melody. The Gettysburg Address, for example, uses a memorable rhythm. And one noted piece of advertising copy was delivered in an unforgettable way: "We make money the old-fashioned way . . . we *earn* it."

Summary

Communicating a message is the first and most basic responsibility of an announcer. The announcer must think in terms of ideas, not words.

Finding key words in the copy is a tool for understanding meaning and ideas. Getting the meaning of the message involves understanding and identifying mood, pace, and purpose. The goal is to communicate, not just to read.

Key words are not always obvious. Often some analysis and digging are necessary to uncover the true meaning and impact of the piece. Noting key words is part of marking copy. Another important part of marking copy is identifying and decoding unfamiliar words and phrases. Wire service phonetic spelling, although it has its limitations, works well within the constraints of typewriters, teletype machines, and typical newsroom operations.

An announcer should make every effort to become familiar with the principles of foreign pronunciation. In addition to learning some language rules, it is important to know how and when to employ foreign pronunciation and inflection. In most cases it is best to follow the rules of pronunciation of the appropriate language but without trying to use the inflections of a native speaker of that language. Speak as you would imagine an educated American would, assuming some familiarity with the language in question. Never hesitate before you say a foreign word.

Names of contemporary newsmakers are pronounced as the person named wants. Names of foreign cities are pronounced according to conventional American usage. In the specialized field of classical music, however, foreign words receive full native accents and inflections.

The major component of marking copy is using symbols to aid interpretation. These symbols act like a musician's notation and guide the announcer to proper phrasing.

Phrasing—the grouping together of words into units forming single thoughts—affects meaning and communication. Marking copy identifies many of the signposts to meaning and communication. Also, it helps the announcer convey the proper rhythm and inflections of words and the melody of the words.

E x e r c i s e s

1. Mark up copy from the drill material in Appendix B and C or copy provided by your instructor. Split into groups of four and exchange copy. Compare similarities and differences. Discuss the differences and why you feel markups are right or wrong.

Next, elect one person to read all four pieces of marked copy, following the markings closely. Others in the group may also do this, depending on time limitations.

2. Using newspaper articles, pick four key words per sentence and write those words down. Do this for an entire article. Many long sentences will have more than four key words, so you will have to use your judgment in identifying the most important words. Be sure to use a straight news article, not a feature or human interest piece.

Read your key words aloud to a partner or to the class. Your partner or the class members must try to *reconstruct the story* from the four key words per sentence. When you read aloud, play out the words broadly and give them as much meaning as possible.

3. Write three approximately 30-second commercials for automobiles, and to the best of your ability write them "to ear." Make up whatever details you wish, but structure the commercials around these three concepts:

Commercial 1: To express elegance and love of luxury. Think in terms of rich leathers, classic interiors, and elegant lines.

Commercial 2: Youth, excitement, adventure.

Commercial 3: Practicality, dependability, durability, value to a growing family.

Have a partner or classmate give an interpretation of the commercials that you have written, aloud or on tape. Critique that performer. Work with him or her until you feel that each commercial is done correctly. Compare your critique with the instructor's critique.

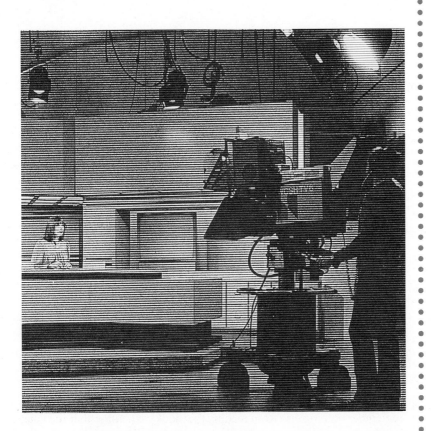

Once he or she understands the basic message, the broadcast communicator must apply those skills to the actual delivery of information. Whether you're reading voice-over copy from a printed script or ad-libbing your way through the morning drive segment of an adult contemporary radio station, the basic requirement is to generate a response from the audience.

In this chapter, we begin by discussing the basic principles of reading copy and then deal with some of the nuances. We discuss ad-libbing in detail. Finally, we'll examine two technical skills that are central to effective delivery of the message: mic technique and camera technique.

Why bother to sit down before a mic or TV camera and read a piece of copy? The answer is not as simple as it seems because, in addition to a good mechanical delivery, a broadcast performer has several goals:

1. To communicate the message accurately
2. To convince the audience, on a *one-to-one* basis, that the performer understands and believes what he or she is reading
3. To breathe life into the message
4. To keep the listeners' and viewers' attention by giving energy to the reading

4

Communicating the Message

Reading Copy

Accomplishing these goals involves proper use of your voice, a genuine and believable delivery, and the addition of style to the reading.

Using Your Voice

Proper use of your voice will help you considerably in communicating, being convincing, breathing life into a message, and keeping the audience's interest.

A good voice is more than an "announcer voice." Today, you can be successful with what was once thought of as an average-quality voice. In news, there has been a trend toward hiring on-air people who act more like journalists and less like performers. The commercial industry often needs voices that express humor or whimsy. Radio station managers and program directors search for true communicators who can reach a specific audience, rather than baritones with "rounded tones."

Two key elements of proper use of your voice were outlined in Chapter 2:

1. A healthy and relaxed vocal mechanism
2. The absence of distracting deviations, such as speech impediments or inappropriate regionalisms

Here we add a third key element:

3. A natural-sounding, genuine delivery

Genuine Delivery

A common beginning mistake is to put on an "announcer voice" and ignore the copy, focusing on the delivery as an end in itself. But even if you remember nothing else from reading this book, remember that the voice is only a tool and the message in the copy is what is important. Your voice *must not distract* from the message.

Your voice must not distract from the message.

Some performers use the message as a vehicle for their voices, a practice that is neither productive nor professional. Actor John Carradine once said that one of the most valuable lessons ever taught to him was not to be "in love with my voice."

It is difficult to define the elements of genuine delivery, because "genuine" implies a sound as natural and unaffected as possible. And yet, the broadcast studio is not a natural setting, and you certainly would not read copy the way you speak to a friend in a restaurant. Although some people advise announcers to talk as though they were speaking to friends in their living rooms, that's not, in a literal sense, what you want to do.

You must work in an unnatural setting and make your performance *appear* natural. You must make your message *resemble* the manner in which you speak to your best friend. If you listened to a tape of a conversation among friends, you would probably decide that it did not meet broadcast standards, especially in terms of diction and energy level.

A genuine delivery adds excitement and interest to a message without injecting artificiality. Mechanically trying to "punch up" copy can result in a strained, unnatural sound. That strained quality sometimes is a result of not

paying attention to the phrasing of the copy. If the words and phrases have been carefully analyzed and the copy marked appropriately, the delivery can sound much more believable.

Lack of artificiality is rapidly becoming one of the most desirable qualifications for an on-air performer. Today's performers in both radio and television are people who can communicate one-to-one. No longer do broadcasters *address* the audience. In radio, particularly, you are often being listened to by one person who is alone.

Top performers who conduct interviews on the air have become particularly adept at the kind of personal approach required of broadcasters today. One of the best in this format is Terry Gross (Figure 4.1), who hosts *Fresh Air*, an interview program heard nationwide on National Public Radio. She is particularly adept at establishing a close rapport with both her guests and her audiences. Although she has an excellent voice, she uses it *conversationally*, putting her listeners at ease as they join her to explore the personalities of her interesting guests.

A style can also be defined as a particular and distinctive characteristic or mode of action. Style is a component of both writing and performing.

Style

Figure 4.1. Terry Gross, who hosts Fresh Air, *an interview program aired on National Public Radio, is noted for her ability to communicate one-to-one with both her guests and her listening audience.*

It is difficult to draw a line between a stylized delivery and an artificial delivery, and even more difficult to try to cultivate a style that works. Trying too hard can result in an affected, phony delivery.

Yet broadcasters, by the very nature of their work, are required to have something distinctive about their delivery and appearance. On-air people frequently become noted for their styles, and unless a performer has something unusual going for him or her, advancement may be difficult.

There is no comprehensive list of styles, nor should you adopt mannerisms based on the approaches given here. Bear in mind, too, that performers use bits and pieces of various style categories to form their own unique styles.

Don't consciously wedge yourself into a style or copy everything a particular performer does. Do, however, remember that all performers pick up things from their colleagues. No one lives in a vacuum, and the way in which other professionals work must have an effect on each of us.

This eclecticism has a plus and a minus side. Johnny Carson admits that some of his style was picked up from the late Jack Benny. The result for Carson was obviously successful. On the other end of the spectrum, the clipped speech pattern of David Brinkley once drew hordes of imitators, most of whom probably retarded their own professional growth by trying to be David Brinkley when one David Brinkley was enough.

Let's look at some style categories and representative performers.

Figure 4.2. Molly McCoy has an authoritative style that brings credibility to her work as an anchorwoman for CNN. (©CNN, Inc. All Rights Reserved.)

Sophisticated Diane Sawyer is an example of a performer who projects a sophisticated air. She projects intelligence, culture, and taste in her bearing, her phrasing, and in her appearance. She is one of only a very few performers who manage to present this image without seeming to be a caricature of sophistication. Former CBS News journalist Eric Sevareid also conveyed an air of cultured intelligence, as does Morley Safer of CBS's *Sixty Minutes*.

Authoritative Someone who projects an air of importance and power comes across as "authoritative," a word that is overused in broadcasting to promote news programming. ABC's Peter Jennings is a good example of authoritative style, as is CBS correspondent Leslie Stahl. CNN's Molly McCoy (Figure 4.2) also conveys authority as an anchor for CNN from Atlanta.

Figure 4.3. Charles Osgood often employs a whimsical style. (Photo courtesy of CBS News.)

Whimsical Advertisers often seek performers who can project humor and/ or vulnerability. The whimsical style works well in specific applications. You would not, though, customarily find this style in the anchor of the evening news. There are certain whimsical *elements* in newspeople and people related to the news business, such as David Brinkley, Charles Osgood (Figure 4.3), and Andy Rooney.

Folksy Without peer in the aw-shucks, down-home approach to communi-

cation was the late Arthur Godfrey, who mesmerized audiences by his folksy, personal manner of broadcasting. A performer who can master this style is sometimes able to parlay it into great trust and therefore great sales power. Godfrey did this superbly.

Walter Cronkite, one of the premier newspeople in the history of American broadcast journalism, projects the aura of an intelligent next-door neighbor. Using phrases like "By golly!" when covering a space flight, Cronkite's friendly, informal style helps give him tremendous credibility. Charles Kuralt also exemplifies the effective use of the folksy style.

Knowledgeable/Didactic Hugh Downs is noted for the knowledgeable/didactic approach. "Ask Hugh what time it is," Jack Paar once wrote, "and he'll tell you how to build a watch." This schoolteacher approach inspires confidence and curiosity.

Bill Moyers appears rather bookish and has a reputation as an intellectual, which he bolsters by his style. He often analyzes a story in a way no typical hard-news reporter would. Frank Gifford, a superb sportscaster, projects this type of image. Newscaster John Chancellor is often described as professorial, and he uses this style element to great advantage. Perhaps the epitome of the didactic, professorial approach is the analytical approach employed by George Will, who indeed once was a college professor.

Aggressive or Hard Sell Performers who seem to leap out of the radio or television set represent the aggressive approach. Mike Wallace has made a living from this style. Some observers have noted the aggressive manner of Geraldo Rivera (Figure 4.4). Rivera's bearing and body language convey a sense of energy—even urgency, although he is noted more for an emotional rather than an intellectual approach. Sam Donaldson carries the aggressive approach to its zenith—or nadir, depending on your point of view.

Figure 4.4. Geraldo Rivera.

Physically Appealing When a performer's appearance becomes part of his or her persona, this physical appeal qualifies as a style element. However, an attractive on-air performer does not automatically fit only this one style. In the most blatant of cases, it is

not difficult to see why an advertiser would feature Meredith Baxter Birney or Tom Selleck. On a more subtle level, newscasters frequently benefit from an appealing appearance. Although attractiveness was certainly not the primary reason for their success, physical appearance has helped Dan Rather and Connie Chung.

Sincere "C'mon, this is a real problem, so help me out here." Phil Donahue has turned sincerity into something of an industry, and for him it succeeds. The sincere and trustworthy approach also works well for commercial spokespeople such as Dick Van Patten, who capitalizes on his father-figure image. Former CBS News anchor Walter Cronkite is still recognized as the embodiment of the sincere and trustworthy news figure. Tom Brokaw projects a youthful sincerity, and Charles Kuralt comes across as a friendly next-door neighbor in his *On the Road* reports for CBS.

Novelty Usually people in the novelty category have distinguishing characteristics that make them virtually unique, yet they often have many imitators. Howard Cosell is a perfect example.

Combinations of Elements The preceding descriptions of the categories are of course not definitive. Many performers cut across style lines, using several elements to hone their particular deliveries. For example,

- *Ed McMahon*. He combines hard sell, sincerity, and a folksy approach.
- *Ted Koppel*. Koppel gives the impression that he plans to get his *Nightline* guests to deal forthrightly with controversial areas, even if it makes them uncomfortable to do so. His style is not threatening. He conveys authority through a combination of sincerity and a knowledgeable approach. His effectiveness is enhanced by the *Nightline* format, which places the guests in a separate studio from Koppel where they don't physically interact with others on the program.
- *Geraldo Rivera*. The style of this controversial television talk show host is remarkably effective in conveying to viewers the impression that he represents them. He uses a "street-smart" image combined with a sincere approach. Rivera alternates the aggressive style of an investigative reporter trying to uncover wrongdoing with the image of a sensitive person who is only putting his guests on the spot because he has to get at some important issues.
- *Bryant Gumbel*. Gumbel (Figure 4.5) combines a direct, "let's cut to the chase" approach with a thoughtful, reflective style that often comes through as the *Today* show goes to a break. His style tends to dominate in brief conversations with co-hosts, a trait that has been

criticized by some viewers. His incisive interviewing techniques are effective in drawing out essential information from guests in the relatively short segments that characterize the *Today* show format.

- *Judy Woodruff.* She combines an authoritative presence, a knowledgeable demeanor, and a measure of physical appeal. Her straightforward style of interviewing conveys no hint of her reactions to the comments of guests, a trait

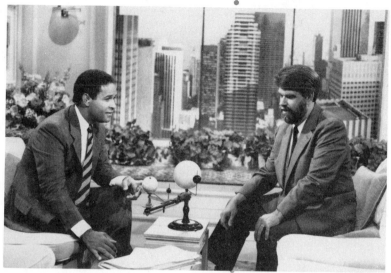

that also seems to characterize her fellow newspeople on the *MacNeil/Lehrer NewsHour.*

Figure 4.5. *Bryant Gumbel, of* the Today show, *interviews Professor Michael Seeds of Franklin and Marshall College. Gumbel's incisive interviewing style draws a considerable amount of information from guests in a relatively short period of time. (Photo by Paul Brawley)*

You can certainly apply the same analysis to most performers you view and, just as important, to yourself.

Developing a Style As we have said, developing a style requires a measured approach, not all-out imitation. It is a combination of assessing your own strengths and weaknesses and experimenting with style elements that capitalize on your strengths. We list briefly several methods for developing a style.

1. Imitate performers who have style elements you would like to adopt. Do this during practice sessions and within the bounds of reason.
2. Before adopting stylistic devices, analyze *why* those styles are successful for the performers who use them. The foregoing section was intended to stimulate such analysis. Ask why the style element bolsters that person's performance.
3. Play up your strengths and make a realistic evaluation of your weaknesses *as you appear to the audience.* Aaron Frankel, Broadway director and acting instructor, points out to students that personal qualities do not always translate to the actor's stage identity. The same holds true for broadcasting. An extremely sophisticated and urbane performer may not *appear* as such on camera or on mic.
4. Experiment. That is what practice is for. If something works, add it to your store of knowledge and experience. If it doesn't work, discard it.

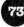

5. Learn from the techniques and successes of others, but do not ape their styles.

Nuances

Many intangibles are associated with communicating a message. Most are subtle, but such nuances often are key elements in getting the message across effectively.

Gestures, *energy*, and *body language* are some of the more important nuances involved in broadcast communication.

Gestures

As an exercise, try delivering a piece of radio copy while sitting on your hands. It's difficult, or should be. Gestures, even on radio, act to color the delivery by their association in our own minds with moods and feelings.

To turn the example around, adding gestures can help radio announcers add expression to their readings. No, the audience can't see the gestures. The audience can, though, sense the announcer's involvement in communicating an idea. Just record a lighthearted radio commercial while smiling and again while frowning. You'll hear the difference.

▼

Learn from the techniques and successes of others, but do not ape their styles.

On television, gestures are obviously more apparent. A television lens magnifies many movements and makes them look exaggerated, so poor use of gestures can also have a negative effect on TV.

For example, restrain your head movement on television. A certain amount of head movement is natural in everyday conversation, especially among animated speakers, but it can be distracting on camera. Be especially conscious of restraining the movement of your head when the TV camera is on a tight shot.

Radio announcers who plan to move into television should restrain their

B O X 4 . 1

Guidelines for Projecting Energy

1. Show enthusiasm for the subject.

2. Project your voice and personality. As one director puts it, "try to jump right into that lens."

3. Vary your pitch and delivery, and be sure to avoid a monotone.

4. *Look* involved and interested, even in radio.

head movement, too. If you have practiced head-bobbing for years in the radio studio, it may be impossible to break the habit when you try to make a transition to television. Avoiding this mannerism from the start is easier than trying to break the habit later on.

Proper gestures, movement, and posture can reflect positively on performance. We address this topic later, in a section on body language.

For many of us, putting energy into a piece of copy requires conscious effort. Low-key speakers appear fine in most normal conversation but can seem decidedly lackluster on the air.

Here is a gray area where the performer has to consciously "punch up" copy but must avoid artificiality. The only way to arrive at a proper compromise is through practice and critique. During practice, it's perfectly all right to overdo the level of energy. If it appears too "hyped," back off a bit. Fine-tune as you go along.

The most important aspect of energy and liveliness is that you cast yourself in the role of being extremely interested and/or excited by what the copy is saying, just as you would be interested and excited when telling a friend you've gotten a great job. That approach may be overdoing it a bit for some products, and much news delivery requires a more somber attitude. But energy is always an important attribute of a performer's talent, and it is worthwhile to cultivate these qualities. The guidelines in Box 4.1 will help you project energy and liveliness.

On the last point, note that most top television performers actually *are* physically fit. The professorial John Chancellor is, in reality, a large and powerfully built man, and even though his physique is not immediately

Energy

5. Maintain good posture when on mic or on camera.

6. Do not use excessive motion. Motion by itself will not inject energy. Appropriate and controlled gestures will.

7. Do not try to inject energy by using a high-speed delivery. Speeding up a monotone won't make it any more interesting.

8. Make every effort to appear and to actually be physically vigorous. Successful radio performers sound vigorous, and successful TV performers look and sound vigorous.

obvious to the viewer, his physical energy and presence are. Walter Cronkite is physically active and aggressive. Jamie Lee Curtis and Jane Fonda typify the vitality and energy that health and fitness provide. Cronkite was at one time a race car driver, and his competitive vigor shows on air. Dan Rather was an energetic although undersized college football player.

Being in good physical condition never hurts and can help considerably in the effort to give energy to your on-air work.

Body Language

Body language has a powerful effect on a performer's appearance and delivery. It is really a combination of gestures, physical energy, and posture.

Body language reflects your attitude toward the audience. Pay attention to body language and your use of it. Some suggestions are shown in Box 4.2.

Ad-Libbing

Many people think of ad-libbing as a matter of opening the mouth and letting the words flow. Even the most experienced performer, however, is never sure exactly what will come out at a given moment. The result of a too-spontaneous ad-lib is frequently embarrassment.

Most good ad-libbers have worked very hard to develop thought patterns that allow them to draw material together in advance, even only a moment in advance, and to use that material appropriately. Ad-libbing is a kind of role playing, and even a second's rehearsal in that role gives the performer an advantage.

The ability to ad-lib (literally, to speak "at pleasure") is becoming one of the most important parts of a broadcaster's arsenal. News reporters today

B O X 4 . 2

Use Body Language to Your Advantage

1. Make your body language show that you are open and at ease. Avoid crossing your arms in front of you, which reflects a closed and defensive attitude.

2. Reflect vigor in your posture. Resist the temptation to slump, which is a particular problem faced by TV performers when sitting at a desk.

3. Use body language to project an interested attitude.

must ad-lib more often than ever before, thanks in large part to modern live transmission technologies.

The first step in developing ad-lib talents is impossible to master in a quick lesson: it is the state of being well educated and conversational in a variety of fields. An announcer cannot fake knowledge. A news reporter must know the facts, a program host must know something about the guest's topic, and a radio personality must, if he or she ad-libs about local matters, be up on current events.

Step 2 in effective ad-libbing consists of learning how to do a quick encapsulation and rehearsal. Give some thought, even an instant's thought, to what you want to say. Break it into coherent, short, and simple thoughts and phrases. Mentally edit what you want to say. The biggest problem of most ad-libbers is their tendency to ramble on too long. One of the authors of this book, for example, was once assigned to ad-lib a 90-second piece from a crime scene live over the air. Just moments on the scene, and panicked by the thought of having to *fill* 90 seconds, he delivered a rambling, barely coherent report that went 6 unbearable minutes. The point? Ninety seconds is not really very long to ad-lib, and the report would have gone much better if the reporter had collected what few facts he did know, assembled them into three or four coherent thoughts, and ad-libbed without trying to fill. This would have turned out to be much closer to the 90-second requirement and would have made much more sense.

The same principles apply to the interview format. Some program hosts are

Components of an Ad-Lib

Leaning slightly forward toward the camera lens gives the impression of energy and interest.

4. Review videotapes of yourself in search of unconscious negatives in your body language. Do you clench your fists while smiling? Do you wet your lips, giving the impression of nervousness even if you are calm?

5. Be aware of how your body language affects others. During an interview program, tenseness on the host's part often communicates itself to the guest.

6. Maintain the posture and breathing habits demonstrated in Chapter 2. Good posture energizes a performance and improves breath support.

more concerned with showing what they know rather than clarifying what the guest knows, and they ad-lib a halting and seemingly endless recitation of the facts during the show's introduction. *Less is always better when it means the difference between a coherent ad-lib and rambling.*

Less is always better when it means the difference between a coherent ad-lib and rambling.

Here is a review of the principles of good ad-libbing followed by an example:

1. Plan and encapsulate. Sum up what you want to say in a few mental notes.
2. Deliver the ad-lib in bite-size segments.
3. Keep it short.

Good ad-libbing involves giving a natural appearance to an unnatural action. When we speak in normal conversation, we don't use the well-thought-out phrases of expert reporters. This is graphically brought home to people who read transcripts of what they have said in court testimony or legal depositions. What sounded quite lucid while being spoken seems almost unintelligible and semiliterate when reduced to the written word.

Thus news reporters ad-libbing live over the air need to organize their material more carefully than if they were describing the scene to someone during a telephone call. Organization and as much pre-air planning as possible are needed. For example, take this scene approximated from a report of a major windstorm.

> This is _____ reporting from the mobile unit. . . . It's really difficult driving because of all the debris in the road, and we don't know when the situation is going to be cleared up. The winds were very heavy, and because of all the debris in the road, police are banning travel. Like I said, it's difficult getting around because of the power lines and downed tree limbs . . . so police don't want people on the roads. No one is quite sure when the situation is going to be cleared up . . .

Had the reporter given a bit more thought to the coming ad-lib, the thoughts could have been broken down into three main points:

1. Police have banned travel.
2. Storm damage is heavy.
3. There is no indication of when the situation is going to be cleared up.

Breaking that down might take all of 5 seconds, but the result would have been a significantly better report:

> This is _____ reporting from the mobile unit, one of the few vehicles on the road now because the police have banned travel in the wake of this evening's windstorm. Debris in the road has made driving virtually impossible . . . the city streets are littered with downed tree

limbs and power lines. At present, police aren't able to give any indication of when the situation is going to be cleared up . . .

The same information is presented, and the report is shorter and more logical.

The principle of planning and encapsulating applies to all facets of ad-libbing. A radio staff announcer, for example, might want to ad-lib about the upcoming Fourth of July weekend. Instead of barging headlong into the ad-lib, she thinks, "I'll come out of the music, read the weather, mention how short the summer has seemed so far— it's almost the Fourth of July— then talk about some of the events coming up."

In addition to being an accurate and coherent expression, an ad-lib should be able to pass the test of appropriateness and should be delivered with a professional-sounding flow.

Appropriateness Just why do you want to ad-lib? To say something, or to hear yourself talk? Try to avoid the latter option. It never hurts to subject a planned ad-lib to this test. A radio personality whose primary purpose is to entertain still must deal in appropriate ad-libs, which touch on common experiences that have meaning to the listeners. In-jokes concerning station personnel, for example, don't meet this test.

Flow Practice eliminating pauses and interjections. Saying "uhh" or making extensive pauses can become annoying to listeners. There is no reason, in most cases, for these delays to collect one's thoughts. Stalling and interjections are primarily nervous habits.

Although the principles just outlined are useful for just about any circumstance, certain tasks require individualized techniques. Let's look at some specific ad-libbing requirements of some typical broadcast performance situations.

In radio today there is considerably less ad-libbing in general than there once was. Most modern radio music formats promote themselves as providing listeners with "more music, less talk." So a steady stream of patter from a "personality"-oriented announcer or disc jockey is counterproductive.

The key is that "less is more." Most radio shifts today call for the announcer to be the facilitator. It is her or his responsibility to make the program elements flow together and create an atmosphere where the audience feels comfortable. Announcers must blend with the overall sound that identifies the station and the format. Ad-libbing helps in that effort by providing information and supplying transitions to smooth the process of getting from one program element to another.

In large-market radio, there are usually strict guidelines for announcers who work an airshift on a music program. In most cases, the music is the star.

Ad-Libbing in Radio

Announcers are expected to talk about things that will interest the particular types of listeners the station is targeted to reach. An oldies station that targets adults between the ages of 35 and 44, for example, wants its announcers to be knowledgeable about the music and the events that occurred when it was first popular.

Many stations will spend a great deal of money researching the music they play to determine how often a particular cut should come up in the playlist rotation and how the music should be blended to meet the desires of the audience. One major-market announcer who was fond of claiming full credit for attracting listeners to the station was invited by the program director to substitute polka music for his normal fare of contemporary hits to see if his sparkling presence was really the crucial element that held the interest of listeners. He declined the challenge. A talkative announcer who wants to be the center of attention can interfere drastically with a carefully designed music format.

For those announcers who are permitted creative leeway, there are fewer restrictions on the style and content of the program. In these programs (often aired in morning drive time), the personality is the focus. Personalities in major markets often work with a producer who helps put together ideas for the program and helps in the studio work necessary to make the material work on the air. Even though greater creative latitude is allowed on personality programs, there is no less attention to the content of the show. The host of a "personality" morning show, for example, often spends three or more hours after the airshift preparing for the next day's program.

At Baltimore's WQSR, the morning air personality sits down with the producer at the end of the show to discuss that day's program. They discuss what worked and what didn't, and talk about ways of improving things that didn't work well. From 11 A.M. until 1 P.M., the producer and the personality go into the production studio to produce the material to be used the next morning.

WQSR's general manager Brad Murray says that to be successful in large-market personality radio, you need to be creative, a good writer, and well informed. Many of the comedy elements used on personality shows are based on current topics in the news. The personality must also be sensitive as to how far he or she can go in flirting with the boundaries of good taste. Top radio personalities and their producers usually know when they're crossing the line, according to Murray. When they get into questionable areas, they ask for an opinion as to whether or not to go with the idea.

Depending on which format you're working with, ad-libbing is either virtually nonexistent, as in some "lite" music stations, or is a major element, as in many contemporary hit radio formats. A brief look at several popular formats will show how widely ad-libbing requirements can vary in radio today.

Country Modern country formats are much changed over the hillbilly styles

of most country stations of an earlier era. As pointed out in the discussion of staff announcing responsibilities in Chapter 5, today's country music recording industry uses all the mixing techniques used in any other category of music. Aside from the major identifying characteristics of steel guitars and lyrics about truck driving and cheating in love and romance, country music stations don't vary widely from many other formats in their overall sound.

Consult Chapter 5 for the general requirements of the country station staff announcer. At this point we'll focus on the special requirements for ad-libbing in this format.

The overriding principle of effective ad-libbing in a country format is "know the music and the artists who create it." While your ad-libbing will be restricted by the same "more music" constraints of all modern music radio, the ad-libs you do use will almost always touch some aspect of the current scene in country music.

If you are new to the category of country music, you'll need to get a quick education. There are several good histories of country music in book form. Check one or two out of the library and bone up.

For actual on-air ad-libbing, here are several principles to guide you:

- *Relate comments to what is going on at the moment on your station.* Don't start talking about the latest Hollywood gossip about Dolly Parton if you've just come out of a cut from Merle Haggard's latest album.

- *Don't depend on your memory of items in the news when making comments about the music or the artists.* Bring clips of information to the studio with you so you can briefly review the information before using it on the air. Chances are listeners are already aware of any news, and you'll lose all your credibility with your audience if you get the facts wrong.

- *Never make fun of the music or the artists.* Country music fans are fierce in their loyalties. Many country music fans regard their favorite artists as "family." Attempts by a radio personality to get a laugh by making comments about an artist are not well received. The same, of course, holds true for all music genres to some extent: listeners may also take offense at remarks about performers as diverse as Bob Dylan or Frank Sinatra.

Adult Contemporary or Lite The concept of the announcer as facilitator of program flow is nowhere more prominent in radio than in the adult contemporary format. Ad-libbing should be used sparingly and often is not even allowed by program directors. Keeping the music flowing is the key here. This format tends to have greater diversity of music styles than many others in radio. It tries to draw from a bit wider spectrum of musical tastes. The

theory is that, even if listeners may not particularly like what's playing at the moment, they will often stay around long enough to hear a selection they do like. But there must be music.

Ad-libbing, when permitted, is very brief and usually is based on the weather, traffic reports, or comments on a current movie or a performance by an artist featured in the station's music format.

For ad-libbing purposes, it is not necessary to have the kind of in-depth knowledge of the music that country music announcers need. Usually the adult contemporary formats have oldies mixed in with more contemporary cuts, but oldies are not the featured aspect of the format, so avoid ad-libs taking off from nostalgia that accompanies a selection. The guidelines to keep in mind for ad-libbing in this format are

- *Keep remarks very general.* Since the audience has a somewhat broader range of interests than those of other formats, you only risk offending part of the group if you give opinions about anything.

- *Submerge your personality.* The announcer's role as facilitator is aided by a certain amount of anonymity. The music should form the central core of the station's sound. Ad-libs that draw attention to the personality of the announcer detract from this goal.

- *When in doubt, leave it out.* If you have any question in your mind about the appropriateness of an ad-libbed remark, don't say it. You'll seldom be worse off by passing up an opportunity to ad-lib. You may, however, regret having interjected an item that turned out to be innappropriate.

Top 40 or Contemporary Hit Radio (CHR) The CHR format, as it exists on most stations, includes more ad-libbing than any other format in radio with the exception of talk radio. The CHR format follows in the tradition of the Top 40 stations of the 1950s, where the personality of the disc jockey figured heavily into the sound of the station. There are several varieties of personality type within the category identified as CHR. They break generally into three basic types:

1. *Rock jock.* This is the modern equivalent of the personality form invented by the famous D.J.'s of the 1950s. They maintain a steady patter laced with information about the music and the artists. Various items of interest to teens and young adults are interspersed, punctuated by humor that appeals to those groups. Energy is the hallmark. The overall sound is heavily produced.

2. *Outrageous.* This style skirts the boundaries of good taste, occasionally overstepping the boundary of what some find offensive. Disc jockeys who affect this style typically insult listeners and often make disparaging

remarks about well-known people. The sound is characterized by short prerecorded segments with heavy use of sound effects.

3. *Shock jock.* This personality type exists primarily in large markets where the personality can afford to annoy substantial numbers of listeners, many of whom will tune in out of a sense of curiosity about how far the disc jockey will go in his or her effort to shock listeners. The bounds of good taste are frequently crossed, and the only restraints seem to be to make obvious word substitutions for language that would be considered too offensive for broadcast.

The requirements for ad-libbing in the CHR format will of course vary, depending on the particular style. The style of personality will often vary by time slot within the same station. There may, for example, be an outrageous style jock for a "Morning Zoo" program in morning drive time and a standard rock jock for midday. Some general principles can be stated for all three categories within this format.

- *Develop a humor style based on the youth culture.* Take a lead from the *Saturday Night Live* and David Letterman types of humor, but be sure to avoid the appearance of being a rip-off artist, who steals phrasing and material directly from these sources. Work on humor that meshes with these styles, but that bears the stamp of your own personality.

- *Keep up with the music and artists that constitute the format.* Read trade press articles about them and keep up to date on news about items such as concert tours, film appearances, and music videos. Integrate this into your ad-libs. This is particularly necessary for the rock jock who has less reliance on humor and shock to create an effect.

- *Maintain a high energy level in your style.* This is helped by the heavy use of short produced program elements that characterize this format. Prepare a list of ad-lib topics and short items, and take it into the studio with you. Check them off as you use them to avoid repeating items. Keep comments short, and move quickly from item to item.

- *Even in the categories of outrageous and shock jock, there is danger in going too far beyond the limits of the acceptable.* The line is difficult to define, but when you have gone too far, it can mean the end of the job and sometimes the end of your career. The best guideline to avoid going too far is to make it a practice to back off when you sense that you may be overstepping the bounds of what you can get away with—with your audience and your station management.

Talk Radio The announcer on talk radio must be able to ad-lib effectively about a wide number of topics. The major key is to be well informed. You should regularly read one or two major national newspapers, a good regional paper, and both general-interest and news magazines. You need to keep up with topics and people who appear on *Nightline* and other public affairs programs on television, and you will have to be generally aware of the books that are drawing a large public following.

In short, the talk show host has to be a well-rounded person who can articulate thoughts with clarity and style. Not an easy assignment, but for those who do it well there are many opportunities for work.

Ad-libbing in this format requires the ability to move quickly from one topic to another and to deal with a wide variety of people. General principles to keep in mind are

- *Bone up on the topic under discussion*. If you are speaking with a guest expert, familiarize yourself with the guest's background and with the books he or she has written. Read the background on topics in the news that are scheduled for discussion.

- *Be careful about expressing opinions*. Unless your assignment calls for a personality who has strong opinions that are supposed to provoke listeners and guests into disagreement and conflict, soft-pedal your opinions. In general, keep your comments as neutral as possible, but don't be afraid to play "devil's advocate" to generate discussion.

- *Don't let yourself come through as a know-it-all*. The most effective host comments in talk radio are made with a certain degree of humility. If you are as well informed as you should be, you will be far more knowledgeable on most topics than the average call-in listener. Never forget, though, that the listener is the most important element of the equation. Treat all callers with respect, but don't get drawn into displays of emotion.

Radio ad-libbing is an art that demands careful attention to context. A reticent talk show host will not succeed; nor will a big-mouth adult contemporary announcer. Many announcers can effectively work in a number of different formats and quickly sense the requirements of ad-libbing. The key is that when it's done effectively, ad-libbing is virtually unnoticeable as such to the average listener. When it draws attention to itself, ad-libbing can detract from the impact of the format in general. The announcer who does so quickly becomes expendable.

Ad-Libbing on Television

Several television situations require announcers to ad-lib. On the local level, news, sports, and weather programming often call on announcers

to ad-lib. Also at the local level are talent assignments involving hosting movie programs, and local talk or interview programs.

Network-level announcing assignments that require ad-libbing include game show hosts, talk show hosts, sportscasting, and news reporting.

Some general guidelines for each category can help prepare you for the ad-libbing requirements of each of these assignments.

Local Local news, sports, and weather talent need to be prepared to ad-lib in these general sets of circumstances:

1. *Between segments on the news set.* The concept known as "happy talk" brought ad-libbing to local news programs all over the country. The extremes of that idea, in which the conversation was specifically structured to convey the impression that the on-camera talent were great friends, has given way to brief segments of conversation that simply function as bridges between segments of the program.
2. *In live reporting situations.* The increasingly common use of live reports from the scene of a news event makes it necessary for reporters to ad-lib news reports that once would have been taped and edited for broadcast. Live sports coverage also uses on-air talent to fill in spots between sports action with ad-libbed material.
3. *During weather shows.* The TV weather reporter is the only person on the news set who works without a written script. The basic information is given on the maps and charts, but it is up to the reporter to present the information smoothly.
4. *When hosting television movie programs.* Although this format is disappearing rapidly, some programs on some local television stations still broadcast feature films in a format that calls for a host to introduce the film and make comments in the spots where there are commercials.
5. *During local talk shows.* Programs in which a host interviews area personalities and visiting celebrities require talent to ad-lib extensively to make the program run smoothly.

Network At the network level, ad-libbing is done by live news and sports reporters, talk show hosts, and game show hosts.

News and sports reporting requirements are similar to those at the local level, although the audience is larger. The same general abilities are required at network and local levels.

Game show hosts have special requirements. Generally, they must create an atmosphere of fun for the participants and the audience.

Talk show hosts at the network level are generally required to interact easily with guests and to move the conversation along so that it stays fresh and entertaining for the audience.

Whether at the network or local level, each of these assignments requires

announcers to draw on their experience to make the unnatural seem natural. Those who succeed in that task draw little attention to their ad-libbing ability. That's the sign that they have succeeded.

It is difficult to draw general guidelines for ad-libbing in these different circumstances, but there are several principles to keep in mind.

- *Prepare yourself as well as possible before you go on camera.* If you are on the news set, for example, plan ahead with colleagues to establish the general sequence of the conversation. If no one knows what to expect, and everyone tries to jump in to fill up the dead air, viewers will sense the confusion and the credibility of the whole news team will be in jeopardy. If you are reporting live, list what you will say in sequence. Do the same thing for live sports reports.

- *Don't be a slave to your pre-set plans.* The best ad-libs are indeed "off the top of your head." The trick is not to have blind faith that something will occur to you once you're on the air. If you have prepared properly, you'll have an idea of what you will say when you are expected to ad-lib. If something better occurs to you later, go with it.

- *Try to think ahead about what exactly will take place during the program or program segment you're involved with.* Not all situations requiring ad-libbing are live, but many are. The more you can anticipate what will happen, the more confidence you'll have. Relaxing and feeling confident improve the effectiveness of your ad-libbing. The same goes for taping sessions. There is a certain amount of leeway for error in some ad-lib situations, but the more professional you are in the session the better you'll feel about your performance.

Ad-libbing in performance situations is the ultimate test of a professional. Those who do it well have considerably broader opportunities for advancement in broadcasting than those who can simply read a prepared script.

We'll discuss ad-libbing more as it fits in with other aspects of various performance situations, in later chapters. For example, there is more on ad-libbing for staff announcing in general in Chapter 5. News ad-libs are explored in the context of overall considerations for on-air work in both radio and television in Chapters 6 and 7, and ad-libbing for commercials is examined in Chapter 10.

Playing to Microphones and Cameras

The rest of this chapter deals with techniques of playing to microphones and cameras. Mic technique and camera technique are major components of basic announcing skills, and they have an enormous impact on a performer's ability to communicate a message.

Interference

Sender

Message

Receiver

Figure 4.6. A basic communication model.

In broadcasting, the equipment necessary to put the broadcast over the air is a very prominent part of the performer's work. The ability of a performer who does not know how to deal with mics or cameras can be seriously compromised by technical errors. By extension, a performer knowledgeable about equipment can enhance his or her performance. Some mics, for example, tend to flatter voices of certain types.

A basic communication model (Figure 4.6) shows that in terms of communication, anything that hinders transmission of a message from sender to receiver is known as *interference*. A great deal of interference may be generated by a performer who is uncomfortable and unfamiliar with the tools of the trade.

There is no necessity for every performer to be a technician. Only a basic knowledge of mics and camera technique is required for skillful on-air work, but that knowledge is essential.

A microphone reproduces sound by means of a diaphragm within the instrument. The diaphragm vibrates in response to sound. Sound is a vibration of molecules in the air or other medium. The diaphragm of the mic responds to that sound in much the same way as our eardrums respond to sound. The mic then converts the vibration of the diaphragm into an electrical signal, which can be transmitted or recorded. The process of converting one form of energy to another is known as *transduction*.

What does this mean to the broadcast performer? Various microphones respond differently to sound. To use the instruments properly, performers should be aware of at least some of these differences.

▼

Only a basic knowledge of mics and camera technique is required for skillful on-air work, but that knowledge is essential.

The Microphone

Microphone Types Mics are classified first according to their internal electronics. The mics most common in broadcasting are the *moving coil*, *ribbon*, and *condenser* types.

MOVING COIL: The diaphragm vibrates in sympathy with the sound that activates it. An attached conductor moves through a magnetic field and creates an electrical signal. Moving coil mics, such as the ElectroVoice 635A (Figure 4.7a), are regarded as rugged and versatile, and are used extensively in field work.

RIBBON: A thin foil ribbon is suspended between two poles of a magnet. Vibrations move the ribbon; the moving ribbon creates an electrical signal. This mic is not very rugged, but many broadcast performers like a ribbon because it is said to impart a warm, rich quality to the voice. RCA's 77DX (Figure 4.7b) is an old-fashioned ribbon mic still favored by many announcers who find that the ribbon element flatters their voices. But ribbon mics do have their disadvantages, one being an extreme sensitivity to wind. Popping of plosives (*p*'s and *b*'s) is very evident on a ribbon mic.

Figure 4.7. Examples of the three main types of mics. (a) The EV 635A, a rugged, dependable, moving coil mic. (b) The RCA 77DX, a fine-quality ribbon mic. (c) The Neumann U-87, a popular condenser mic. (Photos courtesy of Gotham Audio Corporation, New York City.)

CONDENSER: An electrical element called a *capacitor* stores an electrical charge. Actually, "condenser" is an old term for "capacitor" that happened to stick as the name for this type of mic. An electrical charge is applied to the diaphragm and a capacitor plate. The vibration of the diaphragm produces a change in capacitance, which is transduced into an electrical signal.

(a)

(b)

(c)

Condenser mics provide the highest quality of sound reproduction with excellent sensitivity. (A good example is the Neumann mic pictured in Figure 4.7c). For a performer, this can be an advantage and a disadvantage. Extreme sensitivity provides the intimate "presence" so in tune with many FM radio formats. Conversely, a supersensitive condenser mic picks up a great deal of unwanted sound, such as breathing, mouth noises, and console operation.

Pickup Patterns Another major consideration in mic technique is knowledge of pickup patterns. The major pickup patterns are omnidirectional, bidirectional, and cardioid.

The *omnidirectional* mic picks up sound from all directions equally well (except from the very rear of the mic, where the actual mass of the unit blocks sound reception). A very simplified representation of the omnidirectional "pickup pattern" is shown in Figure 4.8a. The pickup pattern chart packed with the mic would contain concentric rings representing the relative volume in units of sound intensity called *decibels*. Technical details are beyond the scope of this book, but if you are interested in exploring further the role of sound and audio in broadcasting, we suggest you consult *Modern Radio Production* by O'Donnell, Benoit, and Hausman, and *Audio in Media* by Alten (see Suggested Reading).

For the performer, an omnidirectional mic is especially useful in hand-held operations where background noises are desired, as in many news applications.

The *bidirectional* pattern (Figure 4.8b), which is characteristic of the ribbon mic, is sometimes useful in a two-person interview.

"*Cardioid*" means heart-shaped, which describes this pickup pattern (Figure 4.8c). Remember, these patterns extend in three dimensions, so a cardioid mic's pickup can be approximated by imagining it to be the stem of a gigantic apple.

A cardioid pickup pattern is useful to the performer in that it cancels out sound from the rear. That feature is often essential in "combo" operations where a radio staff announcer operates the console and other equipment. If noise from the background were not canceled, the listener would be treated to a wide variety of clicks and thumps.

Frequency Response In addition to mic type and pickup pattern, *frequency response* is an important consideration to on-air performers. Frequency response is a complex subject, but basically it means the range of frequencies that can be picked up by an audio system, and because of differences in this response, certain mics emphasize certain pitches and de-emphasize others. One notable characteristic of cardioid mics is known as the "proximity effect," an emphasis of bass frequencies as the performer moves closer to the mic. This can be good or bad, depending on the announcer. Some mics emphasize the frequencies that lend clarity to speech, such as the higher

Figure 4.8. Three mic patterns. (a) An omnidirectional pickup pattern—mic picks up sound equally well from all directions. (b) A bidirectional pickup pattern—mic rejects sounds from the sides, hears only front and back. (c) A cardioid (heart-shaped) pickup pattern—mic rejects sound from the rear.

(a)

(b)

(c)

frequency sounds of consonants. These types of mic are quite useful when maximum intelligibility is required.

Still other mics have switchable patterns. The user, for example, may select a "flat" response for music (all ranges of frequencies receiving equal emphasis), or a "bass roll-off," where the bass frequencies are deemphasized, to defeat the proximity effect and lend greater clarity to speech.

Microphone Selection and Use Selection and use of microphones can have an impact on the performer's image and appearance. Selection of mics is usually done by someone other than the performer, although experienced

announcers do develop a preference for particular mics and use them when available. More important for the entry-level performer is knowing how to translate the information just presented into effective performance. Some practical suggestions are given in Box 4.3.

Learning proper mic technique requires an investment of time and a willingness to experiment. You must also ask questions of engineering and production personnel, who usually will be willing to fill you in on any aspect of mics and their use.

The equipment of television places a variety of demands on broadcasters. Mic technique is not very important because mics in TV are usually clipped to the performer or hung from booms. The unblinking eye of the camera, however, can flatter a performer, or poor camera technique can hinder the performer.

Playing to the Lens One of the major problems faced by newcomers to TV performance is difficulty in becoming comfortable with the properties of the lens on the TV camera.

To play to the lens, work as follows.

1. When you look at the lens, *look directly at it*. Even a small diffraction of the angle of your gaze will be very apparent to the viewer.
2. Take an occasional glance at the studio monitor so that you know what kind of shot you are in. When the lens is on a close-up, you must be careful to restrain movement and gestures.
3. Use proper eye movement. Some of us glance to the side when carrying on a conversation. Although not particularly bothersome in normal conversation, this habit is extremely distracting on TV. A camera lens will mercilessly pick up this movement, and the performer may look "shifty-eyed." When you break contact with the lens, it is much better to glance downward than to glance sideways.

 The subject of camera changes is addressed more completely in the chapter on television news, but it is worthwhile to note that changing the gaze from one camera to another is a good talent to cultivate. Do not make a glassy-eyed rotation of the head. Instead, pretend you are changing conversation partners at a party.

Posture and Bearing Movement and posture are important elements of camera technique. To use movement and posture to improve our on-camera appearance, try the following:

1. *Learn a standard stance and practice it*. This is particularly important to announcers who read while seated at a desk. Considerable practice often

Performing on Camera

91

goes into developing a good-looking and consistent body position. Desk-sitting announcers should practice using the full-front or three-quarters postures (Figure 4.9). The goal is not to slump and to avoid unnecessary movement, while appearing reasonably relaxed.

2. *Don't fidget*. Excessive blinking, table tapping, and constant wetting of lips will imply that you are ill at ease, even if you are not.

3. *Don't use mechanical expressions*. The "raised eyebrow" that some viewers think implies skepticism may simply be a gesture that the newscaster has affected. Not only does it not mean skepticism, it doesn't mean *anything*.

The newscaster's pasted-on "concerned face" can often appear ludicrous and can be offensive to some viewers who know that you really are not ready to break into tears. Some viewers may feel that a maudlin expression is an insincere attempt to appear emotionally moved by a tragedy that is being reported.

Figure 4.9. The three-quarters position is frequently used when on-camera talent is seated at a desk.

Eye Contact Now that prompting devices (Figure 4.10) are common in TV stations, maintaining eye contact isn't as difficult as it once was. Devices such as the TelePrompTer consist of a mirror that is angled over the camera lens. A special camera takes an image of the news copy, and that image is projected onto the mirror. The newscaster or other performer can see the script, but it does not interfere with the camera's view.

You will, though, be required to read directly from copy in many circumstances. In TV news, late-breaking events, election coverage, and so forth all require you to read from printed copy and still maintain good eye contact.

Maintaining eye contact involves the ability to read ahead a sentence or two in the copy. This skill is valuable for radio announcers, too, because it allows them to monitor clocks and look at equipment they are operating. Reading ahead also allows you to spot errors in copy and allows a moment or two to adjust. To cultivate eye contact, use the following guides.

Figure 4.10. A prompting device allows you to read from the script while maintaining eye contact with the camera.

1. Practice reading one sentence ahead of the point in the copy you are reading aloud. This is nowhere near as difficult as it sounds, and experienced communicators can often digest entire paragraphs in advance of the words they are reading aloud.

B O X 4 . 3

Tips for Using Microphones

1. If you have problems with popping plosives, avoid ribbon mics. In addition, position yourself and the mic so that you can speak *across* the diaphragm, not directly into it.

2. Positioning yourself closer to a mic will provide a more intimate feel to your reading. This is particularly true of the supersensitive condenser mics. Be aware that the intimacy can be accompanied by a strong increase in the audibility of mouth noises, such as lip smacking and teeth clicking.

3. Working closer to a mic with a cardioid pattern will lend a deeper quality to the voice. It also may muffle the sound reproduction, which is why some station engineers cover the mic with a thick foam wind filter. The filter mechanically keeps the announcer back from the mic.

4. Wind filters, which come in many shapes and sizes, can sometimes be of use to the announcer who is operating outside in windy conditions or has a problem with popping plosives. These filters, also known as *pop filters*, simply block some air movement.

5. When speaking into a mic, maintain the same relative distance from the instrument. This depends on the piece you may be reading, of course. For an intimate feel you might want to move in closer to the mic, but be sure to maintain that same distance throughout the reading so that the intimate feel is consistent.

6. How close should your mouth be to the mic? The answer depends on your individual speech pattern, the mic itself, and the effect desired. As a *general rule*, 6 inches, about the length of a dollar bill, is a good working distance.

7. You will want to work closer to the mic in noisy situations. Move farther away from the mic if you have a deep, powerful voice and tend to sound muffled during playback.

8. Hard-sell pieces generally sound more convincing when the announcer moves back from the mic. The perspective offered more adequately reinforces the hard-sell message than a close-up, intimate perspective.

Push yourself during practice sessions to scan as far in advance as possible. Reading ahead helps in more ways than maintaining eye contact, because you will be digesting and repeating back ideas rather than words.

2. When reading from a hand-held script, avoid looking up at monotonously regular points. Don't, for example, get into the habit of glancing down at the end of each sentence.

3. Although prompting devices have simplified the problem of making eye contact, they do require some measure of skill. For one thing, a performer using a prompter must avoid staring too directly into the lens. It's natural to keep an eye on the lens, though, so remember to glance down occasionally.

4. Announcers with poor eyesight need the prompters placed close to them. Otherwise, they will stumble over the copy and squint. But performers with very dark eyes must be wary of having the prompter and the camera lens too close, because the movement of their eyes from word to word will be apparent and can be distracting.

Energy One of the most important elements of camera technique and on-air performance in general is the *ability to infuse energy into a performance*, and the most common defect is a lack of that energy. Consider these three remarks overheard or read recently:

• "Be as vibrant as possible," a TV talk show producer recently told a guest for an upcoming segment. "There's something about the medium that robs energy."

• "If you sat next to the announcer on the set," a weather reporter told a trainee as they watched the host of *Good Morning, America*, "he'd blow you away. But on the air he has just the right level of energy. You need that kind of energy in your performance."

• "I am returning your tape," wrote the news director. "Your appearance is good, your voice is outstanding, but your energy level is very low. If you don't care about what you are reading, why should the viewers?"

It is better to inject too much energy than too little. First, what you think is too much might be just enough after the lens and camera have "robbed" the energy. Second, it will be easier to back off than to try to add.

Summary

In the most basic terms, reading copy involves using the voice to facilitate expression, and communicating the *ideas* with an unaffected delivery. The way the announcer does this involves the element of style. Polished performers often borrow style elements from professionals they admire, and you can do the same. However, developing a style must never be outright imitation.

Many of the announcing skills needed to communicate a message involve nuances. Gestures are a nuance that can improve expression even in radio because they add an intangible element of communication. Gestures must be carefully controlled because the television lens magnifies gestures and they can detract from appearance. Energy is another nuance, and a performer should always infuse energy into on-air work. A third nuance is body language, which can subtly convey many impressions to the audience. A talk show host tensely holding the arms across the chest, for example, will convey the image of a withdrawn and up-tight person, a feeling that may be communicated to the audience and to a guest on the program.

An increasingly important basic announcing skill is ad-libbing. To be effective, an ad-lib must be kept brief and must be thought out in advance, even if the announcer can devote only a moment to planning. Break down what you want to say into distinct ideas, and make mental or written notes of those ideas.

Both radio and television performers need to develop the ability to ad-lib. Ad-libbing in radio requires a knowledge of the audience and the format. Ad-libs must blend well with other elements of the overall station sound. Today's "more music, less talk" concept requires music show hosts to make ad-libs short and effective. Talk radio hosts need to keep up with current events and to move quickly from one topic to another. Television situations that require ad-libbing include news, sports, weather, talk and interview programs, and hosting movie shows.

Camera and mic technique are crucial in communicating a message. An announcer who knows how to work effectively within the technical constraints of the media and can take advantage of the properties of mics and cameras will look and sound better. Microphones have varying electronic elements and pickup patterns. The elements are moving coil, ribbon, and condenser. Patterns are omnidirectional, bidirectional, and cardioid. An example of mic technique involves moving closer to a mic for a more intimate perspective.

Camera lenses pick up and magnify any deviation of the eyes from a direct angle to the lens, so a direct gaze, without eye shifting, is important. The properties of a TV camera also require polished movement and posture. Eye contact bolsters contact with the viewer, and cultivating the ability to read ahead in the copy allows greater eye contact as well as improves communication skills.

The most common mistake in television and to a great extent in radio is failure to project enough energy.

1. Cast celebrities in the following hypothetical commercials. Write down which celebrities you would choose for each spot, and what elements in their styles will reinforce the particular message to be communicated.

a. A radio bank commercial specifically geared toward attracting young customers.

b. A radio bank commercial geared to attracting mature investors with a great deal of money.

c. Narration (off camera) for a television documentary on the great science fiction movies of the 1970s.

d. Host (on camera) for a TV special on the earth's volcanoes.

e. Host (on camera) for a humorous look at small-town America. The host must *not* imply anything demeaning about small towns; the humor must be good-natured.

2. Experiment with different body positions as you read several pieces of copy (from the drill section in Appendix B or C or provided by your instructor). Record the readings on audiotape.

Use these modes:

a. Slouching in a chair

b. Standing

c. With gestures

d. Sitting on hands

e. Smiling

f. No expression

3. Practice ad-libbing. Take the following exercises seriously; they can be very effective and useful. Using a portable tape recorder,

a. describe a scene (a busy street corner, looking out a window, a sporting event—anything) for 60 seconds or so. Make it compelling, and more than just a physical description of objects.

b. clip an action news photo from a newspaper and ad-lib a description of the scene (about 60 seconds' worth).

c. ad-lib a brief commercial from the following facts:

- There is a Washington's Birthday Sale at the Acme House of Furniture.
- Everything is marked down 20 percent.
- There's a complete selection of Nordberg Scandinavian furniture, including teak desks and coffee tables.
- Acme will be open all day tomorrow from 9 till 9.

Before you start, let us complicate things a bit. Do this commercial twice: once as you think it should be done for a hit music radio station, and once for a classical music station.

5

Radio Staff Announcing

The staff announcer in today's radio station does far more than just read copy and introduce records. In addition to informing, persuading, and entertaining, the staff announcer must reinforce the station's overall sound. He or she must blend with the production elements and the rhythm and pace of the format to reinforce the basic programming strategy of the radio station. If the format happens to be fast-paced contemporary hit radio, for instance, the staff announcer is expected to convey energy and to inject the right amount of humor to provide an entertaining accompaniment to the music.

Modern radio is very specialized. Formats are targeted for well-defined segments of the population. In radio today, on-the-air performance is measured by the announcer's success in attracting listeners among the station's target "demographics" (population). The primary goal of a staff announcer, therefore, is to attract and hold the interest of the audience segment that the station needs to attract advertisers.

Although reaching those particular audiences is their primary goal, announcers also must know how to operate equipment and how to organize time and perform the tasks integral to on-air work. Small- and medium-

market stations usually require the announcer to work in "combo," operating the mixing console (Figure 5.1) and manipulating discs and tapes, while simultaneously announcing.

Figure 5.1. A radio staff announcer working combo.

In this chapter, we outline the operational and organizational skills required for effective on-air performance in modern radio.

The Staff Announcer's Job

In a broad sense, the duties of a staff announcer can be classified as *performance*, *operations*, and *organization*. There is a great deal of overlap among these categories of duties, but they break down the typical staff announcer's job as well as any other classification. Understanding these categories provides valuable insight into some of the operational and organizational tasks that are not heard by the listening audience but still play an important role in the staff announcer's job.

Much of this chapter centers on programming, rather than on what would strictly be considered announcing, and you may wonder why. Well, programming has been evaluated in such detail because *programming and the role of the performer have become inseparable*. Although 20 years ago an announcer could rely on a good voice and a glib tongue, modern air personalities are evaluated primarily on their ability to fit within the station's format and reinforce the station's programming. *A competent and skilled performer is one who can work effectively within a format and can reach that target audience.*

▼

A competent and skilled performer is one who can work effectively within a format and can reach that target audience.

Performance includes introducing records, entertaining with humor, and reading commercials, weather, sometimes news, and routine announcements such as time and temperature. It also includes the air personality's general patter, which can range from occasional ad-libs to extended comedy monologues.

Performance

The duties associated with getting program elements over the air by means of station equipment (turntables, microphones, the mixing console, etc.) are called *operations*. This category involves such duties as the off-air recording for later replay of in-studio programs or material fed via a network line. Taking readings of the station's transmitting gear also falls in this category. Another operational duty assigned to some staff announcers is answering telephones and taking requests. Many radio stations pay close attention to telephone calls, using them as an informal research tool.

Operations

Never forget that a heavy responsibility can rest on the shoulders of the on-air person during periods of emergency or natural disaster. On-air staff—and sometimes this means the staff announcers as well as newspeople—must pass along crucial information about storm warnings, floods, and other imminent dangers. Each and every on-air person *must* be familiar with the appropriate contacts at local police, fire, and civil defense agencies. In addition, the operator of the radio console is generally responsible for monitoring the Emergency Broadcast System.

Organizational duties include pulling records from the station's library in preparation for an airshift and refiling those records when the shift is completed. Other duties include filling out the station's program logs, lining up commercials and music in advance of airplay, "clearing the wire" (Figure 5.2), and sometimes assembling newscasts.

Organization

With our three categories in mind, let's watch some typical staff announcers at work, focus on requirements of the job, examine the equipment used, and discuss the role of formats in the working world of the staff announcer. The responsibilities of an air personality vary tremendously from station to station. In smaller operations, the announcer may even be responsible for vacuuming the studios. In the top markets, an air personality is just that: an entertainer expected to project a personality, with no or very few operational or organizational chores.

Typical Duties

The following job descriptions and working conditions are typical for stations in the market sizes given. All names are fictitious.

Small-Market Country AM with FM Automation Frank is the morning man at this station, which is housed in a prefabricated three-office building in an open field next to the transmitter and antenna. The station serves a city of 19,000.

Figure 5.2. Clearing the wire.

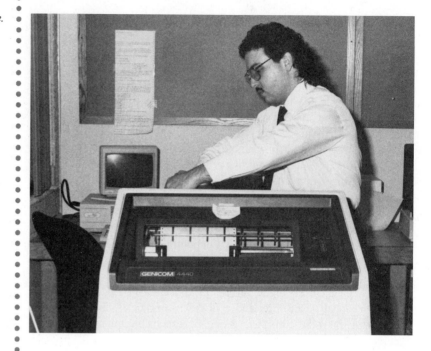

Frank arrives at the station at 5:30 A.M., relieving the all-night person, who is in charge of tending the automation and doing some production. Frank signs on the AM at 6:00 A.M. His performance duties include acting as host of the morning music show until 10. He will also "rip and read" newscasts during the shift. Commercial reading is an important duty. Frank is known for his ability to ad-lib a commercial, and sponsors furnish him with many fact sheets. At 10 he moderates a half-hour telephone call-in swap shop. From 10:30 until 11 he plays a taped religious program, supplied by an organization that buys the airtime. During the tape, Frank must cut two or three commercials. When he is relieved at 11, he goes to lunch and later returns to the station for some more production work.

Operational duties include turning on the transmitter, taking transmitter readings at intervals during his shift, running the board for his own program, running the production board when cutting commercials, and operating all the studio equipment. Another responsibility on Frank's shift is to keep the FM automation running. He must change tapes at half-hour intervals and add material to the program rotation.

Organizational duties include filling out logs, pulling music for his show, refiling that music after the program, monitoring and clearing the wire, and checking the newspaper for local stories. In addition, Frank must keep neat records of the swap shop program because listeners will call in throughout the day to inquire about advertised items.

Summary: Although not a particularly accomplished performer, Frank is well known in the community. He is expected to be reasonably knowledgeable about the music he plays and to be able to communicate effectively on the air. He is in actuality a "personality," but much of his job involves operations and organizational duties.

Small-Market AM Adult Contemporary Lisa, a college student, is a part-time staff announcer at this station, which barely survives in a town of 12,000. The station plays mainly contemporary songs, although there is some country and some "easy-listening" music.

Physically, the station consists of an on-air studio, a small production studio, and two offices. The news wire was removed when the owners fell behind in their payments to the wire service.

Performance duties include acting as a host of a music program and reading an occasional commercial or public service announcement.

Operational duties include running all station equipment. From 7 A.M. until 10 A.M. on Saturday, Lisa will run the board for her own record show, and from 10 until noon she will act as engineer for a Polish music program hosted by a local businessman.

Organizational duties include making standard log entries, filing records and copy, vacuuming the station, and emptying ashtrays and trash cans. Lisa works for minimum wage, as do most of the employees at the station. She receives no benefits of any kind.

Summary: Lisa's primary responsibilities are operational: putting records on air, running the board, and so on. She is not a smooth air personality, nor is she expected to be.

Small- to Medium-Market AM/FM Station George is an announcer on the FM. He plays easy rock and works the afternoon shift. The station is located in a city of 40,000 and is very successful. Headquartered in a reasonably modern building in the center of town, George's station has modest but modern equipment, all of which is well maintained.

Performance duties include introducing records, some light patter, and reading commercial copy and weather. Station policy prescribes back-announcing; that is, George gives the name of the song after it has finished.

Operational duties include running the board for his show and for the local news anchor. He also must hit the network newscast at the top of the hour exactly, and open the network channel on the board.

Organizational duties include pulling music, planning record intros, taking occasional phone calls, and keeping the program log.

Summary: George is expected to maintain a light, pleasant tone throughout, to give brief intros to the music, and to back-announce the songs. Voice quality is important, but there is not a large amount of emphasis on personality.

Medium-Market Adult Contemporary AM This station has a rigidly programmed music format, and heavy emphasis on news, traffic reports, and other useful information. It serves a city of 250,000. Jay, the afternoon staff announcer, also deals with a great number of promotions and contests. His shift runs from 3 P.M. to 7 P.M., although he reports to work at 11 A.M. to handle the heavy production load assigned to him.

Performance duties include heavy ad-libbing, fast humor, and banter with callers who are participating in promotions and contests. Jay reads an occasional commercial, but most commercials are recorded.

Operational duties include the complex job of running the board, which involves handling incoming air traffic reports and frequent prerecorded station identification announcements, inserting commercials, and running the console for the news anchor.

Organizational duties include pulling, but not selecting, music. Music is on cartridges (special tapes described in a later section of this chapter) in a nearby rack. All songs to be played are listed on a log prepared by the station's program director, and Jay pulls the appropriate cartridges from the rack.

Summary: Jay is expected to run a tight board, to handle many fast-paced activities, and to be an excellent ad-libber. He is a good communicator and provides listeners with an entertaining four hours of music, information, and humor.

Medium- to Major-Market FM Rock Angela works in a very high-tech environment. The equipment is state-of-the-art, and there is a great deal of glass in the spacious studio setup. On Angela's shift, from midnight until 6 A.M., she plays long album cuts for a loyal audience in a city of 450,000.

Performance duties include projecting a hip, laid-back style and ad-libbing about the recording artists. She also reads, in her style, short news summaries prepared for her by the late-evening newsperson, who leaves at midnight.

Operational duties include running board, a relatively simple job since long album cuts make up most of the program material.

Organizational duties include pulling records and taking requests. Requests must be logged, because station management wants to know what listeners want to hear.

Summary: Angela is expected to project a certain personality over the air, the aura of the laid-back aficionado of a particular kind of rock music. In addition, she is required to ad-lib about the music, and therefore must be extremely knowledgeable.

Major-Market All-Talk AM Barbara hosts the 10 A.M. to 2 P.M. shift in a station located in a city of one million. She sits in a fairly small studio separated by glass from her engineer, who runs the console. There is a producer for the show who screens incoming telephone calls. To Barbara's right is a device that identifies each caller by first name and hometown.

Performance duties include conversing with the callers and, indirectly, with the rest of the listening audience, and providing information on the topic being discussed. She conducts interviews and reads commercials.

Beyond turning on her own microphone, Barbara has very few operational duties.

Organizational duties include heavy research into the topics being discussed, including a ritual morning's reading of four major newspapers. Barbara also must be knowledgeable about the topics of discussion with interview guests.

Summary: Barbara is expected to be a lively conversationalist and an interesting person in general. She must be a superb ad-libber and interviewer. Also, she is a true one-to-one communicator, an absolute must in the business of talk radio. A comprehensive knowledge of current events is taken for granted.

Major-Market Adult Contemporary FM Bob has the afternoon shift in a network-owned and -operated station in a city of several million. Located in a downtown skyscraper, the studio is lavishly furnished and even equipped with a fireplace, a holdover from the golden days.

Performance duties include introducing records, giving informal patter between cuts, reading commercials, and introducing the news. Bob will cut some other commercials, but not as part of his regular job. He will be paid extra, and very well, for any voice work he does in addition to his airshift.

Operational duties include nothing more than turning on his mic. An engineer in another room runs the console.

Organizational duties are limited to keeping track of the commercial scripts and other announcements handed him by an assistant.

Summary: Bob is expected to perform flawlessly. Sponsors pay thousands of dollars for commercials and expect him to bring that copy to life. He has an exceptional and distinctive voice, which has made him wealthy.

Three Rules of Thumb The examples just given do not cover every situation in modern radio staff announcing. They do, however, illustrate three rules that generally prove true—see Box 5.1.

The tools and experience necessary for an air personality vary with the particular needs of the station and the size of the market. The format, a concept that is examined in more detail shortly, also shapes the requirements.

Smaller markets often seek the so-called jack of all trades. The reason: small market staff announcers simply do not have the support staffs available in larger markets, and must therefore absorb some of the duties that are relegated to other specialists in larger markets. It is not unusual, for example, for a small-market announcer to double as an engineer. A small-market announcer with no technical training will often be required to perform routine

Job Requirements

105

B O X 5 . 1

The Division of Labor in Large and Small Stations

1. Facilities and equipment tend to be better in larger stations. Of course there are poorly equipped, rundown facilities in major markets, and state-of-the-art equipment can be found in smaller markets. But in general there is more money at the disposal of owners of stations in larger markets, hence better equipment and physical plants.

2. The staff announcer is responsible for fewer operational and organizational duties in larger markets than is the case in smaller markets.

3. An air personality is expected to be more professional and talented in larger markets. That person usually will have proved his or her abilities in progressively more demanding arenas before reaching a major market.

maintenance on equipment, such as cleaning heads of tape recorders. Air personalities may also participate in station sales, act as play-by-play announcers, or write copy.

In larger markets, positions are more specialized and require more narrowed and refined talents. The ability to do an interview is useful in small markets, but it is vital to the radio talk show host. What passes for engaging humor in a small market may not captivate audiences in New York, where whole formats evolve around the gag-telling ability of the staff announcer.

Basic requirements for a staff announcer in any market or format include a working knowledge of music and the ability to garner an in-depth knowledge of a particular music style if the situation requires. Familiarity with good grammar and pronunciation is a must. Also important is the ability to work with equipment, since almost every staff announcer must start in a small or medium market and run his or her own board. Lack of this ability definitely hinders a career.

A clear, expressive voice, free of speech and vocal defects, is almost mandatory. Some announcers can turn an odd speech pattern into a trademark, but the odds are against anyone with a distracting defect in his or her delivery.

A resourceful personality and the ability to perform well under pressure are definite pluses. A college education is helpful, but rarely specified in the

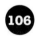

job description. However, being well educated in a general sense is extremely worthwhile for any performer.

As mentioned earlier, operation of equipment is a major portion of a staff announcer's job in most small and medium markets, and a "tight board" is important. Mastery of equipment is not the be-all and end-all of staff announcing, however. Being an air personality involves genuine communication, not just spinning records and manipulating the console. Unfortunately, some air people become fixated on equipment and gimmickry, at the expense of developing an engaging personality and real communication skills.

Even production specialists are wise to avoid thinking in terms of hardware and technical operations instead of focusing on concepts and communication of a message. With that point understood, do recognize that confident operation of equipment is important. Here is a short introduction to some of the equipment found in a typical radio station.

Console To the uninitiated, the console (Figure 5.3) is an intimidating and complex collection of switches and dials. But although the hardware can be complex, the concept is simple. The console is the Grand Central Station of the control room, routing signals, mixing signals, and amplifying signals.

ROUTING: The console is able to take the output of a sound source such as a microphone or turntable and send, or route, it to the transmitter or to a tape recorder. A variable resistor called a *potentiometer* ("pot") governs the loudness of the audio signal. Audio is the electrical signal, which transmits sound.

There is also, in a typical console, an on–off switch that governs the pot. Further details are provided at the end of this discussion.

MIXING: An important duty of the board operator is to mix signals, such as music from a turntable and voice from a microphone. The console allows multiple audio sources to be put over the air at the same time. For example, if the turntable is brought up on Pot 1, and the microphone on Pot 2, the operator, by judgment and experience, will set the correct balance between music and voice.

Equipment

Figure 5.3. A commonly found broadcast console.

AMPLIFICATION: The electrical signal strength of most components in the radio control room is very weak, and the console must amplify these signals to a level high enough to feed the transmitter or a tape recorder.

As stated, the console performs these functions by means of potentiometers, which are manufactured in the form of knobs, similar to rheostats, or as vertical sliders. A potentiometer is almost always referred to as a "pot," with the word also serving as a verb (e.g., "to pot up the turntable"). The on–off switch is commonly known as a "key."

An important element to understand regarding console function is the key. It is generally a *three*-position switch, with off in the middle (Figure 5.4). The *audition* channel is to the left. The *program* channel is to the right. Audition is an off-air channel, used for private listening or, in some advanced applications, for off-air production work on the on-air console. The program channel is the on-air channel. When a pot is keyed to program, the audio source it governs is fed to the transmitter. During off-air production work, the program signal is generally fed to a tape recorder.

An alternative to the audition channel is the cue channel, which feeds a signal to a small speaker usually located in the console, without putting that signal over the air. The most useful application for the cue channel is in listening for the point in a record at which the announcer wants to begin a cut. Then the record can be backtracked so that at a specified time after the turntable is started, the music will begin at the desired point.

Turntables Turntables (Figure 5.5) are essentially record players, but they differ from the home variety in several respects. For example, a broadcast turntable is a heavy-duty unit that has a *plate* (the part that spins) that can be manipulated by hand to cue a record to a point just before the music starts. Older turntables are driven by a gear system, whereas more modern equipment uses a direct-drive method.

For the broadcast performer, working with turntables is basically a matter of learning to cue discs properly and to start them smoothly. This skill is essential in both air work and production.

Compact Discs Compact discs (Figure 5.6) have added a new dimension to broadcasting, and most industry experts predict that the compact disc will eventually supplant the turntable. Because the system uses a digital, computer-aided system to record and play back sounds, the compact disc gives what some feel is a truer rendition of recorded sound. The virtual explosion in recent years in CD use on radio has generally improved things for the on-air performer. There is less need to cue discs than there was when analog turntables were dominant, and there is less chance of damaging CD recordings. Modern broadcast CD players are easily programmed to play many

Figure 5.4. (above left) The key or switch has three positions. To the right is the "program" position. To the left is "audition." The center position is "off."
Figure 5.5. (above right) A broadcast turntable, seen from above.
Figure 5.6. (left) A compact disc player. (Photo courtesy of Sony Corporation of America.)

Figure 5.7. (above left) Tape reels come in various sizes; the most common are 5 inch, 7 inch, and 10½ inch.

Figure 5.8. (above right) A broadcast-quality tape recorder.

music cuts over a period of time. Combined with other facets of computerized operation in state-of-the-art on-air studios, CDs have reduced the amount of physical operational detail for modern radio performers. They have become virtually indispensable in air and production studios.

Reel-to-Reel Tape Machines Reels of tape come in several sizes, including 10½-, 7-, and 5-inch widths (Figure 5.7). The tape itself is generally ¼ inch wide for most broadcast applications.

Audio tape has a mylar or acetate base coated with iron oxide— a fancy name for rust. The iron oxide coating can pick up magnetic impulses and store them by means of the arrangement of the particles. The pattern is encoded onto the tape by the heads of the tape machine. Typically, a tape machine (Figure 5.8) has an erase, a record, and a playback head, and the tape crosses the heads in that order.

Tape recorder heads operate as transducers, a concept introduced in Chapter 4's discussion of microphones. Basically, the record head transduces an electrical signal into a magnetic signal, which is stored on the tape. A playback head reads the magnetic pattern and transduces the magnetic impulse into an electrical signal.

A variant of the reel-to-reel tape machine is the cassette recorder (Figure 5.9). High-quality cassette machines are often found in production and air studios. Portable cassette machines are used extensively in radio news.

Cartridge Machines The cart machine (Figure 5.10) is a record and playback device that uses a single loop of tape. The broadcast cart does not

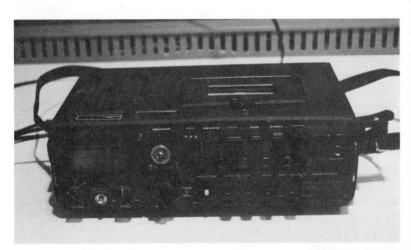

Figure 5.9. (left) This type of cassette recorder is used in many radio stations.

Figure 5.10. (below) This cartridge unit, or "cart machine," represents a type found in many radio stations today.

need to be rewound, since it contains a continuous reel of lubricated tape that feeds from the middle of the spool.

An inaudible tone automatically stops the tape when it reaches the point at which the recording was started. The advantage of a cart over reel-to-reel tape is that the operator does not have to thread a machine and locate the beginning of the program, or rewind the tape when it finishes. Because of the great convenience of the cart machine, much music and virtually all commercials and public service announcements are "carted."

There are other types of equipment available to an on-air performer, and their use is best addressed in a production course. Production skills are indispensable to a radio staff announcer, since in most cases the duties of radio performer and producer overlap. In fact, the ability to use equipment often plays a major role in the overall effectiveness of the communicator. (Just read through the trade journals and note how many help-wanted advertisements for on-air positions specify expertise in production.)

Consider too that if you lack the ability to run the board competently, your performance will be compromised. No matter how good an announcer's voice and delivery may be, constantly flubbed program elements will detract from the message.

In modern radio, the format identifies stations and differentiates one station from another. One of the primary duties of a radio staff announcer is to reinforce the station's format.

Formats and the Staff Announcer

Formats center on more than the choice of music. The format is built by the style of announcing, by the overall pace of program elements, by the choice of announcers, by the sound of commercials, even by the choice of microphones. Any sound element must reinforce the format.

For example, certain FM radio formats center on the "laid-back" air personality who communicates in an intimate way with the listeners. Stations using this format often equip the air studios with highly sensitive mics that pick up breathiness and mouth noises, important components in projecting the "personal" feel. Also enhancing that feel, of course, is the style of the air personality and how well he or she works within the format.

In the past, a typical announcer had a powerful, versatile voice and was called on to do widely differing tasks. A typical shift might have involved reading news, introducing classical music, hosting a live band show, and reading loftily worded commercials.

Glibness and a good voice often were sufficient qualifications for an announcer's position. Auditions usually consisted of tongue twisters and classical music pronunciations, to test the announcer's mechanical ability to render words and phrases.

Today, much more emphasis is placed on communicating a particular message. The news reporter, for instance, is expected to have more than just a voice. He or she must project understanding of the news, a perspective gained only by a professional journalist. Classical music announcers today must show in-depth understanding of the music, not simply the ability to correctly pronounce titles and composers' names.

The specific formats of modern radio call for special abilities and characteristics on the part of the on-air personality. Here are some examples of how an effective on-air communicator must work within a format to reach a particular audience segment.

Adult Contemporary (AC) In what is known as the *adult contemporary* (AC) format, radio station programmers typically try to reach the young adult audience, defined usually as listeners ages 18 to 35 or 18 to 49, depending on the particular *demographic* sought. Demographics are statistical representations of populations.

The demographic data obtained from a study of an audience's density, distribution, and vital statistics are intensely important in the station's overall sales and programming effort. In short, the goal of a commercial station is to "capture" a demographic range and sell that distinct audience to advertisers who want to reach a specific group.

An interesting outgrowth of demographics is psychographics, statistical breakdowns of the audience by lifestyle. Researchers have developed such colorful psychographic designations of audience segments as "minks and station wagons," or "shotguns and pickups." In any event, radio stations use

> Any sound element must reinforce the format.

demographics and psychographics to shape their sound toward reaching a clearly defined audience.

Although adult contemporary programming varies widely within the format, it usually consists of a mixture of light rock, some former hits, and possibly some easy-listening music. Current popular hits are used, but AC programmers steer away from heavy or experimental rock.

To work effectively within an AC format, consider these suggestions:

1. Avoid artificiality. Extremely patterned, singsong "disc jockey" voices are not popular, nor are voices with odd characteristics.
2. Maintain an even pace, not frenetic but certainly not laid back.
3. Be well organized. AC radio relies heavily on the transfer of information (school closings, notes of community interest, traffic, weather, etc.).

In hiring AC announcers, it is not unusual for program directors and station managers to specify "a performer who can provide companionship." This job description might translate into projecting a personality of a friendly and amusing next-door neighbor. As one program director put it, "the kind of man or woman you'd like to have at your cocktail party."

Hit Radio The category that used to be referred to as Top 40 but now is commonly called contemporary hit radio, or CHR, is oriented toward the younger listener. Often, stations are zeroing in on youth in the 12 to 24 age bracket. The format is fast paced, with many different program elements interjected in short periods of time. A jingle may be followed by a commercial, which butts up to a very short station promo, which overlaps the beginning of the music cut, while the announcer "talks up" to the vocal.

To be effective in hit radio, an announcer should

1. Project a very high energy level.
2. Have a good working knowledge of the music. The hit radio announcer won't be required to engage in lengthy discourses on the performers, but some knowledge is necessary. Ignorance of the music and musicians will quickly become evident. Remember, many of the listeners to this format read fan magazines, memorize jacket liner notes, and attend concerts by the performing artists.
3. Handle control room equipment smoothly. A great deal of practice is necessary, because in this fast-moving type of radio the "tight board" is essential.

If you opt for a career in hit radio, remember that you must be able to sustain enthusiasm for the format and for the music. Trends in music come and go, and even announcers in their early twenties often find their tastes

113

moving away from current hits. But on-air enthusiasm must always be evident.

Country There are several formats for country music. One old style was typified by twanging guitars and whining vocals. Some of those elements can still be found in country, but for the most part the format has moved closer to the mainstream of popular music, featuring more sophisticated arrangements and orchestral backgrounds to supplement the guitars. Country can run the gamut from folk to hillbilly to bluegrass to what some programmers refer to as countrypolitan—country music oriented toward a primarily urban audience.

Suggestions for country music air personality work include the following:

1. Study the music and artists. Many listeners are devoted fans, so a good working knowledge on the announcer's part is essential.
2. You must have genuine interest in and appreciation for the music. Enthusiasm for country music is hard to fake.
3. Develop an understanding of factors that relate to rural life. This is not to be construed as implying that all country music listeners are farmers. They are not. Some of the most successful country music stations in the nation, in fact, are located in large cities. However, country music has strong roots in agricultural settings, and many country stations serve rural people. If you do serve a rural area, remember that farming today is a big, sophisticated business, and a modern farmer is just as likely to read the *Wall Street Journal* as the dairy association newsletter.

Country music can be a satisfying format in which to work, since country personalities often attain celebrity status in their markets. This means that an announcer in this format should have a strong desire to communicate and an interest in individuals and the community.

Easy Listening Formats for so-called easy-listening music have evolved in many directions, from "elevator style" background music to more lively programming that incorporates some of the more melodic current hits. In most cases, the music is heavily orchestrated, with few vocals.

Here are some hints to help you function successfully in an easy-listening format:

1. You should have or develop a resonant and pleasant voice. "Mellowness" is one of the more popular qualities stressed by programmers of this format. Also, a mature-sounding voice is an asset, since many listeners to this format are 35 years old and older.
2. You must have or develop the ability to read with great accuracy. Ad-libbing is less important than in other formats, since most material is read.

But since copy is slotted less frequently, and sponsors typically pay a premium for commercials that will stand out, those spots must be delivered with precision.

3. Always maintain a friendly, personal approach. The "friendly communicator" has become something of a buzzword in the easy-listening category.

Easy listening may involve nothing else from the announcer but time and temperature checks, or it can entail a full-scale, albeit low-key, music show. Good voice and diction are especially important in this format.

Album-Oriented Rock (AOR) Although long record cuts and heavy rock are staples, within the AOR format are a myriad of music types and demographic targets. Probably no other format is involved in such precise "narrowcasting," or targeting of a very specific audience segment. One station in the market might, for example, focus on so-called experimental rock, while another might tend toward more popular selections.

In any event, an AOR announcer must have a good working knowledge of the field, since he or she will be expected to ad-lib at some length about the music and the artists.

Other suggestions are as follows:

1. Use an intimate and conversational style. This is virtually the hallmark of the AOR announcer.
2. Study the particular jargon and lifestyle of the listeners, their slang expressions, the concerts they attend, the clothes they wear.
3. Strengthen your ability to ad-lib effectively and at some length. Ad-libbing is important to most radio announcers, but this format, with its conversational approach, requires superior skills.

As with country music, interest in and knowledge of album-oriented rock is difficult to fake.

Talk Radio Talk radio has been around for many years but only recently has emerged into a widespread format, including a very successful series of programs on Talknet. The entire rationale is to elicit responses from listeners who phone in and comment on various topics.

To function effectively in the talk radio format, follow these three rules:

1. Read as many newspapers and newsmagazines as you can. Knowledge in a wide variety of areas is essential. A talk show host caught unaware of an important trend or news development can appear foolish.
2. Develop and practice the interview skills presented in Chapter 8. Many talk radio shows feature an interview segment. If there is no guest, the host must use the same skills to elicit responses from callers.

3. Pay particular attention to time and timing. The talk radio host must know when and how to wrap up a discussion in order to hit the network news or other program element. Also, he or she cannot afford to be caught short, without material to finish a segment.

Talk radio requires the ultimate in one-to-one communication skills and a genuine interest in people and events. Glibness and superficiality are apparent immediately.

Other Specialized Formats These include classical, all-jazz, urban contemporary, and foreign language formats. New formats evolve regularly, and existing formats split into narrower categories. At one time, "rock" was a reasonably accurate description of a station's format. Today there are narrower splintered variations of this format, ranging from new age to soft rock.

The narrower the format, the greater the knowledge required of the announcer. In classical music stations the announcer must be an expert. Besides knowing enough to program music, he or she must be able to discuss the pieces themselves and the life and times of each composer.

Daypart

A station's programming varies within the day, and programming elements in a particular *daypart* will differ from other time periods in the same station. A daypart is a segment of several hours, generally identified in terms of the audience tuning in. In a typical adult contemporary station the morning period, usually from 6 A.M. to 9 A.M. is known as *drive time,* or *morning drive.* As you might guess, that term relates to the heavy listenership as people commute to work. Drive time also includes people in their homes, preparing for the day's activities. These listeners typically are assumed to be eager for news and information, and for a bright companion to get their day started.

As the daypart changes, so does the station's programming elements. The midday audience, listeners from 10 A.M. to 2 or 3 P.M., does not include a great many office or factory workers and is typically thought of at many stations as "housewife" time. The approach of a midday announcer therefore must be different, and at our hypothetical adult contemporary station would be geared toward women. Delivery might be slower; there is not as much flow of news and information, and no traffic reports. Because the listeners have longer periods in which to listen, there may be longer features and interviews.

Later comes "afternoon drive." Here, the input of news and information is stepped up as listeners once again take to their autos. Afternoon drive is generally a bit lower keyed than morning drive.

In the evening, the station's listenership typically skews younger. The announcer may gear his or her approach to college students studying while listening to the radio.

Overnight segments have become more competitive in terms of the

advertiser's dollar. Once thought of as virtually a throwaway, the modern overnight shift often has substantial numbers of listeners, sometimes a very devoted audience. Listener composition typically changes throughout the overnight period. From midnight until 2 A.M. much of the audience may consist of people who have not yet gone to bed, whereas 2 A.M. to 4 A.M. often is the domain of night workers. Starting at 4 A.M., the emphasis may shift slightly to incorporate very early risers. Overnight on-air radio staff announcers often gear their approach and program content with these periods in mind.

To effectively communicate with the target audience, an air personality must combine natural talent and experience. Some elements can be taught, but skill as a staff announcer comes only with experience. Experimenting to determine what works and what doesn't is an invaluable part of the learning process.

Audience feedback over the telephone plays a role, as do ratings. You can also learn a great deal by listening to other air people, selecting elements of their styles with which you can be comfortable. Of course direct imitation is not the goal, but there are very few accomplished radio air personalities who couldn't name five or six other broadcasters who influenced their style.

One guideline that almost never fails is this: be conservative when you first start out. An inexperienced announcer who tries to emulate another personality probably will produce a poor imitation at best and possibly a ludicrous flop. What seems like side-splitting humor to a novice announcer may simply sound inane to the listener.

Start slowly. Learn the station's equipment, program schedule, and format. Ad-lib with discretion. Experience and airtime will point up your strengths and weaknesses. You may find that you have a definite flair for humor. If so, expand on that base *slowly*. Here are two techniques for developing an on-air personality and a perspective from which to approach air work:

1. *Use imitation and trial and error.* Listen to other personalities and identify the elements in their deliveries that are adaptable to you and your station. The key here is to listen critically, both to others and to yourself, to determine whether that joke, approach, or style really works.
2. *Polish your delivery with the audience in mind.* Put yourself in the place of a listener, a listener you believe to be typical of your station. Would you, the listener, find that remark funny, or tasteless? Is that 5-minute feature compelling or boring? Use this acid test before and after a program segment.

The artistic and technical aspects of delivering a commercial are evaluated in Chapter 10. See Box 5.2 for three techniques of commercial delivery that relate specifically to the radio staff announcer.

Techniques of Radio Staff Announcing

Finding Personality and Perspective

▼

Be conservative when you first start out.

B O X 5 . 2

Commercial Delivery

1. *Avoid "going flat" on commercials.* One of the biggest problems encountered by an announcer pulling an airshift is a general flatness imparted to commercial copy. Often a radio staff announcer must read the same copy day after day for weeks. (One author of this book once worked at a radio station where a client's copy remained unchanged over a 15-year period. It became a badge of having earned your credentials as an announcer at the station to have the chance to read this classic, enduring copy on your airshift.) And with the increasingly heavy use of prerecorded commercials, only a few spots may be read live by the airshift announcer. The result: a mechanical, lackadaisical approach.

Keep your energy level and enthusiasm high, by reminding yourself that this is where you directly earn your paycheck. Remind yourself of the fact that the client has only you and your ability to interpret the copy, as a means of persuading listeners of the value of his or her commercial message.

2. *Do not use the same rhythm, pattern, and inflections for every commercial.* Each commercial is an individual work

Entertaining with Humor and Taste

As stated, the development of a personality, as the term applies to on-air radio work, is largely a matter of trial and error and experimentation. Humor and entertainment value, which are important facets of that on-air personality, must be balanced by good taste.

When experimenting, consider that *humor* must be funny. That sounds tautological, but a scan of the radio spectrum suggests otherwise. Three points on humor during an airshift:

1. Avoid in-jokes.
2. Think before you say it. Is it really funny?
3. Don't keep repeating the same line. Listeners will notice.

1. Avoid in-jokes.
2. Think before you say it. Is it really funny?
3. Don't keep repeating the same line. Listeners will notice.

Some radio air personalities subscribe to humor services that provide one-line jokes for a fee. These lines can be incorporated into the patter, and with practice they will sound original and topical. The danger with subscription humor is that you may not adequately make written material "your own." If a joke sounds as though it is being read off a sheet, it will fail.

and must be analyzed in terms of its own intent. What is the goal of the spot? To whom does it appeal? Why? To avoid mechanical reading, you must have an understanding of these points. Find the key words and use the techniques of marking copy described in Chapter 4. But vary your vocal delivery so that each commercial comes across to the listener as distinct and unique.

3. *Read what is written.* The quickest way to get into trouble as an on-air announcer is to take liberties with a client's commercial copy. The key guideline in 99 percent of the situations in which you are asked to read copy live is to *play it straight.* Don't change words, or rearrange the order of presentation. And avoid the temptation to make gratuitous remarks about the copy before, during, or after reading it. If you think you can do a better job of writing the copy, talk to the sales representative and make suggestions. Don't take it on yourself to punch up someone else's copy on the air. In most cases the copy has been cleared with the client, and most clients are quite specific in what they want said and what they don't want said in their radio commercials. The exceptions are commercials in which an announcer is asked to ad-lib a commercial from a fact sheet. When that situation occurs, it will be very clearly stated on the copy sheet.

Entertainment is really what the whole business is about. The overriding goal in the element of entertainment is to get and keep the attention of the audience. The audience must be interested in a commercial, a record, or a public service announcement. Therefore, *you* must be interested, and you must sound interested.

Good taste varies, to some extent, with the composition of the audience. A staff announcer is expected to avoid material and presentations that would offend the audience, unless the announcer's style is one of being offensive. There are, of course, some announcers whose style is built around bad taste, a provocative method of enticing listeners to tune in. But for most purposes good taste is still the name of the game.

In the demanding work of an air personality, there is considerable pressure to be funny and to come up with things to say. Often, this pressure may lead you to say things you shouldn't. When in doubt, especially at the beginning of your career, err on the conservative side.

Some radio announcers' careers are impeded by amateurish attempts to be outrageous or exceptionally funny. Understand that unless and until you

attain the stature of a Don Imus, station managers will be far more concerned with complaints of sponsors and listeners than with your freedom of expression.

Analyzing Yourself and Others

How do you keep improving your skills? One major advantage of being in the broadcast business is the ease with which comparisons are made. Analyzing the strengths and weaknesses of others can significantly help your development.

Listening to yourself is important. Taping a show is an excellent tool. In some stations, monitoring airchecks (a recorded segment of an actual airshift) is a requirement of the job.

Also, solicit the opinions of others. Friends and co-workers may sometimes tell you what they think you want to hear, but often they will be strikingly honest. Feedback may sometimes be tough on the ego, but it is worthwhile.

Sometimes announcers stop learning at a particular phase, perhaps in a small or medium market. Those announcers may never get any better because of a lack of talent or, more probably, because the situation does not force them to improve. If there are no expert programmers critiquing airshifts, and if competition does not force continual improvement, the announcer will not grow professionally.

Always remember that the very best announcers got that way by comparison and critique. At one major-market station, for example, the entire air staff receives a daily critique from the program director.

Careful analysis and self-critique are vitally important to honing on-air skills. Listen to yourself; then listen to others. A good-quality radio with a long antenna can bring in an astounding number of stations. You can immediately compare your performance with others all over the region. At night, when radio waves travel farther, your comparison can extend halfway across the nation.

When analyzing the deliveries of other announcers, refer to a copy of the *Broadcasting/Cablecasting Yearbook*. This annual publication, which is found in most major libraries, lists along with much other information, all the radio stations in the United States by call letters and by frequency. Identifying the size of the station and market will help your analysis by showing exactly what format and market size you're listening to.

Airchecks

You will hear an amazing variety of material. On a major-market adult contemporary station, for example, a twist of the dial turns up a noted personality interviewing via telephone a public relations man trying to promote a product.

Announcer: Can I tell you something?

P.R. Man: Yes, of course.

Announcer: No offense, but you're kind of a jerk. Has anybody ever
 told you that?

This announcer makes a career out of being offensive.

Changing stations to a medium-market hit radio station, the listener encounters a robotic screamer who makes a living out of endless repetition.

> (*Jingle*)
> Hey, that's Madonna!
> (*Station ID*)
> Everybody wins at _____! Nineteen after ten! Comin' at ya with . . .

At a small-market country station, the announcer takes a more original approach:

> Well, howdy. C'mon in. Get set for some mighty fine country music. We've got Merle and Dolly and . . .

This air personality has developed a unique personality and plays the role well. Even his speech pattern, a virtual "country dialect," reinforces his image.

But on the neighboring adult contemporary station, the announcer is not doing so well.

> And that was Whitney Houston. And there's Bob coming in the studio . . . he's been over at Hank's office and we know what they've been talking about . . . heh, heh . . .

In-jokes just don't bolster communication between the air personality and the audience.

But in another state, an FM AOR personality plays personal communication to the hilt.

> How's it going? Wow, what a day, huh? The weather was just great . . . just great. Frank, who's working in the stockroom of the A&P, just called in and says he's depressed about having to work on such a beautiful day, and he thinks a double shot of R.E.M. might improve things . . .

She ad-libs a few remarks concerning that group's last concert in town.

In another city, an announcer at a large station that plays middle-of-the-road music, tending toward nostalgia, ad-libs beautifully.

. . . When that song was recorded she was working as a vocalist with Tommy Dorsey. Nobody thought her style would make it, but after . . .

The announcer, one of the best in the business, gives an insightful and interesting background into the music. How did he get to that plateau? Presumably by doing his homework, listening to himself and to others, and *always trying to improve.* In the fast-changing world of the radio staff announcer, staying still is, in reality, moving backward.

Summary

Radio staff announcing is a complex job, involving entertaining, informing, and providing companionship. The duties and responsibilities of an air personality vary among particular stations and particular markets. Typical jobs involve performance duties, operational duties, and organizational duties. Performance is on-air work. Operations include operation of station equipment. Organizational duties include keeping logs and filing music.

In general, the larger the market, the greater the emphasis on performance duties. This means that the large-market performer must be a superior on-air performer and will generally have fewer operational or organizational duties.

Most announcers have operational duties, though, and even those who do not have operational duties certainly have run the board at one point in their career. The board is a mixing console allowing the operator to mix, route, and amplify signals from sound sources. Sound sources include turntables, microphones, tape machines, and cart machines.

Techniques of radio staff announcing include developing a personality and perspective, a task that involves trial and error, listening to and incorporating suggestions and feedback, and assessing one's performance from the point of view of the audience.

Delivery of commercials is an important part of the staff announcer's job. Two techniques that relate specifically to this task are maintaining energy and enthusiasm and varying delivery. These two techniques are particularly important because radio staff announcers often "go flat" when confronted with many commercials to be read in a shift.

Important to the staff announcer are humor, entertainment, and good taste. What is funny to the announcer may not be funny to the audience, so it is important to subject prospective humorous remarks to the acid test: is it really funny, and will it amuse a listener? The listener expects to be entertained by listening to a radio personality, and there is no surer way for an air personality to be entertaining than to enjoy what he or she is doing. But any humor and entertainment must be subject to the rules of good taste, and evaluating program elements and potential ad-libs with that in mind is worthwhile.

Radio staff announcers have a distinct professional advantage in that they can easily listen to others and compare their performance with that of

announcers in local and distant areas. Use a copy of *Broadcasting/Cablecasting Yearbook* to find out additional information on the markets to which you are listening.

Exercises

1. If you have access to a production facility, combo a 5-minute record show. Pot down the records after the music has been established, and move into another piece of music. The timing is approximate, but the content must include

a. An introduction to three discs

b. A weather forecast

c. A public service announcement (PSA)

d. Station identification

e. One commercial

f. Two time announcements

Do this with any style of music and style of delivery with which you feel comfortable. If at all possible, write your own commercial, PSA, and other material. If production facilities are not available, just read the copy into a tape recorder and pretend the records have played.

2. Repeat Exercise 1, but use music and delivery reflecting these formats:

a. Fast-paced hit radio, with a target audience of very young teens

b. Easy listening, with a very affluent, middle-aged target audience

c. Album-oriented rock, with a target audience of rock aficionados in their early twenties.

3. Select the largest and best radio station you can receive in your area and listen for 15 minutes at a time during three separate dayparts. Write down your impressions of the air personality, and describe that individual's

a. Timing

b. Pace

c. General approach

d. Use of humor

Do not undertake an extended discussion; just make brief notes. Also, note production values, such as how tightly recorded material is played together and integrated.

If possible, listen during morning drive, midday, and afternoon drive. Compare and contrast the air personalities on the dayparts.

Perhaps the most personally satisfying area of broadcast performance is news. News is distinct among broadcast performance specialties because it is a distinct profession with its own professional standards, operating principles, and ethics. Two chapters (6 and 7) are devoted to broadcast news in this text. They address the special qualities that comprise the news operations of radio and television.

Very few newspeople are employed simply to read news on the air. A major part of the day-to-day duties of broadcast newspeople is involved with preparing the news broadcast. The on-air newsperson must be able to gather, write, and produce some of the audio and/or visual elements that give form to broadcast news stories. Even those few individuals at the very top level of broadcast news have some involvement in assembling the elements of the on-air news product. And those people got to the top of that lofty pyramid because they were skilled journalists who advanced through the ranks.

It is beyond the scope of this book to offer a full course in journalism. But Chapters 6 and 7 provide a broad view of the journalistic principles that relate most directly to on-air performance.

Broadcast journalism offers rewarding opportunities for talented and skilled broadcast performers. In television, news offers the greatest number of opportunities for entry into the medium. To succeed in this specialized area, it is highly advisable to include in your preparation some training in

Broadcast News and Radio News Announcing

journalism, both broadcast and print. It is also important to become well grounded in other academic areas, such as economics, political science, English, foreign language, and sociology.

Broadcast News

In an overall sense, a journalist in a broadcast setting is under the same obligations and constraints as a print journalist. The responsibility for accuracy and completeness is no less demanding in radio and television than in a newspaper. Broadcast news takes on some additional importance, however, because of its immediacy. Broadcast, especially radio, is the medium most capable of responding instantly to breaking news. Moreover, the impact of broadcast news is often considered to be greater than that of the print media. This was brought home vividly during the extensive coverage of the war in the Persian Gulf. The immediacy of live reports of events that were taking place as we saw them, and the ability of video to convey the effectiveness of high-tech weapons, were just two elements of coverage that print could not duplicate. Television, with the help of satellite hookups, allowed people at home to experience this war in ways that have never before been possible. In fact, in many ways television viewers probably had a better concept of what was going on at any point in the war than many of those who were actually on the ground in the war zone. Even the U.S. Secretary of Defense noted at one point that he was getting his information on the initial bombing raids over Baghdad from CNN.

Often, broadcast news is looked on as something like show business, and many such criticisms have some justification. For example, the trend toward "happy talk" news programs of the 1970s produced, at the extremes, some inane results.

The power of the rating point in broadcast news is undisputed. No commercial station can afford to ignore audience considerations in news programming. But the charge that broadcast news is "pure show business" is false, and the source of much of this notion—namely, print critics— should be recognized. Print news sources are not exempt from the need to attract an audience, either. Newspapers, which have paid great attention to graphics, artwork, and readability, also show awareness of the "entertainment" function.

A commonsense look at the state of American broadcast news journalism shows that although show business plays an undeniable role, there is a great deal of quality, integrity, and inventiveness at every level of the profession.

Structures and Content

The structures of broadcast news fall into several broad categories that overlap. They are presented here to give an idea of the news functions, not a definitive listing.

Newscast In its simplest form, a newscast involves nothing more than

reading aloud a string of news stories. In longer form, such as television news, the newscast is a mixture of breaking news and feature material. In essence, the newscast is a planned and structured assemblage of news, which encompasses some of the following forms.

Report One element of a newscast, the report, deals with a single news item. It can take many forms, such as the *voice report* on radio, where the reporter delivers a minute or so on a news topic. The voice report, or voicer, is signed off with the reporter's name and affiliation, such as "This is Frank Lombardo reporting for WAAA News." The radio voicer can be expanded to include an actuality, or snippet of an interview or other relevant audio from a newsmaker or news event. Incorporating an actuality into the voice report produces what is known as a *voice-actuality*. This might consist of 10 seconds of the reporter delivering the first section of the voicer, an interview segment cut in for 20 seconds, then the reporter finishing up with a 10-second close and signing off. Actualities without a voice report wrapped around them are often used within the newscast. Sometimes actualities are simply introduced by the newscaster.

Television's version of the voicer is often referred to as a *stand-up*. The structure of the radio voice-actuality piece, when done with video, is usually called a *package*.

Interview The exchange of information and ideas is often the crux of an entire news show, such as *Meet the Press*. The subject of interviewing is covered in detail in Chapter 8. When portions of an interview are used in a news report or newscast, they become actualities.

Documentary A documentary is a relatively long piece done in dramatic style. Generally, a documentary focuses on one issue and has a plot line. A documentary usually reaches a conclusion and makes a point. "Documentary" is clearly distinct from "docudrama," which is a dramatic reconstruction of an actual event in which actors representing real people work from scripts based on eyewitness accounts and the public record.

Hard Versus Soft News *Hard news* generally deals with breaking stories and ongoing events that are newsworthy because of their immediate impact on listeners and viewers. *Soft news*, sometimes called *feature news,* is not necessarily linked to a time element or to a story of immediate impact. For example, the story of a fire in progress is hard news, whereas a follow-up report on the lives of the people thus made homeless crosses into the soft news category.

In many stories, soft and hard news overlap. An investigative report on the influence of organized crime in city government may uncover hard news, or material that becomes hard news.

Requirements and Duties of the Journalist

Broadcast journalism requires a number of specialized skills and talents. Aside from the standard requirements for other broadcast assignments, the following attributes are helpful and in many cases essential.

A Broad Education Knowing something about a wide variety of subjects is a great plus for a broadcast journalist. Proper pronunciation of words and names is largely a function of formal and informal education. It is also important to have an awareness of world events. After all, you can't report the news without understanding the context in which events occur.

Writing Skills Almost all broadcast news on-air people are required to write copy. Remember, too, that occupants of read-only positions generally got there through previous news positions in which they employed writing skills. You *must* develop the ability to write for the ear in broadcast style, a topic addressed later in this chapter.

Ad-Lib Skills The ability to ad-lib is especially important for the voice report, which in modern radio and television is frequently delivered live over the air. New remote gear means that more news pieces are done live from the field, and with improving broadcast technologies there is no question that the ability to ad-lib will become increasingly important in broadcast journalism.

Interpersonal Skills News-gathering personnel must sometimes prod, flatter, or browbeat news sources, depending on the situation. The ability to extract news requires finely honed interpersonal skills. Also, you are likely to encounter difficult situations in dealing with news sources, and often you must be particularly sensitive to the feelings of someone who is emotionally distraught.

News Sense Few of us are born with news sense, but someone lacking it cannot determine what is news and what is not, and cannot assess the relative importance of stories. A journalist develops this ability largely through experience and guidance from other professionals.

News Style and Impact

Style in broadcast news, in a general sense, concerns the way the news is presented. From a performer's standpoint, the desired result of a particular style is to draw attention to the news, not to the newscaster. Exceptional news personalities are usually highly regarded because they make the news coherent, exciting, and immediate for the listener or viewer, not because they are handsome or beautiful.

Yet popular folklore would have us believe that the typical news anchor is chosen exclusively because of his or her looks and voice. There is a kernel

of truth in that, but journalistic know-how and the ability to communicate and convince are the deciding factors in hiring for most anchor jobs.

The factors that make any broadcast journalist able to communicate and convince include believability, energy, and authority.

- Believability. A newsperson with a believable style is able to communicate without artificiality, inspiring confidence in the truth of what he or she has to say. Believability is enhanced by forthright speech devoid of any artificial patterns and by a knowledge of news and current events.

- Energy. Broadcast news performers are expected to inject energy into their delivery, to keep listeners and viewers interested. To succeed in this, the performer must be interested in the copy.

- Authority. The element of authority—a variant of believability—convinces the audience that the newsperson knows what he or she is talking about. Viewers and listeners almost always can tell the difference between a mere reader and a real reporter.

Broadcasters are required by the very nature of their jobs to have something distinctive about their on-air appearance and delivery, and style is important to newspeople as well as to other on-air personnel in broadcasting. Style—which includes the elements of believability, energy, authority, and miscellaneous personality traits and other elements discussed in Chapter 4—is a major factor in the success of many journalists. Box 6.1 gives some examples of newspeople who project various styles.

As the foregoing examples suggest, an effective communicator of news must develop beyond being a reader of copy. An important part of broadcast journalism is the interpretive role played by the newscaster, the energy, believability, and authority the newscaster imparts to the copy.

One caution: the development of your style must not affect content. Never let style distort facts.

Newswriting is a complex field, and shelves full of books have been devoted to it. This introduction describes some basics of newswriting that are particularly useful for the on-air performer.

Why is newswriting important for on-air people? First of all, to succeed as a journalist, you must be able to write. Second, understanding how a news story evolves greatly enhances your ability to communicate facts and ideas.

Let's follow a radio news story from beginning to end. A radio news reporter hears from the police and fire scanner that there's a fire at a major furniture warehouse. She immediately calls the fire department, confirms that there is indeed a fire at that location, gets the name of her informant, receives permission to record the call, and gathers pertinent information.

▼

The factors that make any broadcast journalist able to communicate and convince include believability, energy, and authority.

Newswriting Basics

129

Figure 6.1. Veteran news broadcaster Paul Harvey is very effective with an authoritative style of on-air delivery. (Photo courtesy of Paul Harvey.)

B O X 6 . 1

Examples of News Delivery Styles

- *Paul Harvey.* Known for his distinctive radio style, Harvey (Figure 6.1) projects authority and tremendous energy. A listener could not possibly conjure up a mental image of Harvey reclining in a soft chair to do his show. It is an edge-of-the-seat affair, punctuated with gripping suspense as he builds to the conclusion, pauses, and delivers the punch line.

- *Ted Koppel.* Authority and believability are strong points in Koppel's delivery. His apparent ability to stay completely in control regardless of the situation seems to have been a factor in his selection to act as host of *Nightline.* Although

Q: What's happening right now?

A: Two alarms have been called in. The call came in at 10:47 and we sent the first units. When the deputy chief arrived, he figured we needed another unit, so a second alarm was called in.

Q: Has anyone been hurt?

A: Not that we know of, but rescue firefighters are searching the building right now.

Q: Do you have reason to believe that people are still inside?

A: No, the manager of the building says all employees are accounted for, but we have to check as a matter of routine.

Q: Could you describe the extent of the fire?

A: At last report, the building was about 50 percent engulfed. I just talked to the deputy chief on the scene and he thinks the roof might collapse, so the firefighters on the inside are going to have to get out pretty soon.

Q: Any danger to other buildings?

A: We don't think so. There's not much wind, and no buildings connect to the warehouse.

Q: Do you know what caused the fire?

A: Nope, no idea at this time. Listen, I gotta run because there's another call coming in. Call me back in 15 minutes or so and I'll know more.

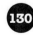

this program often deals with relatively abstract ideas, it also provides a forum for the exploration of ongoing news stories such as hijackings.

- *Ed Bradley.* The no-nonsense approach of this veteran *Sixty Minutes* reporter conveys the image of someone who understands the essential elements of the story he is working on. His style is nonconfrontational, but he conveys to the audience that he is not going to be satisfied with the answers he receives until he gets the truth. Viewers get the impression that Bradley is carefully building his story bit by bit, filling in pieces that will eventually result in a complete picture.

- *Connie Chung.* A straightforward approach enhances Chung's authority and believability. She is a pleasant, serious journalist who does not hesitate to show her concern with the news.

From this information, the reporter can construct a story. Granted, it is far from complete, but that's what the reporter has, and she must go on the air with it in the next couple of minutes.

The first step is to write the lead, the first sentence of the story. The two primary categories of leads in broadcast writing are hard leads and soft leads, but there are many variations. A hard lead is a straight presentation of information, the major facts of the story. The soft lead is a more leisurely approach, designed to stir interest.

In the case of a fire story, an immediate piece of breaking news, a hard lead is called for:

A two-alarm fire is racing through the Hoffman Furniture Warehouse at 511 Clinton Avenue West.

The lead sentence in broadcast news writing is usually shorter than a lead in a newspaper article. Basically, this is because broadcast news is written for a listener instead of a reader. If who, what, where, when, and why are all in the first sentence, a listener will be very hard put to comprehend it. A newspaper lead might look like this:

A two-alarm fire raced through the Hoffman Furniture Warehouse at 511 Clinton Avenue West today, causing no injuries but heavily damaging the building, District Fire Chief Stanley J. Kusinski said.

That is a good newspaper lead, but even though considerations of "why" have been omitted, it would be difficult for a listener to digest.

The radio lead just given is more appropriate, and when followed by other important details it forms the basis for a short, punchy story:

> A two-alarm fire is racing through the Hoffman Furniture Warehouse at 511 Clinton Avenue West. No injuries are reported. All employees are reportedly accounted for, but officials on the scene are conducting a room-by-room search. The building is 50 percent engulfed by flames, and firefighters worry that the roof may collapse.
>
> The initial report was called in at 10:47 this morning. When officials arrived on the scene, they called for additional apparatus.
>
> Fire officials say there's little danger of the fire spreading to nearby buildings. The cause has not yet been determined.

This story could also be written to include an actuality recorded from the telephone interview.

> A two-alarm fire is racing through the Hoffman Furniture Warehouse at 511 Clinton Avenue West. No injuries are reported. All employees are reportedly accounted for, but officials on the scene are conducting a room-by-room search.
>
> Here's how District Fire Chief Stanley Kusinski describes the scene:
> "The building is about 50 percent engulfed. I just talked to the deputy chief on the scene and he thinks the roof may collapse."
>
> The initial report was called in at 10:47 this morning. When fire officials arrived on the scene, they called for additional apparatus.
>
> Fire officials say there's little danger of the fire spreading to nearby buildings. The cause has not yet been determined.

The story will be updated throughout the day, and the lead will progress through several stages:

> Fire officials have finally left the scene of a stubborn, smoky fire at the Hoffman Furniture Warehouse . . .
> Investigation continues into the cause of this morning's fire at the Hoffman Furniture Warehouse . . .

When a story is no longer breaking news, the lead may change from a hard lead to a soft lead:

> It was an exhausting day for local firefighters, as 24 volunteers battled a stubborn blaze that burned for more than 7 hours . . .

In writing a television news script, the same general principles apply. The

difference is that in television you will have the added element of pictures to deal with and your facts will be put together in a different way.

Using the same fire example, but in television scenario, we can illustrate the differences in approach. First of all, there will probably be less rush to get something together to put on the air. In radio, there is usually a regular newscast scheduled a short time after the station's newsperson gets word of the story. As we have shown, the story can be developed over time as more and more details become available. In television, there are far fewer times when news can be broadcast. Usually there is an early evening and a late evening news block, and some stations have a news report at noon.

Because television has fewer newscasts and because it relies on pictures to tell much of the story, a very different approach is needed when a news story breaks. More work needs to be done to get the pictures that will tell much of the story, and more people are needed to do the work. Here is how the job will be set up:

1. Using the facts she has gathered, the reporter does an on-camera "bridge" as a transition between segments taped at the scene.
2. The reporter does an on-camera "stand-up," which will conclude the package when it is edited for air.
3. The reporter and cameraperson return to the studio.
4. The reporter writes copy to be read by the anchor in the studio as live "voice-over" audio while taped pictures of the fire appear on the screen.
5. The package is edited and prepared for use on the air.

The actual amount of writing involved in putting this package together is minimal. Much of the reporter's responsibility centers around quickly gathering essential information, selecting the items that best tell the story, and integrating the information with visual elements of the story.

A major consideration in writing the copy for a package like the one described here is how closely to follow the video. There is a fine line between ignoring what is on the screen and writing too directly about it. It would sound silly, on the one hand, to say, "This is a fire that erupted this morning." People can *see* there is a fire. To have the anchor say, "This is a fire," uses valuable time to provide information that the viewer already has. On the other hand, if you are showing firefighting action, this is the wrong time to talk about the progress of the investigation into the cause of the blaze.

When a television news director receives word of a breaking news story such as a major fire, a reporter and a news crew will likely be assigned to go to the scene and do the story. Several factors may influence the details of how the story is handled at this point.

Let's assume that the story breaks a couple of hours before a scheduled newscast. If the news director feels the story is fairly important, a live remote

may be set up to bring viewers the reports directly from the scene as the story develops. If the story is regarded as less important, the news director may tell the reporter to prepare a "package."

A package usually runs somewhere between 90 seconds and 2 minutes. It includes taped pictures of the news event, and interviews with key people connected to the event. The reporter also records on-camera reports at the scene.

Whether coverage is live or packaged, getting the story ready for the air requires the on-camera reporter to coordinate several different activities. We'll use the fire example to illustrate what a typical television reporter would have to do to get the story on the air.

1. Arriving at the scene of the fire, the reporter tells the cameraperson to get some shots of the fire and the firefighters battling the blaze.
2. The reporter locates the fire official in charge at the scene and does an on-camera interview.
3. The reporter locates workers who have evacuated the building and gets on-camera reactions from two or three of them.

The proper approach at this time might be to give an overview of the facts about the fire. The appropriate lead-in to the script might read:

> Fire officials are still not sure what touched off flames that engulfed this Clinton Avenue furniture warehouse this morning. The facility is owned by the Hoffman Furniture Company. No one was injured in the blaze, which caused an estimated 200 thousand dollars worth of damage to the facility.

Another consideration in writing the on-camera material from the scene is to avoid using material that may change later. For example, if you were to report in your stand-up that "officials are unsure if anyone was injured in the fire," your tape becomes useless if the question of injuries is answered before your report is aired. If you are in doubt about elements of the story, leave it out of your report from the scene and let the anchor fill in the information when the report airs.

As a final note, read your copy aloud as you write it. This is something most broadcast journalists do automatically. It helps you write in a style that is easy to read. For example, the phrase "sixty-six separate series of incidents" might look fine on paper, but when read aloud, problems quickly become evident. Reading your copy aloud is also necessary to determine how long it runs.

Television script writing makes unique demands of reporters. The major consideration is to be as brief as possible and yet to convey a lot of information. It takes a bit of practice to master the techniques of "tight" writing, but once mastered it becomes almost automatic.

Presenting Material

The goal of broadcast newswriting is to communicate facts quickly and accurately, There is little room for excess words. The same principles apply to ad-libbing live reports. In fact, because of the immediacy of broadcast news and the need to get a story on the air as quickly as possible, many reports from a news performer are half written, half ad-libbed. The roles of performer and journalist are inseparable.

To effectively present written and/or ad-libbed material, keep in mind the points highlighted in Box 6.2 and discussed in the text.

First, *use attribution correctly and when necessary.* Attribution is the association of material reported with the source of information. Failure to use correctly attributed information is a common mistake among beginning news reporters.

Controversial statements must always carry attribution. "Chemicals in the village water supply were responsible for the death of 5-year-old Heather Smith" is a statement that must be attributed to a qualified source. An appropriate attribution might be "according to County Director of Public Health Frank Johnson."

Statements of opinion must be attributed in news reporting. For example, "The mayor badly bungled the handling of the school bus strike" must be attributed to the source, such as "according to the Democratic members of the city council."

Legal charges must be attributed. If police arrest a suspect in a bank robbery, the phrases "police have charged" or "according to police" must be incorporated into the statement. It is wise to attribute all information on arrests or charges to the official source. One important reason is that streetwise criminals frequently give names and addresses of other real people when being booked. If you report, "John Jones of 211 Front St. held up the

B O X 6 . 2

Pointers for Effective Presentation

1. Use attribution correctly and when necessary.

2. Paraphrase quoted material.

3. Keep sentences short.

4. Use clear sentence construction and word choice.

5. Write for the ear.

First National Bank" without attribution (such as, "according to Detective Frank Andrews of the city police physical crimes unit"), you are opening the door to legal problems if indeed the bank robber appropriated John Jones's name. This point is not purely academic; it's a troubling area for journalists. Several police officials have noted that use of false identities—someone else's name, address, and even place of employment and Social Security number—is occurring with great frequency today. By the time police sort out the arrestee's real identity, the damage may be done; so always attribute the charges to the legally constituted source.

Caution in handling crime stories is crucial because legal boundaries concerning lawsuits against news organizations are not always clear. Use "alleged" or "accused" when referring to someone charged with a crime. Even this caution is not always a blanket defense should the charges be proven false. Lawsuits concerning crime reporting are not very frequent in daily journalism, but the possibility always exists.

A commonsense guide to the problem is to use attribution when there is any doubt as to the *factuality* and *verifiability* of the statement. For example,

- "The governor visited City Hall today" does not need attribution because it is a fact verifiable by photographs, TV footage, and eyewitness accounts. Viewers and listeners will not expect explicit attribution, nor will the governor's office demand it.

- "The governor will not run for reelection" demands attribution. The statement could, for example, be attributed to the governor: "Governor Masters made the surprise announcement during a press conference here at City Hall." Or, attribution could be made to "a statement from the governor's press secretary." A veteran reporter sure of his or her story and facts may link the statement to a "highly reliable source close to Governor Masters." In any case, the factuality and verifiability must be proven, to the largest extent possible, directly within the story.

Note that in broadcasting, the attribution is often given at the beginning of the sentence: "Police report that a human body has been found in Southtown Gorge," instead of the newspaper type of end-of-sentence attribution, "A human body has been found in Southtown Gorge, police report."

Second, *paraphrase quoted material.* For the most part, direct quotes are not used in broadcast writing. The quote is usually paraphrased. Continual reference to a direct quotation, such as "quoting now," is distracting, and is used only when necessary for absolute clarity in the case of controversial or sensitive material.

Third, *keep sentences short.* Usually 20 to 25 words is the top limit. Although a number of word formulas have been developed, common sense

is the best guideline. Simply break up longer sentences in a natural place, and be aware that keeping sentences short is particularly important in ad-libbing. An occasional long sentence is all right, since continual short, choppy sentences become repetitive in rhythm and unappealing to the ear.

Fourth, *use clear sentence construction and word choice.* Listeners cannot go back and reread what you just said. Avoid using words that are easily confused by listeners, such as *can* and *can't.*

Fifth, *write for the ear.* The material is meant to be read aloud, so read it before putting it over the air. If it doesn't *sound* right, redo it.

A successful journalist must earn the trust and respect of the public. Certain canons of ethics apply to the job, and they are important to any performer who functions in news. Practices and policies vary from station to station, but two terms germane to any discussion of journalistic ethics are *right to privacy* and *libel.*

The Right to Privacy Possibly the reporter's first encounter with the right to privacy will involve the recording of a newsmaker's voice or image. There are a few cases in which you can record someone without his or her permission. Obviously, you do not need permission to record a press conference. In other cases, though, the line becomes blurred.

If you approach someone in a public place with microphone in hand and explain who you are and what you are doing, you're on solid ground to report or broadcast. Entering a private office or residence is another matter and should be considered case-by-case with your news executive.

Telephone interviews can cause problems because the interviewee may later claim to have been unaware of the recording. To protect yourself and your station, a mechanical beep tone is useful. Better yet, inform the person on the other end of the line that you are recording and get his or her consent *on tape.* Be sure to learn your station's individual policy governing recording phone calls before you air any portion of a recorded conversation.

In many cases the right to privacy is clear-cut, but in many cases it is not. Hidden-camera interviews and other investigative techniques should be used only under the supervision of an experienced news executive and/or attorney.

Sometimes the right to privacy is not so much a legal issue as a moral one. Does the grieving widow of a slain police officer have a right to privacy? Is she unnecessarily traumatized by having a microphone thrust in her face and being asked for comment? Common sense and good taste deny the right to invade her privacy just to get a story. By contrast, newspeople have swarmed over artificial heart recipients, and concern has been expressed that the patients' rights to privacy were being trampled. However, because these surgery patients consciously chose to participate in medical experiments of profound significance, the public's need to know seemed to legitimately take precedence over the individuals' rights of privacy.

Ethical Issues

▼

A successful journalist must earn the trust and respect of the public.

137

The right to privacy also depends on whether the individual involved seeks notoriety. A person who is defined as a public figure, such as a politician or a performer, has sacrificed a considerable amount of right to privacy by entering the public spotlight. This has a bearing on the legal interpretations of damage to reputations, known as *libel.*

Libel As recent court cases have demonstrated, there are very few clear-cut answers to the question of what constitutes libel.

Basically, libel is the act of issuing or publishing a statement that damages a person's reputation, defaming his or her character and exposing him or her to ridicule.

Simplistic definitions of libelous versus nonlibelous statements are worse than none at all, since there are many gray areas within the law. The interpretation of libel laws is subject to change according to new court decisions.

To briefly consider the most basic points of libel as they apply to a news announcer, examine the contention that truth is a defense against libel. On close examination, you can see that this is a somewhat simplistic concept, since truth is not always easily definable. If a reporter alleges that the subject of a story is an incompetent physician, can that charge be proven? If the word *incompetent* is used, can it be defined and verified? Has the physician been convicted of malpractice?

Yes, truth is a defense against libel, but often the question revolves around the recognized definitions of the words and terms used in the news item. As journalists Ted White, Adrian J. Meppen, and Steve Young put it,

> . . . proving the truth is not always easy, and the proving must be done by the writer or reporter. If you referred on the air to a labor leader as a racketeer, you had better be prepared to show that he was convicted of such a crime or that you have conclusive evidence of such activity that will stand up in a court of law. Otherwise, you and your station management could lose a lot of money.[1]

Another defense against libel is privileged communication. For example, you cannot be sued for repeating remarks made by members of Congress and judges from the floor of the legislative chamber or in open court; those remarks are privileged communications. Certain other public statements and records are also privileged. In cases less clear-cut than judicial or legislative remarks, always check with a senior news executive if there is a possibility that the statements could be interpreted as libelous.

A fair comment against a public official or public figure is not libel.

[1]*Broadcast News Writing, Reporting, and Production* (New York: Macmillan, 1984), p. 55.

Someone who runs for public office, by the very nature of that act, exposes himself or herself to public comment. The courts have ruled that people who seek publicity have, for all intents and purposes, less protection under libel laws. However, "fair" and "accurate" are subjective terms; a reporter does not have *carte blanche* when dealing with public figures. An irresponsible and unfounded statement against a celebrity can still be actionable (serve as the basis for a lawsuit).

Malice and reckless disregard of the truth are the primary factors a public official must prove in order to wage a successful libel suit. As was the case with William Westmoreland's 1983 suit against CBS, the issue was not only the truth of the allegations against him, but whether the allegations were made with the intent to harm and with prior knowledge that they were untrue. This can be a difficult case to make, as Westmoreland found; he eventually stopped pursuing the case in 1985.

Malice and reckless disregard continue to be criteria for cases involving public figures. But the scope of who, exactly, is a "public figure" appears to be shrinking.

Be aware that libel law interpretation changes as courts make decisions and set precedent, and that libel laws differ from state to state. It is very, very difficult to predict what the interpretation of libel laws will be if any gray area is entered. When in doubt, always check with a senior news executive or the station's legal counsel. (See Box 6.3.)

B O X 6 . 3

A Primer on Privacy and Libel

First and foremost, remember that what follows is a brief summary of libel and privacy law—not specific legal advice. Laws differ from jurisdiction to jurisdiction. So when in doubt, consult with a senior news executive or your station's attorney.

Journalism professor Martin L. Gibson defines libel as published material that subjects a person to hatred, contempt, or ridicule. Beyond that, libel can be established if the person suffers loss of respect or if he or she is harmed in some way.

Certain things must happen in order for libel to be committed. Usually in case law these are called *elements of libel*. They are *publication, damage, identification*, and *fault*. *Publication* is self-explanatory, except that the word also applies

(continues)

Box 6.3 *(continued)*

to something disseminated over the airwaves. *Damage* can be emotional or monetary, but it is often the case that libel suits are brought over a story that causes loss of income to a business. Probably this is because balance sheets are easier to document than emotional suffering.

Identification, again, is relatively self-explanatory, but for the purpose of this discussion it's important to remember that identification usually means specific identification of an individual. Groups rarely sue for libel. Of particular importance to the broadcast journalist is avoiding accidental associations of people and events, such as using so-called wallpaper video showing a car repair establishment to illustrate a story about car repair scams. Someone whose shop is identified by the video may indeed have a viable libel action against you even if you chose that person's shop only as cover video. (*Cover video* simply refers to pictures used to illustrate a television news script.)

The third element is *fault*. It must be shown by the plaintiff that the information was incorrect and fulfilled the other elements. (Note that simply being incorrect does not expose you to a libel case. If you say someone is 6 feet tall when he is really 6 feet, 2 inches, there are very few instances where that would be construed as a mistake that caused damage.) Public people—that is, people who have thrust themselves into the public eye—must prove fault to a higher degree. They must show that the reporter disseminated the information knowing that it was false, and with the intent of causing damage.

There are a number of defenses against libel. For the purposes of our discussion, we will group these defenses into the categories of *provable truth*, *privilege*, *fair comment*, or *public figure exposure*.

Provable truth, as mentioned in the text, goes beyond simply knowing in your heart that the allegation is true. It must be documented and specifically proven in court. That is why news writers frequently avoid words such as *incompetent*. This term is rather nebulous, difficult to prove, and you would be in a better position to simply list your documentation, rather than use the catch-all term *incompetent*.

Privilege applies to statements made on the floor of a legislative body when that body is in session, or in court when court is in session. These statements are granted what is often

called *absolute privilege*, and a reporter enjoys *qualified privilege*, meaning that he or she is protected from libel action as long as the remarks are repeated fairly and accurately.

Fair comment simply means the right to express an opinion. A journalist has every right, for example, to criticize a play, a restaurant, or a public performance. However, that criticism cannot include embellishments of the truth or unrelated and irrelevant personal attack. For example, a Supreme Court opinion handed down in 1990 held that an opinion column could be subject to libel action because it dealt with a serious issue—an implication that a local high school coach committed perjury.

Finally, *public figure*. Our concept of public figure exposure stems back to the 1964 Supreme Court case of *Times* v. *Sullivan*. In that ruling, the Supreme Court held that the American spirit of valuing free and robust debate causes a public official to expose himself or herself to public criticism. As a result, a public official—in this case a southern police commissioner—enjoys less protection.

Decisions following *Times* v. *Sullivan* broadened the definition of a public figure to include famous persons as well as elected or appointed officials. More recent cases, however, have moved the pendulum in the other direction, affording more protection for well-known people who are not public officials.

Privacy. Privacy actions are far less frequent than libel litigations. A good share of privacy case law, in fact, does not relate to news operations. For example, many privacy cases involve appropriation of someone's image for advertising without that person's consent.

The areas that should concern a news reporter are invasions of privacy, which in some way embarrass a person or portray that person in false light. The issues are far from clear-cut. For example, successful privacy actions have been brought against news organizations that have carried "Where are they now?" stories that brought up true but embarrassing tales of what someone did decades ago.

The defenses against privacy actions are as complex as the laws. However, as a general guideline you should remember that an item that embarrasses someone must be newsworthy—a difficult concept to determine. But judgments can and have been made against news organizations that pictured

(continues)

Box 6.3 *(continued)*

people in embarrassing situations simply for the sensational impact. Second, being a reporter does not give you the right to trespass. Third, you should be especially careful when dealing with minors or anyone who might be deemed to have diminished capacity to knowledgeably agree to be interviewed or appear on air. Finally, subjects of certain news stories do lose their right to privacy just because of their bad luck. However, be aware that laws do protect the privacy of victims of certain crimes—especially sex crimes. Remember that, while there will always be exceptions, when someone seeks publicity, or is the subject of a current legitimate news story, you are probably on safe ground.

Radio News

Radio news can be the most immediate of all media. When people need to find out about a breaking news story, such as a weather emergency, they turn on the radio.

Radio news operates under the basic journalistic principles described above. This section deals with some of the specialized methods and equipment by which radio news is gathered and structured, and with the equipment used by radio reporters. Techniques and operations relating to delivery, formats, and news services are examined later.

Gathering Radio News

In radio, newsgathering consists of obtaining facts and sound sources. This can be done at a very basic level by one person working with a telephone and a telephone recording device, as demonstrated by the example of the reporter covering the furniture warehouse fire by phone. On a more sophisticated level, radio newsgathering can involve a staff of street reporters equipped with portable cassette gear, covering specialized beats. In large radio news operations, there are people in charge of editing and production.

All radio news operations are under the command of a news director. In small stations, the news director may be the only newsperson on the payroll. In large radio stations, he or she is an executive in charge of large budgets and staffs. The radio news director usually reports to the station general manager or the program director.

The concept of actuality is very significant in radio news. Gathering actualities by phone or with a portable tape recorder has become one of the radio newsperson's primary responsibilities. Few stations are content to simply read stories over the air; somewhere in most newscasts there is actuality material.

Actualities can consist of an interview segment or a *wild sound bite*, that is, sound other than interview speech, recorded at the scene of a news event. The scream of sirens, for example, could be incorporated into a piece as a wild

sound bite. Wild sounds might consist of the chanting of crowds on a picket line, or the roar of flames in a four-alarm fire. When an actuality consists of an interview segment, it is usually less than a minute long, more often less than 30 seconds. Longer actualities are used in documentary pieces.

The radio news reporter must choose a compelling piece of actuality rather than running an entire interview. When gathering and editing down an actuality, the reporter looks for responses that express opinion or give greater focus to the central issue of the story. A politician's description of what he or she thinks a budget cut will do to the district is far more interesting than a recitation of budget figures.

In general, when choosing actuality, remember that

1. Statements of fact made during the interview are best used in writing the script.
2. Statements that express emotion or opinion are best used as actualities within the news report.

The basic radio reporting tool is the cassette recorder hooked to a good-quality microphone (Figure 6.2). Because cassette tape is difficult to edit mechanically, it is frequently dubbed up to reel to reel for physical splicing, the actual cutting of the tape. In most cases, the appropriate portions of the cassette material are dubbed onto cart.

Radio Reporting Equipment

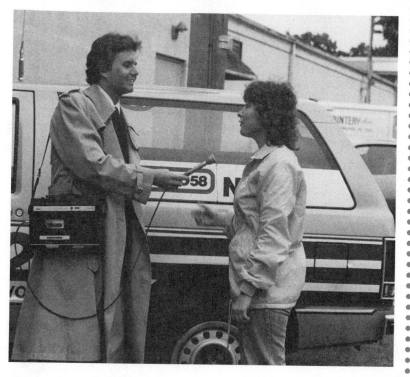

Figure 6.2. A portable cassette recorder used with a good-quality microphone is the workhorse of today's radio news reporter.

Figure 6.3. A small production studio used for radio news production.

Often the newsperson uses a small production studio (Figure 6.3) containing necessary equipment and an electronic link between the telephone and the recording gear.

Carts and cart machines are used extensively to hold voice reports, voice actualities, and actualities for use during a newscast. Practices vary among individual stations, but usually there is a standard method of labeling the cart with the name of the person being interviewed or the reporter filing the actuality, the length of the interview, and the *outcue*. The outcue is the final word or words spoken on the tape. Labeling an actuality with an outcue is a must because it indicates when the newscaster is to begin speaking again. Multiple actualities used for the same news story are usually placed on separate carts, but they can be put on one cart and separated by a stop tone. An interview used as the basis of a story that incorporated two actuality cuts would look like this in final script form:

CITING FAILING HEALTH, STATE SENATOR MARGARET BLANK TODAY ANNOUNCED HER WITHDRAWAL FROM THE UPCOMING RACE FOR REELECTION.
//BLANK #1//

. . . As I'm sure you're aware, I've had several operations within the past four years, and while my health is relatively good, I don't think I'm up to the strain of another term in office.

THE SURPRISE ANNOUNCEMENT HAS THROWN LOCAL REPUBLICANS INTO TURMOIL AS THEY JOCKEY FOR A SPOT ON THE PRIMARY TICKET. AS TO HER POSSIBLE SUCCESSOR, BLANK WON'T PLAY FAVORITES OTHER THAN TO SAY,
//BLANK #2//

At this point, I'm not endorsing anyone. I will pledge to oppose, though, anyone who plans to cut aid to education in our district.

THAT STATEMENT IS INTERPRETED BY SOME OBSERVERS AS A BACKHANDED ENDORSEMENT OF CITY SCHOOL SUPERINTENDENT PAUL WHITE, WHO HAS EXPRESSED AN INTEREST IN BLANK'S JOB.

The carts for this cut would be labeled

- Blank #1:09 (term in office)
- Blank #2:08 (in our district)

The format of capital letters for announcer copy and lowercase letters for actuality is used in many news operations, although practices vary. You should always, though, have the actuality written down, in case the tape fails and you are obliged to paraphrase the statement.

Radio news reporters often feed cuts over the telephone with special wires leading from the tape recorder and sometimes feed taped material and live reports over two-way radios or specialized small transmitters. Stations in very large markets may have a series of these transmitters located throughout the city to boost the signal back to the station or to the station's antenna.

The basics are the same, and a reporter can certainly do a decent job without sophisticated hardware. But as radio news becomes more highly competitive, the use of high-tech equipment will certainly increase.

Typically, a radio news anchor is responsible for gathering, editing, and reading news. The operations involved include making calls to police and fire agencies and scanning newspapers and wire services for important stories. Working with wire service material is covered in a later section. Here we mention the practice, common in radio, of rewriting newspaper stories for broadcast. This practice should be pursued with caution, because when a newspaper story is wrong and a radio reporter rewrites and uses it, the radio reporter is wrong, too. Many newspapers vigorously object to the use of stories gathered by the newspaper staff. Nevertheless, the newspaper will always be an important source for the broadcast journalist, and once you have verified the story and done some additional checking and gathering, you are ethically entitled to use the story.

There will generally be pieces left over from the previous shift or the previous night, such as a report on a city council meeting. The morning news anchor would certainly want to include such material in the early reports, but the council story may be rather stale by noon.

Stories must be written and rewritten throughout the morning. The reporter will follow up on tips from the public, items broadcast over police scanners, and story assignments set up in advance. Street reporters will cover stories in person, and often the morning anchor will take to the streets later in his or her shift.

These are the most basic operations. Now the journalist-performer must take the raw material and make it compelling.

A radio journalist must make people visualize a story in the theater of the mind. Much of this responsibility is shouldered by the writer, who must choose the words and phrases. The performer, who may also have been the writer, has to read accurately with expression and meaning. This really becomes important to the journalist who has to ad-lib a report from hastily scrawled notes. In that case, those words and phrases must paint a picture that is coherent as well as vivid.

Radio News Operations

▼

A radio journalist must make people visualize a story in the theater of the mind.

Painting a Picture with Words

The techniques for understanding the message (Chapter 3) and for communicating the message (Chapter 4) apply here. Some additional suggestions follow (highlighted in Box 6.4):

1. *Describe events with imagination.* Your words are virtually all the listener has to go on. Your ability to describe can be dramatically improved with practice, so practice as much as possible. One program director of a major market all-news station advises reporters to practice describing anything: ride along in the car and describe the countryside; look out the window and describe the neighbor's fence. In your descriptions, pay attention to details, such as the exact color of leaves or the shape of a yard.

2. *Include sound in the story.* Can you get the sound of a fire engine into your street report? By all means give it a try. Also, don't be afraid to incorporate the acoustics of the environment into your story, such as the sound of wind on a report concerning fast-moving brushfires. Do *not* manipulate sound elements in a way that will affect the content of the story. For example, do not use sounds of strikers chanting *recorded during the morning* as an element of a story covering the situation *in the afternoon*, when there were no strikers outside. Also, never use a sound effects record or other device to fake sound elements for a news story.

3. *Make accurate mood changes.* In radio, you have only your voice to communicate changes in moods, and this has to be done with precision, since stories are typically short. One of the most common complaints about poor radio news announcers is the lack of mood change between and among stories.

Mark copy to reflect changes in moods. Do not use the same pitch, pace, and rhythm for a report on a double homicide and for a story on a senior citizens' outing.

4. *Use and stress vivid words.* A television shot of a smoky fire speaks for itself. In radio, you have to paint a word picture. Do not touch important words too lightly. If you are writing or ad-libbing, never be content with pedestrian phrasing. For example, which description is more vivid and compelling?

- "There is a great deal of black smoke coming from the upper window."
- "Greasy black smoke is *boiling* from the upper window."

Simple words can paint vivid word pictures; there is no need to become flowery and lurid. Edward R. Murrow's historic word pictures of London during World War II were effective primarily because of the simplicity of the images and the straightforwardness of his delivery. Murrow used vivid small details to bring the picture to life in the theater of the listener's mind. He was not content, for example, to simply tell the listener that bombs were

B O X 6 . 4

Tips for Vivid Communication

1. Describe events with imagination.

2. Include sound in the story.

3. Make accurate mood changes.

4. Use and stress vivid words.

5. Pay attention to clarity in using actualities.

6. Develop a system for gauging time.

exploding. Instead, Murrow described the burn marks in pavement scorched by hot shrapnel. He was never content to simply describe the sight of people scurrying underground; he invoked other senses, too: "You cannot believe the stench of the air raid shelters."

5. *Pay attention to clarity in using actualities.* If you play an actuality during the delivery of a newscast, identify the speaker *before* and, if possible, *after* the actuality plays. It is best to do this by gracefully including the name of the speaker, such as "Professor Campbell of Georgetown went on to say . . . " If that is not possible, a simple declarative sentence will do: "That was Professor William Campbell of Georgetown University."

6. *Develop a system for gauging time.* Time yourself reading copy whenever possible so that you become able to look at a piece of copy and immediately gauge its length in terms of airtime. Radio news often operates under extremely rigid time requirements, and it is important to be able to estimate how much copy can be read in an allotted time period.

Your reading rate will probably be about 150 words per minute (wpm), although rapid news readers sometimes reach about 200 wpm. Rate of speech is much faster on a long-form announcement such as a newscast than on a 30-second commercial. You can determine your standard long-form reading rate simply by timing a minute's worth of reading and counting the words.

Knowing the average number of words per line of copy will simplify word counting. Most standard typewriters average about 10 words per line of copy, but that will vary according to script formats and typewriters. Machines with outsized type fit considerably fewer words on a line.

If you read 150 wpm, and your script averages 10 words a line, *you now know that 15 lines of copy will fill one minute.* Knowing how many lines of copy you read per minute is the most valuable method of time approximation.

Skilled announcers who must "stretch" copy often develop a method of prolonging vowels and gently slowing the reading rate so that the stretching is not noticeable. You would not want to use this method for stretching a 3-minute newscast to fill 5 minutes, but it is helpful when it appears that 5 lines of copy will fall 5 seconds short.

When news copy is running too long, it may be a simple matter to drop a line or two in the story. However, be sure you are thoroughly familiar with the story so that you don't drop vital elements such as attribution or a punch line. With experience and a complete understanding of the story, you will be able to ad-lib a brief conclusion rather than just dropping some copy.

Fitting News to Station Format

There was a time when broadcast news was looked on as something of a burden, to fill FCC requirements. A pleasant development, especially for the journalist, was the discovery that news could make money. Audiences wanted well-done news, and advertisers were willing to pay for exposure on a newscast.

As a result, news has become just as much a part of a station's program-ming strategy as music and staff announcers. The news must reinforce and complement the sound of the station. This is accomplished in a variety of ways, using every kind of component, from the produced opening of the newscast to the style and pace of the newscaster to the selection of the news itself. A newscaster on an album-oriented rock station with a laid-back for-mat should not use a delivery in the style of a teen-oriented all-hit station.

A modern radio journalist must be able to vary his or her delivery to fit the sound of the station. Unless you have the luxury of having an assured career with one particular format, it is highly advisable to practice flexibility in your delivery. Listen to what works at other stations, and practice communicating effectively within other formats.

The All-News Format in Radio

In 1965, New York's WINS became the first radio station to make a success of an all-news format. The idea was greeted by many with skepticism. The nay-sayers felt that audiences wanted news only in small chunks. It seemed unlikely that anyone would stay tuned to one station for continuous news.

WINS proved that the format could succeed, and in the nearly three decades since its inception, the all-news format has become viable for stations in many markets. WCBS in New York, KYW in Philadelphia, and WPOP in Hartford, Connecticut, all have used the format to become some of the most successful stations in the country. In addition to those listeners who keep their radio dial tuned to all-news stations for the entire time they are listening to radio, many listeners tune in for a brief update on what is happening. This high turnover enables all-news stations to perform well in the category of ratings

known as "cume" ratings—ratings that count the number of different people who tune in to a station during a certain segment of time. The hybrid format of news/talk, combines news programming with listener call-in programming.

The all-news format is a demanding one for on-air news readers. The station's entire sound depends on the style in which the news is presented. That style is a function of (1) the length of news stories and news segments, (2) the selection and arrangements of news stories, and (3) the reading style of news readers.

The on-air performer must be able to maintain a presence over time that is sustained only by the sound of her or his voice. To do so requires considerable skill in several areas:

- *Rate.* The successful news reader at an all-news station must move along at a comfortable pace. If the rate is too fast, readers will miss important elements of the story. If readers are too slow, energy is lost, so the listener's attention is likely to wander. The most effective rate is one that strikes the reader as a comfortable conversational rate.

- *Inflection.* Inflection is probably the most crucial element of a news reader's delivery in the all-news format. A singsong rate is deadly. It could literally lull listeners to sleep. (Incidentally, we have interviewed radio listeners who say that they use the all-news radio station in their vicinity to help them fall asleep at night. A news reader must guard against inflections that unduly emphasize this characteristic of the format.) Vary your inflection enough so that patterns do not repeat. If you tend to drop pitch every time you come to the end of a sentence, for example, the pattern quickly becomes noticeable. Be aware of your inflection and adjust it to avoid repetitive patterns, while guarding against inflections that do not fit the style of the copy.

- *Timing.* All-news radio is delivered in timed segments. A common promotional phrase used by one all-news station is "Give us 10 minutes, and we'll give you the world." Announcers must be precise enough in delivery to be able to read news scripts exactly to time, so that segments end on the dot at the right time. Very often news readers read copy that ends just before the station joins its network for its newscast. Networks begin their segments at the precise time scheduled. If a local news reader runs over or under the time allotted for the copy adjacent to the news, the cue will be missed.

- *Pitch.* Announcers who use a pitch that is too low or too high will stand out because of the length of time listeners have to discern the fault. A common fault among some inexperienced male announcers

is to try to hit an unnaturally low pitch. This can be deadly to all-news performers because an inappropriate pitch stresses the voice. Eventually the constant voice strain of the all-news format will likely impair the announcer's ability to use his voice. Find the correct pitch for your voice, and the delivery will not only conserve your voice but it will sound better.

- *Error-free reading.* The most important hallmark of a good news reader in any circumstance is the ability to read copy without stumbling and with accurate pronunciation. Of course, everyone stumbles at some point, and in a format that demands that you continue reading without interruption for 15 minutes or so at a time, there is much more opportunity for stumbles to occur. Announcers who consistently have trouble reading copy smoothly, however, won't last long in an all-news format. There are no second takes in live on-air work. The performance must be as close to flawless as possible or it becomes distracting to listeners.

- *Proper pronunciation.* Words and names must not be mispronounced in all-news radio. Listeners associate the credibility of the station with the news reader on the air. If you mispronounce the name of a newsmaker or a place name, you can bet that someone listening knows you did it. Your credibility and that of the station is compromised. In the all-news format, credibility is everything. If listeners don't think you are knowledgeable about the news you're reading, they won't continue to listen.

In general, the key to giving a good performance in an all-news format is to be very solid in the principles that apply to all news reading. Credibility is crucial. In the all-news format, the elements of effective performance are emphasized by the long time periods when your talents will be on display. Flaws are magnified many times over, while the absence of flaws won't be noticed much. That is as it should be. Remember that the important element of the format is the news. It is your job as news reader to showcase the news. The most effective performers are noted by average listeners, not because of their outstanding voice and delivery, but because they communicate. The trick is to make the listener think it is easy to do that.

Radio News Services

News services are an important cog in radio news operations and provide a link to news sources not available at the local level. From the standpoint of news operations and technique, a local reporter does well to gain a thorough understanding of these services because they are effective tools for making the station's entire news effort more effective and professional.

One familiar news service available to radio stations is the hourly newscast provided by radio networks through a landline or satellite link. Because

of the increasing importance of formatting, network newscasts are sometimes provided in different forms for various stations, with one feed tailored for rock stations and another for stations serving a middle-of-the-road audience. Networks also provide features that can be broadcast live or recorded for later airplay; in some cases, they furnish voicers and actualities for use in local newscasts.

Another important tool for the radio news professional is the wire service. Wire services such as the Associated Press and United Press International typically provide information via teletypes in the form of ready-to-broadcast copy. This includes newscasts, feature material, weather, and state news. A variety of wire service copy is included in Appendixes B and C.

Wire services offer localized feeds known as "state splits," which can be quite useful to newspeople on slow days. A state report on aid to education, for instance, can be localized further by calling city or town officials and asking for comment.

Wire services do such a capable job that some local operations become overly dependent on the wire, which results in what is commonly termed a "rip-and-read" operation. The best use of a wire service is as a supplement to an active news operation.

For stations that assemble national newscasts at the local level, there are audio services that provide actualities, voicers, and voice-actualities for integration with wire copy. The wire service feeds a print copy describing the cuts, known as a *billboard*, which lists the cuts by number, time, content, and structure. These cuts are fed according to a regular time schedule. A tone precedes each cut so that newspeople can cart the cuts, starting the cart machine at the end of the tone.

A recent arrival in the field of syndicated news services is Zapnews. This service provides national news, sports, features, business news, and what it bills as "information and talking points for newspeople and air personalities." Clients receive Zapnews on a fax machine or a personal computer. Subscribers receive and pay for only the packages they want. Stations may sign up or drop the service whenever they like.

Transmitted from suburban Washington, DC, Zapnews uses CNN, Reuters, and various stringers around the country as sources. A staff of journalists in Washington covers the news from the nation's capital.

Two main features of Zapnews make it attractive to modern radio stations. It costs less to subscribe to than the traditional news services, and there are additional savings in not having to house a teleprinter that runs through mounds of paper each day.

At this writing, plans are to add "Z-Net," a digital audio service that will provide actualities and voicers.

Many private organizations provide news feeds in return for the exposure. Cornell University, Syracuse University, and Dickinson College in Carlisle, Pennsylvania, for example, operate radio news services that provide

feature material to stations free of charge in return for the positive exposure. Figure 6.4 shows a listing of stories provided by the Dickinson College Radio Network.

Figure 6.4. This billboard for the Dickinson College News Network lists news stories that can be recorded from the telephone and used in radio news-casts. (Cour-tesy of the Dickinson College Communica-tions Office)

DICKINSON COLLEGE NEWS NETWORK
OCTOBER SCHEDULE

The Dickinson College News Network, a radio news service providing both wrap stories and supplemental sound bites on current issues and educational concerns, announces its October schedule.

OCTOBER 1
OIL AND THE ECONOMY

Cuts in Middle East oil production have American economists predicting oil prices that could double to $70 a barrel - creating a recession worse than the 1970's. Dickinson College economics professor Michael Fratantuono talks about the impact of shrinking oil supplies and higher prices on the U.S. and world economies.

OCTOBER 8
D.C. SEARCHES FOR A NEW MAYOR

American cities face such grave problems as homelessness, cocaine use and crime - all on the rise. Washington D.C. is now the murder capital of the world and its mayor, Marion Barry, was just toppled from power by his own drug problems. Now, as D.C. residents are about to elect a new mayor, Dickinson College Political Science professor Manley Elliot Banks looks at the city's future under a new leadership.

OCTOBER 15
REBUILDING THE U.S.S.R.

1989 was the year the Soviet Union backed out of the Cold War, mostly because it was too expensive and because Gorbachev needed help from the West for a failing Soviet economy. But some experts say the new opportunities in the Soviet Union are not as promising as Westerners think. Dickinson College economics professor Leif Rosenberger discusses the stability of the Soviet economy and future investment opportunities there.

OCTOBER 22
TRICK OR TREAT OR DANGER

With Halloween around the corner kids are looking forward to candy and other treats. But some communities have outlawed traditional Halloween fun because of increased tampering with trick or treat candy. Dickinson College Sociologist Martin Needleman looks at the dangers of Halloween in today's America.

OCTOBER 29
PENNSYLVANIA VOTES

The November election for governor has candidates ready, defining their strategies on important Pennsylvania issues. But does this really affect how Pennsylvanians will vote? Dickinson College Political Science professor Jim Hoefler who is conducting a pre-election poll in Cumberland and Dauphin counties talks about what factors help decide how Pennsylvania will vote in the upcoming race for the governor's seat..

News reports will begin on Monday mornings and will run for a week. To record stories and actualities for on-air use, call toll-free in Pennsylvania:
1-800-422-7279

If you would like to arrange an interview with any of the sources listed above, or if you would like more information about the news network or Dickinson College, call 717-245-1289.

Summary

Radio news is a sophisticated business, requiring much more than an ability to read aloud. In addition, radio is *not* television without the picture. It is a medium offering a unique blend of immediacy, intimacy, and drama. Broadcast news is a field dominated by journalists; therefore, a radio or TV newsperson is bound by the responsibilities and ethics applied to all journalists. Although it undeniably has elements of show business, broadcast news is a serious and formidable type of journalism.

The general structures of broadcast news include the newscast, the report, and the interview. The documentary is a long form of broadcast news containing dramatic elements. Broadcast news content generally can be categorized as hard news or soft news. Hard news deals with breaking stories. Soft news presents feature material.

The basic requirements of a broadcast journalist include a broad-based education, the ability to write, the ability to ad-lib, the ability to interact with people, and the possession of a news sense. Style is an important element to an on-air broadcast journalist. The journalist must project believability, energy, and authority.

Anyone who aspires to a news anchor position must know how to write. Most newspeople do their own writing, and even the ones who no longer write the material they broadcast achieved their positions by being skilled writers and journalists. Broadcast news consists of a short but informative lead, followed by a succinct and compelling recitation of the facts. Among the skills to be mastered in writing or ad-libbing a news story are correct use of attribution and the ability to paraphrase quoted material accurately. Using short sentences, using clear sentence construction and appropriate word choice, and writing for the ear are also important.

Ethical issues have an impact on the broadcast journalist, who must have a basic understanding of when and how someone's image or remarks can be recorded. Because the issues of right to privacy and libel are complex and the related rulings are subject to change, you must ask for guidance by your news executives when dealing with sensitive issues.

The foregoing principles apply to both radio and television news. Addressing radio news specifically, it is important to have an understanding of how radio news is gathered and structured. A basic component of radio news is the actuality, the recorded sound of a newsmaker or event. Radio actualities can be inserted into a story in a number of ways.

Radio news anchors and reporters are generally responsible for gathering, editing, and reading news. Sources include news services such as the radio networks, wire services, and news services offered by private organizations.

Radio journalists must be able to paint a picture with words. This process involves describing with imagination, including sound in the story, making accurate mood changes, and using and stressing vivid words. To preserve clarity and flow in the word picture, the announcer must pay attention to clarity of stories and actualities, and be able to gauge time effectively.

News is a component of the station's overall format, and the news effort and news announcers' deliveries must be compatible with the station's overall sound.

1. Take five local stories from the newspaper and rewrite them into broadcast style for a 3-minute newscast. Record the newscast, making sure it runs *exactly* 3 minutes.

2. Write brief, descriptive phrases for the following circumstances. Feel free to take some liberties, since you are not operating from a strict factual base, but keep within the bounds of reason. The goal is to use descriptive, colorful adjectives and punchy verbs. Use the active, rather than the passive, voice. For example,

- *Circumstance:* A tractor trailer carrying chemicals tipped over on the expressway and broke open. The payload of chemicals went onto the highway.
- *Description:* A tractor trailer ruptured, spewing chemicals onto the expressway.

Get the idea? Take out those flat-sounding words, and make the sentence paint a picture. Try these circumstances:

- *Circumstance:* An escaped convict was shot and killed while running away from the police.
- *Circumstance:* A tree was blown over by the wind. The roots were pulled out of the ground and stuck up in the air. The falling tree broke through the roof of a house.
- *Circumstance:* An angry Senator Jacobs called his opponent a liar. Jacobs said his opponent should withdraw from the race. Said his opponent was lacking in morals. *Hint:* Come up with variations for "said" and "called."
- *Circumstance:* Tractors were driven by farmers into the grounds of the state capitol. Onlookers were frightened by the onslaught of tractors. *Hint:* Use the active voice.
- *Circumstance:* People at a funeral walked past a casket,

walking slowly. The wife of the slain policeman began to cry loudly as she passed the casket. She leaned on top of the casket.

3. Select one of the newscasts created in Exercise 1 and critique it. Rate from excellent, fair, to poor on the following categories:

a. Were ideas presented clearly?

b. Was energy level sufficient?

c. Was there an adequate change of mood between stories?

d. Were all pronunciations correct?

e. Was delivery natural sounding?

f. Did the reader sound interested in the material?

Compare your evaluations. If there is disagreement among critics, play back the tape and examine the specific instances. Be prepared to defend your criticisms.

Much more is involved in on-air work in television news than sitting before a studio camera and mouthing words convincingly. Television newspeople function as a part of a team that must work closely together to get the news on the air.

Television news reporters and anchors are expected to know how to put together a story from start to finish in a short period of time. So they must be able to write clearly and quickly and be familiar with the basics of video production. The performer must have a firm grasp on how television news is gathered, structured, and produced. You simply cannot do the job without understanding the basics.

A tremendous amount of advance planning and thinking about content is necessary for TV news coverage. Getting each report on the air involves a technical crew and a reporter. So personnel must be scheduled with care so that all important stories during the day can be covered, with flexibility for breaking stories.

After the story has been photographed, the pieces are assembled and a script is written. The finished report must pass the scrutiny of the station's news executive(s), who decide whether it will be used. Sometimes news reports do not pan out, and they are pulled. In many cases, news items are

7

Television News Announcing

Television News Basics

157

bumped to make room for more timely stories. The entire process is often harrowing, always exciting. This section examines the basics of the business, including gathering the material, structuring it in a form useful for telecast, and putting it over the air within a newscast.

How TV News Is Gathered and Structured

Television news operations vary quite a bit in scope, depending on market size and other factors. A small-market newsroom might house only four or five full-time employees, while a major-market operation may have close to a hundred participants.

Although the particulars of staffing differ from station to station, the basic functions of the TV newsroom are roughly similar in all markets and operations. In larger markets, with bigger staffs, the operations are more specialized. Basic functions include administration, production, gathering, and reporting.

News Administration This function, headed by a news director, involves decision making on news coverage and responsibility for staffing and budgeting. News directors in major-market stations often find themselves rather removed from actual newsgathering, having to focus instead on fighting for budgetary allotments, new equipment, and additional personnel. The news director of a small station may supervise only two or three other reporters, and will cover stories and perhaps anchor the evening newscasts, as well.

The number of administrative layers in a news department varies according to the size of the department. Most medium-market stations employ an assignment editor, whose responsibilities include scheduling crews and reporters and assigning and developing stories.

In summary, the functions of news administration are

- Personnel and budgetary management
- Decision making and editorial policy
- Planning coverage of news

News Production In recent years news production has been revolutionized by development of lighter, more easily portable video equipment. The transition from film cameras to videos, which took place through the early 1970s, has significantly enhanced our ability to report the news quickly and creatively.

Production duties range from the basic technical jobs of such staffers as audio specialists, to the producer, who is in overall charge of assembling the production elements of a newscast and often some editorial elements. The producer reports to the news director.

Within the production function are such specialists as camera operators in studio and in the field (Figure 7.1), studio assistants, control room operators, and field producers. A field producer, as the name implies,

supervises the production function outside the studio. The job description varies in different markets, however. In very large markets and networks, associate producers and assistant producers work under the field producer's supervision in gathering news from the field.

In larger markets all duties become more specialized. A major-market operation may have one or more people responsible for electronic graphics, and the graphics designer may be an executive who supervises the entire "look" of the newscast. Some people specialize in editing, the process of arranging and rearranging the raw materials of news into a final product.

Figure 7.1. ENG equipment is now commonplace in television news coverage.

Although not strictly a part of the production function, broadcast engineers keep equipment maintained and operating, as well as supervising ongoing technical functions. A particular requirement for production engineering concerns live remotes, where a microwave unit is used to transmit directly from the news scene.

In summary, duties of news production people include

- Operating equipment needed to record or air the news
- Presenting visual elements, such as graphics and sets
- Editing and assembling raw materials

Newsgathering and Reporting Once news administration has assigned stories, journalists must gather the facts, outline the story elements, write copy, and deliver the copy to the camera either in a field report or as an anchor segment during a newscast. In larger markets, full-time writers compose copy, do research, and to some extent edit and revise copy. In some cases, writers are assigned to work with a reporter in the field, a function bordering on field production.

The primary duties of the newsgathering and reporting arm of the television news effort include

- Assembling facts and writing stories
- Working with the production function to get visual and aural elements such as interviews and cover shots
- Delivering the news copy

The various functions interact a great deal. An on-air member of the newsgathering and reporting arm cannot operate without understanding the other functions and working closely with staffers in the other areas of television news.

How the TV Newscast Developed

In the early development of television, a newscast was radio with pictures, and very few pictures at that. Typically, newscasts were no longer than 15 minutes and featured a camera focused unblinkingly on a news anchor, a personality who virtually carried the show.

Not surprisingly, this format did not have tremendous appeal. During the late 1940s and early 1950s, television was looked on as a poor relation of radio.

The evolution of the modern newscast came about through experimentation. At the local level, stations expanded coverage of sports and weather into separate segments. But even through the late 1960s, the local news was often done halfheartedly, and might feature only one or two short film pieces juxtaposed with the reading of an anchor.

At the same time, broadcast executives began to realize that the newscast could produce revenue for the station. That revelation brought about gradual but tremendous change. For one thing, the increased competition for audience shares sparked innovation and creativity as news and station executives sought new ways to attract viewers. The many developments that have changed the news picture since the 1960s include the supplanting of film cameras with portable video gear, vivid graphics, fast-moving and evocative formats, and *the increasing focus on the newscaster as an informer, performer, and personality.*

Personality did, indeed, become important in the content of the vast majority of TV news shows. Packaging became and remains a prime issue, as pointed out by the increase in news consultants. These specialists advise on the impact and acceptability of elements within the newscasts, from newscasters to news writing, from selection of stories to the color schemes of sets.

A formidable amount of criticism has been aimed at the consultant trend. That criticism has been balanced by the vigorous pursuit of ratings by station management. Many seasoned journalists and critics feel that accepting consultants' recommendations was selling out to show business and that news judgments were being subjugated to non-news considerations designed solely to increase revenues.

Station executives are motivated by a desire to survive. Rating points translate into salaries and jobs, including the salaries and jobs of the news staff. So ratings are important for the health of the station and the very existence of the news operation.

In reality, the pendulum swings both ways. In the early 1970s it became apparent, especially in light of the ubiquitous "happy talk" formats, that

extremes were being reached in terms of gimmickry and audience hunting. Today the newscast is a product with a reasonable balance between journalism and show business. It is important to realize that the on-air reporter must meet a variety of requirements, in terms of both journalism and entertainment.

On-air news work is generally done under extreme time pressure. Here is how a television news operation might handle a typical day's developments:

The Typical Process

9 A.M. The news director arrives at work, scans the files of upcoming events, and discusses stories with the assignment editor. The assignment editor looks over scripts done by the two early-morning newspeople and arranges for news crews to be sent out.

Among the major preplanned stories today are a news conference on police sting operations, a meeting of the mayor's task force concerning whether a new municipal building will be constructed downtown, and the arrival in town of a famous rock singer. The celebrity's imminent arrival is causing great excitement, and the news department's live transmission facility, the "Live Eye," will be stationed at the airport. Breaking stories include a brush fire threatening to spread in the far western region of the county and a state police manhunt for an escaped convict.

Some of the feature stories, known around the news department as "back of the book" material, were photographed yesterday but are being edited together today. The feature piece is a three-part series on adoption, running tonight and the following two nights.

10 A.M. The producer begins putting together a rundown of the stories that are being considered for the newscast. This rundown will change many, many times before the 6 o'clock news. The producer and the assignment editor discuss some of the visual elements of the stories, too.

Through the morning, the assignment editor is in radio contact with reporters covering assignments in the field.

1 P.M. There are now several other breaking stories. A tractor trailer has overturned on the expressway, and a photographer is dispatched to the scene to take footage of the accident. A writer will gather facts over the telephone and write a script for a voice-over. Tonight, the anchor will read the story off camera while the video of the accident rolls.

3 P.M. The newscast is beginning to take shape. Writers are com-

posing some of the script material that will hold up throughout the day, "timeless" stories that won't change by 6 P.M. Some reporters have returned from field assignments, have written up their scripts, and are working with production people in editing together the package (Figure 7.2).

The manhunt for the escaped prisoner continues, so a script will not be written until shortly before airtime. If the situation does not change, some cover video that was shot early in the day will suffice for the voice-over.

Production people are looking at and editing videotape, making decisions on the amount of time to allocate to each story.

4 P.M. The producer and the news director find themselves with several piles of video cassettes. These tapes include

- Four packages (stories filed by reporters), including the reporter's introduction and closing, along with an interview segment and other material.

- Seven pieces of cover video, to be used while an anchor reads over the footage. In the case of the truck accident, for example, there will be a shot panning the scene of the accident, and the anchor will read the story over the video. Total time for the voice-over is 15 seconds.

Figure 7.2. Editing stories for The News at Noon *at WPVI-TV in Philadelphia.*

- A segment of the three-part piece on adoption. Editing was finished late in the afternoon.

4:40 P.M. Here is what the producer and news director do *not* have:

- Any idea when the rock star will arrive. Her plane was supposed to land shortly before news time, but it is going to be late. The assignment editor is given the responsibility of coordinating with the airline to figure out when the plane will arrive.

- Any footage of a serious house fire that broke out minutes ago. One person is believed dead. A crew is on its way.

- Anything new on the manhunt.

5:05 P.M. The list of stories is firming up. The production staff is choosing the artwork, which will be projected behind the anchors; the sports and weather people are preparing their segments (details on this in Chapter 9); and the assignment editor is beginning to think about the 11 o'clock newscast. He has to cover several meetings and schedule the crews for their dinner breaks.

5:35 P.M. A voice on the police scanner indicates that shots have been fired at the site of the police manhunt. No further information is available by phone from the state police. There's no time to get a crew out and back, and no one knows for sure what the shots mean.

Meanwhile, the control tower at the airport says the plane will be only five minutes late, allowing plenty of time for coverage by the Live Eye. The arrival of the country's most famous rock star certainly is a major story, but the shots fired at the manhunt site indicate the potential for an even larger story. Was the convict shot? Was a policeman shot? No one knows, and there is no time to find out, for if the Live Eye is to reach the remote site by airtime, it must leave the airport now.

"Go to the search site," the news director orders. His reasoning: any deaths or injuries occurring in the manhunt would amount to a major story. Also, the manhunt is in the third day with no end in sight, and the other two local stations have backed off coverage; thus there is potential for a scoop. No one here knows where the competitors' remote vans are, of course, but it's worth a gamble to be the only station in town to have coverage of the capture—if, indeed, there is a capture.

One other point influences the news director's decision. Tape of interviews with the rock star's fans waiting at the airport has already been fed back to the station.

6 P.M. Airtime: the anchors introduce themselves and tease (read a short piece of copy that tells viewers about top stories coming up) the top stories of the evening. One anchor must ad-lib, from hastily assembled notes, the introduction to the live manhunt coverage, the signal for which is just coming over the air.

The reporter covering the manhunt has just arrived and has absolutely nothing to go on other than the sound of shots, heard a half-hour ago. She ad-libs a brief stand-up from the scene, giving some background on the search and the convict, who is believed to be hiding in the woods. Then she indicates that the story will be followed up shortly.

Back at the studio, anchors read through their scripts, several copies of which have been distributed to them, to the prompter operator, and to the producer, the director, and the audio director. Anchors will read some stories straight to camera, do voice-overs for taped footage, and introduce reporters' packages.

During a commercial, the director cues the anchors: "We're going to the Live Eye right after the commercial." The anchor again must ad-lib an intro. This time, there's dramatic live footage of a wounded prisoner being led to an ambulance. Also played back is a tape made moments ago showing the actual capture. The reporter on the scene must, of course, make sense of all this and communicate the excitement of the situation to the viewer.

This action is produced by a corps of on-air performers who, as we have seen, must not only speak to the camera but must also work within the technical constraints imposed by television. Part of their job is to create material under intense time pressure and be able to communicate with accuracy and completeness.

This extended examination of a "typical" day shows the primary difficulty, and appeal, of the challenging field of TV news. It takes a great deal of stamina just to cope with the pressures and physical activities of the job. And, of course, considerable skill and experience are necessary to be able to deliver a story coherently to a camera. The work of a television reporter may look easy, but this is only because of many reporters' competence and ability to work under pressure, and because these on-air journalists have acquired a grasp of techniques and operations.

Up until now, our exploration of TV news has centered on the structure and elements of the operations. This section examines the considerations of newspeople who actually go before the camera, the techniques of effective delivery and working on the air with the tools of the TV news trade.

TV news delivery incorporates the general principles described in Chapters 3 and 4. The following areas are specific to the on-air newsperson.

Phrasing Giving the impression that you understand what you say is extremely important. As phrasing relates to TV news, the important element is to group words together in natural-sounding patterns and to communicate thoughts, rather than words. It is crucial to be "on top of" the copy, reading a sentence or phrase ahead. Getting lost in the copy, or hesitating in your delivery, can seriously impair credibility.

Pace You can improve your chances of success in television news by developing a proper pace, a pace that is not rushed yet conveys energy. Equally important to an anchor is development of a *steady* pace. Production people have to roll tapes according to the news anchor's reading of a script, and constant speeding up and slowing down plays havoc with this process. In your drill and on-air work, strive for a consistent pace.

Emotion A newscaster must be able to communicate feelings as well as facts. The expression of feelings, however, should not be maudlin or phony. A mechanical "sad face" on a newscaster who is narrating a story that truly *is* tragic, borders on being offensive. Although it is natural for people's facial expressions to reflect emotion, television is not a natural medium. Some practice is necessary to acquire a serviceable technique.

Review tapes of yourself to judge your expression. The most common mistake is the adoption of robotic expressions obviously called up to match the story. Scan tapes for the "sad face" or "happy face," and modify these expressions in further air efforts.

The next most common problem in expressing emotion is giving mixed signals: for example, maintaining a stern and rigid posture when reading a light story. The practical reason for mixed signals or improper expression may simply be that the on-air person is thinking about the next camera change or trying to remember when the next package will be introduced. Mixed signals due to lapses in concentration can be eliminated by focusing on the thoughts and ideas of the story.

Interest A news reporter in any situation must *show* interest in the subject at hand. Practice is essential because it is possible to be extremely interested in the copy and still appear indifferent because of poor delivery technique.

Television News Techniques and Operations

TV News Delivery

▼

A newscaster must be able to communicate feelings as well as facts.

Ideally, you should practice on videotape. If that is not possible, audio tape will do. Get any airtime possible to develop your skill of projecting interest in the story.

Projecting interest involves enthusiasm for the task at hand and involvement in the material. Remember that you cannot evince genuine interest in a subject of which you have no understanding, so a wide-ranging knowledge of current events will help.

Finally, determine as much as possible *why* each story is of interest to you and your viewers. Does the city council's action translate into higher taxes? If so, stress that connection. If you grasp the essential points, your manner and communicative abilities will get the message across.

Credibility Related to the need to understand the material and for the viewers to understand you is the viewer's faith in what you say. Polls regularly show that the most trusted people in the United States are television network newscasters. Trusted newscasters are perceived as honest and impartial, and having the experience and intelligence necessary to understand the news and give a fair rendering.

This concept affects the American tradition of using journalists as on-camera performers. A news director could hire much better and better-looking readers from the ranks of actors than from the world of journalism. This has in fact been tried—but without much success. The actors, people without news backgrounds, do not project credibility. Some successful news anchors do not have backgrounds in journalism, but they are the exceptions, not the rule. With the increasing focus on journalistic background for anchors, aspirants are well advised to develop a strong background in news and newsgathering.

There is no magic formula for developing credibility. It may largely be a function of avoiding negatives: do not mispronounce local names, do not use poor grammar, do not be uninformed or appear to be uninformed of local news and newsmakers, and do not look sloppy.

Contact On a tangible level, contact means eye contact. On an intangible level, the concept of contact is defined by how well an on-air performer seems to move off the screen into the living room. Many of the subtleties can be developed after a good grounding in the proper techniques of eye contact, particularly in news reading and interviewing.

One trademark of on-air professionals is knowing what to do with one's eyes. For example, note how interviews often portray the questioner as being calm, forthright, and direct, while the guest (or victim) appears nervous and shifty. This often has to do with eye movements, natural movements that the TV performer has learned to override. Many of us, during conversation, shift our eyes downward or to the side. While quite normal during conversation,

shifting of eyes, especially from side to side, is both apparent and distracting on television. It inevitably creates a poor impression.

The only way to correct eye contact problems is by viewing and critiquing tapes. Remember, you must maintain steady and unwavering, but not glassy-eyed, contact with the lens. Even being slightly off in gazing at the lens is perceptible.

The job of the field reporter is crucial to the success of any station's news programming. Taped news packages are the building blocks of television news programs. Without them, even the most talented, credible news anchor would be useless. The days are long gone when a news program could be carried by a "talking head" reading copy. Television news today depends on pictures. And those pictures are gathered and explained by field reporters and news crews.

Field Reporting in Television News

The job of a television field reporter requires resourceful men and women who can quickly grasp the news value in a variety of situations and make solid news judgments in a short period of time. They must be able to shape the story, plan the sequence of events, gather the visual elements of the story, write a script, and do on-camera work—all very quickly and often several times a day. Several specialized skills and techniques are used by effective field reporters that must be mastered by anyone who aspires to this kind of work. Bear in mind that the immediacy of on-camera field work requires that reporters be guided by a strong sense of ethics (see Box 7.1).

Getting the Information. The first thing you must do at the scene of a news event is find out what's going on. Generally you will get some information about the event when the story is assigned. Usually, though, the information is very sketchy, and sometimes it is wrong. Moreover, in fast-breaking stories things may change rapidly. So you must catch up on the facts as soon as possible after arriving on the scene.

The best way to start is to try to find someone in a position of authority. If the event involves breaking news, getting information may mean just walking up to someone who looks as if he or she should know something. At a fire, you need only ask any firefighter who is in charge. When it is not immediately obvious who is in charge, just start asking questions of people in the vicinity. It usually won't take you long to get to the right person. There is usually only a limited amount of time that a news crew can spend at the scene. Other stories may need to be covered, and the report still must be edited for broadcast, so there is always a need to work quickly.

While the reporter is looking for information, the camera operator can be getting tape of the general activities at the scene. When it is time to edit the story, there will be a need for tape that shows generally what is going on at the scene. Shots of firefighters at work, or striking workers picketing a work site,

167

B O X 7 . 1

The Ethics of Field Reporting

Television field reporters need to be keenly aware of the standards of excellence and fairness that govern their role as journalists. Many news departments and several national associations have codes of ethics. Many of those codes, including the code of the Radio Television News Directors Association (RTNDA), insist that video be used in such a way as not to alter its context. You should not use a cutaway shot, for example, that makes someone appear furtive or nervous when that might not really be the case, or if a subject's nervousness is simply normal stage fright and not an indicator of guilt.

Suffice it to say that television news reporters have powerful tools in their hands. Misrepresentation for the sake of sensationalizing a story or to introduce drama simply cannot be tolerated. The cardinal principle of television news reporting is to tell the story accurately. Don't embellish or distort. Never manipulate information to prove a preconceived idea of how the story should go together. Hard work and persistence pay handsome dividends for those fortunate enough to work in this exciting profession. Those who engage in shady practices and clever manipulation seldom last long.

or crowds gathered at the scene of a homicide are some examples of tape that can be shot while the reporter gets information.

On-Camera Interviews Lining up the interviews is the next priority for the reporter. First you need to decide who should be interviewed on camera. Some events require bystander reactions. At other times you'll want a spokesperson who can respond to questions about an organization's activities or a police investigation, for example.

The neighbors of a gun-wielding homeowner who has taken a hostage may provide insight into the person's recent behavior that may shed light on the reasons for his or her actions. A homicide victim's relatives and friends can provide comments that set the story in context. An official spokesperson for a college can talk about the institution's response to community complaints about a noisy fraternity.

Interviews fill out the news story factually and help convey its human dimensions. Field reporters must develop a good sense of which subjects will

Interviews fill out the news story factually and help convey its human dimensions.

best add the necessary impact to the story. Once you have decided whom you want to interview, sometimes you must persuade them to appear on camera. People at the scene are often shy about going on camera, or may simply not want to get involved. Officials of organizations are often fearful about their comments being "taken out of context." Or they may fear looking foolish when a difficult question is posed.

In such circumstances, be persistent without being annoying. Coax, rather than browbeat. If you can reassure subjects that they are talking to you as a reporter and not to the camera, they are more likely to relax. You can reassure them that serious mistakes can be edited out, and that they can stop and try again if they make a mistake or say something that they suddenly realize they shouldn't have said. Use this technique only when necessary, to reassure particularly nervous subjects. If you make such an offer routinely, you may encounter subjects who ask for endless retakes in order to improve their performance. Others may feel that they have the prerogative to ask you to edit out any comments that, on reflection, they decide may be misinterpreted.

When conducting the interview, follow the techniques of effective interviewing described in Chapter 8 of this text. Avoid long interviews. This will help in editing, and minimize the uneasiness of the subject. Don't be afraid to keep questioning the subject, though, if you don't immediately get the answers you need. Keep in mind that you are looking for those few seconds that provide a key element of information or add insight to the story.

Usually the reporter stands near the camera and slightly off to one side. Have the interview subject look at you, not at the camera lens. It is generally not good to have a lot of background activity when you're interviewing someone. The viewer's attention should be focused on the subject of the interview and on what is being said. If your tape shows a lot of activity in the background, the viewer's attention is likely to wander away from the subject. Often reporters use tight close-ups for interviews. This eliminates background distractions and lets the person's facial expressions be seen more easily.

Cutaways and Reverses. When you have completed the interview, you will usually have your camera operator shoot cutaways and reverses. A *cutaway* is any shot that can be edited into your interview segments to make smooth transitions when you want to edit out some of the interviewee's comments without breaking continuity.

If you butt together two segments of tape showing the interview subject at two different times of the interview, you most likely will get a sudden change in facial expression or bodily position. This jump looks unnatural and is distracting to the viewer. To avoid this, a different video element, the cutaway, is inserted at the point where the edit occurs. This eliminates the jump cut and establishes smooth continuity.

Some news organizations, though, now prefer using jump cuts rather than

covering the cut with video. The reason is that a jump cut emphatically demonstrates to the viewer that something has been taken out of the tape, and the time frame of the statements compressed.

One reason for the increased use of jump cuts is new technology that creates a dissolve effect. This technique is often used in CBS news reports, for example.

Some shots that are commonly used as cutaways are a group of reporters at a news conference, firefighters at work, an emergency vehicle with flashing lights, a cover shot of a building, crowds at the scene, or even a street sign (a street sign achieves the added function of locating the news event visually).

Reverses are shots of the reporter doing the interview. They are shot from behind the interview subject—a reverse of the shot featuring the interview subject. Reverses are commonly used as cutaways. Reverses can also be used however, to re-ask a question. This is usually done only when it is deemed useful to show viewers how the reporter asked a particular question. If a question draws a dramatic response, featuring hitherto unknown information, it may be desirable to show viewers how the question was asked.

Be careful when you do such a reverse shot. It is important to try to duplicate the original question word for word. Inflections should be the same, as should the facial expressions of the reporter. Of course, this can be done without the interview subject in the shot, but usually you'll want to have the subject visible when the "re-ask" is shot. Never use this technique just to convey the impression that you can ask tough questions. It is considered a serious breach of professional ethics to create a false impression through editing techniques.

When your camera operator is shooting reverses, to be used as cutaways, the mic is usually off. The reporter needs to appear to be listening to the subject of the interview, so that the reverse appears to have been taken during the interview. Good reporters try to keep the subject talking. They use this informal conversation with the interview subject to get further information that may help put the story together. The subject is usually more relaxed at this time than when the mic is live. This may be the time that a subject gives you something that he or she didn't feel comfortable saying while the mic was on. Such information will often make your story just a bit better than the one done by the competition. It can also provide information useful for your stand-up or in writing copy to be read in the studio by the anchor.

Stand-ups. The stand-up gets its name from the fact that it is shot with the reporter standing up in front of the camera at the scene of the news story. When the story is edited into a package back at the studio, the stand-up serves to open and/or close the report. Stand-ups are almost always done as the last segment recorded at the scene. (As we point out later, it is increasingly common for reporters to do their opens and closes live from the scene during the newscast.)

You'll write short pieces of copy for delivery during your stand-up. This copy usually must be memorized before you go on camera. There are no prompting devices in the field, and you don't want to read word for word from your notes.

Memorizing your open and close should not be too difficult. Since you wrote it, you probably have played with several versions of the copy before you got it the way you want it. By the time you've written it to your satisfaction, it will be well established in your mind.

When the camera is running, though, many things can keep you from concentrating on memorized copy. There are usually bystanders watching. You have to think about your cue from the camera operator, your facial expression, and the inflection and rate of your delivery. Most of the time you don't need to be concerned to get each word exactly the way you have written it. As long as your delivery is smooth and natural, altered phrases won't matter much.

Occasionally, though, the situation is such that you must stick to exact wording. If each word is vital, be sure to take the precaution of overmemorizing your copy. One technique that helps you memorize copy verbatim, is to build the piece in your mind sentence by sentence. Repeat the first sentence over several times until you have it fixed in your mind. Then repeat the first two sentences over and over. Next repeat the first three sentences, and so on. In this way you'll be reinforcing your memorization of the earlier parts each time you add a sentence.

Another technique is to focus attention on the words at the beginning and end of each sentence. Most people who get lost trying to deliver memorized copy segments, do so at the end of a sentence. They get through one or two sentences fine, but they can't recall the next sentence. To avoid this, memorize the words that form the transitions between sentences. For example, memorize the last word in the first sentence in conjunction with the first word in the second sentence, and so on.

If the stand-up is complex, remember that there is no shame in glancing at your notes. Key words, on a notebook that is held just out of the camera shot, can help you move from point to point. Even the top pros sometimes use their notes in stand-ups. If you do use a notebook that you want to keep out of the shot, by the way, be sure to tell your camera operator to keep the shot tight enough so the notebook does not show. When you use a notebook with key words, write in large letters with a black felt-tip marker.

Some reporters have opted not to worry at all about memorization. They rely instead on electronics. It is a relatively simple matter for a script to be read into a small, portable audiocassette recorder. The reporter can then play back the recorded piece through an earpiece while speaking into the camera. This method takes some practice to master, but it can provide for impressive eye contact during delivery of a long or involved story in the field.

A recently developed device called The Ear Talk System™ is specifically

designed for use in such circumstances. Ear Talk improves on the cassette recorder by eliminating the wire that leads to the earpiece. The earpiece receives a signal from an induction loop connected to a small tape recorder. The loop is worn under the shirt, blouse, or sweater. There is a small switch, worn elsewhere on the body, that lets the reporter pause the audio tape at any point. The earpiece is completely undetectable to the viewer. The device is particularly useful for long stand-ups with few intervening taped segments. It is also helpful for on-camera narrations.

The device has an in-studio setup that allows on-air talent to stay in communication with the control room. The loop is simply mounted under the anchor desk. Separate loops can be provided for each member of the news team and at various locations in the news studio, such as the weather map area, for example.

Dealing with Crowds. When you show up at a news scene with a camera crew, you automatically become a "moron magnet," to use a phrase coined by one frustrated field reporter. People often want to get behind you and perform, while you're on camera trying to do a stand-up or when you're conducting an interview. Several things can be done to cope with this kind of situation.

If you have trouble with crowds in the background, try doing your on-camera work against the wall of a building or, if you happen to be near a body of water, next to the waterline with the water in the background. Sometimes you can get permission to use private property where public access is restricted. If there are police on the scene (at a demonstration, for example), crowd interference can sometimes be minimized by setting up near a concentration of uniformed officers.

Sometimes you can get rowdy crowds out of the shot, but their noise interferes. In that case, try holding the mic close to your chin. That usually minimizes background noise.

Sometimes you must deal directly with the crowd and try to reduce the incentive for interference. Veteran television reporters have developed several techniques that sometimes help in this kind of situation. One technique used occasionally by one author of this book as a field reporter was to co-opt one member of the group. In a group of rowdy kids, for example, he would seek out the biggest, toughest-looking member of the crowd and persuade or pay him to act as an enforcer (encouraging the use of intimidation rather than physical violence).

If you have a television monitor in the field, have the camera operator take a tight head-and-shoulders shot of you. Place the monitor where it can be seen by the would-be troublemakers. They'll note the fact that their background activity is not in the shot, and sometimes that will discourage further antics.

Another reporter tries to wear down the crowd by doing an endless number of takes of the same script. Eventually the crowd gets bored and

leaves. Tape doesn't roll until the crowd departs. Then the reporter does his real take. He says the phony takes help him smooth his delivery and memorize his copy.

Sometimes there is no alternative but to appeal to a sense of decency. It sometimes helps to point out to disruptive kids that immature, idiotic behavior may prove embarrassing when they actually see it on the air. Worse yet, their friends, parents, and teachers will also see it.

A final point about dealing with crowds: it is important that the reporter realize his or her responsibility to protect the camera operator, who is extremely vulnerable. When the camera is running, the operator is looking straight ahead. He or she can't see trouble coming. A disturbing indication of the increasing number of dangerous news assignments crews are covering these days is the recent appearance of trade journal ads for body armor for camera operators.

Working to the Camera One factor that complicates good contact is the multicamera setup unique to the TV news studio. An anchor must shift his or her attention from one camera to another without interrupting content and flow. When a performer does camera changes well, that is not noticed by the audience. But those who make camera changes poorly do call attention to the process.

If you find camera changes difficult (and some performers do), pay attention to the sort of movement by which you naturally change glances, during a party, perhaps. Use the same natural motion you use to address another person.

Often the transition can be made easier by a brief glance at the script; that is, down. In fact, brief downward glances are a good idea even if you are reading from a prompting device. An unblinking stare is rather unnerving to the viewers. When changing from one camera to another, you may choose to take a short downward glance at the script and then raise your gaze to the other camera.

Here are three additional points on working to the camera. First, TV cameras are equipped with tally lights to indicate which camera is on air. If you look to what you think is the proper camera but there's no tally light, you must make a decision. Do you hunt for the right camera or wait for the director to follow you and punch up the camera to which you are looking? Generally, a floor director's cues and gestures can help sort the situation out. Discuss this matter with the director in advance, and always follow the floor director's instructions.

Because the floor director cannot speak to you, he or she must rely on gestures, and you must understand these gestures. Figure 7.3 shows some of the more common cues used by floor directors. Television news and interviewing are the most common areas in which you will encounter floor directors.

Figure 7.3. Some of the cues frequently used by floor directors in a television studio. Signals in common usage vary among stations, so always go over the signals with your floor director before air or taping time. A pointed finger (a) means "You're on!" A sweeping and pointing motion (b) indicates a camera change. One finger twirled (c) is often used to mean "speed up." A motion imitating stretching a rubber band (d) means "stretch" or "slow down." Two-handed twirling motion (e) means "wrap up." Finger drawn across throat (f) means "cut."

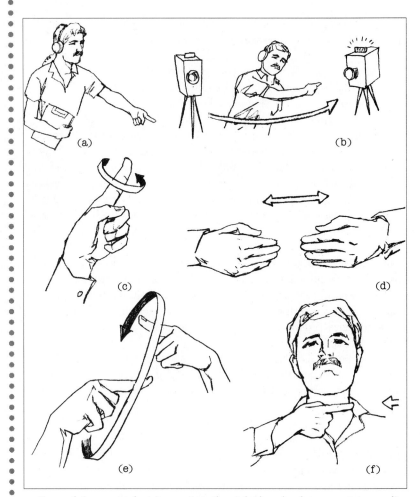

Second, in most television scripts the right-hand column contains audio; it is a narrow column that is scanned by the lens of the prompting device camera as the script is dragged—vertically—on a sort of a conveyor belt underneath the camera. (The prompter camera points straight down.)

The image, projected on a mirror directly in front of the performer's camera lens (the script is visible to the performer but not to the viewer) produces a "roll" in which there are only several words per line. Precisely timing the roll—the job of the crew member who operates the prompting device—is demanding. See Box 7.2 for some tips on using the prompting device.

Third, remember that changing cameras will also result in a closer or wider shot. Because of the visual requirement of the medium, transitions between identically framed shots are almost never used. Close-ups call for

Figure 7.3 (continued). When hand signals serve to indicate time (sometimes printed cards are used), minute cues are generally given with the fingers of one hand: (g) means 2 minutes, (h) means 1. In many stations, a clenched fist (i) means 30 seconds remaining, and crossed arms (j) mean 15 seconds, but these two signals are often used to indicate exactly the opposite timings, so check the custom in your station. Counting down on fingers (k) is often used to help you keep an exact time: 8 seconds as indicated.

caution in movement. Move too much, and you will be out of the frame. Wide shots allow for more expressive gestures to make up for the increased perceived distance between the performer and the viewer.

In news, a medium shot includes part of the desk and the newscaster. A close-up includes the head and shoulders, while an extreme close-up generally shows the face from the chin to the hairline.

Robotics

Many television news studios today are equipped with automated cameras—sometimes referred to as robot-operated cameras, or simply robotics. The distinguishing characteristic of studios using these camera systems is that there are no camera operators in the studio. The cameras are programmed to respond to commands conveyed electronically from the control room.

Robotics are generally used in situations in which camera shots are fairly simple and there is not much need for cameras to move around. The most

B O X 7 . 2

Some Tips on Using the Prompting Device

It is often difficult for announcers to pick up the tricks of the trade when reading from a prompting device. Some hints:

• Read the prompter at a steady pace. That way, the operator of the device will have a better handle on your reading rate.

• Although it is tempting to try to compensate for variations in the crawl speed, remember that it is the newscaster's job to set the pace and the prompter operator's job to follow. Don't get involved in a game of catch-up. Dictate your own speed—but be sure you read at that speed steadily.

• Some performers find it a great help to read a specific line of the prompter crawl. Try reading the third line down. This usually gives you some cushion above and below. Once the operator perceives that you are consistently reading the third line, he or she will be able to develop a steadier hand in operating the device.

• Remember to look down from time to time. The audience can be unnerved by an unwavering stare. Also, remember that you must keep your place in the written script that you hold in your hand. If the prompter breaks down—and it often does—you'll need to immediately go to the written script.

commonly found robotics studios are news sets. NBC television has used automated cameras on its evening news broadcasts and in other news-type programs since 1988. NBC is reported to be satisfied with its system, which was purchased from Eversshed Power Optics (EPO).[1] Several local news studios have been equipped with robotics systems for many years.

Early systems tended to have control problems now and then. It could be quite disconcerting for both talent and viewer to notice the automated camera panning away from the news reader while she was still in the middle of a

[1]See "Robot Cameras Debut at NBC,"
TV Technology, 4(6), April 1988:
p. 9.

story, to say nothing of the distress felt by the control room people. Today's systems, however, have eliminated most such problems. When they do occur, they are usually the result of an incorrectly entered command, and a manual override can usually rectify the problem before it becomes noticeable.

Nevertheless, it can be somewhat disconcerting to on-air talent to work in a studio with no human operators at the camera positions. In many robotics studios, there is still a floor director to cue talent to the proper camera and to alert them to impending shot changes. In these studios, air people need to learn to concentrate on the floor director and trust the cues they give. You need to disregard other camera movement in the studio and work to the camera that is currently operating. While this is also true of cameras operated by people, the potential for distraction increases when unmanned cameras start to move around, seemingly on their own.

In cases where there is no floor director, you need to pay attention to control room directions received through your earpiece. This can be distracting while you are reading, but with practice you will be able to take in the comments of the director in the control room while seeming to be fully engaged with your viewers. If you become confused, ask questions during commercial breaks or prerecorded segments.

If automated cameras start to move improperly during a shot, the on-air talent should try to adapt as much as possible. There isn't much you can do if a camera starts to pan or tilt away from you as you are reading. You can't move with it, so you'll just have to play it straight and hope that control room people quickly fix the problem. In such a situation, you might lose sight of the prompting device on the camera you're working to. If that happens, use your script. It may be possible to shift to another camera's prompter, but that may distract viewers even more than the errant camera shot. Probably it is best simply to read from your script. It is wise to practice doing that from time to time anyway, in case a prompting device develops problems at some point.

The automated studio is becoming more and more commonplace in news studios, and in other applications where camera shots are relatively uncomplicated. Learn to be comfortable in such situations, and gain an understanding of how these systems can affect the operation of studios so equipped. A little bit of knowledge about the attributes of automated studios can go a long way toward maintaining your composure should something go wrong.

Even the finest readers stand little chance of success in news if they cannot ad-lib. From the standpoint of the field reporter, ad-libbing is the name of the game. Anchors must be able to speak extemporaneously in introductions to breaking stories or for coverage of special events such as elections.

Some special considerations apply to ad-libbing in news situations. First, you are doing news and will be held accountable for what you say. Liberties

Ad-Libbing for News

Figure 7.4. A studio camera focused on a single performer.

with the truth cannot be taken. A storm of controversy can erupt over an ill-chosen phrase used in relation to a sensitive story. Always ad-lib in phrases

1. *That you know to be factual.* If you are repeating a statement of opinion or conjecture, be sure to qualify it as such.
2. *That are not subject to misinterpretation.* Using shorter sentences and phrases can help keep meanings clear.

Time is limited for newspeople ad-libbing stories. You may not have the luxury of doing five or ten takes. During live coverage, of course, there is no second chance.

The process of compartmentalizing and encapsulating thoughts outlined in Chapter 4 is applicable to news ad-libs and helps both in ensuring accuracy of facts and in producing mistake-free takes. To apply the principles of Chapter 4 to a news ad-lib, consider the following framework:

- *Step 1.* Be well informed about the issue. You must be able to call up names, facts, and figures.
- *Step 2.* Do a quick encapsulation of thoughts and rehearse what you are going to say, mentally or out loud. Break up the ad-lib into complete thoughts. List those thoughts, either mentally or in a notebook, before speaking.
- *Step 3.* Deliver the ad-lib briefly. Do not be concerned with stretching for time, and never try to expand without adequate information. Strive for a definite ending of the ad-lib, a brief conclusion or summary.

Production Equipment

A performer does not always have to be an expert on production, but knowledge never hurts. Such expertise enhances ability to work creatively and within technical constraints and also will help you earn the respect of production people on the news team. In many cases, especially in small markets, the on-air person will have to do editing and other production work. Here, of course, a good grounding in production is essential. Reporters in the field often call their own shots and must be aware of the visual rules of assembling TV news. Our discussion of working with equipment

is only the briefest of introductions to the tools of the trade of modern television.

The studio camera, as shown in Figure 7.4, is a large camera equipped for smooth movement across the floor. It has a zoom lens. Attached to certain studio cameras is a prompting device (see Figure 4.11).

Cameras and on-air people work in the studio. As Figure 7.5 indicates, the studio is brightly lighted for the sake of the cameras, which need more light to produce a sharp image than the human eye does. The studio is connected electronically to the control room (Figure 7.6). In the control room, production specialists such as the director, the audio operator, and videotape operators

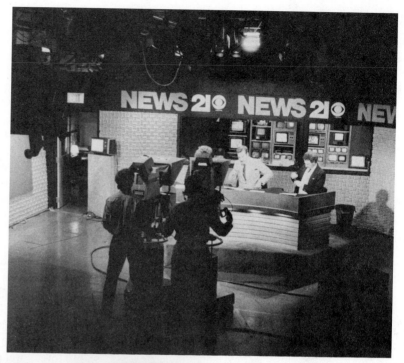

Figure 7.5. A television studio.

Figure 7.6. A television control room.

Figure 7.7. Tape-editing equipment.

physically put program elements over the air.

Portable electronic newsgathering (ENG) cameras, such as the one pictured in Figure 7.1, produce a signal that is often recorded on 3/4-inch videotape ("3/4 inch" refers to the width of the tape), which is housed in a cassette. Cassettes are edited in a system such as that pictured in Figure 7.7. This 3/4-inch editing system consists of two tape machines interlocked to a master unit, which controls both. The physical process of editing involves dubbing one tape to another. The operator might, for instance, place the raw tape in the left-hand machine and dub onto the right-hand machine. Controls allow the operator to assemble the raw stock in virtually any sequence wanted. Audio can be dubbed separately from video, so a voice can be recorded separately and added over cover shots.

Many stations are moving toward adoption of a half-inch format for news, involving different tapes and tape machines that offer especially high-quality reproduction.

Integrating Technical Tasks

A performer needs to understand how the technical aspects of TV affect him or her. As shown throughout this chapter, an on-air journalist must have a base of technical knowledge, if only for decoding the typical TV script. An example of a script is presented in Appendix B of this book.

As performers become more comfortable with technology, they frequently invent shortcuts and adopt labor-saving devices. Here are two examples.

1. *"Slating" takes in a field report.* Many journalists find that identifying the cuts on the tape makes the editing process much smoother. A slated cut is easier to find and easier to edit: "This is the introduction to the bank robbery story, take two, rolling in five, four, three, two. . . ." This cut would not be hard to extricate from a reel of material. The countdown would also aid in cueing up the tape for the editing process.

 It is best, incidentally, to avoid saying the number "one," since there's a chance of that part of the countdown winding up on the air. Skip over the number, but give a silent segment in the same rhythm. Start the report where you would ordinarily say "zero."

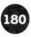

2. *Carrying and using a small audiotape recorder.* This allows you to capture the interviews and stand-up material that also have been recorded on video. On the way back to the station, the street journalist can play back the audiotape, using it as a guide to choosing sound bites. When time is tight, virtually the entire script can be written in the notebook during the trip back to the studio.

These are just two examples of how an understanding of the technical function can make work simpler for the performer. There are others, and after some trial and error you will certainly invent your own.

Television news today is undergoing gradual but significant change. The widespread, sophisticated use of technologies such as satellite remote trucks and improved microwave transmission technology let TV news producers air remote broadcasts live from almost anywhere. Add to this a host of new syndication services that focus on the "news you can use" variety of feature material, and even stations in the smallest markets in the country can offer their viewers a level of professionalism undreamed of even 15 years ago. A wider variety of news stories and features can be presented on a regular basis, and production quality is maintained at the highest levels.

Recent Trends in TV News

When it comes to actually putting the newscast together, many stations today have installed computerized news automation systems that streamline the process of developing and delivering newscasts. Stations that can afford to invest in such systems have increased flexibility in organizing and arranging stories for broadcast, and producers can update material right up to the time that a story is actually aired.

With this increased capability, stations can more readily attract and hold the attention of their audiences. And the trend in many markets toward devoting more airtime to local newscasts means that the increase in numbers of news features and expanded coverage through live remotes need not necessarily displace harder news stories.

Stations that once received feeds only from the network with which they were affiliated can now look at several sources and choose the feeds that best fit their style and time requirements. So stations can do a better job of reporting on important national stories and can present feature material that would otherwise cost so much to produce that it would not be profitable. Sports reporting is also greatly improved by the availability of a better selection of taped highlights from major games and sporting events from all over the country.

It is important for those who want to enter the field of television news to be familiar with these services and to develop the skills needed to work effectively with them. Let's look at some of these developments a bit more closely.

Live Remote Coverage

Just a few years ago, live broadcasting from a remote location was a novelty for most TV journalists. As stations began to explore the capabilities offered by live remotes, they often seemed to be straining to find uses for the technology. Live reports from the scene of news events implied that the event was very important and that it was necessary to be at the scene live to provide coverage that included the very latest information. Unfortunately, events that received such coverage very often just happened to be going on while the news block was on the air. Viewers were often left wondering why a reporter had to be on the scene to report immediately on the latest developments, when the news event was relatively unimportant in comparison with other happenings in the area.

Today, with live coverage becoming more common, stations have learned how to better integrate this immediacy into the rest of the newscast. Live reports often serve only as an expanded stand-up in a news package that features segments taped earlier. Brief on-camera interviews are sometimes included as a part of live remote coverage, but less attempt is made to convey the impression that the live presence is necessary to bring viewers the latest developments. Live reporting is used in such situations to add interest and variety.

The concept of using live remotes to provide viewers with the latest developments in an ongoing story can still be important, however, when breaking news is unfolding moment by moment. In 1989, stations in Harrisburg, Pennsylvania, for example, put live reporters on the scene of a major prison riot in the area (see Figure 7.8). Live reports from the prison let local

Figure 7.8. When riots broke out at this penitentiary in Camp Hill, Pennsylvania, television stations from nearby Harrisburg made frequent live news broadcasts from the scene.

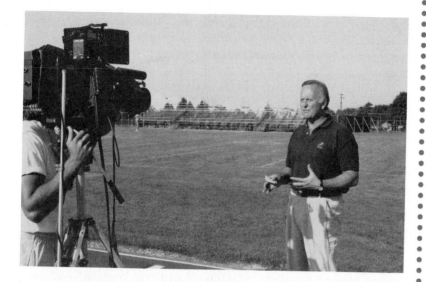

Figure 7.9. Popular Washington D.C. sports anchor Frank Herzog of WJLA-TV does his evening sports report live via satellite transmission from the summer training camp for the Washington Redskins at Dickinson College in Carlisle, Pennsylvania.

residents stay abreast of exactly how the situation was changing while local news programs were on the air. The situation was confusing and volatile. There was possible danger to residents if the situation got completely out of control, and it was important to viewers to have current information on the situation.

Sportscasts also benefit from live coverage (see Figure 7.9). The sports anchor can increase audience interest in the sports segment by reporting from the spring training camp of the local baseball team or from the scene of a major golf tournament in the area. Nothing much changes about the arrangement and variety of stories covered. The lineup is usually pretty much the same as it would have been anyway. The station shows its interest in the event and its capability of keeping up with developments through the live presence at the event. As in news, live interviews from the scene often add a dimension of interest as well.

By allowing reporters to move off the news set and out into the community, the feeling is conveyed that the station is interested and involved in the community. (One medium-market television station used its live remote capability to move the entire news set out to various community locations for several days while their studio set was rebuilt.) Stations can use this capability to increase audience interest and attract viewers in a particular community. Although some view this as a questionable compromise, when used judiciously little harm is done to the integrity of the news.

In general, on-air talent must be more flexible when dealing with live coverage. The stand-up you deliver live on camera from city hall will be done in one take. If you usually flub the first two takes of your stand-up, you will want to practice getting through your material with no mistakes. Your an-

nouncing style on a live report can be more relaxed than is usually the case in a package. The whole idea of the live report is to convey immediacy. If your live report looks well rehearsed and tightly scripted, you won't come across appropriately.

This doesn't mean you don't need to prepare. If anything, you generally need more preparation for live reports than you otherwise would. You may need to fill additional time or to respond to questions from the anchor in the studio. There is always some uncertainty about how the live segment will unfold. The better you have prepared by becoming completely informed about the situation, the better able you'll be to respond to any unexpected circumstances that may arise while you're on the air.

Syndicated Feature Services

Not too many years ago, most TV news directors depended solely on the network they were affiliated with to provide feeds of news events that took place outside their coverage area. The same was true for sports highlights needed for local sports reports. Today, though, stations have available to them several news feeds that can be picked up and used by anyone who has a couple of satellite dishes to receive them. Services like CNN's Newsource, Conus, and Med/NIWS provide more stories each day than some stations can even look at. These services provide substantial competition for network services like NBC's Skycom satellite service, by offering affiliates and independents a wider variety of news feeds supplied by stations from virtually everywhere in the country.

CNN offers its two hundred affiliates 24-hour service. Its sole product is news, so it need not interrupt other programming to provide live coverage of breaking news. Affiliates may broadcast news-breaking special reports as they occur. Thus CNN affiliates were able to tap into live reports during student demonstrations at Tienanmen Square in Beijing, for example. More recently stations carried live reports from CNN reporters in the Persian Gulf (Figure 7.10). In fact, there was considerable consternation and dismay among newspeople at CBS, NBC, and ABC, as many of their affiliates opted for CNN reports from the Gulf rather than carrying the coverage provided by their usual broadcast networks. This was

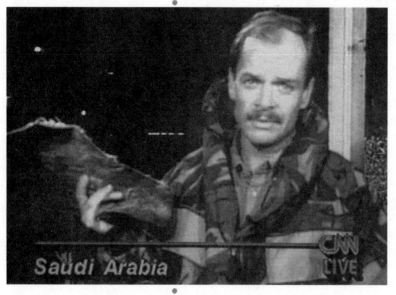

Figure 7.10. CNN's Charles Jaco's live reports from Saudi Arabia brought the drama and uncertainty of the Persian Gulf War to television viewers worldwide. (© CNN, Inc. All Rights Reserved)

particularly true at the outbreak of the war when CNN was providing exclusive coverage of the first allied bombing raids on Baghdad. Affiliate stations are allowed to excerpt package features from *Headline News* to carry in local news programs. And they may elect to carry up to four *Headline News* half-hours on local air per day.

CNN Newsource provides a daily series of news feeds that includes national and international breaking stories, features on topics such as medical and science news, nutrition and women's issues, for example, and sports highlights. This allows local news directors to integrate this material into local newscasts, using local announcers for voice-overs and intros.

TV news directors also have available to them a large selection of syndicated feature material that can be integrated into newscasts in ways that give viewers the impression that the segments were produced locally. Products such as *Consumer Reports TV News,* produced using the resources of the Consumers' Union (which puts out *Consumer Reports* magazine) provide stations with short features several times a week.

Typical syndicated packages run about 90 seconds, and stations receive three features a week. Depending on market size, features might cost a station anywhere from $3,000 a year to $40,000. The packages usually feature a split-track audio, which allows the station to use its own talent to narrate the piece rather than the talent used by the original producers. This conveys the impression that the reports are produced locally.

Many stations find that using syndicated feature material lets them cover specialized news beats, such as business reports and medical news, without the considerable expense of producing the material themselves. According to Walter Gilbride, a syndicator of news features, many news directors find that using such material frees up their own reporters and resources to do a better job of reporting local features.

Some stations use the syndicated material as the foundation for five-day-a-week segments on a particular topic. The voice of the reporter is used in the syndicated material and the station's own reports (usually featuring a local angle on the general topic) are produced by the same reporter. Often, by the way, that local reporter is a member of the profession most closely related to the topic area covered in the reports. A local doctor is often used as the reporter on feature segments about medical topics, for example. If the syndicated material is integrated smoothly, and local production quality is matched to that of the syndicated material, the audience will have the impression that the station produces all five reports each week.

The increased use of syndicated feature material and satellite news feeds requires reporters to be able to mesh effectively with the styles of those who produce the syndicated packages. In hiring, this may mean that news directors will be looking for more generic styles for some slots than they might look for in others. The announcer whose style seems generally reminiscent of news

reporters may be more useful in some circumstances than a reporter with a distinctly individual style. In contrast, some openings in television news may require reporters with specialized knowledge and with expertise in specific areas. Rather than emphasizing on-air talent, for example, a station may want to fill a slot that covers a distinctive beat such as crime reporting or consumer affairs.

Another consideration for on-air talent when working with syndicated feature material is to keep in mind that the appeal of the feature material is its usefulness to viewers. It is the material itself that is of paramount importance. The role of talent in such circumstances is to localize and smooth out the presentation of the material but not necessarily to draw attention to the reporter.

To prepare for the changing requirements for on-air talent in television news, try to become adept at a variety of styles. Take the time to watch the news reporters on as many different stations as you can. Take note of both the differences and similarities. See if you can categorize various newspeople in terms of the styles they use. Do styles change for various types of reporting—a feature on how high school students choose a college, for example, as opposed to a news report about citizens who oppose the construction of a landfill near their housing development? Can you tell what elements of rate, inflection, energy, and facial expression are responsible for defining the style? Through close observation of many different newspeople and styles of presentation, you'll begin to know how to adapt your own delivery to create different styles.

The next step is to practice the different styles. Write scripts of your own that are representative of different assignments you have noticed in your analyses of various TV news operations. Practice the scripts using various styles of delivery. Notice how inappropriate some scripts sound when they don't fit the news story. Work on nuances of inflection and rate that make the delivery particularly effective.

Beware of overdoing it, though. Remember you are trying to draw the viewer's attention to the story, not to you. Get feedback on your performances from others. Don't just go to professors or other broadcasting students—try to find people who are *not* familiar with the devices you're using. They will be in a better position to tell you how you might be coming across to the average viewer.

Later in this book, when we talk about ways to prepare for your first broadcasting job, we stress the importance of broadening your academic background beyond the field of communications or journalism. Syndicator Walter Gilbride, who has studied television news operations all over the country, recommends that students get a solid educational background in areas that might be helpful in reporting on specialized areas. Gilbride says that news reporters, trying to report on complex topics such as AIDS or personal finance, often make fundamental mistakes that could have been avoided if

the reporter had some formal education in the area. For those interested in crime reporting, for example, one approach might be to major in communications or journalism as an undergraduate and go on for a master's degree in criminology. Other experts recommend a double major as an undergraduate.

One of the most dramatic advances in television news in recent years is the development of computerized newsroom systems. With sophisticated computer hardware, running specially designed software programs, modern television newsrooms can streamline all their news functions in ways that add speed and quality to news coverage.

Dynatech Corporation's NEWSTAR, for example (see Figure 7.11), provides word processing, sorting and filing of wire service material, electronic mail, a script-writing format, convenient storage and retrieval of important phone numbers, and an archiving capability for storing stories that have already aired. The latest software developed for NEWSTAR lets a system operator control the way the show goes on the air. It can drive the prompting device, feed a character generator, and control a video cartridge machine holding taped inserts. The timing of all stories is monitored both as the newscast is assembled and when it airs. If need be, a story can be rewritten after the newscast begins. All the times are then recalculated and the corrected script is sent to the prompting device.

The advantages of such software are many. Breaking news can be updated instantly without the need to laboriously refigure how the update affects the timing. The software automatically calculates new in-times, out-times, and

Newsroom Automation

Figure 7.11. Dynatech Corporation's NEWSTAR allows the news producer to change the news lineup or rewrite stories up to the last minute. Changes and updates are often entered after the newscast is on the air. New copy can be entered and transferred to the on-air prompting device directly from the news producer's desk.

back-times (the point in a script where a videotaped insert must roll in order to reach the proper playing speed when aired) of new material so that the necessary adjustments can be made. Producers can instantly check on the status of any story and find out if it is ready to go on the air. There is less chance that the wrong tape will play, because tapes can be controlled automatically. Automation systems can be configured to meet the individual needs of any station. Various options are available for inputting wire service material and information from remote news bureaus, for example. Costs to stations vary depending on the types of hardware and software options selected.

The impact of computerized newsrooms on on-air talent is great. The modern television newsroom requires a familiarity with computers. Basic operations are not difficult to master. If you can operate word processing systems and understand how computers control systems, you will be in the best position to make the latest technology function to enhance the station's competitive standing.

▼

The modern television newsroom requires a familiarity with computers.

On-air talent must be adaptable and ready to make changes in stories right up to the last possible moment before air. Reporters have to follow developments on breaking stories more closely and be prepared to update them when new information becomes available. It may be necessary to rewrite copy many times before the story actually hits the air. Anchors must be ready for last-minute changes to the story rundown. They must be able to cope with last-minute script changes while maintaining their professional manner on camera.

For producers and news directors, computer automation means that it is easier to assemble the newscast. It is simple to determine the status of the newscast at any point in time, and to monitor the progress of individual stories as they are being written. With this technology, people responsible for putting the newscast together will be expected to provide more timely stories than in the past. To do so, they will need to closely monitor reporters and news crews and follow the progress of breaking stories that are subject to change. In simplifying the physical assembly of the newscast, computer automation also demands more minute-to-minute decision making on the part of news executives.

The skills you will need to cope with automation include good journalistic judgment and computer literacy. A pleasant appearance and the ability to read copy smoothly will not take anyone far in television news. People who want an on-the-air news position increasingly need to provide a certain degree of technical capability in addition to a solid on-air presence.

Appearance

It goes without saying that good appearance helps a television news performer. In fact, news requires exact attention to certain aspects of appearance because the credibility of the performer is involved. The following brief guidelines are particularly helpful for newspeople.

For men, the choice of clothing is really not an issue. Newscasters wear a virtual uniform of suit or sportsjacket and tie. Women have a wider choice, but most newswomen stick to simple clothes with basic lines. For field reporters, simple and durable clothes are an advantage because the afternoon's story may involve slogging through a potato field. Box 7.3 gives some basic tips for achieving a good appearance.

BOX 7.3

Guidelines for Dressing Well on the Air

1. *Avoid complex patterns.* Herringbones can cause a wavy effect, especially when photographed by older cameras.

2. *Check with your station engineer regarding the chroma key color.* A chroma key is one device used to remove a background from a TV scene and insert a new image, usually a slide behind the newscaster. In modern facilities, the clothes-versus-chroma-key problem is not serious, but older gear may be insufficiently selective as to which shade of blue, for instance, it chooses to eliminate. If your clothes are too close to the chroma key color, they may be replaced with the keyed image.

3. *Avoid stiff clothing.* Men seated at news desks have a particular problem with stiff-woven jackets bunching up behind the neck. A tailor can take out the "roll" in the upper back and keep the collar down.

4. *Make sure clothing is not restrictive.* Tight European-fit double-breasted jackets are not a good choice for a weather reporter who has to move and gesture.

5. *Avoid too masculine a look in women's clothes.* There was a time when women entering the field felt it necessary to wear man-tailored clothes. Those times are pretty well past, but simple women's clothes are still advisable. Frills and bows have a habit of coming out of place and can also be distracting to the viewer.

(continues)

Box 7.3 *(continued)*

6. *Be conscious of what your clothing looks like from the rear or side.* The camera may occasionally catch a view of you from an off-angle. Men, be sure your jacket covers your middle when you sit.

7. *Avoid extreme cuts of any clothes.* Although bizarre or unusual clothes may build an image for an actor, newscasters have never gained recognition for their style of dress, except for the very low key style represented by Peter Jennings. Jennings dresses conservatively and with a European flair, a *very subtle* differentiation from other newscasters.

8. *Avoid gaudy jewelry.* The camera has a tendency to emphasize and, in both a literal and a figurative way, to magnify. A large pair of earrings may look grotesque on the air.

9. *Remember that cameras also magnify girth.* If you need to lose weight, lose it now, before cutting audition tapes. If you have a blocky appearance, concentrate on clothes that lessen that impression. Women can do especially well with V-necks. Stocky men must avoid checks, blocks, or any lateral design element. Stick to plain colors or vertical pinstripes.

Beware of a tendency to dress inappropriately for the role of a newsperson. Steven Osborne, former news director of WOR-TV in New York (now WWOR-TV in New Jersey), says that he notices a trend among some television newspeople to present themselves as fashion plates. "They should remember that they are newspeople, not aristocracy," he says. High salaries and their position as celebrities in the community often provide an affluent lifestyle for newspeople, but on the air they should not draw attention to their socioeconomic status through their appearance, says Osborne. "Clothes shouldn't say 'Look at me—I can afford nice clothes.'"

He notes that too many of today's television newspeople drip in heavy jewelry or wear expensive furs when covering stories on location. He recommends simplicity when it comes to clothing. Men should avoid heavy plaids in coats. Ties should be relatively simple in pattern. Women should watch out for loud patterns and outlandish colors. Hair styles on women should be conservative, not flashy.

Osborne cites Faith Daniels (Figure 7.12) of NBC's *Today* show as an example of someone who consistently chooses the right style for a television newsperson. Her clothes are fashionable but not flashy. Her hairstyle is becoming and natural for her image as a credible news reporter, he says. WWOR's Sara Lee Kessler is another example of a news anchor who has found the right formula for presenting herself appropriately without letting her appearance distract from the news she reports.

Another crucial tip is to *get a good haircut!* Find a barber or stylist who will work with you to get the style you want, and request the same person for every visit. Frequently, television stations will trade out advertising for haircuts at a particular salon.

Men often do not pay much attention to their hair, and it shows. To dramatically improve the neatness of your hair, get it cut every 2 to 4 weeks. One warning: tell your regular barber that you will be getting frequent cuts and want a relatively *small* amount of hair taken off each time.

Men also usually do not experiment with styles as much as women, and do not receive as much guidance from stylists. Experiment with different lengths and partings to show off your best features and to camouflage poor features. Box 7.4 provides some hair tips for both men and women.

Figure 7.12. The Today *show's Faith Daniels has the proper hair style and clothing type to look stylish without her appearance detracting from the news she reads. (Photo courtesy NBC)*

BOX 7.4

Style Your Hair to Enhance Your Appearance

- Short hair makes weak facial features seem stronger.
- Long hair camouflages too-strong features.
- Long hair in back emphasizes the jawline, and can make up for a weak jaw area.
- Attention can be drawn away from a large nose by hair that projects higher on the head and farther out from the forehead.
- Parting the hair higher (closer to the center of the head) visually narrows the face. Parting hair closer to the temples widens the face.
- A lock of hair down on the forehead breaks up a too-wide or too-high forehead appearance.
- People with very round faces should avoid very short hair.

Makeup

Professional makeup kits are available at many television facilities. These provide talcum-based makeup in stick or cake form. Makeup experts also use a variety of special effects to add wrinkles, paste on facial hair, or make a character appear threatening. For most television applications, you won't need the type of theatrical makeup used to create characters in acted presentations. You'll probably be content with

1. *A compact containing an oil-absorbing makeup.* The makeup should be a shade darker than your normal skin tone. For most work, you don't need special theatrical makeup; the stuff available from the drugstore will do just fine. Make sure to apply it in short, downward strokes. Don't smear it when applying. The advantage of a compact, by the way, is that it can easily be used in the field and carried in your pocket or bag.
2. *Eyebrow pencil.* Eyebrows are expressive features, but some people have wispy and/or very light eyebrows. An eyebrow pencil or mascara brush is a useful tool for both men and women.

Don't be afraid to experiment. Try different types of makeup and see what works best for you. Remember, though, the final criterion in judging how well it works is not how you look in the mirror, but on the monitor.

Skin, Teeth, and Eyes

Developing a skin care regimen is a healthy idea for both men and women. In lieu of experimenting with various preparations to clear up skin problems, visit a professional. Dermatologists can frequently clear up long-standing problems that have not responded to inexpert trial and error.

Teeth deserve the same special attention. As you will notice from a quick scan of local channels, TV newspeople hardly ever have bad teeth. A cosmetic tooth problem could cripple your on-air career, so attend to those conditions now. New developments such as invisible braces and bonding can correct a variety of problems.

Eyeglasses may become part of a newsperson's style, but in general they are distractions, another barrier to contact between the news reader and the viewer. That is why many on-air people opt for contact lenses. Modern lenses are much, much easier to adapt to than those of a decade ago, and new improvements are expected. Even people with moderate astigmatism can be fitted with contacts. In addition, soft and gas-permeable lenses are more comfortable than the old-style hard contact.

The major drawback to contact lenses is the difficulty many people encounter in adjusting to them. Yes, it is difficult to adjust to foreign objects in your eye, and it may take months or a year to become comfortable with the idea of wearing contacts and *not wearing glasses.* In truth, though, inserting and using contact lenses is far less traumatic than many people imagine. If you cannot see well without glasses, it would be worthwhile to investigate this option.

All these appearance factors add up to that semitangible concept of an image. Although there is no prescription for a proper image, do weigh various appearance factors and make sure they don't work against you. A good appearance *is* important. You need not be strikingly beautiful, nor particularly good looking, but you must be well groomed and have a generally attractive appearance as a news performer.

Remember, too, that image and credibility are much more than simple matters of cosmetics. Physical impressiveness will never compensate for a lack of professional or intellectual depth.

Image

Summary

Television reporters are journalists as well as performers. TV news is a team effort, and there are many people involved in coverage of news events. The basic components of a TV news organization are news administration, news production, and the gathering and reporting of news.

The typical television newscast has evolved over the years. In the early days of television, the newscast was little more than an audio newscast with a picture of the reader. Today, many different program elements are integrated into the newscast. Gathering and assembling news events for a TV newscast involves teamwork, quick decisions, and hustling on the part of reporters and crews. In addition, news and production people must be flexible because the typical television newscast is often being put together seconds before airtime.

Television field reporting requires good judgment and the ability to work quickly. The field reporter must be able to interview with skill and write, memorize, and record copy on camera. Other duties of the field reporter may include directing the activities of the camera operator and dealing with crowds.

Television news delivery involves proper use of phrasing and pace, as well as the expression of emotion and interest. News reporters must project an aura of credibility. Contact with the viewer is enhanced by smooth use of prompting devices and good physical eye contact with the camera. Working to the camera is an important part of TV news delivery, and it involves making frequent transitions from camera to camera and following the orders of a floor director. The news reporter must be aware of tally lights and must realize that the relative closeness of the shot will change when the director changes cameras.

Ad-libbing is an extremely important skill for the newsperson. A reporter must be certain to ad-lib in words and phrases that are factual and are not subject to misinterpretation. The same techniques used in basic announcing are applied to news ad-libbing.

Television news involves working within technical constraints and working with equipment. Equipment includes studio cameras, prompting devices, and the studio and control room in general. A major innovation in television news was 3/4-inch cassette editing equipment.

Many TV stations use live reports from the scene of news events. There is also increased use of syndicated feature material, some of which is localized by using a local announcer as the reporter. Many newsrooms are becoming automated with computers that make it possible to update stories right up to the moment they are aired.

The TV news announcer should understand the technical aspects of the field well enough to take advantage of them in preparing for his or her performance. Slating cuts to keep track of edit points and using a portable audiotape recorder are two examples of integrating technology into one's work habits.

Television news requires particular standards of appearance. Part of being a successful news reporter is paying attention to clothing, hair, skin, and teeth. Contact lenses are often useful. All the factors of appearance and performance add up to the newsperson's image. However, success in TV news is not a matter of cosmetics. You must be a journalist and a competent performer.

Exercises

1. Design and execute a mock-up newscast. This is an ambitious three-day project, but worthwhile if you have the time and facilities.

Day 1: Elect, or ask your instructor to appoint, a news director, who will appoint

a. The head of production for the class news department

b. The head writer

c. The assignment editor

Those three people will then choose classmates to work under their direction. You will need approximately 25 percent of the class working in production, 50 percent in writing, and 25 percent as on-air people. On-air people will be chosen by the assignment editor. The duties are as follows:

- *Production people* will design the newscast with whatever equipment they have available. If there is no video equipment, the newscast will be presented to an audience. Production people will determine the construction of the set, placement of cameras, and so on.

- *Writers* will each decide on one story, preferably an easily done local story. The stories will be assembled in the next

class session. Each story must be no longer than one minute when read.

- *On-air people* will file some of these stories as taped reports, if equipment is available, and the two anchors will coordinate the newscast.

Day 2: The news director and all three department heads will meet to decide story assignments and other production details. If remote gear is not available, reports will be delivered directly to the camera or audience during the newscast.

Day 3: Now prepare the final lineup and assemble the script; this must be done in less than 15 minutes. The newscast itself is to be 20 minutes long, and must start *exactly* 15 minutes after the start of class.

This set of guidelines is intentionally open-ended. The duties and time frames must be adapted to circumstances in class. Also, particular sequences and responsibilities are not specified because in an actual TV news situation, getting organized and figuring out who will do what, and when and how it will be done, is half the battle.

In this exercise, *teams* will have to decide what can be done and what resources can be allocated, all within a time limit. If you are selected to work on the air, you will certainly find that the backup and cooperation you receive go a long way in determining how good you look on air.

2. Do the following exercise, strictly to time. It is a good one to do during class and in front of other class members.

Your instructor will clip a daily newspaper and assign stories to class members. You will have 10 minutes, no more and no less, to study the story and take as many notes as you can fit on one side of a 3-by-5 index card. Your goal is to ad-lib a 1-minute report before the class, with each class member giving a report according to random selection. If facilities allow, tape the reports.

Maintain as much eye contact as possible. *Hint:* Copious notes crammed on the 3-by-5 card will not necessarily be as helpful as a concise outline.

3. Choose a network or well-known local news reporter for each of the following hypothetical assignments. Pick the

person you believe could do the best possible job and explain why in one or two paragraphs. Specify what qualities of this reporter would make him or her the best choice for the job.

a. A host for an hour-long documentary on the stock market. Technical information must be made interesting to a wide audience.

b. A host for a morning news/entertainment program in an industrial city where audience research shows that many of the workers arise at 5 A.M. and want a show and host to brighten their day.

c. A reporter for a 10-minute segment on the plight of the homeless in New York City.

d. A reporter to do a 5-minute feature on inflatable furniture.

e. A host for a 15-minute feature on fine wines.

f. A reporter to confront a tough big-city mayor on charges of corruption in municipal government.

g. An anchor to handle the first reports of possible outbreak of a war involving the United States. You would likely want someone adept at presenting breaking information, someone who inspires confidence and remains calm under pressure.

h. An interviewer to talk to the mother of a servicewoman killed in one of the initial skirmishes of the war.

Ask a simple question and get an answer. It seems simple enough to do. But when you're a journalist, getting the right answer is more complicated than it might seem.

Whether you're talking about print journalism or radio or television, the skill of the interviewer can spell the difference between a news report that actually contains news and one that merely fills space or time. Interviews can be tough. Some interview subjects are extremely nervous on camera. Some are unresponsive or evasive. Others talk only about their own specific interests no matter what question is asked. To add to the pressure, the broadcast newsperson often works under rigid time and technical constraints. Regardless of the obstacles, though, you as a reporter are charged with the task of coming up with an interview that is logical, informative, and interesting.

The focus of this chapter is to explore and demonstrate the principles and techniques that will help you conduct an effective interview. Whether the interview forms the basis for television news, a radio talk format, or an entire program in which a single guest is the subject of an extended interview on a variety of subjects, a succession of pat, bland questions will not provide much useful and lively information. Successful interviewing involves three steps:

1. Determining the type of interview and adjusting the approach accordingly.

8

The Craft of Interviewing

2. Preparing for the interview, which involves selecting questions and topics, narrowing the topic for a logical discussion, prescreening guests, and doing a good deal of homework.
3. Executing the interview, which entails proper attention to the logistics of an interview, making it flow logically, and avoiding major pitfalls.

Types of Interviews

A broadcast interview is not always conducted in a comfortable chair in an air-conditioned studio. With the advent of modern television gear, television on-air personnel find themselves in a wide variety of situations, which boil down to two basic types: the *actuality interview* and the *studio interview*. The actuality interview is generally a straightforward attempt at obtaining information. The studio interview can be of several varieties, ranging from brief personality interviews to in-depth discussions of serious and complex topics.

The Actuality Interview

An actuality is a response or statement from a newsmaker, which is typically edited and used in another format, such as the "package" described previously, or used in a newscast after an anchor's introduction. The key to successful actuality interviewing is obtaining a response in a form that *can* be edited out and used in, perhaps, a 90-second report. Since you're looking for short, succinct answers, the way you phrase each question is important. Ways to devise questions are suggested throughout this chapter.

The Studio Interview

Although parts of an interview conducted in the studio may be used as actuality, most studio interviews are meant to be broadcast in full, with a definite beginning, middle, and end.

Generally a specific amount of time is allotted for a studio interview, but usually there is more latitude in terms of time and content than is the case for the actuality interview.

Dealing gracefully with time restrictions is one of the most difficult aspects of interviewing. An interview to be edited can run to virtually any length, but a talk show type of interview must make its point and wrap up when the clock (and the director) says so. This means that pacing within the interview must conform to the time frame. A half-hour interview should not reach an emotional peak in the first 5 minutes and coast downhill from there. Likewise, there should not be important questions left unanswered at 28 minutes into the program.

The broadest categories of studio interviews are the personality type and the issue type.

The *personality interview* is an exploration into the life or career of an important or well-known individual. Entertainment value comes into consideration here. In most cases the interviewer is expected to keep the session reasonably light and engaging.

In the *issue interview,* the personalities of the guest and host are less in focus than the topic at hand. The interviewer, generally a program host, is

expected to highlight various points of view and present them fairly. In-depth analysis and discussion are frequently used in the issue interview.

Keep the foregoing distinctions in mind, because style and execution of the interview differ for each type. The elements are not mutually exclusive, of course, for there certainly can be entertainment in a talk show presentation of an in-depth analysis of a serious topic. But if discussion of a serious topic is too flip, the results can be offensive.

Likewise, the interviewer will not want to adopt for an issue interview the same style that would be used in an actuality interview. Have you ever watched a half-hour talk show that seemed to consist of nothing more than an endless, hypnotic interrogation? What you were seeing was a host who asked for specific fact or reaction but neglected to ask the guest to *discuss* the issue and *analyze its meaning*. The chance to discuss and analyze is the main strength of the studio interview, and failing to take advantage of it can lead to an awkward and boring product. Listening carefully to responses can help you develop relevant follow-up questions.

Regardless of the type of interview, the goal is the same: to obtain interesting, relevant, and provocative responses. Some factors will be out of your control, but the most important aspect is your responsibility: you must adequately prepare for the interview.

Off-camera/off-mic interviewing will comprise a good deal of the interviewing you'll be doing. Although at times the interviewer barges in with lights burning and cameras rolling, most interviews are set up well in advance, and information has been gathered before the videotapes or audiotapes roll. The information-gathering process might involve calling up the interviewee and putting together some basic facts before inviting him or her to the station for a studio interview.

How much information to gather before turning on the cameras and/or mics is a judgment call. On one hand, too little preparation before the tape rolls can result in a clumsy session, and it will be obvious to the audience that it was thrown together at the last minute. At the other extreme, too much advance preparation can result in a "flat" interview over the air. The interviewee who is responding to the same set of questions for the second or third time may sound as if he or she is being very patient with a slightly stupid interviewer. Also, too-extensive preparation can put guests on guard, giving them a chance to prepare evasive responses to questions they'd rather not answer.

There is one other important point. Many people will be reluctant to give you the most mundane information when you start the conversation with microphone in hand. Some subtle, low-pressure questioning in a conversational tone, done off-mic or off-camera, often elicits a much better response for the air. One additional advantage of preparatory information gathering is

How the Type of Interview Affects Style

▼

Listening carefully to responses can help you develop relevant follow-up questions.

Preparing for the Interview

Preparing Questions

that guests are very hard put to omit or refuse to comment on information they have already given to you or confirmed before the tapes rolled.

The Importance of Research

Research is an important factor in interview preparation. An interviewer's lack of knowledge is usually very apparent once the conversation starts. Never let cockiness and overconfidence seduce you into walking into an interview unprepared. Preparation should always be a priority for two major reasons, one obvious and one not so obvious.

1. You can conduct a much more intelligent interview by being well informed.
2. You can fulfill your responsibilities to management, your audience, and yourself by not letting outrageous statements slip by unchallenged.

For example, let's say you are host of a talk show and your guest, the leader of a neighborhood group, assails the city for not providing enough low-income housing. After the program airs, you receive an angry call from a city official who informs you that there have been low-income units sitting vacant for months. This situation was highlighted at the city council meeting last week. It made all the papers. Where were you?

Some basic research would have allowed you to question your guest more closely, challenging the assertion by citing the recent council discussion. Lack of preparation in the following areas can also lead to on-air gaffes or unnecessarily dull interviews.

1. *Not knowing the political opinions of your guest.* Politics color responses, and if you do not know a guest's politics you will have trouble filtering out the party line. Or you might fail to follow up on an important statement by not realizing when a politician has *opposed* the party line.
2. *Not knowing or not completely understanding the vested interests of your guest.* For example, if your guest is employed by an organization or lobbying group to promote a particular product or belief, it is your obligation to know this and point it out to the audience. It is also important to find out if a politician has any personal interest in a particular piece of legislation, or what boards of directors a banker serves on. Knowing the background of, and reasons for, a guest's position on a subject are vital to an open, complete interview. Only careful questioning and research in advance will determine whether the guest is an impartial observer or a paid spokesperson. Having incomplete information in this respect is, in effect, a distortion in itself.

Research Material and Resources

One good way to prepare for an interview is to check through newspaper or magazine clippings on the topic, and the best place to start is often the public library. In some cases you can gain access to the files of the local newspaper.

Another avenue is to simply ask questions. Quiz co-workers, friends, and neighbors. You cannot accept everything they tell you as a fact, but the leads you gather can be useful in opening other areas of research. Writers of nonfiction, who use this technique extensively, gather a great deal of material just by continually broaching a subject among various groups, even at cocktail parties. It is extremely surprising how often casual conversation can steer you to an appropriate resource or helpful individual.

One final note concerning research and preparation: the success of an interview, especially a studio interview, depends on selecting a guest and a reasonable narrowing of the topic.

By prescreening guests, you can sometimes avoid having to deal on the air with someone who is too nervous or obstinate to give a productive interview. Unfortunately, there are no foolproof predictors of a guest's performance. Oddly, the guests who initially, off-camera or off-mic, appear to be the most blasé about the prospects of being interviewed are often the ones who "freeze up." Your initial dealings with a prospective guest may lead you to believe that he or she either is not interested enough to give an enthusiastic interview, or is covering fright by adopting an uncaring attitude. If this happens, you will have to work harder at making the guest feel comfortable. You might boost the guest's ego by explaining how pleased you are that someone of his or her stature or knowledge of the subject has agreed to be interviewed. Try to make the reticent guest more self-confident.

One way to avoid trouble is to put the guest at ease and explain what is going to happen during the interview. This is especially appropriate for TV talk shows, where there is a great deal of motion on the set, and some noise also. The setting probably is unfamiliar to your guest and is likely to be perceived as threatening. Remember, the guest who has not been briefed may not understand what's going on. It's not unusual for a guest to turn and stare at the wild gesticulations of a floor manager who's trying to get your attention. Guests have been known to freeze in panic as a camera ominously slides toward them.

Think about it from your guests' standpoint. Explain, while you are preparing to go on the air (Figure 8.1), that there is a great deal of activity in a televi-

Selecting a Guest and Topic

Figure 8.1. Pre-air preparation is essential. Here, on AM/Philadelphia, *a long-running television talk show aired on WPVI-TV in Philadelphia, guests are prepped just before airtime.*

sion studio, but none of it need concern them. Let guests know that they should not look at the monitor, and warn them specifically that cameras may move. Remember that radio can be intimidating to guests, too, and a pre-air orientation can be calming to an interviewee.

The discussions you have with your guest before the actual taping or airing of the program should also serve to narrow the topic. Usually, a guest will press you for a specific list of the questions you plan to ask. As suggested earlier, giving out a list of questions before airtime is not a good idea. First, the guest may respond with rehearsed, flat answers. Second, if the guest

B O X 8 . 1

Dealing with Telephone Call-Ins

- *In the radio talk interview, never allow your attention to wander.* A call can go sour very quickly, and degenerate into obscene or libelous invective. While most stations have a delay system, those systems are not always infallible; many things slip by. By keeping ahead of the caller, you may avoid the necessity of cleaning up an embarrassing mess.

- *Be especially careful not to misidentify the caller.* Most stations have some sort of monitor arrangement with which the host is shown the name, and sometimes the hometown, of the caller. (In small markets, there are still cases where the engineer writes the name and town on a piece of paper and holds it up to the glass.) An occasional mistake is unavoidable, but continually saying hello to "Marjorie from Trenton" when it's really "Bob from Brooklyn" ruins your credibility in a hurry.

- *Keep callers to time limits.* Timing is always difficult. Many talk show hosts, such as Bruce Williams, who moderates an exceptionally popular finance-oriented program, makes a diligent effort to wrap up segments before a commercial break. Williams can't always manage to finish each discussion on schedule, but he usually does. Listening to him is instructive. Note that he's not shy about prompting callers to condense their story. Also note that he speeds up his responses and questions as time grows short, thus cueing the caller to pick up the pace of the conversation.

assumes that these are the *only* questions to be covered, he or she may balk at any question that was not on the list.

To lay the groundwork for the interview, however, a definition of the areas to be discussed is necessary. For example, your initial off-camera/off-mic discussion with a state economic development official may prompt you to narrow the topic to explore the revitalization of your city's downtown area, as opposed to a shotgun-type discussion of the official's office and what it does.

One of the more difficult aspects of interviewing is dealing with callers on a telephone call-in program. Some suggestions are given in Box 8.1.

A successfully executed interview is usually the result of a three-pronged effort to

1. Get an interview that is appropriate for the format or intended use, also making sure that the topic is of interest to the target audience.
2. Work effectively within technical limitations (such as time limits) and performance considerations (such as opening and closing the show, keeping the interview flowing, and making the program run smoothly).
3. Elicit responsive answers from the interviewee.

Let's examine these principles of execution in detail.

Doing the Interview

News interviewers are frequently sent out to obtain a specific fact ("What will next year's tax rate be?") or reaction ("What is your opinion about the sentence given to the defendant?"). Often the fact or reaction is edited down into a short piece that can be inserted into a newscast. Thus an interviewer looking for a response from which 30 seconds can be edited might ask, "What will be the most immediate impact of the rise in the prime rate on an average-income American?"

A reporter at a press conference is also seeking specific answers. Even if the segment is to be shown in its entirety, the goal is still to elicit facts or reactions about a specific subject. An awkward way to phrase the same question under this circumstance would be "Mr. Smith, what is the long-range impact of the increase in the prime rate, and how will it affect the various segments of the economy, such as manufacturing, services, and, eventually, the consumer?" This question is likely to provoke a full-blown lecture, not a succinct reply.

Appropriateness of the Interview

An interview is not a natural situation, although a skilled broadcaster can make it appear so. If an excellent interview has the character of a conversation in the host's living room, it is because the host is skilled in working within the technical limitations of the TV or radio facility and equipment. The graceful wrap-up that appears so simple and easy is probably a product of preparation, experience, and instinct.

Technical and Performance Considerations

Following are some suggestions on ways to work within the confines of broadcast structure and format and to deliver a professional-appearing performance. Specific techniques of the question-and-answer aspects of the interview itself are discussed later in this chapter.

Preparing Introductions and Closings Do not put too much faith in your ad-libbing abilities; you can ruin an otherwise good talk show by flubbing the beginning or the end. On a talk show, it is the host's responsibility to set the scene properly. Four elements should be part of an opening:

1. What the topic is
2. Who the guest is
3. Why the guest is worth listening to
4. *Why the audience should care about the topic*

The final factor is vital. A show on economics might be of little interest to viewers or listeners unless you explain that the prime rate will determine whether they can buy new houses. A show on food additives won't have much appeal unless you specify that certain additives, which may be harmful, may be in the food your audience and your audience's family will eat for dinner. It is generally good practice to write notes on the openings and closings and use them for reference.

Preparing Questions and Follow Up Prepare questions, but don't be a slave to your list. Preparing questions helps to focus your own thinking on the thrust of the interview. A prepared list can be a lifesaver when an unresponsive guest fails to give answers that lead into other questions. A list of prepared questions is useful, but it should not be the end-all of the interview. Here is an excerpt from an actual interview.

Interviewer:	Mr. _____, what do you think of the majority leader's actions?
State Representative:	To be honest, it makes me feel ashamed of the whole system. This sort of thing just takes the heart out of you, and I don't feel right associating with the system. I don't think I'm going to run for reelection.
Interviewer:	Now, what do you think of the chances for a tax hike next year?

This interviewer stuck to a prepared list to the point of ignoring an unexpected answer and managed to miss a major story. Always *listen* to the answers to your questions and follow up when appropriate.

Keeping Audience Attention A major responsibility of an interviewer, of course, is to keep the audience from tuning out. Lack of interesting material is a major culprit, but distractions also steal the audience's interest from the subject at hand. See Box 8.2 for some suggestions for avoiding distractions and keeping the viewers' and listeners' interest levels high.

B O X 8 . 2

Suggestions for Holding Your Audience

1. *Don't make meaningless noises.* You might say "uh-huh" 30 times in a normal conversation, but it appears down-right silly on the air. "I see," "yes," "right," and "you know" are other verbal tics to be avoided.

2. *Fill in your listeners and viewers from time to time.* The first piece of advice usually offered to play-by-play sports announcers is "Give the score, because if the listener doesn't know the score, you're not doing your job." The same advice, to a lesser degree, goes for talk show hosts. The audience won't always know exactly what the interview is about if they tuned in late or weren't paying attention, and it is up to you to fill them in, perhaps after a commercial: "We're back with Dr. Frank Adams, who is telling us how to get in shape for spring sports. . . ." That's all it takes.

3. *Stick to the subject.* If you are talking to a fire chief about ways to prevent house fires, you do not want to get into an extended dialogue about the social problems that cause arson. Some examination of that issue is important, and probably necessary, but it should not take over the show. Be particularly wary of guests who wander into controversial areas that are not within the boundaries of their expertise.

4. *Establish the guest's qualifications, and reaffirm them from time to time.* The audience wants to know why they should bother listening to your guest: "We're talking about poison prevention with Dr. Janice Jones, who is a toxicologist, a specialist in the study of poisons, and is head of University Hospital's Poison Control Center. . . ."

(continues)

Box 8.2 *(continued)*

5. *Don't assume too much knowledge on the part of the audience.* If you are conducting an interview about vacation travel, remember that a good share of your audience may never have been on an airplane. Likewise, don't assume that every viewer or listener has an up-to-date knowledge of current events.

If the discussion starts at a level beyond the knowledge of a good share of your audience, you will lose the attention of many listeners and viewers. Set the groundwork simply and completely, giving information that will be obvious to some members of your audience but not to others.

Dealing with Time Restrictions One of the most awkward aspects of a talk show format is dealing with the clock. A good segment can be spoiled by having to cut off a guest in midsentence with a frantic closing.

One of the most frequent questions guests ask before going on the air is how they will know when to stop talking. Try telling your guest, "Just watch me. You'll know when it's time to wrap up."

You usually don't have to do anything special; having the guest tuned into your body language cues is often enough. After all, can't you tell when someone is in a hurry, regardless of whether that person states it verbally? If you find that the subliminal approach doesn't work, and you are having trouble getting out of the show in time for commercials or the program end, you may elect to set up some sort of cue with guests.

Using Your Guest's Talents Although the principle of taking advantage of a guest's talent sounds obvious, many interviewers have become infatuated with the technique of asking comedians about the tragic aspects of their lives. A little of this is all right, but a little also goes a long way. Be sure to give your funny guest an opportunity to be funny. The audience expects this and will, by and large, be disappointed if it doesn't happen.

Likewise, if you are interviewing a wise analyst of current affairs, be certain to give the guest the latitude to do what he or she does best. Along the same lines, don't try to steal the show from your guest. Remember, the audience is listening and watching because of the guest, not because of you. If you were the star, the station wouldn't bother cluttering up the set with interviewees.

Eliciting Responsive Answers Despite the considerable overlap between the performance considerations just discussed and the specific techniques of questioning discussed next, it is productive to concentrate on some of the methods used by interviewers to obtain logical, reasonable, and useful responses. Here are some principles and their applications.

Avoiding "Dead-End" Questions Sometimes an interview can grind to a halt because the questions just don't lend themselves to lively conversation. There are two main methods of preventing this from happening.

1. *Avoid asking questions that can result in yes or no answers.* Instead of saying, "I gather you don't think this is fair?" try asking, "What do you think is unfair about the situation?" A yes-or-no question may be very useful, however, if you are trying to pin down a guest who is being evasive.
2. *Avoid obvious questions, and avoid obscure questions.* Do not ask a politician who has lost an election if he or she is disappointed. On the other end of the scale, do not start off an interview by quizzing a scientist on the molecular structure of a high-performance ceramic, unless you are doing an in-house presentation geared for people who have a technical understanding of the subject.

Getting a Complete Answer Often, through accident or intent, an interviewee fails to provide an entire answer, or leaves an issue hanging. The hallmark of a skilled interviewer, however, is the ability to elicit complete answers to his or her questions. This often involves waiting for an answer to be completed or, at the end of a response, stating that the question hasn't been answered completely. To get a complete answer, use the following techniques, which are highlighted in Box 8.3.

1. *Wait out a noncommunicative interviewee.* Some people may not be willing to give complete answers, but some are simply terse and short-spoken. When you need a more complete answer, just keep looking at the interviewee. He or she will get the message that more is expected.

 If the interviewee is trying to evade giving a full answer, he or she may just stare back at you—but that is an answer in itself. Usually, though, interviewees will give in before you will.

B O X 8 . 3

Get a Complete Answer

1. Wait out a noncommunicative interviewee.

2. Point out that you are not getting an answer, and repeat the question.

3. Take your responsibilities seriously when looking for an answer.

2. *Point out that you are not getting an answer, and repeat the question.* Never be afraid to say, "Excuse me, Senator, but that's not what I was asking. My question is . . ."

 Many public figures are experts at avoiding unpleasant questions and giving the answer they want to give regardless of what is asked. It's up to you to get the interview back on track and not let the evasive answer go unchallenged. For example,

Interviewer:	Do you expect another round of layoffs?
Corporate Vice President:	We anticipate a very healthy turnaround of the economic situation, especially when our new division opens in 18 months, when we actually expect to add jobs to the payroll.
Interviewer:	I'm glad to know the long-range job situation looks good but what about the immediate future? Do you expect another round of layoffs before the new division opens?

3. *Take your responsibilities seriously when looking for an answer.* Do not become pontifical on the subject, but remember that a broadcast interviewer is, in effect, a representative of the public. You have a right to ask questions and a right to a reasonable answer.

 Always be polite, but never let yourself be cowed by a high-ranking official who is 30 years your senior. Never mind how well the interviewee says he or she knows the station manager. Do your job, and remember that you are not doing your job if you let yourself be intimidated.

Developing a Style The key to developing a successful interviewing style lies in finding the approach that works best and polishing it. The boyish appearance and demeanor of one excellent interviewer gain him a stunning amount of cooperation and information. His approach is usually something along the lines of "Gosh, I really don't understand this, and I'm sort of in a jam to get a story so I'd really appreciate any help you can give me." He uses his style very well, and invariably comes away with more information than do overbearing, bullying competitors.

Perhaps an aggressive attitude is best for you, however. Style is a matter of experience, so experiment and cultivate methods that work well on an individual basis.

Understanding Why Questions Backfire In an interview situation, the host can inadvertently create negative impressions of himself or herself and

of the guest by falling into the traps of mincing around unpleasant questions and being a cheerleader.

1. *Don't be hesitant about asking unpleasant questions.* Suppose you are interviewing a former convict who now works with a children's group. Questions about why the guest was in prison and what he or she learned from that experience are unavoidable, so ask them straight out and don't hedge.

 Your inclination to preserve the dignity of your guest is perfectly natural. Remember, though, that a direct question will be far less damaging to your guest's dignity than a mincing, indirect approach, which leads the audience to believe that the subject is distasteful to you.

2. *Avoid being a cheerleader for a guest.* You may be interviewing a celebrity whom you greatly admire, but your audience won't be well served by having you gush all over him or her for 30 minutes. Maintain your perspective.

Focusing the Issue Perhaps the clearest distinction between a poor interviewer and a good one is that the good interviewer keeps the discussion focused on a central theme, whittling away verbiage to keep answers understandable and to the point. Two valuable techniques for focusing the issue are *using transitions* and *paraphrasing.*

First, *focus the issue with transitions.* People being interviewed for talk shows or for newscasts may wander from the point, either by accident or because they want to avoid the topic under discussion.

The interviewer can politely steer the conversation back on track by using a smooth transition. For example, assume that you are interviewing a home economist on the subject of budget-saving meals. The economist has mentioned the inexpensiveness of Chinese cooking, but has gotten off on a tangent about the benefits of Mandarin versus Cantonese spices. You can gently return the conversation to the subject by saying, "Yes, Chinese food is very good and very inexpensive. Are there other ethnic foods that represent good bargains?" This gets you back to the topic of budget-saving meals tactfully, without making an abrupt jump, and the conversation can continue naturally. You may, of course, want to be abrupt when an interviewee is obviously trying to duck a question.

In some cases, the guest may stray from the point because he or she has an ax to grind. For example, the head of a police union, asked if a strike by uniformed officers would endanger residents of high-crime neighborhoods, might overlook the question and begin a discourse on how the city failed to bargain in good faith. If you want to preserve the ambience of the interview without taking a blunt approach at that particular time, you can use a gentle transition: "Well, the collective bargaining has been going on for months, with no solution in sight. But it seems that the situation in high-crime areas

during a police strike could be an immediate problem, and I wonder if you could tell me . . ."

If the transition fails, you may elect to resort to the more direct principle of stating flatly that the question hasn't been answered. This heavy-handed technique, though, is generally more useful in an interview that will be edited than in a talk show. The reason? If you start pressing a guest 5 minutes into a half-hour talk show, you may have 25 tough, uncommunicative minutes ahead.

Second, *focus the issue through a paraphrase.* In many cases the answer you receive from a guest simply won't make much sense, either because the guest cannot express it better or because he or she does not want to say it more clearly. For example, a politician being quizzed on government finance might say, "Well, as the people of this great state know, budgets are tight in this day and age, and some form of revenue enhancement may be in order to preserve the programs that have made this great state a leader in . . ." One way to make sense of such a response is to paraphrase what you think the interviewee just said and see if he or she agrees with it: "Governor, do I understand that you are saying there may be a tax increase next year?"

Now you are forcing an answer and focusing the issue. The governor can agree with what you said, back off from what he said, refuse to make a specific statement at this time, or blandly offer another waffling answer. A more detailed response is necessary, and you may have finessed him into predicting a tax increase in plain English.

Keeping Statements Fair Interviewers are not required to judge the validity of every statement made by every guest, but they are responsible for challenging what appear to be unfair attacks and illogical or unsupported statements. As a representative of the public, you have a duty to call attention to unfair or misleading statements.

Specifically, you must balance both sides of the issue and keep the discussion logical.

▼

As a representative of the public, you have a duty to call attention to unfair or misleading statements.

1. *Balance the issue.* A trend in talk shows is to invite several guests with opposing views and let them battle it out before mics and cameras. Guests on the same show may differ widely in their eloquence and communication abilities, so it is up to you to see that a less-skilled interviewee is not trampled by an aggressive guest. You may have to play devil's advocate, just to ensure that all sides of a matter are fairly represented.

 Your most important responsibility as a pseudoreferee is to make sure that if charges are made, they are supported or are clearly identified as unsupported allegations or personal opinions. Potentially damaging allegations should not be left hanging. Try to resolve such matters before moving on to the next point. The next technique may be quite useful in this regard.

2. *Keep the discussion logical.* A discussion of formal logic is beyond the scope of this book, but if you have the opportunity for further instruction in logic, take advantage of it. Essentially, it is your responsibility to ensure that the statements presented by your guests are factual, and that the conclusions and inferences drawn make sense. Here are some examples of lapses in logic that should make your antennae tingle:

- An interviewee says that all homosexuals are dangerous deviates and that "Dr. Smith" has proven it. Don't let something like this go unchallenged. Who, exactly, is Smith? What is he or she a doctor of? Exactly what does the proof that is claimed consist of?

- A guest says that "ten people died in yesterday's fire because there were no smoke detectors." This is a dangerous type of statement because it may be true, though unprovable, and even if it's not true at all (seven victims were in a narcotic stupor, two were unattended infants, and the guy who set the fire left a suicide note in a metal safe), there's an element of validity that tempts the broadcaster to violate the rules of logic.

- A politician running for reelection contends that the fears of the elderly in a certain rundown neighborhood are groundless. He cites statistics indicating that an elderly person has less chance of falling victim to street crime in that neighborhood than a young person.

Statistics are very difficult to sort out, but a broadcast communicator should always be prepared to challenge them. In the case of the politician and home for the elderly, the interviewer remembered that the neighborhood in question contained a very large nursing home.

Interviewer: But Mayor _____, don't these figures include residents of the _____ Nursing Home?
Mayor: Well, yes.
Interviewer: There are hundreds of elderly people in that nursing home, and many of them are bedridden. They couldn't be victims of street crime if they *wanted* to. Doesn't this cast some doubt on your statistics?

You will not always be able to score this type of coup, of course. But a healthy understanding that statistics can be extremely misleading if used with self-serving intent may shed light on many illogical contentions put forth by interviewees.

Drawing Out Reluctant Guests Fear is a strong element in the perfor-

mance of a guest. Being on the air *can* be frightening, even to experienced performers. Remember, too, that some people simply are not verbally oriented. A "man of few words" can be admirable in many respects, but he may not make an ideal interviewee.

Two ways of getting a guest to open up include *personalizing the questions* and, if the situation really deteriorates, using your list of *disaster questions*.

Personalizing questions is a useful technique because guests who are afraid of repercussions often are reluctant to give complete and responsive answers. A lower-level manager of a social program, for example, may be very edgy about providing specifics because he or she "can't set policy." If you are confronted with such a situation, avoid questions that make the guest seem to be a policymaker. Instead of asking, "What is your agency's position on . . . ," try the following approach: "What sorts of things is your agency doing to overcome . . ." This approach is *very useful* when dealing with workers in a highly structured bureaucracy.

Some people do not fear repercussions; they just don't like to talk, aren't very interesting, or don't care very much about getting their message across. For some reason these people can and do appear on talk shows, so you need to know some techniques for opening them up.

A good way to elicit a response from an untalkative guest is to ask, more or less, "What does your program (service, etc.) mean to our audience? How could it affect them?" Even the most uncommunicative guests will be reluctant to admit that what they do with their lives has no impact on other people. This is what makes personalized questions good "disaster questions," as discussed later. Such questions also lend themselves to follow-ups.

Sometimes, however, interviews just go badly, and you must be prepared for that rare guest who "clams up." The reasons may be varied, but often they are seated in people's ignorance of the impression they make on television or radio. Thus a guest may sit as tight-lipped as a murder defendant for 30 minutes to keep from appearing "too gabby," or "undignified." But at the conclusion of the program, he or she will turn to the host with a worried look and ask, "I didn't run off at the mouth too much, did I?"

In such situations, when a guest only mumbles monosyllabic answers, you may need some of the following *disaster questions.*

1. "What are some of the personal success stories you've had in your experience with the program (agency, organization, etc.)?" It is a rare guest indeed who doesn't have something he or she is proud of, and willing to talk about at greater length.
2. "Why did you get into this line of work (support this cause, etc.)?" This is an intensely personal question, and even the most uncommunicative guest will not let it slide.
3. "What advice would you give to someone starting off in this line of work (interested in supporting a similar cause, facing this problem, etc.)?"

Likewise, personal questions, which give an opportunity for the guest to draw on his or her experience, are very difficult to slough off.

This is not the definitive list of disaster questions, and you might want to develop some of your own. The key, of course, is the personal angle, an angle that just might help in all your interviewing tasks. Why? Because the prime factor in any type of interview, with any purpose, is *what the subject means to people*. People and their lives, not facts and theories, are what interests an audience.

Summary

Interviewing can be made difficult by a number of factors, including rigid time restrictions, nervous guests, and interviewees who want to use your program as a soapbox. Overcoming these obstacles and conducting a successful interview involves determining the type of interview (i.e., studio or actuality), preparing for the interview, and doing the interview.

Preparing for the interview involves drawing up a list of questions and doing research. Selecting the guest and topic is often the interviewer's responsibility, also. Doing the interview entails effectively working within technical restrictions and performance considerations, and eliciting valid responses that are appropriate for the format or intended use of the interview.

The technical restrictions and performance considerations just mentioned involve openings and closings of interview segments, proper use of prepared questions and following up on questions, and keeping listeners' and viewers' attention. Time restrictions must be dealt with effectively, and the interviewer must grasp the techniques of closing an interview segment gracefully.

An interviewer must be concerned with getting a *response*, not simply an answer. Techniques to spur continued conversation and get complete, relevant answers are essential.

Some questions backfire for reasons not immediately apparent. Reasons may include interviewer hesitancy toward asking unpleasant questions or, conversely, an obvious "cheerleading" attitude toward the guest.

Skilled interviewers know how to focus an issue. They do this through use of devices such as transitions and paraphrases.

It is the interviewer's responsibility to keep statements and allegations fair. Inherent in this responsibility are the tasks of balancing issues during an interview and keeping the discussion and contentions within the bounds of logic.

Some guests are very frightened or simply uncommunicative. Talk shows with such guests can be disastrous, but the technique of personalizing the question can often elicit good responses. Every interviewer should be prepared with a list of "disaster questions," material that can be used at any time and almost always will resurrect the interview. Such questions involve explorations of the individual's personal success stories or lifelong goals, and usually are not sloughed off by even the most uncommunicative guest.

213

E x e r c i s e s

1. Ask a classmate or co-worker to read a newspaper article on a particular subject and to take notes. Your job is to interview him or her for five minutes on that topic.

This is a realistic type of interview situation, because many of your interviewees will have a limited knowledge about the topic, and the interviewer will have to stay within certain boundaries. Admittedly, you and your guest will be operating from a small data base, but this exercise will prove helpful if you try to maintain a rhythm and a level of interest, regardless of the rough spots.

2. Prepare a list of the five most immediate and pressing questions you would want to ask in the following circumstances. Assume that you will have a limited amount of time, so make the questions brief and to the point. List them in descending order of importance.

a. You have arrived at the scene of an explosion and have cornered the police chief. Your questions, for example, might be "Is anyone hurt or dead? Are people still in danger? How did the explosion happen? How will the investigation proceed? Is this incident related to a similar explosion last week?"

b. You are interviewing an actress who will open tonight in a play she also wrote and directed.

c. You are asking a person who has just been acquitted of a crime for his reaction.

d. You are speaking with the head of a suicide hotline agency about how teenage suicide can be prevented.

e. You are interviewing a college professor who says that the elderly in the United States are treated very shoddily and do not get the respect they deserve from the younger generations.

Discuss your list of questions with classmates or co-workers.

3. Watch a television interview program and keep track of the questions asked by the host. Grade those questions on how interesting they were *to you*. In other words, how badly did you want to ask that question yourself?

Keep track of issues you feel were left hanging, or weren't dealt with adequately. Also, write down questions you feel the guest evaded or did not answer completely.

By taking careful notes, you will wind up with a virtual flow sheet of the interview program, and you should have a much better idea of how such programs progress when they are done well, and even when they are not.

You can explore a number of specialty areas as a professional on-air broadcast performer. Sports reporting and play-by-play announcing, weather reporting, hosting radio talk shows, and narration are some common examples. Some broadcasters move into one of these areas by chance. For others, a career as a sportscaster or weather reporter is a lifelong goal, attained after years of preparation for that big break that brings success.

Every area of on-air endeavor has its own special requirements. The special talents and skills needed for success in any given area are developed with experience. No one can prepare to be a great play-by-play announcer without on-air experience. Certainly practice off the air can help, but the actual pressure of being live and on the air provides the special incentive that lets you exceed even your own expectations.

Despite the fact that you can only hone your skills and develop the specialized knowledge you need through practice, the main requirement for proficiency in any specialty assignment is the same as for any on-air assignment. You need to start out as an effective broadcast communicator.

This chapter discusses some specialty assignments in broadcasting and gives a broad overview of the techniques used. The basic principles are refinements of the broader elements of good communication presented throughout this text. And broadcasting specialists use many of the specific techniques covered here:

9

Television and Radio Specialties

- A sportscaster often must conduct an extensive interview (Chapter 8) and, during play-by-play, must do a good job on commercials (Chapter 10).

- A weathercaster, especially in times of weather emergency, must gather and present facts lucidly and responsibly in the news function (Chapters 6 and 7).

- A narrator must have an effective voice (Chapter 2) and must be able to grasp the essentials of the copy (Chapter 3).

There is really no way to explain how to become a sportscaster or a weather reporter. A few lessons and drills will never come close to providing the specialized knowledge required. That's why this chapter is brief and primarily introductory, touching on sports, weather, narration, and acting as host of special types of programming such as children's shows and movie presentations.

Sports

Knowledge of sports cannot be faked. Sports fans are often experts themselves, and this means that an aspiring sportscaster must have a strong interest in, and knowledge of, the games to be reported. A sports anchor must be well informed about all sports, even activities he or she may not find personally appealing. In many cities, for example, competitive bowling is extremely popular. Hence, the sports reporter must project knowledge and enthusiasm, qualities that come about only by painstaking homework, in a sport that may be unfamiliar.

In addition, a wide personal data base is important because opportunities for sports coverage open very quickly. Should a major fight be booked for your city, someone will have to handle the story, and if you work in the sports department, that someone is likely to be you. It is worthwhile to be aware of and interested in all the various types of sports work.

Types of Sports Assignments

Sports work generally falls into four categories: anchor work, sports reporting, play-by-play, and color. Anchor work in sports parallels that of news. Sports reporting also translates the role of radio or TV reporter from news to sports.

Play-by-play is unique and requires a specialized set of abilities, discussed later in this section. Color work, dealt with in the section on play-by-play, is the providing of commentary and insight.

Personality in Sports

It has been said that the sports reporter provides as much entertainment as the sport being covered. Personality and entertainment value play a much stronger role in sports than in news. In one market, for example, a popular feature of the top-rated sports reporter is a weekly recap of all the blunders that occurred in various sporting events, complete with musical background.

Such an approach obviously could not be used with news. Neither would the remark of a reporter that he had egg on his face (after an inaccurate prediction) be followed by the cracking of an egg on the reporter's forehead, as once happened in sports. Although this example is extreme, be aware that sports does allow for more interjection of personality and entertainment values, and therefore places an additional demand on the sports announcer.

Sports certainly is not all fun and games. As recent drug scandals show, sports have a far-too-serious side. So while an element of entertainment is part of the sports broadcaster's repertoire, he or she must also function as a reporter. Sensitive information must be dealt with responsibly. Also, anyone who has ever mixed up a score on the air knows that there is no room for error in the recital of who beat whom. Fans find such mistakes virtually unforgivable.

Typically, many games are still running or just ending as the TV sportscaster is about to go on the air. Network sports feeds, showing highlights of games and events, are fed at 5:10 P.M., 7:35 P.M., and 11:10 P.M. EST. In many cases this means that some segments for the 11 o'clock news are recorded and put on air by a production person. The sports anchor, who has not seen the material, knows, from a printed rundown fed in advance, only that there is a 50-second piece on the Boston–New York game.

To further complicate matters, the sports anchor must keep track of games in progress. Some stations have courtesy arrangements with broadcast and cable networks that televise certain teams. These arrangements allow sportscasters to air clips of the contests but in many cases *after each game has ended.* Imagine the rush to get a clip on the air when a home run in the bottom of the ninth inning breaks a tie game at 11:15!

The sports reporter, who often is an alternate anchor on weekends, helps out with production in stations large enough to support more than one sports person and also files local packages to be integrated into the sports segment.

Sports anchoring, then, requires the on-air enthusiasm of a die-hard sports fan combined with the pressure-handling ability of a wire service news editor. Sports reporting calls for the ability to assemble a news package and an eye and ear for stories that will interest fans. Some suggestions for effective anchoring and reporting are given in Box 9.1.

A facile play-by-play announcer can generally find abundant work in local markets, although this work will generally be on a part-time basis. In small and medium markets, newspeople, staff announcers, and even sales personnel add to their income by broadcasting local sports. This is a difficult assignment, however, requiring good on-air skills and an extensive knowledge of the sport.

One important aspect of play-by-play is the differing nature of individual events. Think of the different approaches and knowledge bases required for

▼

The sports reporter provides as much entertainment as the sport being covered.

Issues in Sports Coverage

Sports Anchor Work

Sports Play-by-Play

B O X 9 . 1

Tips for Sports Anchors and Reporters

1. *Stress stories that interest your local audience.* Remember, taking a new job and moving to a new area involves learning what makes headlines in local sports. In parts of Texas, for example, high school football often creates more excitement than the pro sport. Other cities in various parts of the nation have a strong liking for greyhound racing, candlepin bowling, or lacrosse.

2. *Prewrite as much as possible, and overplan for the sports segment.* Because of the last-minute nature of TV sports, expected segments do not always materialize and you must have material to fill.

3. *Write your copy as close to the visual as possible.* Unlike news, where it is considered undesirable to point copy to the video, in sports you must do so. Copy has to coordinate

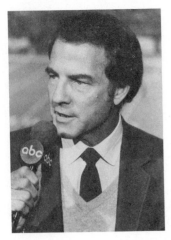

Figure 9.1. Frank Gifford is a veteran sports commentator whose articulate, polished style has attracted a wide following among football fans. (Copyright American Broadcasting Companies, Inc.)

hockey and for football. To illustrate, we contrast the attributes of play-by-play announcers for baseball, football, basketball, hockey, and boxing.

Baseball games have many periods of little or no activity, so the play-by-play person must be able to fill with talk of interest to the audience. This ability will become particularly apparent in rain-delay situations.

Baseball play-by-play also entails the ability to follow action quite a distance away. Good vision, or the ability to compensate for poor vision by an in-depth knowledge of the game, is essential.

Football is a technically oriented game, and the play-by-play announcer has to be up on the plays and able to follow them. In-depth analysis is often provided by a color commentator. There are many statistics to be followed, including downs, yardage on previous carries, and so on.

Things happen fast in football, and it takes great skill on the part of the announcer to convey the action accurately and add an element of excitement. Frank Gifford (Figure 9.1), a former running back, combines his knowledge of the game with fine verbal skills to do a superb job. Listening carefully to Gifford is one of the best exercises an aspiring play-by-play announcer can undertake.

Basketball, from the announcer's standpoint, can almost become nightmarish in its complexity. Listeners want the announcer to keep track of how many fouls a player has, how many rebounds, and how many points each

precisely with what appears on the screen at any given moment: "and he whacked this pitch . . ."

4. *Pay particular attention to variety in reading scores.* In radio especially, the sportscaster must invent many verbs to take the place of "defeated" or "beat." A long list of scores requires some imagination. A phrase such as "Boston overpowered New York, 9–3," adds color. Other useful verbs include, "squeaked past," "downed," and "hammered." Avoid stretching too far, though. "Obliterated" and "decimated" get a bit tedious. In fact, some local sportscasters can become rather comic in their attempts to hype the delivery of scores. If you do not feel comfortable using this type of device, it is better to avoid it. If possible, write the verbs right into the copy.

5. *Always keep your energy level high.* Speak with intensity. Enjoy what you are doing, and let it show.

6. *Remember that the personalities of the athletes are as important as the outcome of the games.* Listeners and viewers are interested in personal items relating to the players, too.

player has scored in the game so far. There are fewer players than in football, however, and the announcer usually is stationed in a press box close to the action or on the floor next to the playing area.

Hockey is challenging. By the time the announcer has told the audience who is in possession of the puck, the game has moved to the other end of the rink. Hockey play-by-play announcers must be able to paint vivid word pictures on radio and keep up with the action on television.

Boxing entails the ability to do speculation and analysis. Since almost all boxing broadcast today is televised, the play-by-play commentator must be able to do much more than relay reports of who hit whom. The broadcaster must analyze the bout to determine why one fighter's style makes him vulnerable to the punches of the other or whether one fighter is being tired by body blows. It is also necessary to speculate, for example, whether a contestant's jabs are piling up points with the judges.

There are occasional opportunities to cover sports such as golf, where an announcer must constantly fill time, and track and field, where the play-by-play person must keep close track of the shifting positions of runners.

Although the requirements for individual sports differ widely, some of the basic skills and procedures remain constant. In terms of game coverage procedures, none is more important than preparation. Rosters must be obtained, along with as much factual information about the team and its

players as possible. In most colleges and all professional organizations, sports information directors prepare kits of information especially for the play-by-play and color commentators. Pay close attention to special rules, such as a three-knockdown rule in boxing or a sudden-death playoff in football. Learn the positions of the players, and check for hard-to-pronounce names.

Circumstances will dictate how much help you will have in preparation and actual coverage of the game. In football, spotters may be provided. For baseball, you will want access to the official scorer, who can inform you of rulings. Baseball fans have a particular interest in rulings, wanting to know, for example, if the player will be credited with an RBI (run batted in) or if the run resulted from a fielder's error.

John Madden, whose play-by-play announcing of NFL football broadcasts for CBS has made him one of the most popular personalities in sports broadcasting, spends many hours preparing for every broadcast. As former coach of the Oakland Raiders, Madden brings an in-depth knowledge of the game to his telecasts, but colleagues say he still spends hours talking and reading, trying to stay current.[1]

The popular combination of play-by-play announcer and color commentator allows for a logical division of duties and enables each sportscaster to concentrate more fully on the game. Although in many cases the color and play-by-play roles are integrated into one announcer's duties, when a separate color announcer is employed he or she is expected to provide highly informative insights into the sport, including

1. Details the casual fan might miss.
2. Anecdotes about the game and the players.
3. A personalized "feel" for what it is like to play the game—for example, how it feels to be checked into the boards or caught for a safety in the end zone.

The chemistry that makes certain announcing teams successful is an elusive concept. Among the more easily spelled out play-by-play and color principles are the following:

1. Let yourself become excited by the sport. Many former players are successful sportscasters because they love the game and are thrilled by a fine play, not merely because of their technical knowledge.
 Phil Rizzuto's famous exclamation, "HOLY COW!" is more than just a trademark. He loves baseball and is not afraid to show it.
2. Don't repeat yourself. Listeners do not need to be told "It's a beautiful day here in Cleveland" more than once or twice. Reacting to the pressure

[1]"The Sportscasters," by Charles Siebert, *The New York Times Magazine,* August 19, 1990, p. 37.

of the need to fill time, announcers often become repetitious, and the only cure is awareness of this pitfall and an adequate supply of material to fill time.

However, audience members do appreciate frequent repetition of the score. When in doubt and desperate for something to say, the score is as good as anything. Time can also be filled by reading scores of other games.

3. When in doubt about a play, wait until you know for sure to make the call. Earlier we recommended analyzing Frank Gifford's style, and if you listen carefully one of this broadcaster's strengths will become apparent. Gifford has the ability to maintain a natural rhythm in calling a play while waiting to see *for sure* who has the ball or who made the tackle. In other words, he gracefully avoids giving the player's name until he is certain. Gifford very seldom has to correct himself after having called the wrong player.

Identifying football players can become difficult, especially on a muddy field when uniform numbers become obscured. However, a delay in calling a play sounds much better than having to backtrack and figure out who really did take the handoff.

4. When using statistics, communicate with those numbers rather than repeating them. The audience may or may not be interested to learn that the man at the plate is a .310 hitter. To be compelling, the announcer might say, "The pitcher is left-handed and the batter is a .400 hitter against lefties. He's also known as a good man in the clutch, and this is really one of the clutch situations of the season, with the Sox down by one run in the bottom of the ninth with a runner on second . . ."

5. Never let up on energy or enthusiasm during the commercials. Play-by-play announcers are often called on to do commercials and should keep in mind that those commercials help pay their salaries.

6. Be sure to keep up with rule changes and ground rules. Getting acquainted with an official who can fill you in on changes is an excellent idea. Similarly, learn officials' hand signals.

7. It is better to give the score and time remaining too often than not often enough.

8. Practice and develop your own methods of quickly spotting players and plays. Many knowledgeable sportscasters maintain that a sportscaster who lags behind the public address announcer is not doing his or her job.

9. Pronunciation of names is often a problem. In college and high school games, one of the best ways to check on pronunciation is to ask the cheerleaders, who often know the athletes personally. Use this option if you don't have time to track down coaches, players, or sports information people.

10. In play-by-play, avoid using numbers to designate people. Each player has a name, and it should be used.

223

Weather

Today's weather forecast has evolved into a high-tech, graphically stunning presentation. In addition, weather forecasters are called on to make highly localized predictions that will have an impact on hundreds or thousands of audience members in a particular region.

The Weathercaster's Role

The modern weather reporter is often both a meteorologist and an entertainer. The American Meteorological Society has established qualifications for meteorologists, and this professional organization issues a seal that is displayed on approved weather forecasters' programs.

For all practical purposes, a meteorologist entering today's world of broadcasting needs a four-year degree in that field. Although it is perfectly legal to be employed as a weather forecaster without a degree, meteorologist John Flanders of WPRI-TV in Providence, Rhode Island (Figure 9.2), notes that the competition for jobs is stiff and a degree in meteorology may be a decided advantage.

▼

Competition for jobs is stiff and a degree in meteorology may be a decided advantage.

Why is it advantageous for a local weathercaster to be a trained meteorologist? Advancing technology has made weather forecasting a more exact science, and the process of giving a detailed weather forecast now involves much more than ripping a paragraph or two off the wire machine and drawing warm and cold fronts on a map.

Listeners and viewers now expect more specific and more localized forecasts, and a forecaster with training is better able to predict such events as the likely path of a snowfall or a thunderstorm. Remember, a small variation in the path of a thunderstorm can make an enormous difference to the city that is either hit or missed.

Figure 9.2. John Flanders, weathercaster for WPRI-TV in Providence, Rhode Island.

Note, too, that all forecasts are not the same. In periods of good weather, forecasts are similar. It is bad weather that introduces the factors subject to analysis and interpretation. The modern meteorologist-entertainer provides this type of information, and does so in a way that holds the interest of the audience.

There has been gradual change over the years in the image of the TV weathercaster. At one time it was common for the weather segment to be treated as comic relief for the local news block. The weathercaster was often cast in the role of buffoon. He or she always got the forecast wrong, but went on day after day oblivious to this incredible ineptitude. The weathercaster stood in front of a crude map on which he or she drew crude lines with a marker. If the weather person was a woman, she was often chosen for her good looks and treated as a bubblehead.

Most local weather people today are cast in an image

that is the complete opposite of the incompetent buffoon or the insulting image of empty-headed blonde. Weathercasting in general is given the status of a scientific endeavor that can affect the safety and well-being of viewers as well as their lifestyles. The weather person, as a result, is treated with the respect appropriate for a knowledgeable expert in a complex field.

Computerized Weather Graphic Systems

The image of competence in weather people is enhanced by the high-tech surroundings that now make up the typical weather segment. Sophisticated computerized graphic systems like the one in Figure 9.3 make complex weather patterns and principles easy to understand for even the most unscientific of viewers.

Accu-Weather's Joel Myers, whose Pennsylvania-based weather service is used by some two hundred television stations in the United States and Canada, says that the sophisticated weather graphics came into their own during the 1980s. It was a time of "dramatic transition from hand-drawn weather maps and magnetic boards to sophisticated, attractive graphics prepared on microcomputer graphic systems," says Myers.

Among the graphics offered by Accu-Weather are regional maps, temperature band and thunderstorm graphics, and jet stream graphics that show movement. A staff of 100 meteorologists and artists create the graphics and are available to speak with on-air talent, according to Myers.

Stations such as KHAS-TV in Hastings, Nebraska, use an Accu-Weather system called Amiga Weather Graphics. The system, which can be purchased or leased, allows the on-air weather person to call up any of approximately 1,200 graphics created by meteorologists and artists at Accu-Weather and supplied each day by telephone line or satellite.[2] Another system, called "Liveline 5," from ColorGraphics, allows stations to show animated graphics. The map shows moving symbols. Lightning flashes and tornadoes spin.

The NOAA Weather Wire is another service available to weather forecasters. It is distributed by CONTEL and provides data that originate with the National Weather Service. Users of

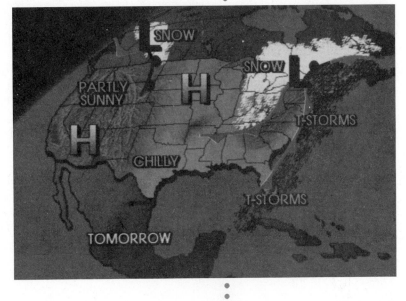

Figure 9.3. This surface map by Accu-Weather is one of several varieties of weather graphics available to its clients. Maps are updated throughout the day and delivered to clients via phone line or satellite. (Photo provided courtesy of Accu-Weather, Inc.)

[2] Much of the information in this section is taken from an article called "What's New in Weather Graphics," by Rob Puglisi, *Communicator*, October 1988, pp. 13–18.

this service receive information on a 30-inch diameter receive-only satellite antenna. It is used by both radio and television stations to get the latest Weather Service data quickly so that listeners and viewers can be apprised regularly of changes in weather conditions in the listening and viewing area. The user receives and pays for only those reports requested. Once data are received, they can be converted to various forms that help in developing detailed forecasts. Television stations use the service to create the severe weather advisories that are broadcast using a crawl across the television screen while regular programming continues.

Incoming data can be stored and manipulated to show movement of weather systems and give visual representations of weather phenomena such as lightning. Available computer software allows meteorologists to develop customized weather information from raw data without having to be an expert in computer operation.

In television, the extensive use of weather graphics means that weather people often work closely with station art departments to create tailor-made computer graphics that combine the capabilities of more than one system. Computer "paint" systems combine with the general weather graphic systems to allow for specialized maps that focus on specific weather features of particular interest on a given day.

For the aspiring weather person, all this technology means that to prepare for a job in TV weather, you need enough computer literacy to let you learn how to operate computerized graphic systems that use the latest innovations in software. Systems vary widely from station to station and they change continually. Your best bet is to become generally knowledgeable with computer graphics, so you'll be able to apply your skills to whatever system you may encounter.

In small-market operations, it is often the weather person alone who prepares the graphics that form the centerpiece of weather segments. In some markets there may be assistance from art departments, but the weather person still does much of the hands-on work of preparing the maps. Most veteran weather reporters say that the best way to get this experience is by interning at a local TV station. Although difficult to come by, weather internships will give you a substantial advantage in learning what's currently available in weather graphics and how they can be used to create an authoritative on-air weather segment.

In radio, weather is seldom a specialty for on-air talent, although some stations use reports by area meteorologists to lend authority to forecasts and to tailor them specifically to the listening area. For most stations, weather information is supplied by the same wire service that provides news and feature material to the station. The sheer volume of weather information on the AP radio wire service seems out of proportion to its presence on the air. Figure 9.4, for example, shows the kinds of data supplied by the AP wire. The

reason for the high volume of weather information, of course, is the fact that stations have little need for old weather information. Timely forecasts are essential, as are accurate data on current conditions. All wire service clients receive forecasts for a number of regions. They then select the data that fit their particular needs at the time.

Some radio stations subscribe to satellite-delivered data systems like those offered by CONTEL. Others use radar tracking systems to track the movement of weather systems.

Figure 9.4. Weather information from the Associated Press wire.

```
AP-PA-HTEMPS    V0000 07-30 0217

AP-PA-HTEMPS<

12PM EST PENNSYLVANIA THIS HOUR
```

TOWN	WEATHER	TEMP	WIND		FLSLK	VIS	HUM	BRMTR	HI	LOW	PCPN
ERIE	HAZE	83	S	14	92	6	57%	29.88F	83	69	
FRANKLIN	HIGH CLDS	79	S	12	87	7	64%	29.96F			
PITTSBURG INTL	HIGH CLDS	83	S	9	96	7	65%	29.95F	83	66	
PITTSBURG ALGY	HIGH CLDS	79	S	6	90	7	64%	29.95F	79	67	
LATROBE	PTLY CLDY	84	SW	6		8		30.00F	84	63	
DU BOIS	MSTLY CDY	78	S	7	87	10	64%	30.00F	78	62	
BRADFORD	MSTLY CDY	78	S	12	84	10	60%	30.01F	78	60	
ALTOONA	HIGH CLDS	77	SW	5	88	10	69%	30.00S	78	63	
WILLIAMSPORT	MSTLY CLDY	81	SE	3	94	15	65%	29.98F	81	67	
HARRISBURG	HAZE	79	NE	6	91	6	69%	29.97F	79	69	
MIDDLETOWN	MSTLY CDY	78	E	6	92	7	76%	29.96F	79	70	
WLKS BRE SCRTN	PTLY CLDY	81	N	5	90	12	54%	29.98F	81	64	
ALLENTOWN	HAZE	80	S	6	90	5	60%	29.98F	80	69	
READING	MSTLY CDY	82	SE	7	99	7	77%	29.95F	82	74	
WILLOW GROVE	HAZE	81	E	6	91	6	58%	30.01S	81	68	
PHILDLPHIA INT	MSTLY CDY	80	E	8	90	7	62%	29.98S	80	69	
PHILDLPHIA NE	MSTLY CDY	81	NE	9	91	7	60%	29.98S	81	68	

```
AP-NP-07-30-90   1204EDT<+
```

Figure 9.5. A detail of a TV weathercaster's weather map, which is fed to the station by special printing machines.

The use of radar systems in radio allows stations to track weather systems over time and alert listeners to changes in conditions in specific localities. There are dial-up systems for radio stations that supply weather data over phone lines. And there are computerized systems such as Weather Check 2 a product of WeatherBank, a Utah-based service, that supplies stations with National Weather Service data fed into a computer to produce forecasts, road conditions, and wind conditions.

Weather, then, has become a broadcast specialty that requires some very specific skills on the part of on-air talent. In television and to an extent in radio, those reporting weather need more than an ability to perform well on the air. They also need a good basic knowledge of meteorology, and the computer skills necessary to effectively use the sophisticated computerized graphic and information systems that have become major components of modern broadcast weather reporting.

Meteorologists working exclusively in radio often are employed by one of a number of forecasting firms that provide local feeds to radio stations.

A Typical Workday for a Weathercaster

In television, the weathercaster for the 6 and 11 o'clock news might arrive at the station at 3:30 and begin to extract weather information from a computerized data base. Several different weather maps are fed via special printing machines, and the information on those maps must be studied and digested. Such information includes patterns of upper air movement, temperature, and wind direction. The weathercaster then begins to prepare his or her maps. In modern stations, the maps are computer generated, like the one pictured in Figure 9.5.

Preparation for the Show

For some weathercasts, as many as 15 or 20 different maps will be prepared. Data are updated constantly and stored on computer disk for recall during airing of the weather. Before the weather segment airs, the forecaster will have prepared the maps and determined their order. He or she does a quick rehearsal of the patter that accompanies each graphic.

Graphic	Audio
Large satellite projection	A nice day in the Northeast today, with only a bit of light cloud cover from Pennsylvania . . .
Closer projection	The only trouble spot is this warm front, which will move . . .
Fronts illustrated on colored map	. . . into our area by tomorrow morning.

Good weathercasting requires poise before the camera, a confident delivery, ability to ad-lib, and careful attention to posture and gestures. Many beginning weathercasters have a tendency to speak too quickly. Slowing down and delivering the forecast with greater interest and intensity can almost always improve the effort.

Remember that during most weather presentations you'll be standing in front of a blank wall. Although actual physical maps are sometimes used in weather forecasting, computer images electronically projected behind the announcer are becoming the norm.

The first rule is to keep a close eye on the camera that shows the map (and you) on the prompting device. Ask the camera operator to move as close to you as he or she can in order for you to clearly perceive the relationship of you to the map which is electronically keyed in behind you.

Second, don't be too quick to point to a particular area on the map. Pointing in an imaginary dimension (at a blank wall while you are coordinating your hand motion with the image you see on the prompter) takes practice. While you're picking up the skill, try to confine your gestures to general regions—or else you may wind up talking about tornadoes in Kansas when you are pointing to Illinois.

Weather Emergencies

In times of potentially unpleasant or violent weather, the weather forecaster's job becomes pressured. Weather reporting is particularly intense during the thunderstorm season in midsummer and in periods of heavy winter snowfall. Probably the most white-knuckled of all forecasting is done in the Midwest, where tornadoes are a major threat, or along the East Coast and Gulf Coast during hurricane season. Weather forecasters may be called on to do extensive explanations of weather phenomena and must be prepared to respond to audience questions during weather emergencies.

If you plan a career in weather, be aware that there is more involved than designing maps and developing an on-air style. In times of weather emergency, you will have the heaviest responsibilities in the news report.

Narration

The art and science of reading audio to juxtapose with video is rapidly developing into a distinct specialty. One reason for this is an increase in the use by firms and organizations of videotapes and slide–tape presentations.

229

Documentaries also frequently use an off-camera narrator. Some narration is done on camera, but the vast majority is done voice over video. However, since the term *voice-over* has acquired a separate meaning in relation to commercials and news, the word *narration* more accurately describes the process of reading a script off the camera.

The Purpose of a Narration

A narration must reinforce the program, providing an ebb and flow and matching with the video image on the screen. The voice must communicate effectively without being intrusive. Box 9.2 highlights some effective narration techniques.

Synchronizing Narration with Video or Slides

Narration can be recorded with the performer looking at a monitor, or simply taped and edited in later. Many producers favor narration working to picture because it saves them additional work in the editing process. A good share of announcers, though, favor recording the narration straight, without the distraction of a monitor. Some narrators will choose to work one way or the other, depending on the situation. Will Lyman (Figure 9.6), narrator of the PBS series *Frontline* and *Vietnam: A Television History*, notes that his technique varies. "*Frontline* is occasionally done without seeing the video. But for the Vietnam series, I requested to work to picture so I would know what kind of scene I was speaking over. I didn't want to blast through some shocking picture."

Hosting Special Programming

Many of the more interesting assignments in broadcast work, such as acting as host of a children's show, are for the most part extinct on the local level. Others, including being host of a radio call-in program, are increasing. The role of host in any presentation, though, can be an interesting one. Many of the specialty assignments described in this chapter are good part-time options for a broadcaster. Play-by-play, for instance, is an interesting way to supplement your income in a small market. Rare assignments such as game shows or movie programs will by their very nature be part time.

If you have an opportunity to try a specialty assignment, take the job if at all possible and if the job will not sidetrack you from your ultimate career goal. Exposure to the demands of these jobs will do nothing but help you improve as an all-around broadcast professional.

Master of Ceremonies

An infrequent but challenging assignment involves MCing such events as telethons or on-air fund-raisers. Here, the performer must have the ability to ad-lib virtually indefinitely. Also, he or she has to keep track of various and sundry schedules and activities.

The MC job, as those who have tried it know, entails a huge amount of physical and mental strain. Humor, intelligence, and good interviewing skills are essential. The primary responsibility is the ability to inject excitement into what may be intrinsically dull.

As discussed earlier, the role of talk show host is demanding. It primarily demands interviewing skills, but in addition requires good to excellent ad-libbing ability and strong projection of a personality.

Because radio talk is an entertainment medium, a host's career will be short-lived if he or she cannot captivate an audience. Another useful attribute is a sense of humor, because callers can be rude or abusive. Helpful, too, is a good sense of when the talk is bordering on the slanderous.

A broad base of knowledge is essential to the talk show host's job. You simply cannot do without it.

Radio Talk Show Host

B O X 9 . 2

Effective Narration Techniques

Industrial narrations, news narrations, and documentary work require some specialized skills. The vocal approach to a narration is not the same as for commercials or news. Among the techniques useful for this task are the following:

1. Strive to develop an open easiness, a personality behind the voice that communicates but does not dominate.

2. If working to picture, position the screen and your script where both can be seen easily, so that you don't have to strain and adopt an unnatural posture. The problem of awkward posture, with its negative effects on voice and delivery, is common in narration situations but not often recognized.

3. Pay close attention to the projection of mood, a major requirement in narration. Project what you feel is the appropriate mood, along with the appropriate measure of personal involvement with the copy.

4. Avoid a hard-sell delivery. Narration, for the most part, requires more subtlety than other assignments.

5. If long segments must be delivered strictly to time, use the mark-ups shown in Chapter 3 to indicate time cues. The right reading, for example, might have the second paragraph begin 2.5 seconds into the manufacturing scene. A note of this on your copy can indicate whether an adjustment is in order to hit the next scene properly.

Figure 9.6. Will Lyman, narrator of the PBS Frontline *series and* Vietnam: A Television History.

Movie Host

The "sprocket jockey" still flourishes in some markets. The setting is usually a simulated screening room, but some presentations involve the host in costume, particularly the shows that feature horror movies.

Very few if any announcers make their entire living from hosting movie presentations, but it is an interesting assignment. The prime requirement is the ability to act relaxed and natural in an unnatural situation. Knowledge is important, too. Movie buffs can be more fanatical about trivia than even sports fans.

Your job, in essence, is to promote the film and make viewers want to watch it. Enthusiasm and a positive approach are the keys.

Children's Show Host

It is probably impossible to manufacture an on-screen liking for children if you prefer to avoid them in real life. Hosting a children's show involves understanding youngsters and being able to talk with them, not at them or down to them. Many elementary school teachers have become successful hosts in this sort of programming.

On the local level, children's shows are largely a thing of the past. A well-intentioned FCC regulation prohibiting the show host from delivering commercials or introducing the product has resulted in a decline of local advertisers, which has all but eliminated this important source of funding.

Game Show Host

Although rare, local game shows still exist, often in the form of quiz programs that pit one school against another. On the national level, only a handful of personalities make a living at game shows.

The requirements for hosting programming of this type include the ability to handle figures easily, since almost any game requires tallying points. You'll have to think quickly if something goes wrong, and above all you must be able to instill excitement and enthusiasm in each contestant's performance.

Health and Medicine Reporting

An increasing number of local television stations employ on-air talent who cover, either as their entire beat or as a part of their job, issues related to health. In some areas, especially large markets, those reporters are often physicians. General-assignment reporters, though, can and do take on these assignments.

Often the health and medicine report is mated with material fed from various satellite news services. The national reporter, who may be a physician, will feed material that can be localized and integrated with material gathered locally.

Although physicians and other health professionals have a natural "in" for such coverage, it's probably safe to say that any reporter can cover the medical beat as long as he or she knows how to talk with medical professionals, gather information, and relate it to viewers' and listeners' everyday lives. In fact, an experienced journalist has an advantage over the health professional in some

respects, in that the journalist generally has few preconceived notions or biases and is likely to have a keen insight into what topics interest the average citizen.

Consumer Reporting

Just as physicians have worked their way onto the air as health reporters, many attorneys find themselves employed as consumer reporters. But being a lawyer is certainly not a requirement for this job; tenacity is. You generally cover stories of long duration; investigating a complaint may take weeks or months of waiting for responses by mail or telephone.

The role of the consumer reporter is sometimes broadened to that of something like a free-wheeling social critic. For example, a very successful series that ran in the New York area recently dealt with drivers' increasing propensity not to yield the right of way to ambulances and fire trucks. This is an example of "consumer" reporting, because taxpayers are paying for services slowed down by inconsiderate drivers, and it also touches on some deep and important social issues.

Summary

Specialty assignments in broadcasting can be challenging. Although they call for special skills, the basic requirements of broadcast communication still form the underpinning of the announcer's abilities. To specialize successfully, one often needs a specific academic and/or practical background.

Sports requires a great deal of knowledge and a willingness on the part of the announcer to learn about sports new to him or her. Many sportscasters make their reputations as "personalities," but there are serious issues in sports coverage, and journalistic skills are necessary.

Sports anchoring is stressful because it involves a great deal of last-minute checking before going on the air. Sports anchors must appeal to local audience interests, and they must be energetic and versatile in their on-air approach. Play-by-play announcers must have an in-depth knowledge of the sport. Each sport presents its own particular set of problems. Football, for example, is hard to follow because it involves so many players, rules, and technically oriented plays.

Play-by-play announcers must be excited by the games they cover. They must avoid repetition, and they must not call plays before they have verified the information. Also, announcers must do a good job on commercials.

Weather reporters are often certified meteorologists. They work with computerized data bases and, for television, must be able to create attractive graphic presentations. In addition, the weather anchor must present the information succinctly and with poise. The job of a weather forecaster becomes very tense in times of weather emergency.

Narration is a specialized skill. Good narrators do not intrude on program content. Narration must be relatively low key, and the projection of the proper mood is imperative.

Broadcasters occasionally have the opportunity to act as hosts of special

types of programming. Except for radio talk show hosts, most of these assignments, such as telethon MC and host of movie presentations or children's shows, are not full-time jobs but offer supplemental income and interesting opportunities to expand skills.

E x e r c i s e s

1. Use a portable cassette machine to record a play-by-play segment for a televised basketball, football, baseball, or hockey game. Do your preparation by compiling information from prewrites in the newspaper. If there is not enough information in the local paper, pick up a relevant copy of a sporting magazine. With the TV audio down, of course, record your own version of the play-by-play, and review the tape.

2. Record the narration from the script in the drill section, Appendix B, of this book. You can get a fair idea of the video components from the shot descriptions immediately above the copy to be read by the narrator. Pay particular attention to mood and pace.

3. Watch three weather forecasters on the three major network affiliates in your area. Take comprehensive notes on program elements. In a few paragraphs, compare and contrast the weathercasters in terms of the following:

a. Level of interest they show

b. Level of interest they instill in you

c. Energy conveyed

d. Credibility

e. Use of graphics

Combining commercials and acting in one chapter may seem odd at first glance. Acting is usually considered to be an artistic endeavor. And critics of broadcasting often give us the impression that commercials could never be an art form.

In fact, however, broadcast commercials are done with the highest production standards, using the best talent available. The people you see and hear in broadcast commercials have usually had years of classical training and considerable experience in drama. The competition is fierce, the rewards great, and the work exacting.

This chapter discusses the basics of commercials and the performer's role in them. The techniques of acting are presented and discussed, with a focus on how they apply to radio and television commercials. The chapter closes with an exploration of freelance commercial roles.

In the past 20 years, broadcast advertising has come into its own as a separate discipline. Production capabilities are part of the reason. In the early days of television, for example, a standard commercial might involve nothing more than one camera pointing at an announcer pouring a glass of beer and giving his pitch. Only occasionally did any sort of drama come into play.

Modern commercials, though, run the gamut from 30-second mini-dramas, to collages of action scenes, to the mundane hidden-camera testimonial.

10
Commercials and Acting

Basics of Commercial Announcing

Radio commercials have evolved, too. In the early days of radio, many advertisements featured grand-sounding speeches describing the high quality of a particular product. Today the emphasis has shifted to shorter phrases that usually do not so much describe the attributes of the product as portray its benefits (how it will make you feel better, look better, etc.). Radio advertising now also makes much greater use of the dramatic scene, the mini-drama.

But the biggest difference in modern radio advertising is the focus on communicating with a *particular* audience. Commercial producers often fashion several versions of an ad: one for hit radio, one for country, one for easy listening, and one for adult contemporary formats. Hitting a specific target audience is what modern radio is all about. A really good performer can gear his or her reading to a specific audience.

Types of Commercials

Commercials come in several shapes and sizes, and a familiarity with them is helpful to a performer. Although there is some overlap, our breakdown is in terms of radio and television.

Radio Commercials Most ads fall into the categories of a *straight reading* of a script, a *donut,* an *ad-lib,* an *acted scene, a man-in-the-street,* or a heavily produced *montage.* Many spots contain elements from several of these categories. The following descriptions include a summary of the particular demands the respective categories place on a performer.

STRAIGHT READING: All you have to work with are the words in the copy. A straight reading demands careful attention to variations of pitch and pace. The performer must also be aware of the need for proper emphasis on words. Vocal quality is important, as is a good level of energy in the voice. The straight reading sometimes has music underneath the voice, called a music "bed."

DONUT: Usually furnished by an advertising agency, a donut has copy already recorded on the beginning and end. The commercial is called a donut because it has a "hole" in the middle, which a local performer is called on to fill. For example, a typical donut may open with 10 seconds of a jingle for shock absorbers, then 10 seconds of musical bed, followed by another 10 seconds of jingle and copy. The 10 seconds of musical bed in the middle—the hole—allows the local franchiser of the shock absorbers to give his (or her) message. From the performer's standpoint, a donut requires particular attention to timing; the copy must be read in the time allotted. Also, the performer needs to match the style projected by the prerecorded elements. Reading over a bed requires timing and attention to the flow of the music.

AD-LIB: "Ad-lib" means improvised, done extemporaneously. An ad-lib commercial is usually done from a fact sheet, like the one on page 250. Sometimes, skilled broadcast performers can construct a convincing ad-lib by playing

around with the wording of a set script. Ad-lib spots are quite popular at radio stations that employ one particularly good, well-known announcer. The ad-lib commercial is usually done live, although sometimes it is recorded for later airplay. Some buyers of airtime are fond of the ad-lib commercial because they feel that their product or service will benefit from identification with the air personality. In fact, the ad-lib commercial gives the appearance of a personal endorsement of the product.

The ad-lib is probably the most difficult type of radio commercial to do well. Rather than simply reading a phrase, you have to think of that phrase at the exact second you need it and deliver that line convincingly. The only way to train for this skill is constant practice. Bill St. James, one of the top free-lance announcers in New York, recalls that he developed ad-lib ability by inventing descriptive copy for magazine photos. This is a good practice, and one of the exercises in this chapter focuses on it.

Incidentally, an announcer who can ad-lib convincingly has an eye and ear for detail, which also is developed only by practice. Keep alert for the inspiration you can draw from the sleek lines of a car, or the condensation on a bottle of beer. Good ad-lib skills are extremely valuable to an air personality.

ACTED SCENE: Normally, two voices are used in this kind of commercial, often a male and female. Because radio spots are short and lack visual cues, every effort is made to avoid distraction, hence the variation between voices and the limit on number.

The dialogue is usually informal, uncomplicated, and often humorous. At best it is the beautifully timed exchanges of Bob and Ray or Dick and Bert. At worst, an acted scene is a local "husband and wife" enactment, something to the effect of "My, dear, have you seen the prices at . . ."

The acted scene demands a skill often overlooked in typical broadcast training: the ability to assume a character and sound natural while doing it. Remember, the husband who complains about scratchy collars is not supposed to sound like Don Pardo announcing a game show contestant, and the wife is not convincing if she delivers a line about spray starch like Dame Judith Anderson playing Lady Macbeth.

Acting skills are essential for performers who wish to pursue commercial work, and those skills are addressed in a later section of this chapter.

MAN-IN-THE-STREET: The man (or woman) interviewed about a product or caught unaware in the act of choosing the sponsor's detergent is not always a professional performer, although professionals do appear in such ads. It is not unknown for aspiring actors and actresses to write companies praising a product in hopes of securing a man-in-the-street role. When a professional performer does assume such a role, a natural and unaffected manner is an absolute must.

HEAVILY PRODUCED MONTAGE: In the fast-moving genre of hit radio, some commercials contain many production elements and brief snippets of copy. This

category can entail a combination of almost all the others: a sound effect, a quick dramatic scene, several pieces of music, and so forth.

This type of commercial requires the ability to put a great deal of meaning and excitement into a few words. Since you do not have time to develop thoughts or characterizations, those words must be precisely right. "Stock car racing at the fairground—the time of your life!" is an example. That one line has to convey all the excitement and allure of the event.

During production of these montage commercials, a good sense of timing is also required, since a phrase might have to fit precisely between two sound effects or other production elements.

Television Commercials Many of the structures common in radio are adapted to television, although the TV ads have their own particular set of nuances. The basic categories of TV commercials are *mini-dramas, spokesperson presentations, pitch presentations,* and *voice-overs.*

MINI-DRAMA: In TV, this kind of commercial is usually more than just an acted scene. It is a full-range 30- or 60-second drama that presents characters, conflict, and resolution at breakneck speed. When done for national agencies, these commercials are at the very top level of production lavishness and can be incredibly expensive. They involve the top competitive actors and actresses in the field, often chosen because they have the right smile or an interesting, arresting face.

Although some of these mini-dramas appear downright hokey, keep in mind that they generally do the job they're constructed to do. Who can forget Madge, the manicurist, or the crises once provoked by the infamous specter of ring around the collar.

The "ring around the collar" scenario is a good example of the compression of all the elements of drama into a short space. The wife's peace was shattered by the embarrassment of being discovered—on a cruise ship, perhaps—with a husband suffering from "those dirty rings." Hence, characterization and conflict. The wife squirmed in the agony of indecision, whereupon there was an interruption and the proper detergent was introduced. In the happy resolution, the rings disappeared and husband and wife resumed their trouble-free life. Effective performance in a mini-drama requires acting skills and a high level of energy.

SPOKESPERSON PRESENTATION: This type of commercial often involves a celebrity using his or her actual identity, or it can be an *implied identity,* using someone who is recognizable as a character, but not necessarily himself. John Houseman, for example, once did commercials in the thinly cloaked persona of Professor Kingsfield from the movie and television series *Paper Chase.*

A spokesperson does not have to be a celebrity, but he or she must have some sort of implied identity. In other words, an unknown but distinguished-looking performer can give a very convincing spokesperson presentation for

a product or service. In this case, it is the performer's implied identity as a distinguished and intelligent person, rather than celebrity status, that lends authority to the commercial.

What does this require of a performer? Basically, an authoritative presence and an honest, convincing delivery.

PITCH PRESENTATION: This harkens back to the old days of television, when the "pitchman" would deliver a sales message about a product. The difference between a pitchman and a spokesperson is that the former is identified neither as a celebrity nor as a particular kind of individual. The product is of prime importance, the pitchman purely a conduit of information.

For example, consider a well-known celebrity who sells life insurance and dog food (not at the same time, of course). When he sells life insurance, he acts as a trusted spokesperson, implying that he, as an intelligent and trustworthy person, endorses the insurance. When he gives a stand-up dog food commercial on the set of a variety show, he is not claiming any expertise but only touting the product's benefits, acting as a conveyor of information. The dog food is the star, not the performer.

A performer in a pitch presentation must have a very high energy level and must move well and handle props with ease.

VOICE-OVER: The performer who reads the copy is not seen in a voice-over commercial. Rather, the performer's voice is heard as a major component of the sound track.

The voice-over format is an extremely popular way of constructing commercials. It has the advantage of giving top billing to the product, not to an on-camera performer. A variant of voice-over work is dubbing in the voice of an actor who looks but does not sound the part in a commercial.

What we usually refer to as voice-over requires an excellent sense of timing, the ability to read voice to picture, and the skill to communicate vocally without distracting from the visual elements of the presentation. In many cases, the voice-over announcer is virtually anonymous, in the sense that a trumpet player is anonymous in an orchestral setting. After all, no one listening to a musical bed in a commercial stands up and says, "Listen to that trumpet!" If that were the case, the trumpet player, regardless of his or her skill, would have detracted from the message. This is a rather roundabout way of making the point that the viewer is not supposed to be astounded by the voice-over announcer's fine delivery. In fact, much of the general public probably is not aware that there is such a category as voice-over announcers. Voice-over work is quite challenging and under the right set of circumstances very profitable.

Radio and television commercials take a variety of incarnations. Keep in mind that there are many hybrid forms that use several elements of the foregoing categories.

Now that we've defined the *whats,* let's examine some of the *whys.*

Goals of a Commercial

It is often assumed that the goal of a commercial is simply "to sell a product." In the long run that may be true, but there are many intermediate steps in the process. Is the purpose of a line to "sell" a bank or to make the listener believe that the bank is staffed by knowledgeable and helpful people who take an individual interest in their clients? More often, the latter statement is the immediate goal, with selling the bank a broader objective.

A performer really has to understand the goal of a commercial before he or she can come up with a decent delivery. Dig a little deeper into the copy. Find out what the copywriter is trying to get across in each word and phrase. For example, do not assume that the only goal of a travel agent's commercial is to sell vacations. In the long run, that may be true, but the immediate goals for a broadcast communicator might be to

- Make the listener aware of how absolutely miserable this winter weather is
- Convey a sense of excitement concerning the possibility of visiting a Caribbean resort
- Communicate the idea that this vacation is a real possibility, an affordable option

Being fully aware of the goals of a commercial will give you valuable cues to the points that ought to be stressed, and to the proper inflections and rate of reading. This applies to any line you're delivering as an "announcer," or any copy being delivered in the character of someone else, an "acted" part.

Straight Versus Acted Delivery

As mentioned earlier, one common fault of commercial performers is the inability to assume a role, the tendency to take the guise of an announcer when the performer should be donning the persona of a character in a play. There is a very fine line between a *straight delivery,* as in the delivery used by a radio personality reading a script, and an *acted delivery.* The importance of understanding acted deliveries lies not in differentiating but in being able to play a role convincingly.

For example, the producer of a college promotional film auditioned for the role of narrator a number of announcers who made their living in broadcasting, and actors who made their living on stage and in film. An actor won hands down. "I wanted someone who could convince the audience that he was an alumnus of our college," the producer said, "and who could assume that role. The fellow we chose had only an average voice, but he really slipped into that identity. Most of the announcers would have been inappropriate."

Do not assume, however, that a broadcast communicator is always required to take on an identity. Whereas an identity was indicated for the college film, the narrator of a *National Geographic* documentary would appropriately use a straight delivery, almost a news style. The narrator, in that case, is not taking on a role.

In most cases, the producer of a commercial or other work will give you guidance on which type of delivery to give. The crucial thing from your standpoint is the ability to summon acting skills when you are called on to play a part.

Although this book cannot present an acting course per se, acting skills are essential to a performer and are often overlooked in broadcast curricula. Many professionals in the commercial field recommend that students take as many drama courses as possible, and that's good advice. You cannot be trained as an actor in one chapter, but some exposure to the principles of acting is valuable, both for picking up practical skills and as a jumping-off point to further instruction.

In this overview we discuss the methods of *assuming a role,* giving a *natural delivery,* and using actors' *techniques.*

Many jokes have been made about the actor who stops in midscene and asks the director, "But what's my motivation?" That is often a legitimate question, because motivation is the key to assuming a role and carrying it through a situation described in a plot.

Why does a character say a line? Why does he or she say it in a particular manner? Why does the character look, talk, walk a certain way? All those aspects should reflect motivation, and being able to convey motivation is what spells the difference between an actor and a mere reader of lines.

An actor playing a southern gentleman type will have to do more than work up a drawl. If the character is indeed a southern gentleman, he will undoubtedly have a certain way of moving: courtly and gentle gestures, perhaps. A southern gentleman is likely to have a proud bearing. If he is older, he will undoubtedly move differently from another southerner, 20 years younger.

A wide array of physical traits make up a character. As the great acting teacher Konstantin Stanislavski noted, small physical actions ". . . and the moments of belief in them" acquire a great deal of significance on stage.

Other traits will play a role in the actor's rendition of a character. Do highly educated people speak differently from people with little education? In most cases, they do, of course. And these traits must be *consistent* within the portrayal of a character. That is why television and screen writers often work up a complete biography of a character, including education, military service, political affiliations, and family history. Most of this information is never used directly, but it is important to the actors for the sake of character development and consistency. Novelists often undertake much the same process, drawing up an extensive biography of each character before the book is started.

You must do the same as an actor in a commercial. If background information is not presented to you, invent some. Make the character a *real* person. Assume you have been assigned to do the voice of a banker in a

Acting

Assuming a Role

▼

Motivation is the key to assuming a role and carrying it through a situation described in a plot.

commercial. What kind of neighborhood does she live in? What does her family mean to her? What political party does she belong to? How much education has she had? Many of the questions may seem irrelevant. Indeed, in terms of the immediate needs of the role, they very well may be, but filling in the details that make a character human can help you bring that character to life.

Let's look at another example. You have been cast in the role of a tough cop in a TV commercial for cold medicine. The advertiser, who wants to overcome the "macho" male's disdain for taking medicine for the sniffles, has constructed a commercial featuring a big-city patrol officer walking down the street, saying, "You know, when people are depending on me, I have to be at my best. I can't let a cold get me down. So when I feel the first signs of a cold coming on, I take Coldex. It's tougher than even *my* cold."

The lines have all been written, the camera angles all blocked out, but it is your job to do the most important part. You must bring this character to life. How do you do it? By creating a personality sketch and relating those traits to your character's traits. Here is a possible—but not definitive—point-by-point analysis (highlighted in Box 10.1).

- *Voice quality.* Do big-city cops talk softly? Hardly. A gritty, rough voice is a possibility, as is a faint hint of an Irish brogue.

- *Posture and movement.* Most likely this character would have a purposeful stride, with a great deal of confidence in his step. One realistic gesture quite in keeping with this character is to point to the camera (the viewer) when he says, "You know, when people. . . ." When he finishes the line ". . . tougher than even *my* cold," this character just might point to himself with his thumb. Gestures would typically be heavy and broad.

 Assuming this manner of posture and movement would be helpful even if the characterization were for radio. Many radio performers use posture, gestures, and facial expression as a way of reinforcing the character.

B O X 1 0 . 1

Traits of a Character

- Voice quality
- Posture and movement
- Facial expression
- General character traits

- *Facial expression.* In the movies, police officers run the gamut from social smiles to angry insolence. Perhaps the image of a concerned but tough Irish cop would be in order here, assuming you physically look the part of an Irish cop.

 Talking slightly out of the corner of the mouth would be appropriate for this character. (Remember, *appropriateness* is the key. Talking from the side of the mouth would not be appropriate for the character of a librarian.) Another appropriate trait would be a squinty expression, common among patrol officers who walk dusty, windy city streets. Other facial expressions? Try a knitted brow for the line ". . . when people are depending on me" and a slight jut of the jaw for the line ". . . tougher than even *my* cold."

 Note that the goal is not to assemble a mechanical grab-bag of expressions, but rather to decide what expressions and mannerisms would be believable in this character and would accentuate the message.

- *General character traits.* We want the character to be likable, so let's invent some likable points. He is easygoing but tough. Our cop has a lot of street smarts, but probably not an extensive formal education. He likes making small talk with the merchants on his route, and has a real fondness for kids, but he won't take any guff from them.

 A little personal history: he is the father of six, his brother is a priest, and he gets misty-eyed at Irish ballads.

 Obviously, all these details will not be reflected point by point in the commercial, but the traits will build a persona for the character you invent. The personality traits add up to a satisfying whole, rather than a cardboard cutout.

Think in terms of those four categories—voice quality, posture and movement, facial expression, and character traits—for any character you portray in a radio or television commercial. And although acting in a dramatic series is beyond the scope of this book, keep in mind that the process of defining characters applies to all types of drama.

Now let's apply those four categories to two different characters.

Personality Sketch

Character: A young male homeowner telling us why he got his mortgage at a particular bank.

Voice quality: You would not expect a gravelly voice or a deep bass from a younger man. However, the voice should transmit the qualities of confidence and responsibility. After all, he is trying to convince you of the right way to make an important decision.

Posture and movement: Youth is important here, to show that young people can get mortgages, so the character's posture and movement must reflect health and vigor. He probably exercises regularly, perhaps playing racquetball. His body language would surely be open and direct. He would not sit hunched over with hands crossed over his chest. And although his posture reflects confidence, he doesn't have a cocky swagger, and he projects a certain vulnerability.

Facial expressions: Smiles easily, but definitely is not the giggly type. Sincere, he has a level, but not challenging, gaze. By contrast, our policeman friend probably had eyes that drilled right through you.

Character traits: Probably well educated, an engineer perhaps. He is organized, neat, owns a station wagon, and is a member of the JCs.

Personality Sketch

Character: A 25-year-old career woman searching for a new car. The commercial copy is intended to show that she knows what she wants, and knows that the people at Smith Dodge can give it to her with a minimum of fuss.

Voice quality: Bright and energetic, but certainly not sultry and definitely not dumb-blonde breathless. There's no aggressive quality in her voice, just a confident assertiveness.

Posture and movement: She walks purposefully, and her posture is straight. She does not make unnecessary movements.

Facial expressions: Intelligent expression, level gaze, smiles easily but is not a jovial type.

Character traits: Well-educated person with strongly shaped goals. She probably works very hard at her job. She is physically active and has a variety of hobbies and interests, such as skiing and jogging.

Employing character sketches has the advantage of helping you determine whether an action will be in character or out of character. Basing the personality on character sketches allows the actor to assume a role and deliver the lines with naturalness.

A "Natural" Delivery

Aim at giving a "natural" delivery. The word "natural" is somewhat deceptive, since a radio or TV commercial is not a natural situation. Instead, the important element is the *appearance* of naturalness. In real life, people mumble, have speech impediments, and exhibit other characteristics we generally do not want to reproduce in a performance. "Naturalness" boils down to an unaffected performance, a projection to the audience of a recognizable character. The broadcast communicator must make every effort, when assuming a role, to avoid a cloud of artificiality.

Here is where *motivation* comes into play once again. There's nothing more to motivation than understanding something about the character and understanding why he or she is delivering the line. Is the character surprised? Angry? Patiently trying to convince us of something?

For instance, expand on the character of the career woman looking for a car. To give some additional insight into the character, here are some invented lines of dialogue: "I want a car that fits my lifestyle—practical, but not *too* practical. After all, what's life without a little excitement?"

These lines reveal a little more of the character's personality. She is a bit adventuresome and wants a car that does something besides transport her from place to place. However, she's a hard-working career woman, not an heiress, and probably would not opt for an exotic, expensive auto. So the lines assume a new meaning, and the actress would be wise to add just a touch of mischief to her voice and expression, some hint of the thirst for excitement that dwells beneath a staid exterior.

Another example concerns a different motivation. It is a scene in a shabby auto repair shop where the mechanic tells a young man he needs a new exhaust system.

"A whole new exhaust system?" he replies. "But you put in a new system just a month ago!" What is the motivation for this line? Frustration, anger, disgust with the whole operation. The character will, of course, go to the sponsor's shop next time. His reaction is pretty obvious. Other reactions and motivations might require more thought, especially in a voice-over, where there are no visual cues to reinforce the message. In most cases, the voice-over calls for a straight delivery, not assuming a role, but there is no reason not to assume certain personality traits if they are appropriate. Here are some possible ways to analyze the motivation behind voice-over copy:

Copy: Voice-over for special airline fare to California.

What the performer wants to communicate: A sense of excitement, almost incredulity, at these extremely low fares. The voice-over performer is a bearer of good news.

Copy: Voice-over to convince small investors to deal with a certain brokerage house.

What the performer wants to communicate: The voice-over performer's vocal qualities and delivery must imply that he or she is a sincere person who really wants to tell others about the good service at this particular brokerage house. The voice-over announcer might think in terms of playing the role of an intelligent neighbor.

The point is that unless these lines are delivered with motivation in mind, some artificiality will be projected into the delivery, regardless of whether the performer assumes a character. The voice-over for the airline fares, as a

case in point, would not be very effective if the delivery were somber. The investment brokerage spot would be very ineffective with a singsong, top-40 disc jockey delivery. Would *you* invest with a brokerage house represented by an announcer who sounds as if he or she is about to say, "Hey there, girls and guys"?

One other point: it is entirely possible to assume a character and understand the meaning and motivation of the copy and still appear artificial. If character and motivation are in order, the causes of artificiality (highlighted in Box 10.2) can include the following:

1. *Unnatural pronunciation.* Be wary of saying "thee" for *the* or "ay" as in *skate* for the article *a,* which is usually pronounced "uh." Don't overenunciate.

 If the script calls for a dialect, make sure you can speak it convincingly. Critical listening with a tape recorder is the only reliable guide. Most acting textbooks contain phoneticized dialect guides, and it would be very helpful to study them. Dialect work is extraordinarily difficult, and there's no disgrace in not being able to master it. Many broadcasters don't; just turn on your radio anywhere in the country on St. Patrick's Day.

2. *Stilted dialogue.* Sometimes artificiality is the copywriter's fault. However, the performer usually can't change dialogue. If you are having trouble with a line such as "My, this certainly is a wonderful product, Joyce; we must order it right away," walk away from the line for a few minutes. Try to say the line in your own words, paying attention to believable phrasing. Now, give the stilted line with the same type of delivery you used when in your own paraphrase. Some pieces of dialogue will never sound right, but this method can sometimes help.

3. *Overacting.* Putting too much into a performance is just as bad as injecting too little. The most effective way to catch overacting, or "a stench of ham,"

B O X 1 0 . 2

Causes of Artificial Delivery

- Undeveloped character
- Lack of character motivation
- Unnatural pronunciation
- Stilted dialogue
- Overacting
- Inappropriate movement

as it is sometimes called, is to have a knowledgeable teacher or colleague critique your performance. Video and audio taping helps, too, of course.

4. *Inappropriate movement.* A gesture that is completely in character with the part you're playing may appear totally inappropriate on television. On TV, you are working in a confined space and must often create the illusion of movement rather than executing the movement itself.

For example, a commercial that calls for you to walk across a used car lot requires compact and controlled movement, because the distortion of the TV lens would make a normal gait appear as though you were bounding across a basketball court. Walking and moving on television is a skill in itself, which can be developed only by practice and the viewing of tapes.

Factors that add artificiality to an otherwise well-constructed performance can be eliminated only by awareness and constant practice. There are very few "naturals" who can stroll onto a set and walk and talk well, because appearing on television is, as mentioned, an "unnatural" situation. The same principle applies to radio, perhaps more strongly, since a performance relying entirely on voice can be difficult to pull off well.

In addition to the abilities to assume a role and to bring about a natural delivery, television and radio commercials, whether acted or with a straight delivery, require mastery of certain specialized techniques. A technique is loosely defined as a method whereby a performer treats certain details of his or her craft. Techniques unique to television and radio are considered in the sections on those topics, but we'll close this acting session with a discussion of techniques for improving any type of broadcast performance.

Of primary importance is the ability to *animate your delivery.* Animation literally means "putting life into," and that's exactly what you'll be called on to do when reading copy. Veteran New York voice-over commercial actor Nick Schatzki (Figure 10.1), who has voiced commercials for clients such as Eastman Kodak Company and New York *Newsday,* notes that one way to bring copy to life is to visualize someone to whom you are speaking. Picture a single individual, he advises, and talk directly to that person. If necessary, form a mental image of that person sitting, in miniature, on top of your microphone.

Breathing life into copy is not accomplished purely by voice quality. When talent agent Lester Lewis judges the ability of a performer, he listens for the ability to animate copy. "Don't assume that just because you have a good voice you can do commercials," Lewis says. "It's not the voice, but what you do with the voice, that's important. Also, don't think that reading 30 seconds of copy is going to be a cinch. You have to bring that copy to life. Look closely at the copy: What is the copywriter trying to say? What are the important points in the copy? Without understanding that, you can't give a good reading."

Techniques

Figure 10.1. Nick Schatzki, an actor who frequently does voice-over work, brings copy to life for accounts like New York Newsday, Olympia Beer, *and Eastman Kodak.*

▼

One way to bring copy
to life is to visualize
someone to whom you
are speaking.

Understanding copy is largely a function of the methods of analysis discussed in Chapter 3. If you combine that analysis with the techniques of identifying motivation and determining the goals of a particular commercial, you can attack the job with a thorough comprehension. The following pointers are important to developing commercial technique:

1. Good acting skills will always increase your ability to communicate and animate copy. Acting training usually focuses heavily on methods of infusing life into a character. Many pros, including Lester Lewis, recommend that you take a variety of drama courses and get some stage experience, if you can.
2. Working before a live audience is a helpful experience to any broadcast communicator because it gives a sense of how things play. Broadcasters trained only in broadcasting sometimes lack a sense of comedic timing, for example, a skill best honed in front of living, laughing people.

The ability to animate copy is a technique useful in both radio and television commercials, and for all practical purposes, in any other form of broadcasting, too. Techniques specific to each medium are discussed next in the sections summarizing radio commercials and television commercials.

Radio Commercials

Earlier, the basic types and structures of radio commercials were described. Since radio spots rely entirely on sound, the broadcast communicator must be particularly sensitive to what sound can do and must be adept at maximizing the impact of the sound elements. This means that you will be concerned with more than just the vocal delivery. Also important is the ability to play off other elements, such as music and sound effects. In addition, special talents are required of a radio commercial performer, talents unique to the field.

Unique Aspects of Radio Commercials

In a sense, the producer of a radio commercial has a more difficult task than someone constructing an ad for television. Why? Because the radio copy must be aimed with pinpoint precision at a target audience. In another sense, this can be interpreted as a factor making the job easier, since the TV producer is in the position of having to please almost everyone.

The essence of the discussion is that radio is a one-to-one medium. The successful performer on radio is the performer who can put across a message on a personal basis. You will be called on to do some tasks unique to the medium. Of primary importance is ad-libbing from a *fact sheet*.

Fact Sheet The ability to do a credible job ad-libbing from a fact sheet, and the related ability to please sponsors, can take you very far in modern radio. The effectiveness of an ad-lib commercial lies in the injection of the performer's personality into the spot. In radio, personality is still very much alive. In earlier times, personalities such as Arthur Godfrey could maintain

that kind of role on television. Godfrey was the acknowledged master of the ad-lib commercial, both on radio and television. His folksy, absolutely natural delivery was stunningly effective in pleasing sponsors and motivating buyers.

There are many differences between radio and TV commercials, but the injection of personality, as shown in Box 10.3, is one thing that makes radio such a unique and compelling medium.

Production Basics

Often in radio the performer is the one who also does the production work. This requires basic skills such as using an audio console, mixing sources, and operating a variety of equipment. The skills are essentially the same as those outlined in Chapter 5. In a commercial, the goal is to use these skills to enhance the commercial message.

The performer must be sensitive to production details such as relative levels of sound from different sources. For example, reading over a music bed requires a delicate balance. The music can't be loud enough to drown out the voice, but the music must not be so soft as to be imperceptible.

Extensive instruction in production is beyond the scope of this text. Note that a knowledge of production can always be helpful to a performer, so even if your ambitions lie in on-air work, taking as many production courses as possible will be extremely worthwhile. Why? Notice how a good grounding in production techniques can help you enhance a message in a radio commercial in these examples:

- You are reading a piece that is set outdoors, but you're in the studio and picking up a lot of echo and reverberation from the walls. A basic knowledge of acoustics would let you make your spot more believable by setting up a simple baffle to block sound reflection and eliminate the echo and reverberation.
- Knowing the characteristics of different mics can enable you to choose a mic with a great deal of "presence" for an intimate feel in a perfume commercial.
- A knowledge of special effects and how to produce them can add to the message. Use of filters, for example, can cut down on the frequencies passed through the console and can produce a weird, unearthly effect, useful for attracting attention if used appropriately.

Delivery Techniques

Two more specialized techniques are indispensable in radio, and also have some specific applications in television, especially in voice-over work. The techniques are *reading to time* and *compressing copy*. They are two of the most useful skills you can develop, and frequently are the talents that separate a good performer from one recognized as being top drawer.

Reading to Time Some professionals maintain that reading to time calls for an ability you are, or are not, born with. Others contend that constant practice can develop this skill, and we're inclined to agree with the latter view.

249

B O X 1 0 . 3

Ad-Libbing from a Fact Sheet: An Example

Build an effective ad-lib around this fact sheet.

• The Charter House Restaurant, 411 Grand Avenue, serves the widest array of seafood dishes in the city.

• Seafood is caught fresh every day and brought right from the boat to the kitchen.

• Specialties include lobster for two, a complete dinner with wine, Caesar salad prepared at the table, and baked potato. All for $27.95.

• Colorful atmosphere, including the Clipper Ship Lounge where fishnets line the walls. There are brass nautical decorations. One-ton anchor outside entrance.

• Owners Joey and Paul Italiano provide first-class hospitality at bargain prices.

Here is one way, but not the only way, a radio air personality might do the ad-lib:

When you dine at the Charter House Restaurant, you get a great bargain, and you can choose from the widest array of fine seafood dishes served anywhere in the city. Do you know where the Charter House is? Well, it's up on 411 Grand Avenue, right off the Seashore Express-

The bottom line in this dispute is that no one can teach you how to read copy in exactly 30 seconds. It is a talent that can be achieved only by experience. The goal is to develop an internal clock that lets you know when the pace has to be picked up or slowed down.

Why read to time? Well, in many commercials there is a certain time slot allotted for copy, and if it is 19 seconds the copy *has* to be 19 seconds, no more and no less. In most radio stations 30-second spots must last precisely 30 seconds, since they may be used in a "hole" provided in a network newscast, and therefore can't fall short or run long.

Although there is no magic formula for developing this skill, incorporating the following suggestions into your practice can help speed the process of learning.

way, and that's important because if you know that section of the city you also know that the Charter House sits right on the water, next to where the fishing boats dock. The seafood comes right off the boats and into the Charter House kitchen, so whenever you eat at the Charter House you're getting today's catch.

Right now you can enjoy the "Lobster for Two" special, a complete dinner that comes with a Caesar salad prepared at your table—hey, that's a show in itself—and you also get wine and baked potato. All for $27.95 . . . remember, that's for two people, $27.95 for a complete dinner.

By the way, the food at the Charter House is only part of the experience. If you've never been there, make it a point to stop in and have a drink at the Clipper Ship Lounge . . . that's the place where they have fishnets on the walls and all those brass nautical gizmos. And you'll know you're in the right place when you see the one-ton anchor outside the door.

We were there last week and had a great meal and great service, too. The owners, Joey and Paul Italiano, make sure you get first-class hospitality at bargain prices. That's the Charter House Restaurant, 411 Grand Avenue.

This announcer gave the sponsors a good deal for their advertising dollar, both in terms of content and time. And this type of commercial provides for variety: a good performer could ad-lib it four or five different ways during the day or week, giving a different emphasis each time.

1. *Develop a familiarity with music and music phrasing.* Listen critically to music and learn to identify key changes, or the distinction between a trumpet solo and a clarinet solo. This is helpful because music beds can be used as cues. If, after a couple of rehearsals, you find that you should be giving the prices of the products when the musical key changes from C to G, you can use the key change as a landmark from which to adjust the rate at which you read the rest of your copy. In the long run, this will be easier and less distracting than trying to keep one eye glued to a timer or stopwatch. Knowing the background music also helps you to match your delivery more naturally to the music bed.

2. *When you start practicing development of a time sense, shoot for hitting 10 seconds, not 30, on the dot.* Once you have mastered 10 seconds, try

reading 30-second spots exactly to time, thinking in terms of three 10-second segments. Another way to practice is to read a 30-second spot and then cut it down to 25 seconds. Do it again, aiming for 35 seconds.

3. *Mark your copy with time cues, as shown in Chapter 3.*

Compressing Copy

Successful performers frequently point out that one of the most valuable skills in their arsenal is the ability to put a lot of words into a short time. The reason is simple. Time is money, and the more commercial words a sponsor gets for his or her time allotment, the happier the sponsor will be. As a result, copy is often written very tightly, and frequently there are more words in a 30-second spot than could normally be read comfortably in 30 seconds.

This requirement frequently gets out of hand. A merchant once presented one of the authors with a page and a half of single-spaced typewritten copy and requested that it be "squeezed into" a 60-second spot.

Compressing copy, reading rapidly without a rushed, chatterbox delivery, is a valuable skill that can be enhanced by practice and the following specialized techniques.

First, *use a musical analogy.* When an orchestra speeds up a piece of music, the relationship among the notes and rests remains the same: a quarter-note is still one-fourth as long in duration as a whole note, but both will be shorter in duration when the tempo is picked up. The same is true of rests between notes. They remain proportional.

The biggest fault of the performer who produces a rushed, hurry-up sound is reading the elements of the copy out of proportion. The result is a change in the phrasing, sometimes eliminating all natural pauses between words and/or phrases. Another symptom of the hurry-up syndrome is a monotone, where the "melody" of the copy is altered.

When you have to speed up your delivery, remember not to change the *relative* rate of delivery, and don't alter the melody of your voice. Speed up everything, but do not change the relationship among words.

Second, *read ahead in your script.* Reading ahead allows you to speed up the copy and retain its naturalness. Typically, in a hurry-up delivery, the performer forms a direct connection between eye and mouth, becoming less a communicator and more a reading machine, concentrating on speed and losing meaning and flow. Stay a sentence ahead in the copy, and you will phrase the words in a more natural way because you will be saying a sentence, not reading words.

Television Commercials

Earlier, we examined some types of television commercials and discussed what they demand of a performer, as well as how to create a character for television or radio. This section explores some specific techniques of making television commercials.

It is important to understand that the television commercial industry is, in most cases, not a part of the television broadcast industry. Many commercials

are produced by independent production houses, and the performers generally are trained as actors, not broadcasters. In television voice-over work, there's a greater percentage of broadcasters.

Local TV stations do produce commercials, but there is usually not a major amount of on-camera work for the broadcaster in these markets. Voice-over work is, however, typically assigned to the broadcaster in local markets.

On the national level, commercial production is a highly specialized business, with spots written by ad agencies and produced by independent houses. In this environment, performers typically work on a freelance basis.

Regardless of whether the assignment is on a local TV spot or nationally syndicated, the importance of properly creating a character and giving a genuine delivery cannot be overstated. In addition, TV has some very stringent technical requirements that, if not adhered to, can put performers out of the running before they get a chance to show their talents. These techniques are unique to on-camera acting.

A television camera is a merciless instrument, capable of picking up every detail of a performance, good and bad. An actor or performer must constantly be aware of the power of this unblinking eye and must develop the following specialized skills.

Ability to Control Movement Turning to face someone, a simple act in everyday life, can be horrendously complicated in a television studio. The performer must be able to turn without causing the studio lighting to cast uncomplimentary shadows. Too large a movement will pull the performer from his or her mark, usually a piece of tape on the floor, thus throwing off all the camera angles.

Performers frequently must be able to talk with another on-air person without looking directly at him or her. In the theater, actors typically direct their gaze downstage, toward the audience, so that more of their faces are visible to the audience. In some circumstances, you must do the same on TV: look in an unnatural direction during dialogue so that more of your face is seen by the camera.

Television, like football, is a game of inches. The performer must develop the necessary skills to stay on a mark, move the same way in subsequent takes, and remember his or her body positions at the end of a take so that they can be matched up with the beginning of the next take.

Ability to Control Mannerisms "You wouldn't believe some of the faces people make when they're on camera," says Vangie Hayes, casting director for the J. Walter Thompson advertising agency in New York. She notes that "some performers feel that they have a talent for punctuating everything they say with a raised eyebrow. But that mannerism becomes very distracting."

On-Camera Acting

▼

A television camera is a merciless instrument, capable of picking up every detail of a performance, good and bad.

Ability to Project a Type Since time in a television commercial is so limited, there is little opportunity to build a character by dialogue or exposition. Much of the character's personality must be readily apparent, which is why the woman who plays a young mother has to be a young mother "type." Her identity must virtually leap from the screen.

Types in commercial acting include the young mother, the young father, the distinguished spokesperson, the sexy leading-lady type, the macho male, and the "character" part. Cultivating your particular type, whether you are destined to play college professors or cab drivers, is important. Obviously, you must be believable within your type, meeting age and physical requirements. A strong Brooklyn accent may work to your advantage in seeking cab driver parts, although you would be well advised to lose it for any other type of mass media work.

Type casting is very important in commercial work, and specialists often put "young father" or "character type" right on their résumés. Identify your strengths, especially your ability to play a type, and exploit them.

Handling Props

The days of the stand-up commercial with prop in hand are pretty well past, although some local stations still use this structure and on occasion a national spot will do it for novelty. When a product is held, the close-up often features a professional hand model.

In terms of simply handling a prop, the rule of thumb is not to let it glare on the camera lens. A book, for example, must be tipped at the proper angle to keep the reflection from the lights from making the cover glare badly. A second, but just as important, rule is never cover the product with hand or fingers.

Props in modern commercials are more likely to serve as items to be consumed. Commercial performers frequently are called on to ingest a product, and they must do so with as much satisfied, ecstatic zeal as can be summoned within the bounds of common sense. If you are eating a slice of pizza, the director will expect you to be capable of reacting to the taste of the pizza. If you are drinking milk, be prepared to communicate enjoyment.

You will be expected to portray an enormous amount of delight in the consumption of a product. Remember, if you ever are lucky enough to secure a part in a commercial such as this, you will be operating in a big business and will be expected to perform on cue, as a professional.

Freelance Assignments

As has been noted, national commercial work is for the most part done on a freelance basis. Many of the performers are actors, and some, especially in voice-over work, are broadcasters. On a local level, the participation of professional broadcasters is much greater.

Freelance assignments are available on the national and local levels, although an employee of a particular station may frequently find restrictions

placed on the types of outside work in which he or she may engage. Parts in commercials are obtained through

- Ad agencies, which handle advertising accounts for clients and often do the scripting and casting for the commercial
- Model and talent agencies, which supply talent and take a cut of the talent's compensation
- Production houses, the firms that actually film or tape the commercial
- Broadcast stations, which assign commercials to in-house talent and sometimes hire freelancers

The competition for parts in commercials, especially TV commercials on the national level, is intense. Before you even enter the ring, you should have tapes (audio and/or video, depending on your interest) of your best work to present to the casting director of the organization you approach, or to an agent. You will also need a résumé summarizing your previous commercial experience, if any, along with your training. An 8-by-10 black-and-white portrait photo is also required.

In some cases, a commercial performer must belong to a union, such as the Screen Actors Guild (SAG) or the American Federation of Television and Radio Artists (AFTRA). Unions are examined more closely in Chapter 12.

What are the qualifications for picking up a commercial role? The principal quality casting director Vangie Hayes looks for is ". . . the ability to talk to someone. There was a time when most announcers were the 'deep, disembodied voice,' but today the emphasis is on communication."

One attribute of a performer's voice, Hayes notes, is the level of interest it carries. "I think a good voice is a voice that you would hear on a TV in another room, and walk into that room just to see what's going on. A good voice is also an interesting voice . . . perhaps even a voice with a little rasp in it."

Hayes agrees with those who advise that practice is the only way to improve. Hear yourself on audiotape, she says, and see yourself on video. Compare your performance to those of professionals, and always be aware of areas in which you can polish your skills.

A Final Note

Commercial performance can be extremely lucrative, a comforting thought when you consider that broadcasting on-air work as a whole does not pay very well. Yes, top performers do make a great deal of money. But at the local level, especially in small markets, on-air talent generally makes less than salespeople or management and in very small stations, than secretarial help. Remember that those at the top *are* at the top, the very top, of a fiercely competitive pyramid. The top news anchor jobs, for example, are not easily obtained.

Securing commercial roles is never easy, but the field does offer quite a bit of opportunity. And for staff radio personalities and certain television staff on-air performers, the ability to deliver a commercial convincingly is a sure step to career advancement. *Never* underestimate the role of commercials and the value of developing the talent to do them well. As long as there is broadcast advertising, the performer who can convince us to use a product or service will be in demand.

Summary

Broadcast advertising has emerged as a separate discipline. Modern commercials take many forms. Among those forms in radio are straight reading, donut, ad-lib from a fact sheet, acted scene, man-in-the-street, and heavily produced montage. Forms in television include mini-drama, spokesperson presentation, pitch presentation, and voice-over.

The long-range goal of a commercial is to sell a product or service, but there are many intermediate steps. The commercial, for example, might seek to create a sense of excitement in the listener and then communicate that the product or service offered is affordable and a realistic option. It is much more sophisticated than simply saying, "Buy this product."

It is very important for a commercial performer to be able to do a straight delivery (announcing) and an acted delivery (assuming a role).

Acting is a discipline within itself, and proficiency can require years of study. However, familiarity with some basic principles is helpful to any broadcaster interested in commercial performance. The primary consideration in acting a role is determining the motivation, the complex of factors that cause a character to say a line in a particular manner.

The actor must do an analysis of a character and determine that character's physical traits, level of education, voice quality, posture and movement, facial expression, and other traits. It is vital that the actor's delivery be consistent with the overall personality sketch of the character.

Commercial actors must particularly avoid unnatural-sounding speech, stilted dialogue, overacting, and inappropriate movement.

The way a performer treats his or her craft is often defined as technique. In very basic terms, applying to both television and radio, technique is the means of animating copy, bringing it to life.

There are unique aspects of radio and television commercials to which special techniques must be applied. Radio commercials involve polishing the technique of reading from a fact sheet, being able to integrate production basics into the overall effort, and such specialized delivery techniques as reading to time and compressing copy. Television commercials call for the specialized techniques of on-camera acting and handling props.

Most performers in commercials that are broadcast nationwide work on a freelance basis. Parts for commercials are subject to stiff competition, but the financial rewards are great. In fact, the entire broadcast commercial industry offers handsome rewards to performers at many levels.

1. Write a 30-second television commercial for a raincoat. The commercial must contain a dramatic scene, with one actor talking about why his or her raincoat is a great piece of apparel. Here's an example.

Video	Audio
Salesman gets off airplane, coat slung over his shoulder	My St. Cloud raincoat has put up with a lot . . . down-pours in New Orleans, snow in Buffalo, wind in Chicago.
Puts coat on	It's even been stuffed in a travel case and used as a pillow. But it always looks good . . . and I look good in it.
Salesman sees distinguished-looking client, walks up to him, shakes hand, turns to camera	And in my business, you can't afford to look sloppy. I've got to look sharp and be sharp.

In addition to writing a commercial, prepare a personality sketch of the main figure. Decide on voice quality, posture and movement, facial expressions, and general character traits. For example, traits for our salesman would probably include a hard-driving personality and a lack of tolerance for poor products. Because he is demanding, he picks a good coat, which is the point of the commercial.

Do this for the following four characters. The characters can be male or female, and you can vary the characteristics of the coat (it does not have to be a dress topcoat). Write a script and a personality sketch for

a. A fisherman

b. A rich, dashing man or woman about town

c. An international reporter

d. A detective on a long outdoor stakeout

After you have written the commercials and character sketches, perform the scene. Do it from the standpoint of each of your four characters.

2. Tape three versions of a standard 30-second radio script, using copy from the drill section (Appendix C) or copy

provided by your instructor. Do one version in exactly 25 seconds, one version in exactly 30 seconds, and another in exactly 35 seconds.

3. Ad-lib a 60-second (approximately) commercial from a magazine ad. Use as little of the ad's direct wording as possible. Try to draw inspiration from the photo, rather than the text.

Polishing Your Skills

What separates those few broadcast performers who reach the top from those who seem to get stalled down below? The answer is complicated; it has to do partly with native skill, luck, and ambition. But beyond those factors, what most characterizes people who get to the top and stay there is the ability and the determination to improve. Those are the people who learn from their mistakes, and benefit from self-critiques and critiques by others.

This chapter, though brief, is very important. It tells you how to use self-evaluation to improve your skills. These are the methods used by top professionals. If you regard self-improvement as a lifelong discipline, you'll be less likely to stagnate in your career and more likely to rise to the heights of this very competitive field.

There are two ways to improve on-air delivery:

1. Listening to or viewing a tape of yourself and doing a self-critique
2. Having a teacher, supervisor, or co-worker critique your performance

The second option is often more productive, but sometimes more difficult to come by. In small markets, for example, few people may be willing and/or able to offer a worthwhile critique and suggestions for improvement.

Evaluation

▼

Viewing or listening to
your own tapes, at
regular intervals, during
all stages of your profes-
sional advancement,
is invaluable.

When an external critique is available, it frequently comes as part of the process of grading in an educational setting or standard performance evaluation in an employment situation. Such advice is valuable, and although it may not always be correct, it is wise to listen, file the information away mentally, and use it for reference whenever you engage in self-criticism.

Evaluating your own performance may lack objectivity, but it can provide an irreplaceable insight into performance. Viewing or listening to your own tapes, at regular intervals, during all stages of your professional advancement, is invaluable.

What to Look for in Tapes

Be as objective as you can, and don't make excuses. Don't think, "Well, I really meant to say something else, but I understood what came out." Evaluation must be done from outside your own head, so to speak, from the standpoint of the listener or viewer. *Evaluate in terms of pure communication.*

Be sure that ideas and moods are communicated in such a way that they will be perceived immediately by the audience. Ask yourself if the communication elements are clear.

Next, break down the *whys*. Why was a commercial not as good as it could have been? Where were the mistakes, and how could weak areas be improved? Do not settle for a general overall negative feeling: *break down problem areas into specifics.*

Be vigilant in hunting for mistakes in pace, a lack of variety in the reading. Is the pitch right? Does the delivery sound phony? Isolating any and all of these factors can help in your quest for self-improvement. If the pace is inappropriate, for example, experiment until you arrive at a pace that reinforces the message, rather than detracting from it.

As noted in Chapter 3, any interference in communication detracts from the impact. In addition to the problem areas just specified, distractions such as poor diction, regionalism, unusual voice patterns, or oddities in appearance divert the audience's attention from the message. When viewing or listening to tapes, *identify distractions.*

For example, do you constantly raise one eyebrow during a newscast? Make a consistent effort to keep that eyebrow down from now on. If your pitch drops repeatedly at the end of each and every sentence, work on vocal variety.

You can use evaluating in terms of pure communication, breaking down problems into specifics, and identifying distractions for airchecks or in practice sessions. Practice sessions are a must for improving on-air ability and provide a low-pressure environment for ironing out the problems uncovered during self-critique. Additional applications for practice sessions are listed in the following section on improvement.

Self-evaluation can be painful but extraordinarily productive. Use tapes as much as possible; at the very least, practice before a mirror. Look and listen objectively. One excellent prescription for self-evaluation is to have someone tape you when you are not aware it is being done. This way, you will be natural and won't be *trying* to do an exceptional job.

This strategy works well with critiquing sports play-by-play. Have your play-by-play recorded and set the tape aside for a few days. Then listen to your description; and if you can follow the game by what you've said, you probably did a good job. It is important not to play the tape for two or three days, because if you listen right after the game, you will be filling in from memory many of the details that should be clear from your description alone.

Remember that self-evaluation can be positive as well as negative. Note what you do well, in addition to finding fault. This will identify strengths and head off discouragement. *Do not give up. Keep working.*

When listening to or viewing a tape, keep the checklist shown in Box 11.1 before you. The section titled "Voice and Diction" applies to both television and radio; "Visual Presentation" contains items specific to television.

As you evaluate your performance, jot down the "no's" on a separate sheet of paper and, if possible, the counter numbers of the audio- or videotape machine at the point where you noticed the particular problem. This will give you the opportunity to go back and review the negative aspects of your performance. You may wish to note the positive aspects of your work, too. Also write down some coherent notes (notes you will understand next week or next year) to yourself on your separate sheet of paper.

Performance can be evaluated many ways. Sometimes you may want only a quick review, at other times an in-depth study. This list is kept flexible so that you can tailor it to your individual needs. Exercise 1 at the end of this chapter provides a possible framework for complete self-evaluation. Keep your notes and your tapes *forever*. This way, you can establish a lifelong baseline from which to judge your improvement. A checklist for long-term plans is shown in Box 11.2.

A Complete Self-Evaluation

BOX 11.1

Self-Evaluation Checklist

Voice and Diction

Pitch	Does my voice rise and fall naturally, without any artificial patterns?	Yes ___	No ___
Voice quality	Is there resonance in my voice?	Yes ___	No ___
	Is it free of a tight, pinched quality?	Yes ___	No ___
	Is it free from hoarseness or a guttural quality?	Yes ___	No ___
Diction	Do I clearly separate words? Do I say "it was," rather than "ih twas"?	Yes ___	No ___
	Is my delivery free from regionalism?	Yes ___	No ___

(continues)

Box 11.1 *(continued)*

			
	Is diction free of clipped, too-precise quality?	Yes ___	No ___
	Is my diction free of other distractions? Do I say "bottle," rather than "bah-ull"?	Yes ___	No ___
Breath control	Is my voice free from breathiness?	Yes ___	No ___
	Do I sound as though I have an adequate air support and supply? Do I avoid running low on breath during reading?	Yes ___	No ___
	Do I have adequate diaphragmatic support during the reading (check this during the on-air session)?	Yes ___	No ___
Interpretation	Do I understand the basic ideas of the copy?	Yes ___	No ___
	Do I *appear* to understand the basic ideas of the copy?	Yes ___	No ___
	Can I now, after listening to the tape, immediately repeat the flow of ideas in the copy?	Yes ___	No ___
	If the piece is a commercial or public service announcement, can I now summarize the thrust of the copy in a single sentence?	Yes ___	No ___
	Checking the reading against the script, do the key words I had marked still appear to be the correct words?	Yes ___	No ___
Expression	Did I give proper stress to the key words?	Yes ___	No ___
	Does the reading make sense and lead to a compelling point?	Yes ___	No ___
Mood	Do I project a proper and appropriate mood for the copy?	Yes ___	No ___
	Is the reading devoid of overplaying, overacting, or a maudlin quality?	Yes ___	No ___
	Are transitions clear? Is it perfectly evident where one piece of copy stops and another begins?	Yes ___	No ___
	Does mood change during transitions?	Yes ___	No ___
Pace	Is the pace appropriate to the piece? Does it reinforce the message?	Yes ___	No ___
	Does the pace sound natural?	Yes ___	No ___
	Does the pace vary within copy? Are the variations appropriate?	Yes ___	No ___
Naturalness	Does delivery sound conversational?	Yes ___	No ___

	Does it sound like speech, and not like reading?	Yes ___ No ___
	Is my reading believable?	Yes ___ No ___
	Is my reading sincere?	Yes ___ No ___
	Is my reading free of elements of obvious and outright imitation?	Yes ___ No ___
Phrasing	Are words naturally delivered in phrases?	Yes ___ No ___
	Is the reading free of any unclear phrasing (an adjective that "dangles," for example, leaving the listener unsure of exactly what is being described)?	Yes ___ No ___
	Are pauses used properly and effectively?	Yes ___ No ___
Energy and interest level	Does the delivery interest you, and would it interest members of the audience?	Yes ___ No ___
	Is energy level appropriate to the copy, not too hyper or too laid-back?	Yes ___ No ___
	Do I appear to care about what I am reading?	Yes ___ No ___

Visual Presentation

Appearance	Is my on-camera presentation free of visual distractions such as unruly hair or poorly fitting clothes?	Yes ___ No ___
Gestures and movement	Are gestures natural, instead of seeming stiff or forced?	Yes ___ No ___
	Is eye contact direct and level, while still seeming natural and comfortable to the viewer?	Yes ___ No ___
Facial expression	Is my expression appropriate for the copy?	Yes ___ No ___
	Do my expressions change during reading?	Yes ___ No ___
	Is head movement natural and not distracting, free of bobbing, and always within the frame?	Yes ___ No ___
Posture and body language	Does my posture express interest and energy?	Yes ___ No ___
	Is body position natural and not rigid or stiff?	Yes ___ No ___

Take your self-evaluation seriously, and be critical. If you are fortunate enough to have a colleague willing to provide an honest critique, share this checklist with him or her.

B O X 1 1 . 2

A Checklist for Long-Term Plans

Evaluation does not end with an examination of the mechanics of an aircheck. There is also a strong need for lifelong, career-wide checks and plans. Ask yourself the following questions.

Do I have a daily regimen of vocal and breathing exercises, such as those described in Chapter 2? Yes _____ No _____

Do I have a target body weight, and do I maintain that weight? Yes _____ No _____

Do I take advantage of any opportunity to ad-lib (sports coverage, acting as host of telethon, etc.)? Yes _____ No _____

Do I constantly develop my vocabulary by reading widely and looking up unfamiliar words? Yes _____ No _____

Do I read a variety of material, including news magazines, trade journals, and literature? Yes _____ No _____

Do I observe and learn from others? Yes _____ No _____

Do I have long-term goals? Yes _____ No _____

Improvement

Once problems have been identified, you can practice to eliminate the distracting or inappropriate elements. You need a low-pressure environment in which to practice the following skills:

1. *Hone your ability to read a sentence or more ahead in copy.* This is valuable for radio as well as television. To repeat an important point made earlier, radio announcers must be able to glance up from copy to read clocks, find carts, or look for other pieces of copy. Reading ahead helps you think in terms of communicating phrases and thoughts, rather than just reading words.

 When you are practicing, force yourself to keep your eyes moving ahead in the copy. Aim for staying a full sentence ahead, but experiment by going as far ahead as possible.

2. *Ad-lib.* You can't be embarrassed by clumsy ad-libs made during practice, and practicing extemporaneous skills can prevent those ad-libs from being clumsy in the future. Ad-lib anything during practice: humorous patter, record intros, news reports based on notes. Ad-libbing is largely an acquired skill.

3. *Fine-tune your sense of timing.* Practice condensing 30 seconds worth of copy into 15 seconds. This skill will be a lifesaver when you are trying to hit a network newscast "on the money." Also practice reading copy strictly to time, developing the accuracy of your internal clock.

Improvement is more than eliminating the negative. The positive points in your delivery, and your particular strengths and abilities, deserve to be accentuated, too.

The first goal of a broadcast communicator should be to correct deficiencies. But once those problem areas are uncovered and corrective work is under way, start thinking about exploiting those strong points.

Accenting Your Strengths

- Do you have a strong sense of logic and analytical thinking? You may be able to develop world-class interview skills.

- Do you have an engaging personality? Perhaps a career as a radio personality, specializing in strong personality identification, is for you.

- Do you have a strong interest in people and their ideas? Then you may have a valuable advantage in the radio or television talk show field.

- Do you have an interest in, and understanding of, business and finance? Try your hand at some business-related news reporting, and you may find yourself in demand.

- Are you a good writer? Think about strengthening that skill and applying it to radio or television news. Good writing, to a newsperson, is *always* an asset.

- Are you a hustler and self-promoter, always making calls, meeting people, and making deals? Think about possibilities in freelance commercial and/or voice-over work, where talent and the ability to promote yourself can lead to high financial rewards.

The list is just about endless. Look within yourself and your background for special qualities that can be polished and strengthened.

A Word About Health and Fitness

Physical vigor, a key to success in broadcasting, is often overlooked as a factor in skill building and career advancement. Realistically, you need not be a bodybuilder or marathon runner to compete in on-air broadcasting. You must, however, have the stamina to work long hours and still appear bright and energetic on mic or camera. Remember, too, that taking time off from work due to illness is very much frowned on in the broadcast industry.

Although broadcasting is a demanding job, both physically and mentally, those demands won't contribute to your level of physical fitness. A mail

carrier benefits from walking and a warehouse worker from lifting, but you'll spend most of your working hours sitting in a studio or driving from appointment to appointment. That is why a personal fitness program is beneficial and just as important as any skill-building program. There is no shortage of good physical fitness advice today, so take the responsibility for researching the issue and finding what's right for you.

A special note for TV performers: weight will always be a concern to you, so consider diet strongly when planning a fitness program. Face facts. Few fat people stay on the air, and gaining weight can hinder your career advancement.

Case Histories

The material presented in this chapter is not isolated theory passed down from an ivory tower. Almost any successful professional has a history of career experimentation and broadening professional horizons, combined with a calculated plan of personal improvement. Various career paths might be taken. Consider, for example, the case of a salesman for a large manufacturing firm. This man was extremely successful but not very happy. He had a background in amateur theatricals and decided to audition for some part-time television and radio work.

His audition showed promise, and he was signed on to do some television booth announcing. Booth announcers were rapidly becoming an endangered species, however, so he began to supplement his income with commercials. What a natural career extension for a salesman! His contacts and knowledge of advertising helped him to become highly successful.

Success in commercials brought him to New York City, where a role in a soap opera was added to his résumé. Quality of life in New York was not up to his expectations though, so he applied for, and got, a weathercaster job in his hometown, a smaller market. The weather job evolved into a host position on a magazine-type show.

The career path did not stop there, however. His knowledge of advertising eventually led him to establish an advertising and public relations agency, which provides artistic and financial rewards, combined with the challenge of running a small business.

Although this broadcaster tried a number of career paths, none were false starts and none of the effort was wasted. All this experience and all the skills acquired add up to a whole in his present job.

Persistence and a constant drive for self-improvement pay off. Take the case of an announcer who worked weekends while in college. He was a jock at a teenybopper station, but that job soon became unsatisfying and the pay was poor. He was offered work at a station doing album-oriented rock, and it proved to be an excellent slot. But the station's format was changed to nostalgia, which he did not particularly like. He did a competent job, though, studying the music and making a tremendous effort to fit within the format.

Eventually, a sales position opened at a country station, and he took it,

wanting to discover whether sales was really the part of broadcasting that would make him happy. That did not turn out to be the case. Air work was his goal, and he started sending out tapes and extending feelers through friends in the business. He did not regret having tried sales, because the question of whether sales was his natural spot always would have been a haunting one if the effort had not been made.

The result of his career search? The morning drive job in an AOR station in one of the nation's largest markets. The program director who hired him was impressed not only with his radio background but with his demonstrated willingness to work hard and adapt.

The ability to recognize and correct deficiencies is crucial. Note the case of a young woman, a recent college graduate. Rather stocky and having a coarse-sounding voice, she lacked at first some of the physical attributes expected of a news reporter.

Her main attribute was her skill as an on-air newsperson, cultivated by endless, backbreaking experience. Eventually, she also made some improvements in appearance and vocal ability.

After college, she returned to her hometown and became a volunteer at the cable station, doing anything and everything she was asked. On-air work didn't come until a year later, when she convinced the cable system director to let her produce and host a 15-minute weekly feature. The feature enjoyed moderate success, and after another year she asked the director of the cable station to help her find a job in news. The director made some calls and secured an interview for her at a small station.

The woman advanced to a larger station. It happened to be in the same market as her college, so she could ask her former performance professor to watch her newscasts and critique them. Eventually, she moved on to a good job in one of the larger medium markets.

Although she did not have a large amount of natural talent, her constant efforts to improve, and her willingness to seek and accept criticism, *made* her a good on-the-air communicator.

Some people stall at roadblocks, but others look around them, try to decide what's wrong, and make changes. Al Roker (Figure 11.1) is the weatherman for NBC's Sunday *Today* show and regular stand-in for Willard Scott on the weekday *Today* show. He is also weeknight weather anchor for WNBC in New York City. He attributes much of his success to being at the right place at the right time, but also points out that he made conscious efforts to improve his on-air skills and appearance.

"When I was in Syracuse I wanted to move on, but something was holding me back," he says. "I had been up for a job in Washington, D.C., but was turned down. Word got back to me that my weight had been part of the problem."

Roker lost weight and was again seen by an executive of the station in

▼

The ability to recognize and correct deficiencies is crucial.

Figure 11.1. Al Roker of WNBC-TV, New York, New York.

Roadblocks

Washington. This time, he got the job. The next stop was in Cleveland. "After five years in Cleveland I felt that I had grown professionally as much as I could there," Roker says. "I was stalled and had to figure out what was going wrong. What I did was to concentrate on other parts of my career, such as reporting and interviewing."

Roker took on additional duties as host of a talk show, for which he won an Emmy. He also began focusing on field reporting, and won an Emmy and a UPI award in that category, also.

Roker says he is not sure whether those additional skills were directly responsible for landing the job at WNBC but notes that versatility never hurts. "In New York, those skills may not necessarily open the door, but once you're through that door they'll help you stay in the room."

Other broadcasters can point to similar efforts to pass a roadblock in their careers. Anne Montgomery felt she was encountering a credibility problem as a female sportscaster, so she immersed herself in sports as a referee. Skeptical station managers could hardly doubt the sports knowledge of someone who had officiated in so many different events.

Meteorologist John Flanders progressed through a series of markets to reach his present position in a highly rated New England station. Surprisingly, though, he began his career in Albany, New York, as a broadcast technician. He became bored with repairing videotape recorders, and when there was an opening for a weekend meteorologist, Flanders pointed to his radio on-air experience and his dual-major degree in communications and meteorology. He got the job but also stayed in his position as a technician. Flanders worked seven days a week—technician during the week, weathercaster on the weekends—for two years. His break into full-time weather forecasting came when he secured a job in a good market in the Midwest, a position he probably would not have qualified for without those years of part-time experience.

Persistence pays. Will Lyman, now one of the best-known voice talents in the country, worked for years without much recognition until the break into the *Frontline* program. Then things began to take off.

Not all of you will achieve national fame, or a regular job in a major or medium market. But each of you can and should make the most of your talent, constantly working to improve. Otherwise, you are cheating yourself.

Summary

The ability and determination to improve is as important to the on-air broadcaster as raw talent. Evaluation is vital to improvement; you can listen to or view a tape of yourself, or have an instructor or colleague monitor the tape and offer criticism. When reviewing your own tapes, be as objective as possible. Evaluate in terms of pure communication. Break down problem areas into specifics. Identify distracting elements, such as poor speech habits. Use the self-evaluation checklist presented in this chapter, as well as the checklist for long-term planning.

Once problems have been identified, you can begin the process of improvement. In addition to working on problems uncovered in critique, an improvement program centers on enhancing strong points. Discover your special abilities and capitalize on them.

Many pros project the image of smooth success. Often, however, it took struggle, failure, and more struggle to get where they are today. And it took determination, careful attention to improve, and the willingness to adapt and to sample opportunities.

E x e r c i s e s

1. Evaluate one of your tapes, using the checklist provided in this chapter. Prepare a tape in a field you particularly enjoy and hold as a career goal, such as rock music air personality work or television news.

Make an effort to check yes or no in every category. If the answer to a question is yes, grade your performance on that particular attribute excellent, good, or fair. For example, after answering this question

Does the pace sound natural? Yes_X_ No____

try to quantify the naturalness of the sound on a scale of 1 to 5. Was the level of naturalness good (4) or excellent (5)? In the margin of the checklist, make notes on these and other items.

2. Use the same method for evaluating the performance of an on-air professional in your selected field. Choose someone whose work you particularly admire.

3. Design a series of five exercises to deal with the particular problems you encounter in your on-air delivery.

One announcer who had problems with ending patterns, for example, read 10 minutes' worth of copy and played back the tape, carefully scrutinizing the ending patterns. The tape confirmed that every sentence ending went down in pitch, over and over and over. Then the announcer wrote notes in her copy to help overcome the problem. Her notes represented changes in pitch and looked like this:

 still public.
would be the
 unavailable to

These notations, and constant repetition, were able to help the situation significantly.

Remember that the point of self-evaluation and self-improvement is that no standard set of exercises will help everyone in every situation. As a professional, you must take responsibility for isolating problem areas and working toward their resolution. The five exercises you develop can be a good start toward this goal.

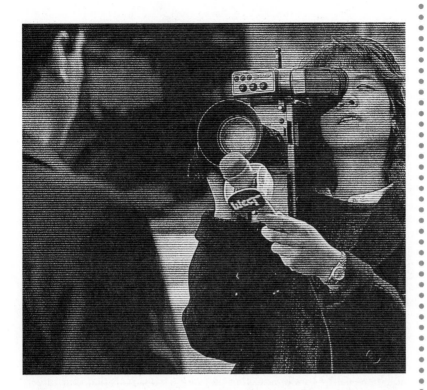

Career Advancement

Talent, skill, hard work, and a desire to improve are useless if you can't get a job. On-air broadcast work is difficult to break into. Competition is tough even for low-paying, entry-level jobs. And if your career pattern is typical, once you have broken into broadcasting you will change jobs several times.

Your first job will probably be the toughest to get. The pay will be low and the work demanding. But you'll probably learn more about the business of broadcasting in your first job than in any course you take. Professionalism in on-air work comes only through experience. Broadcasting is a business you learn in the business.

In this chapter, we focus on what you need to do to get and hold a job. We discuss opportunities available to broadcasters and pass on hints from broadcast managers and talent agents about what techniques are most likely to help you get started in the field. We also discuss the tools of getting hired—résumés, audition tapes, and developing contacts. And finally we look at salaries and contracts.

On-Air Opportunities for Broadcasters

With the understanding that a beginner will be paid as a beginner, even with a college degree, you are ready to start your search for a broadcast on-air position. That first job will almost certainly involve duties you will not like or want to do, but versatility is essential. Although your goal may be TV news anchoring, you may have to pull many radio music show shifts. Aspiring ra-

dio personalities must do news. Sportscasters may have to produce commercials. All duties you will be asked to perform must be done with a smile, for realists understand that there are dozens of applicants for even the most humble positions, and hundreds for the desirable jobs.

You must be in good physical condition, because your career will frequently involve terrible hours. A shift may start at 5 A.M., continue until 2, and then begin again with the evening newscast at 5 P.M. In radio, shifts of six days per week are common. And don't expect holidays off. The show, so to speak, must go on. Colds and the flu won't automatically qualify you for a day off, either. If you are expected to sign on the station at 6 A.M., you *must* be there unless you can rouse the manager out of bed to take over your shift.

You must be in good physical condition, because your career will frequently involve terrible hours

After a year or so of successful and dedicated work in a small market, you might, repeat *might,* be able to move on to a better small market or a medium market. Never take such advancement for granted, because the competition is stiff. A modest broadcast job, which does not pay more than that of a kitchen helper in a good restaurant, can easily attract a hundred applicants.

If these prospects do not discourage you, if you are so set on on-air work that you can ignore the odds, and if you realistically think you possess the talent to overcome the challenge of hundreds of other applicants, you may have a future as on-air talent.

On-Air Jobs

An important consideration in the life of an on-air performer, in news or radio personality work or any other part of the industry, is that your career path is likely to resemble that of a gypsy. Your résumé will look like it was written by Rand-McNally, as some broadcasters say.

There is no reason why a broadcaster must move from market to market if he or she is content to work in a small town. Broadcasting from small towns often is of high quality, and the small-market environment offers safety and ease of existence unknown in major cities. Small-market broadcasters do not become rich and famous, but they enjoy a fine quality of life and a great deal of influence.

Medium-market on-air people also can enjoy good-quality lifestyle, and cities considered to be medium markets, such as Syracuse, New York, or Austin, Texas, offer, in smaller doses, every advantage of a major city. Medium markets frequently have professional sports teams, symphony orchestras, and major universities. They also are more likely to have affordable housing than major markets.

The big money, however, comes in the major markets, the Bostons and Philadelphias. Radio personalities make generous salaries, and the salaries of TV news anchors are in the six-figure range. The majors are difficult to crack, however, and there is no accompanying rise in job security.

Sometimes newcomers to broadcasting elect to settle in major markets and work their way up through low-level jobs, such as mail room or even janitorial duties. This approach has pluses and minuses, which are discussed shortly.

As mentioned, the beginner will have to do many jobs not directly related to what he or she perceives as an ultimate career goal. Such exposure is beneficial for two reasons:

1. Trying a wide variety of jobs gives you exposure that will be valuable later on in your career. The value might not be apparent immediately, but any experience in the business usually is an asset regardless of your career path. If, for example, you wind up in some form of management, that period in sales or production will certainly enhance your knowledge of the business overall and make you a better manager.
2. You may not have enough ability to pursue the career path you think you want to follow. Or, you may want to do well as a disc jockey but find that you hate the job. Many an aspiring disc jockey has found more satisfaction in news, and vice versa.

People in a position to hire you will appreciate—even demand—versatility and a willingness to work in a variety of assignments. Virtually without exception, they will place a higher premium on demonstrable professional experience than on a professor's statement that you were a fine student. And you may be required to start in an off-air job and earn the chance to go before the camera or microphone.

Humility is important, not so much as a rite of initiation but as a realistic approach to the task of finding a broadcast job. Your realistic self-assessment and willingness to work will translate into what broadcast executives think of as a good attitude.

Jeff Rosser (Figure 12.1), news director of WNEV Television, Boston, discusses the advantage of a good attitude for an applicant. Sitting in his office in the station's modern headquarters, he gestures toward a table stacked twelve-deep with videotapes. "All those tapes," he says, "are from professionals with years of experience in small and medium markets. Yet I still receive applications from recent graduates who want to start on-air."

Rosser and other broadcast executives echo the contention that the chances of a newcomer, slim to begin with, are often made worse by a somewhat arrogant approach to the application process. Many neophytes refuse to hear of anything other than on-air work, even though production or writing or other duties might be the only available avenue toward their goals. Other applicants destroy their credibility by overstating their résumé qualifications, for example, by listing "extensive experience in documentaries" to describe participation in two college projects.

In essence, Rosser advises that Boston is not the place to start looking for a job. "Start at a smaller station. You'll be allowed to try a wide variety of jobs, and will get to make some mistakes and learn from them. The only way to learn a job is by doing it.

"Some people do start as copy-rippers in major markets, but a lot of them, after a couple of years, are asking themselves, 'Why am I still ripping copy?'

▼

"Start at a smaller station. You'll be allowed to try a wide variety of jobs, and will get to make some mistakes and learn from them. The only way to learn a job is by doing it."—Jeff Rosser.

Figure 12.1. Jeff Rosser, news director of WNEV-TV, Boston.

Wouldn't it have been better for that person to have gone to Vermont and learned how to write, or how to run a camera?"

While Rosser's advice is aimed at aspiring newspeople, it applies well to graduates in any broadcast field. And his final point perfectly sums up the goal of the applicant in the broadcast industry: "When I hire someone, I tell that person, 'All right, you're good, and I'm going to grant your wish. I'm going to put you on air, and provide you with a staff of more than a hundred people to help. We're also going to provide you with millions of dollars' worth of equipment for you to use in preparing your work. Then, we're going to take your piece and present it to hundreds of thousands of people. And we're going to pay you very well in the process.' Now, who could hear that and not be enthusiastic about the job?"

Moving into Management or Related Duties

A realistic assessment of on-air work shows that it is difficult to obtain, and advancement involves tooth-and-nail competition among a veritable army of dedicated, talented people. But even though on-air work does not become a lifelong career for many, it does provide an excellent springboard into other occupations. Some on-air talent moves into management, especially in radio. Program directors often started as announcers. Today's radio program director has a job that is often a cross between chief announcer and executive in charge of the music, programming legalities, and overall station sound. News on-air people can move into news management. Most news directors have some on-air background, which contributes to their understanding of the overall news effort. The top levels of station management are generally drawn from the ranks of sales. But there is nothing to prevent a radio staff announcer from combining his or her early career with experience in time sales. In some markets, selling is part of the job. In almost any radio market, good salespeople outearn on-air talent.

The entire chain of human communication is interrelated at almost all levels. On-air performers frequently elect to move into positions in advertising and public relations. Contacts made during and after working hours facilitate this kind of change, and the insights picked up during years of on-air work will help in this or any other career.

Preparing for Your First Job

Your first job in broadcasting will probably be the most difficult to get. There is intense competition. If you have talent, though, and are willing to take a job that may be less than ideal, eventually you will get hired. Once your foot is in the door, you have a chance to compile a record of performance. Then you will be better able to select the kinds of situations that let you advance in the career direction that suits you best.

Preparation for a career in broadcasting involves two major components: academics and practical experience. For on-air work, a third ingredient is a certain amount of native talent. Since there is little to be done about your degree of innate talent, let's look at the things you can do something about.

It is difficult to recommend a precise academic program without knowing exactly what career path you will follow. You will probably explore several areas before settling into your major career focus. Let's look at some academic preparation that can be helpful in on-air work.

Since you're reading this textbook, you are probably taking at least one academic course in broadcasting or communications. Preparation in this area can be a focused program given in professional training schools, a slightly longer preparation in two-year schools, or a four-year program that adds other courses and awards a bachelor's degree. More advanced work at the master's-degree level and beyond is usually designed to prepare people for broader professional responsibilities in the communications field.

Whether you're aiming for on-air work in radio or TV, in news or entertainment, one overall guideline applies: *Learn as much as you can about as many things as you can.* You're looking for depth *and* breadth.

If you're a communications major in a four-year program, take as many courses outside that major as you can. Try for a good mixture of such areas as political science, history, economics, and literature. Earlier we recommended that you consider a double major. If you do, select your second major in one of the areas just mentioned.

If you aspire to a career in television news, you might want to consider journalism as a possible major or second major. According to talent representative Sherlee Barish, an increasing number of people being hired for TV news jobs have had experience in print journalism. They know how to write, and they know how a news story goes together. Barish says that being knowledgeable in political science and economics can be very helpful to TV news reporters as well.

In modern "personality" radio formats, on-air jocks need to be extremely creative. They need to know how to write and produce material quickly and professionally, according to General Manager Brad Murray of Baltimore's WQSR-FM. To prepare for that kind of work, courses in creative writing and drama would be very helpful.

Courses that help you with technical aspects of broadcasting will be an asset. Particularly at the entry level, a knowledge of camera operation and editing in television news, and of audio production in radio, is usually necessary. Formal training in performance skills is also valuable, of course.

Preparing yourself academically is easier to do *before* you get a job. If you find out later that you should have taken more history courses while you were in college or that advanced TV production would have been helpful, it can be difficult to correct the deficiencies. Get as much academic preparation as you can while you are still in school and you'll improve your immediate employment prospects as well as your ability to advance.

In broadcasting, a vital ingredient in preparing for a career is getting practical experience. Get all the practical experience you can while you're in school.

Academics

▼

Learn as much as you can about as many things as you can.

Practical Experience

People who do the hiring in broadcasting will invariably ask you what you did as a student to develop your skills in a practical setting.

You can get a certain amount of useful practical experience by working at the campus radio station. If you're interested in broadcast journalism, you can also gain useful experience by writing for the student newspaper or literary publications. If you're fortunate enough to have television facilities on your campus, take advantage of any opportunities to work on production crews or in other assignments related to television.

Give yourself an advantage when you get involved in these on-campus "laboratory"-type experiences: take them seriously. The more disciplined you are in such situations, the better you will be prepared to work in a professional setting.

This is the place to make mistakes. And, like everyone else, you'll make plenty of them. The difference between your on-campus job and the professional setting is that in the campus setting there usually is life after mistakes. Try not to write off mistakes by assuming they don't matter because "it is just the college station." Instead, find out what you need to do to correct the problems. Don't let yourself develop a careless attitude about your performance. Strive to be as good as a paid professional broadcaster.

All the campus media experience you can get will not take the place of work in an actual professional setting. Internships and summer work offer you the best chances to get real professional experience while you are still a student.

Landing an entry-level position in broadcasting is tough enough. If you have not had an internship, it's even tougher. Most people who hire broadcasters say they consider internships more valuable than a heavy concentration of academic work in broadcasting.

Learn as much as you can early in your college career about how to get the internships that will give you the kinds of experience you need. Most internship programs have good and bad jobs. Try to find out which internships provide solid experience. Don't be afraid to branch out from on-air work. The fact is that there simply aren't many opportunities for on-air work in most internship programs. Do try, however, to aim for the general area you want to work in. If you're interested in radio, don't jump at the first internship that comes along in a TV promotions department.

And when it comes to internships, you don't necessarily gain an advantage by looking for the biggest market. According to Sandy Moore, in an article written titled "Tips for Scaling the Job Hunt Wall" (in *The Quill,* published by the Society of Professional Journalists), most professionals recommend smaller markets for internships rather than large operations.

The pros with whom Moore spoke noted that in large media operations interns often get stuck running for coffee. In addition, large operations often have too many levels of staff people who do the kinds of work that you're trying to learn. So you are less likely to actually perform hands-on tasks.

Shoot for something smaller. There are usually plenty of opportunities to get into the thick of things in medium-market stations. You'll also have a better chance to get feedback from supervisors. One broadcaster Moore consulted said that, in his experience, large operations often tend to give some students an unrealistic view of the broadcasting profession. In most broadcast settings, fewer staff people do more things. The large operations, with several people assigned to most areas, are the exception rather than the rule.

If the market is too small, you may find it difficult to get any feedback. Often in such operations interns get shunted into an area that is not covered by other staff people. In such situations, you can get tied down to performing a single task throughout your internship. As a result, you have less chance to gain experience and knowledge outside of that single area.

Regardless of operation size, it is of primary importance to get at least one internship. If you have the opportunity to do more than one internship, take it. The experience you get from internships is worth sacrifice and hard work. Remember there are many more applicants than entry-level jobs in the broadcasting profession, and the vast majority of those you'll be competing with will have either professional experience or internships on their résumés. To compete effectively, you'll need the edge that internships can provide.

Once you have finished your academic and practical preparation, you begin making your bid to enter the broadcasting field. Getting your first job is extremely difficult. Many more people are looking for on-air work than there are good jobs. People with talent who really want a job badly will find opportunities, and eventually there may even be well-paying, prestigious positions. The key is to persevere long enough to get your foot in the door.

You will find it particularly difficult to start out in TV on the air. You will be competing for jobs with experienced people with tapes that show actual news-reporting assignments. Those who manage to land on-air TV jobs usually start out as news reporters.

In a small market, the job of reporter can include camera operation and tape editing. The hours can be long and the work exhausting. When your contemporaries work 9 to 5 and earn much better money, it can be difficult to hang on long enough to turn the corner in your career.

Sherlee Barish, who represents on-air talent in television news, weather, and sports, says that people who want entry-level positions in television should be willing to start in a small market and relocate every couple of years as they try to move to larger and larger markets. "It's a glamour industry and it's overpopulated," says Barish.

Barish says that the current economics of television have reduced the size of news staffs at many stations. Huge debts incurred in purchasing TV stations at enormous prices have led to efforts to economize. "A station that once

▼

The experience you get from internships is worth sacrifice and hard work.

Job Hunting

Television

277

had seven or eight news crews may have had to cut back to three or four," says Barish. Economics have also caused shrinkage in the level of salary increases as well. "Stations that used to give 10 to 15 percent pay increases are now giving 3, 4, and 5 percent increases," she says. In some cases, anchors have even taken salary cuts, according to Barish.

Radio

Brad Murray, general manager of WQSR-FM in Baltimore, says that getting started in an on-air career in radio is a matter, for most, of learning the ropes in small markets and shooting for the larger markets when you have made your mistakes and learned how to handle yourself in a variety of situations. Murray says that there are virtually no opportunities on the air for entry-level on-air people in the large markets.

Hiring in major markets is very precise. Murray's station tries to hire on-air people who fit the demographics of the listeners. His station appeals primarily to people ages 35 to 44. On-air people in that age range are far more likely to understand what the music means to listeners than is someone who doesn't have the same associations between life experiences and particular record cuts.

Breaking into radio at the small-market level is a matter of being willing to take jobs that may not offer much pay and benefits. Be willing to take almost any on-air opening you can get as a first job. Your objectives are to start building a résumé, get as much experience as possible, and perfect your skills as an on-air performer. Once you've gotten some practical experience, you can begin to look at opportunities that more precisely fit your requirements for salary and career advancement.

Whether you're looking for your first job or shooting for that major-market anchor position, though, you need to develop some specific tools and techniques to present yourself effectively to whoever is doing the hiring.

Self-Marketing Techniques

Now that the groundwork has been established, let's consider the nuts-and-bolts business of getting hired and, once hired, furthering your career. Your college experience and academic preparation will serve as a good foundation. To properly showcase your academic preparation and practical experience, you'll need to put together an effective résumé and a showcase tape, two of the tools commonly used in self-marketing.

Résumés and Tapes

Although a good résumé and tape are important for a beginning broadcaster, they are not the be-all and end-all of a job search. A beginner's résumé rarely if ever contains elements evocative enough to urge a program director, news director, or station manager to hire that person based on the résumé alone. A tape is obviously important, and must demonstrate raw talent, but in the absence of good, solid, professional on-air work, a tape is not in itself a very powerful marketing tool for the beginner.

Experienced broadcasters can send a tape and résumé and expect results. The tapes and résumés of beginners will commonly be in direct competition with those of experienced professionals, and experience is usually the deciding factor.

Résumés and tapes are only tools in the marketing effort. They will not get the job done by themselves. Being hired requires interviewing, following up on leads, and making contacts. With the understanding that a tape and résumé are the first steps in job hunting and career development, let's examine each tool.

Résumés A good résumé will stress experience. Recognizing that experience for a recent graduate will be sparse, stress whatever coursework or internships you have had that are particularly relevant.

Richard Labunski, a faculty member in the School of Communications of the University of Washington in Seattle, noted in a primer prepared for conferees and interns of the International Radio and Television Society, "Generally speaking, a résumé of a new college graduate with internships and work at the campus radio station should only take one page." In a seminar on job seeking, Labunski advised, "If you need to, you can run your résumé to two pages, but under no circumstances should it be longer than that." The résumé shown in Figure 12.2 is an example of a good résumé format.

Activities or work experience unrelated to your field are superfluous on a résumé unless an entry for a civic or voluntary activity reflects favorably on you. Two other points are advocated by Labunski.

1. Avoid putting in your résumé an "objective" or "position sought" category. You can always discuss in your cover letter why you are seeking and are qualified for a certain job. Keep your résumé as generic as possible so you can use it for many different positions.
2. You do not need to list references in your résumé if the space would be better allocated to something else. An employer will almost always ask you for references anyway, before you start in the job. If the résumé looks too short, references can be used to fill space.

It goes without saying that your résumé must be clearly typed and free of any mistakes. Have the résumé typed on an excellent-quality typewriter or computer printer, and shop around for a good printing job. Be sure that the reproductions are crisp and clear. One worthwhile option that is not especially expensive is to have your résumé reproduced on stiff, good-quality paper. Ask for a bond paper with 25 percent rag content.

Audiotapes Your audiotape should reflect experience with the kinds of duty available at the station to which you are applying or needed for the particular

Figure 12.2. A sample résumé.

Deborah Smith-Jones
422 Spruce Street
Highspire, PA 17034-1526

Phone: 717-555-2765

Qualifications Summary: Experienced radio and television news reporter and anchor. Strong writing and verbal communication abilities. Skilled in making complex issues understandable. Clear perception of the need for concise presentation of information through effective writing, and the skilled use of production techniques.

Experience:

Weekend and fill-in anchor and field reporter for WWWW television, ABC television affiliate in Grand Isle, Iowa. Experience gained over a 4-month period as student intern in television news. Received commendation from news director for a report on Grand Isle's homeless population.

Wrote and produced a series of five-minute radio features on personal finance for teenagers called "Fun and Finance." Series ran for two years as a regular feature on WNNN, the university-owned FM radio station serving the Grand Isle area. Also performed as on-air talent for the series.

On-air radio news anchor and Director of News and Public Affairs for WNNN radio. Wrote and delivered news broadcasts for station over a three year period while a student at the University of Iowa, Grand Isle. Served as director of News and Public Affairs during senior year. Received Alpha Chi Rho award for a series called "Students in the Neighborhood." The series, on student/community relations, was credited with improving community understanding of student life in the community.

Accomplishments:

Selected by university president to represent the university at a meeting of student leaders held in Washington, D.C. to discuss ways that college and universities can better communicate with residents of the communities in which they are located.

Recipient of the Alpha Chi Rho "Broadcaster of the Year Award," for District 7.

Wrote a feature article titled "The Students Among You," published in *The Sunday Grand Isle Gazette.* Article presented the student point of view on community living, and listed ways in which relations between residents and students could be improved.

Education:

B.A., broadcast journalism, University of Iowa Grand Isle (May 1992). Courses include: TV news reporting, mass media in society, broadcast news writing, news gathering and writing, and mass media law; and courses in economics, history, political science, sociology, and English.

References:

Available on request.

Audition Materials:

Talent samples on video and audiotape, available on request.

job you seek. If the job involves afternoon drive at a radio station featuring a hard-rock format, you will be well served by a tape featuring a similar approach.

For audio, cassettes are acceptable but small reels are better. Reel-to-reel tape machines are usually hooked up to better-quality speakers, and you can gain a subtle advantage by presenting your tape in this manner. The best way to present a tape is at an interview.

For audiotapes, you can probably do some individual tailoring, since radio production equipment is more readily available than video. But in many cases you will have to produce a general tape showing basic skills. For a basic audiotape, consider assembling a brief—5 minutes or less—collection of pieces that includes the items shown in Box 12.1.

If you feel confident that you will specialize in radio news, your tape can emphasize that area. But do not rule out airshift work because that may be all that is available.

Videotapes This, of course, is the ideal situation. Tapes are difficult and expensive to produce, especially for television. Realistically, you must make

B O X 1 2 . 1

An Audiotape Collection for Job Hunting

1. *A few record intros.* Do not, of course, play the records all the way through. Fade down the cuts after a few seconds. Demonstrate your enthusiasm in this very brief time, as well as your ability to match vocal style to the music and to handle the console.

2. *A brief newscast.* Pay particular attention to showing contrast between and among stories and to reading with meaning.

3. *One or two commercials.* Show your naturalness and acting ability.

4. *An ad-lib.* The ad-lib can be part of your music intros. Have it show humor, have it show knowledge of music, but above all make it demonstrate *your ability to be conversational.*

do with what is available at your school or campus station. A job for a general-assignment reporter at a TV station requires a tape with one or more packages, perhaps a minute or 1:30 in length. If you have the ability to produce a videotape in school, by all means do so, because hiring a professional studio is very expensive. One method of putting together a tape is to showcase a broad range of skills in television performance. A tape that does this (on 3/4-inch cassette) might include the items shown in Box 12.2.

If you're shooting for a job as an on-camera news reporter, showcase your various talents in that area. According to Lou Fox, a talent agent with many years of experience in placing people in broadcast news positions, such a tape can make you or break you.

Fox says that too few students coming right out of college submit audition tapes that truly represent their talents in news reporting. Fox lists the following guidelines in preparing a new audition tape.

1. *Begin with the piece that does the best job of showing you and your talents.* Saving the best piece for last is not a good idea. If a news director

B O X 1 2 . 2

A Videotape Collection for Job Hunting

1. *A news anchor segment.* Show eye contact. Use a TelePrompTer if one is available. Demonstrate as much as possible your ability to convey information and show your interest in the news.

2. *A stand-up commercial delivered straight to the camera.* Write a commercial yourself, and deliver it. If possible, use props.

3. *A short interview* (no longer than two minutes). Put an opening and closing on the interview to demonstrate that you can manage time restrictions. Show that you can handle yourself and others in an on-air situation and that you can get right to the heart of a topic.

4. *A news package, if available.* If not, deliver a stand-up news report to the camera.

doesn't see something good right away, chances are he or she will stop the tape and never see that great piece you used as the grand finale. So although you may have looked like a budding Connie Chung, no one will know it. Remember that the story is not the important thing. It's better to have a school board story that features you, than a tornado story with your only appearance being a brief stand-up at the end.

2. *Include samples from a variety of different types of reporting assignments.* Include stand-ups, live interview segments, voice-overs, and feature pieces that you put together. Don't assume that a lengthy segment at the anchor desk is going to do it. Most first-time jobs will be in general-assignment reporting, not anchoring. So focus on the category that counts.

3. *If possible, include something that shows how well you edit and handle a camera.* The small-market news reporter will need to have those skills. Don't overdo this part, but try to include it somewhere, possibly as the last thing on the tape.

4. *Don't put a lot of leader on the tape.* Busy news directors who must scan 150 to 200 tapes don't want to sit through 30 seconds of color bars and 10 seconds of black before they get to what they want to see.

5. *Make sure the first thing anyone sees on the tape is you.* Don't lead off with 50 seconds of a fire chief's long-winded comments and end with 15 seconds of your stand-up. By the same token, take the time to compress the actuality segments. The news director is not interested in 90 seconds of the fire chief after you've asked him a 5-second question. Edit out the extra material and keep the focus on you. Total length of your tape shouldn't be more than about five or six minutes.

6. *Spend the necessary time and effort to produce the best tape you can.* When the news director is getting down to the final two or three tapes and all are pretty good, he or she is looking for reasons to eliminate one or more of them. Don't give him or her a reason to dump you simply because you didn't correct something minor that you thought would be overlooked. You'll seldom know why you didn't get the job or how close you came. Don't take the chance of missing out just because you didn't want to be bothered to do another take or because your production was sloppy.

It can of course be difficult, when you don't report news every day, to come up with a tape that does everything. Fox advises candidates to be creative. Ask for help from local news directors. They probably won't put a camera crew and studio time at your disposal to produce your tape, but they might spend a few minutes telling you what they look for in a good tape. That will help you avoid the considerable expense of commercially producing a tape that is useless because it contains the wrong material.

In rare cases, you might be allowed to tag along with a news crew for a day or two. If things work just right, the crew may let you reinterview a

news subject and use the tape in your audition. One of the authors of this book, who had just appeared as a guest on a live segment of a local newscast, was asked if he would mind being reinterviewed on tape by a candidate for a reporting position at that station. As it turned out, the candidate did the reinterview more professionally than the reporter did the on-air interview.

The point is that if you want to beat the odds and land that first job in TV news, you must be creative and aggressive. If one approach doesn't work, try another. Persistence may well pay off in a tape you can be proud of.

It is unlikely that you'll get your tape returned. With videotape, this can get expensive. You can improve your chances by enclosing a stamped, self-addressed envelope. You may be able to present your tape at an interview if the hiring station has only requested résumés and letters as the first step in the search for candidates. But given the large number of candidates who desperately want the jobs that become available, most stations can skip that first step and simply request tapes in the initial ad. In that case there's no point in telling them you'll be happy to supply a tape if and when you're interviewed. Go ahead and duplicate your master tape, and write off the cost as an expense of your job search.

Job Leads and Sources of Leads

One of your best tools for uncovering job leads is an effective letter. It may be the cover letter for your résumé, or simply a letter addressed to the program director, manager, or news director of a station in which you are interested. Such a letter to a station executive should do three things:

1. *It tells the program director that you are going to be in town on a particular date.* Broadcast executives are more likely to agree to talk to you if you will be in the area anyway, because they are very reluctant to invite anyone to travel a long distance to discuss a job that may not exist.
2. *It lets you meet the executive and discuss the station and the broadcasting business in general, not a particular job or future employment at that station.* Again, giving the impression that you are courting an immediate job will often draw the response "We don't have any jobs." A more general request can often be more productive.
3. *It introduces the writer, tells something about his or her background and qualifications, and shows that the writer has undertaken to research that particular station.* Never send out a form letter, either as a cover letter or in scattergun applications.

Be sure to send letters to a person, not a title. This shows that you have made some effort to find out the identity of your prospective boss. To confirm his or her name, you can call the station's news department (in the evening,

284

to save telephone tolls). Also, if you can show that you understand the community and its needs, so much the better. If you secure an interview, you may have a chance to play your tape and to discuss career goals and opportunities at this particular station.

Volumes have been written on the technique for a successful interview, and little can be added to this body of knowledge other than to emphasize the most important points of all:

- Express enthusiasm and a willingness to work in any capacity.
- Know something about the station, its format, and its audience.

Information about stations and station personnel and information on cable operations can be gleaned from the same source that yielded the name and address to which you sent the letter: *Broadcasting/Cablecasting Yearbook*. This expensive volume (about $80 at the time of writing) is available at the reference desk in larger libraries and furnishes the call letters, addresses, telephone numbers, and names of management personnel for all radio and television stations in the United States. Other information concerning technical specifications, format, and special programming is also supplied. Remember that broadcast employees change jobs frequently, and if your budget permits, call to confirm that an executive listed in the *Yearbook* still works at the station.

Other sources of job leads include the classified sections in *Broadcasting*, a weekly periodical also found in many large libraries. You may want to subscribe to this magazine, and the address is provided in the Suggested Readings at the end of this book. Do not rely too heavily on the classifieds in *Broadcasting;* very few employers will pay for an ad in a nationwide trade to recruit beginners.

Your first job may be turned up by a job search, or may surface from word of mouth. That is why contacts are so important.

Friends, friends of friends, and even their friends can be valuable to you in the search for employment. Broadcasting is a tightly knit club, and many jobs are never advertised. They open, are heard about on the grapevine, and are filled by someone who knows someone.

This is a business where an announcer might quit on the same day you walk in, tape and résumé in hand. By virtue of being in the right place at the right time, you may land the position. Or a friend in the station may let you know about the opening. Sometimes the executive with whom you have had a "getting to know you" interview will remember you, like you, and retrieve your telephone number from the top of the résumé.

Every contact you make, every interview you arrange, is a factor in your favor. Do not look on "contacts" as a dirty word, because in the business of

Developing Contacts

broadcasting it is not. Broadcasting is a business of contacts. Here are suggestions for developing your own set of contacts:

1. *Stay in touch with your college communications department and with alumni associations.*
2. *Keep in touch with alumni.* Write down the names and addresses of alums and keep track of their progress. College and university "old boy" networks can be extremely valuable.
3. *If you are turned down for a job, try to keep the person who turned you down as a contact.* Never, never burn your bridges with an executive who does not hire you. You may have been a close second choice, but if you express anger and outrage at not getting the job, you'll never be in contention again. Instead, contact the person who did not hire you and find out, in a nonconfrontational way, why you didn't get the job. Say that you are concerned with self-improvement and would like to know how to better yourself. Perhaps it was a simple matter of needing more experience, and the job could be yours next time.

The Business End

Broadcasting is a business run by businesspeople. Some of these people may have been performers at one time, but they are not generally motivated by artistic goals. Quite properly, they are concerned with turning a profit. The fact that broadcasting is a business means that we must discuss pay and general working conditions.

Salaries

Salaries in the broadcast field, particularly for on-air performers, are generally far lower than most members of the general public might expect. This is particularly true in small markets, where even well-known local broadcasters may be making close to minimum wage.

At the entry level in broadcasting, pay is very low. Along with print journalism, broadcasting ranks among the lowest professions in terms of the salaries paid to beginners.

Until you have established a track record, there isn't really much to be done about the poor pay level. This situation holds generally true whether you're looking at television or radio. Expect to be offered no more than $14,000 to $15,000 per year in most small- and medium-market stations if you're looking at news jobs.

Talent agent Lou Fox points out that many entry-level TV news reporters with no commercial experience start out in the $11,000–$12,000 range. On that salary, he notes, they not only have to pay the same living expenses as everyone else, such as food and place to live, but they also need to have a very good wardrobe. Their on-camera appearance must not reflect the poverty-level wages they're making.

Vernon A. Stone, a professor in the School of Journalism at the University

of Missouri, Columbia, each year compiles statistics on broadcast salaries for the Radio-Television News Directors Association. He says you can expect to dwell at the bottom of the salary ladder for a year or two at the beginning of your career.[1] If you stay in the business long enough to reach average salary levels in news, you can expect something in the range of $20,000 to $30,000 in 1990 figures.

In radio, entry-level salaries can still begin in the range of $13,000 to $15,000. At the top levels, radio personalities in the major markets working in drive time can make up to $200,000. In the Baltimore market, the highest salaries for radio personalities are in the range of $150,000 in 1990. More commonly in a market the size of Baltimore, salaries for staff announcers with a morning, afternoon, or evening airshift range from a low of about $25,000 up to $70,000.

Large-market radio personalities often supplement their income by making personal appearances. They can often add $20,000 or so to their annual salaries through these extras.

In medium markets, radio air staff often move up to the program director level. In suburban Virginia, program directors are paid between $30,000 and $40,000 in 1990 dollars.

TV newspeople in mid-career outpace their news counterparts in radio, though large-market radio news directors are currently averaging around $30,000.

In general, as has been discussed, salary is pegged to market size. Market size is described by the ratings of *areas of dominant influence,* commonly known as ADIs. There are slightly more than 200 ADIs in the United States, with New York being the largest and Los Angeles the second largest. The smaller the ADI number, the larger the market. Thus New York is ADI 1 and Los Angeles is ADI 2.

A beginner generally does not have a good chance of cracking the top sixty or so markets. That means, for a while at least, working in a smaller market and accepting a small salary. Your starting salary will reflect the size of the market, the health of the station, and the worth of your position. Every station manager has a good idea of the maximum value of a particular job. The morning drive announcer at a local radio station, for example, will never be paid more than the position generates in advertising revenue. The station owner and/or manager, obviously, will also have to deduct overhead and allow for a fair profit. Therefore, the person controlling the purse strings will know that no morning announcer, no matter how good, is worth more than

[1]For a discussion of entry-level salaries for various broadcast jobs, see Vernon A. Stone, *Careers in Radio and Television News* (Washington, DC: Radio-Television News Directors Association, 1989), pp. 9–10.

$250 a week for this particular position. The market reaches a point of diminishing returns.

The particular economic conditions in a market, such as the popularity of the station and the amount of competing signals from major stations, will determine the maximum value of that position. There is so much variety among markets that quoting salaries based on market size is misleading. One profitable radio station in Watertown, New York, for example, will pay a morning drive announcer in the neighborhood of $35,000 per year, even though the market size is in the 160 category. Other markets deep in the hundreds might pay a fraction above minimum wage. One television reporter in the 60th market makes about $23,000 per year, despite almost two decades of experience. He works at a station with poor profits in a market dominated by competing TV news operations.

Yes, major-market air professionals make a great deal of money, but that is a long trip down a difficult road. And even a moderate salary in a larger market can leave you devastatingly poor because the cost of living in a big city is so high. When considering jobs, check the cost of apartment rentals before committing yourself.

Contracts

You may be asked to sign a one- to three-year contract after being hired by a broadcast station. This is not likely for a beginner, however, since most small markets do not have contracts.

Contracts specify many different things but always put salary figures in black and white, often with built-in escalator clauses. Sometimes the salary is renegotiated yearly.

A contract entails an obligation on your part and on the station's part. It will state a specific period of time in which you agree to stay in the station's employ, but in *most* cases stations will not hold you strictly to this clause. You can typically escape a contract as long as you are not going to a directly competitive station within the market. If you want to move to a competitor before your contract has expired, however, you may have a fight on your hands.

Contracts also work for you, specifying some of your working conditions and hours. Most contracts say that you can be discharged only for "good cause." That vague term is not ironclad protection, but it is better than none at all.

Agents

For top performers, an agent is a necessity. For beginners, an agent is out of the question. Agents act as middleman between a performer and management. In return, they take a percentage of a broadcaster's salary.

As a beginner, your salary will be too low to attract any agent who works on a percentage basis. As you progress, you may wish to engage an agent, or, when the time is right, an agent will contact you.

Many big-time performers find that an agent not only attracts and screens

assignments and negotiates the best possible financial package but also serves as a buffer between management and the performer. A performer will not have to haggle directly with his or her boss.

The primary union for on-air talent is the American Federation of Television and Radio Artists, known as AFTRA. Other unions that may have some involvement in a performer's career are the National Association of Broadcast Engineers and Technicians (NABET) and the Screen Actors Guild (SAG). Unions set minimum salaries for employees at covered stations, along with guidelines for working conditions, hours, duties, recording fees, and residuals.

You do not have to be a union member to be considered for a job at a union station. Because unionized stations are generally, but not always, those in the larger markets, most beginners will not have to join a union. As you progress, you may be hired at a unionized station. Then, after a certain grace period, you will be required to join the union.

Union shops may restrict your activity to the duties described in a rigidly drawn contract, which is why large markets with tightly specified union restrictions are not the place to experiment with various aspects of the job.

Broadcasting is a simple business, really. If programs on the air do not deliver a sufficient audience, the station gets rid of the programs—and with them, the talent. The business of broadcasting must have a bottom line, and the rating system determines much of that bottom line. Although everyone involved in broadcasting agrees that current rating systems are far from perfect, they are the only way broadcasters can quantify success or failure.

A rating is a percentage of all possible listeners or viewers in an area who are watching or listening to you. A share is the percentage of listeners who are watching or listening at a particular time who are tuned into a particular station. Thus a 2 rating and a 20 share on a radio program means that the program had 2 percent of people with radios tuned in, and of all the people tuned in, 20 percent were listening to that particular show.

The primary rating systems for television are conducted by Arbitron Ratings Company and the A. C. Nielsen Company. In radio, Arbitron and Birch Consumer Research, Inc., are two of the primary services, although there are many others. Ratings are done by electronic monitoring, by the filing of written logs, and by other methods including telephone polling. In all but the smallest markets, ratings are vitally important to a station and to a performer. Ratings are published at different intervals, depending on the size of the market, ranging from monthly to semiannually. These published figures are commonly referred to as "the book."

Jobs are lost when ratings fall. If you are a news anchor, and your newscast is last in two consecutive books, your job may be in serious jeopardy.

Station executives will make a variety of program and personnel decisions

based on the book. From a performer's standpoint, remember that ratings are nothing more than information. Station management may recommend changes and policy based on analysis of those ratings, and those changes may directly affect you. Perhaps the ratings indicate a need to appeal to a more youthful market in a morning drive program. The music and overall approach of the program may be changed, and the announcer is expected to adapt his or her delivery to reflect those changes. Similar situations may be encountered in news, or in any portion of the broadcast schedule.

Conclusion

Your study of broadcasting in college and your early work experiences do not lock you into an announcing career. If your career does not develop as you wish, your broad education and communication skills will serve you well in any type of job.

Many interesting alternatives are related to announcing. The authors of this book, for example, have intertwined years of work as air talent with jobs in teaching, journalism, advertising, writing, public relations, civilian and military broadcast management, and acting.

Yes, it is a tough business. But do not be unnecessarily discouraged, because although many who study broadcast announcing do not make it, *thousands DO!* If you honestly believe you have the talent, motivation, and drive, *go for it.*

Appendix A

Foreign-Language Pronunciation Guide

This table is designed for quick reference when you are trying to determine the correct pronunciation of words in the four most frequently encountered foreign languages in American broadcast copy: French, German, Italian, and Spanish.

Russian words in broadcast copy are transliterated from the Cyrillic alphabet used in written Russian. The process of transliteration is based on supplying the English-speaking person with the spelling that yields the closest approximation of the correct pronunciation.

Often the copywriter or news service provides a pronunciation guide to the conventional English pronunciation of foreign names and places. By taking advantage of resources like this guide and pronunciation guides available to broadcasters, you will develop a sense of foreign pronunciation that will greatly improve your rendering of most foreign words.

Using the Pronunciation Guide

The chart that follows is designed for quick reference. The sounds most frequently encountered in foreign pronunciation are listed in the left-hand column. In the next four columns, you can find the treatment of that sound in the four most common foreign languages.

A short example of each sound is provided for each language listed. Where there is more than one possibility for a sound, the alternatives are given. In each case, the simplest and briefest explanations are given. For a sound that can be easily described by a term, such as "aspirated," the description is used. In other cases an example from a uniformly pronounced English word is given to illustrate the sound.

This chart is designed for convenience and ease of use. By making it a practice to read copy containing foreign names and words, you will gain the ability to deliver such material with confidence and naturalness.

Vowels	FRENCH	GERMAN	ITALIAN	SPANISH
a	*as in:* "f<u>a</u>ther"	*as in:* "f<u>a</u>ther"	*as in:* "f<u>a</u>ther"	*as in:* "f<u>a</u>ther"
aa		"g<u>a</u>te"		
ae, ai	"<u>ai</u>," "b<u>e</u>t," or "g<u>a</u>te"	"<u>ai</u>," "r<u>i</u>de"		"<u>ae</u>," "<u>ai</u>," "r<u>i</u>de"
au	"s<u>o</u>"	"c<u>ow</u>"		"c<u>ow</u>"
e	"b<u>e</u>t" or "<u>u</u>p"	"g<u>a</u>te" or "b<u>e</u>t"	"g<u>a</u>te" or "b<u>e</u>t"	"g<u>a</u>te"
é	"g<u>a</u>te"		"g<u>a</u>te"	
ê	"b<u>e</u>t"			
è	"b<u>e</u>t"		"b<u>e</u>t"	
eau	"s<u>o</u>"			
ei	"b<u>e</u>t"	"r<u>i</u>de"		"g<u>a</u>te"
eu	"b<u>ur</u>n"	"s<u>oi</u>l"		
ey	"y<u>e</u>t"	"r<u>i</u>de"		
i	"gr<u>ee</u>t"	"gr<u>ee</u>t" or "k<u>i</u>ss"	"gr<u>ee</u>t or "<u>y</u>" (before or after vowels)	"gr<u>ee</u>t"
ie		"gr<u>ee</u>t"		"<u>yea</u>"
o	"sh<u>o</u>re" or "<u>u</u>p"	"s<u>o</u>" or "s<u>a</u>w"	"s<u>o</u>" or "s<u>a</u>w"	"s<u>o</u>"
ô	"s<u>o</u>"			
ö, oe		"t<u>ur</u>n," "s<u>ay</u>" (pursed lips)		
oi	"w<u>a</u>ft"		"b<u>oy</u>"	"b<u>oy</u>"
ou	"st<u>oo</u>l"			
Consonants*				
b		sounded as "p" when at the end of a word		
c	as "k" when final sound in word; "s" before <u>e</u>, <u>i</u>, <u>y</u>; "k" elsewhere	"kh" before <u>a</u>, <u>o</u>, <u>u</u>	"ch" before <u>e</u>, <u>i</u>, <u>y</u>; "k" before <u>a</u>, <u>o</u>, <u>u</u>	"s" before <u>e</u>, <u>i</u>, <u>y</u>; "k" otherwise
ch	"sh" "ck"	(aspirated)	"k"	
ck			"kk"	
d		"t" when at the end of a word		"th" within or at the end of a word
dt		"t"		
f	as in English	as in English	as in English	as in English
g	"zh" before <u>e</u>, <u>i</u>, <u>y</u>; elsewhere as in "get"	as in "get" when first sound in word; sometimes guttural "ch"	"j" before <u>e</u>, <u>i</u>, <u>y</u>; as in "get" before <u>a</u>, <u>o</u>, <u>u</u>	"h" before <u>e</u>, <u>i</u>, <u>y</u>; as in "get"
gh			as in "get"	
gl			before <u>i</u>, similar to "bi<u>ll</u>iards"	
gn	"ny" as in "onion"		"ny" as in "onion"	

*Pronounced very much as they are in English; exceptions are noted here.

Consonants*	FRENCH	GERMAN	ITALIAN	SPANISH
h	silent	as in English	silent	silent
j	"zh"	"y"	often as "i"	"h"
ll				"y"
m, n, ng	when preceded by vowel, in the same syllable, the vowel is nasalized			
ñ				"y" added before following vowel sound
q	"k"			
qu	"k"	"kv"	"qw"	"k" before <u>e</u>, <u>i</u>
r	guttural, rolled or trilled	guttural or trilled		
s	as in "see"; "z" between vowels	"z" when beginning word or before vowel; as in "see"	as in "see"	
sc	"sk" before <u>a</u>, <u>o</u>, <u>u</u>; "s" before <u>e</u>, <u>i</u>		"sk" before <u>a</u>, <u>o</u>, <u>u</u>; "sh" before <u>e</u>, <u>i</u>	
sch		"sh"	"sk"	
sp		"shp" at beginning of a word		
st		"sht" at beginning of word	"t"	
t	as in English	as in English	as in English	as in English
th	"t"	"t"		
v		"f"		"b"
w	"v"	"v"	rare, like "v"	
x				"s" when preceded by consonant
z		"ts"	"ts" as in "cats" or "dz" as in "fin<u>ds</u>"	

*Pronounced very much as they are in English; exceptions are noted here.

The material in this section is copy that has been provided by several radio and television broadcasters. There is a selection of news, sports, and weather copy, and some items of information that stations might use as general, miscellaneous information in D.J. shows or other formats.

Some of the material is wire service information from the Associated Press. Other material has been written by local newspeople at the station level. There is both radio and television news copy included. We have selected copy that is broadly representative of copy you are likely to encounter in day-to-day broadcast operations.

To make most effective use of this copy, take the time to analyze the material. When you've completed your analysis, identify the techniques you as the performer can use to breathe life into the written message and to help viewers and/or listeners understand the information.

Keep in mind that nearly anyone can render an understandable reading of this copy. But of those who try, very few succeed in the competitive arena that leads to the top of the broadcasting professions. To succeed, you must combine your innate talent with careful attention to the techniques described in this book and a determination to bring something unique to each piece of copy you encounter. The process takes time, hard work, and persistence in addition to a fair amount of good, old-fashioned luck.

Wire service copy provides broadcast stations with continuous current information about ongoing events. Everything from the latest sports scores to the most recent developments in foreign and domestic news is available at any time of the day for subscribers to these services. What follows in this section includes a representative sample from a single day's feed from the Associated Press Radio Wire.

Use the information to practice reading and ad-libbing skills discussed in this book. A variety of copy types have been included. We begin with a feature called "Today's Highlight in History."

"Today's Highlight in History" is most frequently used by morning drive announcers. It supplies interesting facts about significant historical events that took place on that day's date.

Appendix

Drill Material: News, Sports, Weather, and Miscellaneous Wire Service Copy

Wire Service Copy

ASSOCIATED PRESS BROADCAST REPORT FOR MONDAY, JULY 30TH, 1990

TODAY IS MONDAY, JULY 30TH, THE 211TH DAY OF 1990. THERE ARE 154 DAYS LEFT IN THE YEAR.

TODAY'S HIGHLIGHT IN HISTORY:

TWENTY-FIVE YEARS AGO, ON JULY 30TH, 1965, PRESIDENT LYNDON B. JOHNSON SIGNED INTO LAW THE MEDICARE BILL, WHICH WENT INTO EFFECT THE FOLLOWING YEAR.

ON THIS DATE:

IN 1619, THE FIRST REPRESENTATIVE ASSEMBLY IN AMERICA CONVENED IN JAMESTOWN, VIRGINIA.

IN 1729, THE CITY OF BALTIMORE WAS FOUNDED.

IN 1792, THE FRENCH NATIONAL ANTHEM "LA MARSEILLAISE" (LAH MAR-SEH-YEHZ'), BY CLAUDE JOSEPH ROUGET DE LISLE, WAS FIRST SUNG IN PARIS.

IN 1863, AMERICAN AUTOMAKER HENRY FORD WAS BORN IN DEARBORN TOWNSHIP, MICHIGAN.

IN 1864, DURING THE CIVIL WAR, UNION FORCES TRIED TO TAKE PETERSBURG, VIRGINIA, BY EXPLODING A MINE UNDER CONFEDERATE DEFENSE LINES. (THE ATTACK FAILED.)

IN 1889, VLADIMIR ZWORYKIN, OFTEN CALLED THE "FATHER OF TELEVISION" FOR INVENTING THE ICONOSCOPE, WAS BORN IN RUSSIA.

IN 1916, GERMAN SABOTEURS BLEW UP A MUNITIONS PLANT ON BLACK TOM ISLAND NEAR JERSEY CITY, NEW JERSEY.

IN 1932, THE SUMMER OLYMPIC GAMES OPENED IN LOS ANGELES.

IN 1942, PRESIDENT FRANKLIN D. ROOSEVELT SIGNED A BILL CREATING A WOMEN'S AUXILIARY AGENCY IN THE NAVY KNOWN AS "WOMEN ACCEPTED FOR VOLUNTEER EMERGENCY SERVICE"—ALSO THE "WAVES."

IN 1975, FORMER TEAMSTERS PRESIDENT JIMMY HOFFA MYSTERIOUSLY DISAP-
PEARED IN SUBURBAN DETROIT.

IN 1975, REPRESENTATIVES OF 35 COUNTRIES CONVENED IN HELSINKI, FINLAND, FOR
A CONFERENCE AIMED AT ENSURING PEACE IN EUROPE.

TEN YEARS AGO: THE ISRAELI KNESSET PASSED A LAW REAFFIRMING ALL OF JERUSA-
LEM AS THE CAPITAL OF THE JEWISH STATE.

FIVE YEARS AGO: OFFICIALS OF 35 COUNTRIES BEGAN MEETING IN FINLAND TO MARK
THE TENTH ANNIVERSARY OF THE HELSINKI ACCORDS. SOUTH AFRICA RECALLED ITS
AMBASSADOR-DESIGNATE TO WASHINGTON FOR CONSULTATIONS.

ONE YEAR AGO: IN LEBANON, THE PRO-IRANIAN GROUP ORGANIZATION FOR THE
OPPRESSED ON EARTH THREATENED TO KILL AN AMERICAN HOSTAGE, MARINE LIEUTEN-
ANT COLONEL WILLIAM R. HIGGINS, UNLESS ISRAEL RELEASED SHEIK ABDUL-KARIM
OBEID (AHB'-DOOL KAH-REEM' OH-BAYD'), A CLERIC SEIZED BY ISRAELI COMMANDOS.

TODAY'S BIRTHDAYS: ACTOR EDD BYRNES IS 57. MOVIE DIRECTOR PETER
BOGDANOVICH IS 51. FEMINIST ACTIVIST ELEANOR SMEAL IS 51. U-S REPRESENTATIVE
PATRICIA SCHROEDER (DEMOCRAT, COLORADO) IS 50. SINGER PAUL ANKA IS 49.
ACTOR-BODYBUILDER ARNOLD SCHWARZENEGGER IS 43. SINGER KATE BUSH IS 32.

THOUGHT FOR TODAY: "AN EFFICIENT BUREAUCRACY IS THE GREATEST THREAT TO
LIBERTY."-FORMER U-S SENATOR EUGENE MCCARTHY (1916-).

AP-NP-07-29-90 2344EDT<+

Wire Service News Feeds

Through each day and night AP feeds subscribers news copy ready for reading on the air. "Newswatch" is a compilation of the latest news stories, presented in a format that can be used as copy for regularly scheduled newscasts. There is more than enough material for a five-minute newscast, but many stations select stories from the feed and combine them with local stories to build their own newscast.

A shorter summary of the latest news is presented in the "Newsminute." It takes about 60 seconds for the average announcer to read the material in this feature. It is used for quick updates on current stories.

In addition to news presented in a format, some stories are simply fed as stand-alone items. These can be substituted for stories in the newscast format or simply integrated in the station's own newscast format.

We have included two versions each of "Newswatch" and "Newsminute." Notice how the arrangement of stories changes over time. Stories are also rewritten to provide freshness.

We have included several stories that are fed in stand-alone fashion. They can be used in place of stories in the "Newsfeed" feature.

Included in this section of the drill material is a pronunciation guide to names found in the stories that make up the day's news. This is one of the first items fed in the day.

```
AP-PRONUNCIATION GUIDE (MONDAY)

NEWS

   CORAZON AQUINO-KOR-AH-ZOHN' AH-KEE'-NOH

   BAGUIO-BAH'-GEE-OH

   ABU BAKR-AH'-BOO BAH'-KUHR

   RODRIGO BORJA-BOHR'-HAH

   CABANATUAN CITY-KAH-BAH-NAH-TOO'-AHN

   FORT CHAFFEE, ARKANSAS-CHAF'-EE

   PEDRITO DY-PEH-DREE'-TOH DEE

   IAN GOW-EE'-UHN GOW

   KHMER ROUGE-KUH-MEHR ROOZH

   BRUNO KREISKY-KRY'-SKEE
```

LUZON—LOO-ZAHN'

TADEUSZ MAZOWIECKI—TAH-DAY'-OOSH MAH-ZOH-VEE-ET'-SKEE

MEDELLIN—MEH-DEH-YEEN'

FRANCOIS MITTERRAND—FRAHN-SWAH' MEE-TEH-RAHN'

HOSNI MUBARAK—HAHS'-NEE MOO-BAH'-RAHK

KAZIMIERA PRUNSKIENE—KUH-ZIH-MAY'-RUH PROONS-KEH'-NUH

READING—REHD'-IHNG

MARGE ROUKEMA—RAH'-KUH-MUH

DAVID SOUTER—SOO'-TUR

SPORTS

DANIELLE AMAMACCPANE—AHM-AHM-UH-KUH-PAHN'-EE

GIANNI BUGNO—JAH'-NEE BOON'-YOH

GARY GAETTI—GY-ET'-EE

PAUL MOLITOR—MAHL'-IH-TUR

AP-NP—07-30-90 0755EDT<+

AP-8THNEWSWATCH 07-30 0422

HERE IS THE LATEST NEWS FROM THE ASSOCIATED PRESS:

SUSPICION IS FOCUSING ON THE IRISH REPUBLICAN ARMY IN THE WAKE OF TODAY'S CAR-
BOMB KILLING OF A MEMBER OF PARLIAMENT. THOUGH POLICE HAVE NOT YET CONFIRMED THE
VICTIM'S IDENTITY, THE BRITISH CONSERVATIVE PARTY SAYS IT WAS IAN GOW (EE'-UHN
GOW), THE CHAIRMAN OF PARLIAMENT'S NORTHERN IRELAND COMMITTEE. A CONSERVATIVE
PARTY MEMBER SAYS NO ONE ELSE BUT THE I-R-A COULD BE BEHIND THE KILLING.

THE REBELS HOLDING GOVERNMENT OFFICIALS HOSTAGE ARE NOT THE ONLY PROBLEM FACING AUTHORITIES ON TRINIDAD. THE ATTEMPTED OVERTHROW HAS PROMPTED LOOTING BY THOUSANDS OF PEOPLE, WHO'VE BEEN STEALING EVERYTHING FROM POWDERED MILK TO MAJOR APPLIANCES. MEANWHILE, IT SEEMS NO SOLUTION TO THE COUP ATTEMPT IS CLOSE. THE ENERGY MINISTER SAYS THERE'S LITTLE REASON TO HOPE FOR A QUICK SETTLEMENT.

DOCTORS IN THE PHILIPPINES SAY 27-YEAR-OLD PEDRITO DY (PEH-DREE'-TOH DEE) CAN THANK HIS GOOD PHYSICAL CONDITION FOR HELPING HIM ACHIEVE A NEAR-MIRACLE: SURVIVING FOR TWO WEEKS UNDER THE RUBBLE OF AN EARTHQUAKE-COLLAPSED BUILDING. DY WAS PULLED FROM THE RUBBLE TODAY, DEHYDRATED BUT OTHERWISE UNINJURED. HE SAYS HE BECAME SO DEPRESSED DURING THE ORDEAL, HE TRIED TO KILL HIMSELF BY BANGING HIS HEAD AGAINST THE DEBRIS.

A FEDERAL COURTROOM IN READING (REHD'-IHNG), PENNSYLVANIA, IS PROVIDING THE SETTING FOR THE LATEST DEBATE ON THE CHARGED ISSUE OF ABORTION. A JUDGE TODAY IS TO CONSIDER ARGUMENTS ON PENNSYLVANIA'S ABORTION LAW—THE MOST RESTRICTIVE OF ANY STATE'S. OPPONENTS SAY IT'S ILLEGAL, BUT THE STATE ATTORNEY-GENERAL'S OFFICE SAYS THE RESTRICTIONS ARE PERMISSIBLE UNDER EXISTING SUPREME COURT RULINGS.

PROSECUTORS IN TAMPA, FLORIDA, ARE RELISHING WHAT THEY DESCRIBE AS AN IMPORTANT VICTORY IN THE DRUG WAR—THE CONVICTION OF MANUEL NORIEGA'S (NOH-REE-AY'-GAHZ) FORMER PERSONAL BANKER AND FIVE OTHERS. A FEDERAL JURY YESTERDAY CONVICTED THEM OF A SCHEME TO LAUNDER 32 (M) MILLION DOLLARS IN COCAINE-SMUGGLING PROFITS. PROSECUTORS SAY IT'S THE FIRST TIME INTERNATIONAL BANKERS CONDUCTING OVERSEAS TRANSACTIONS HAVE BEEN CONVICTED OF U-S MONEY-LAUNDERING LAWS.

SALVAGE WORKERS IN TEXAS ARE HAVING SUCCESS IN PUMPING OIL OUT OF ONE OF THE BARGES DAMAGED IN A WEEKEND COLLISION IN THE HOUSTON SHIP CHANNEL. BUT IT WILL TAKE LONGER TO BEGIN PUMPING OIL FROM A SECOND BARGE THAT ALMOST SANK AFTER THE ACCIDENT, BECAUSE IT'S MORE COMPLICATED.

U-S ARMY AUTHORITIES HAVE LOTS OF QUESTIONS ABOUT A FRIDAY NIGHT HELICOPTER CRASH THAT KILLED FIVE SOLDIERS IN FORT CHAFFEE (CHAF'-EE), ARKANSAS. THEY HOPE TO GET SOME ANSWERS AFTER EXAMINING THE WRECKAGE, WHICH IS TO BE RECOVERED TODAY BY HELICOPTER AND RETURNED TO THE ARMY BASE.

ZSA ZSA GABOR'S WEEKEND IN THE POKEY ENDS TODAY, AND IT CAN'T COME SOON ENOUGH FOR THE OFFICERS WHO RUN THE EL SEGUNDO, CALIFORNIA, JAIL. ONE OFFICER WHO ANSWERED AN INQUIRING PHONE CALL YESTERDAY SAID HE HAD "NOTHING TO SAY"—AND COMPLAINED THAT ALL THE PHONE CALLS WERE INTERFERING WITH JAIL OPERATIONS.

AP-NP-07-30-90 0752EDT<+

AP-8THNEWSMINUTE 07-30 0171

HERE IS THE LATEST NEWS FROM THE ASSOCIATED PRESS:

NOBODY'S CLAIMED RESPONSIBILITY FOR A BOMB ATTACK TODAY THAT KILLED A CONSER-VATIVE MEMBER OF THE BRITISH PARLIAMENT. BUT THE IRISH REPUBLICAN ARMY IS COMING UNDER SUSPICION. THE BOMBING VICTIM CHAIRED THE NORTHERN IRELAND COMMITTEE IN THE HOUSE OF COMMONS.

THE CRISIS THAT HAS SEIZED THE GOVERNMENT IN TRINIDAD AND TOBAGO IS NOW IN ITS FOURTH DAY—WITH NO END IN SIGHT. MOSLEM REBELS ARE STILL HOLDING THE CARIBBEAN NATION'S PRIME MINISTER AND OTHER GOVERNMENT OFFICIALS.

A MAN RESCUED FROM EARTHQUAKE RUBBLE IN THE PHILIPPINES SAYS HE PRAYED CON-STANTLY AND GAVE HIS LIFE TO GOD. PEDRITO DY (PEH-DREE'-TOH DEE) WAS FOUND TODAY IN THE RUINS OF A HOTEL—14 DAYS AFTER THE QUAKE THAT KILLED MORE THAN 16-HUNDRED PEOPLE.

SALVAGE TEAMS IN THE HOUSTON SHIP CHANNEL HAVE BEGUN PUMPING OIL FROM A BARGE DAMAGED IN A SATURDAY COLLISION. BUT ANOTHER BARGE, WHICH NEARLY SANK, COULD BE A BIGGER PROBLEM. MEANTIME, A FIVE-MILE-LONG OIL SLICK FROM THE COLLISION IS FLOATING ACROSS GALVESTON BAY.

AP-NP-07-30-90 0804EDT<+

AP-13THNEWSWATCH 07-30 0415

HERE IS THE LATEST NEWS FROM THE ASSOCIATED PRESS:

WITNESSES IN MONROVIA, LIBERIA, SAY GOVERNMENT TROOPS STORMED INTO A REFUGEE CAMP TODAY AND KILLED AT LEAST 200 PEOPLE—MOSTLY WOMEN AND CHILDREN. ONE WITNESS SAYS HE SAW "DEAD BODIES ALL AROUND." THE TROOPS REPORTEDLY BROKE INTO THE COMPOUND WHILE MOST WERE STILL SLEEPING. MOST OF THE REFUGEES WERE FROM TWO TRIBES ALIGNED WITH REBEL ARMIES WHICH ARE LOCKED IN BATTLE WITH PRESIDENT SAMUEL DOE'S CRUMBLING GOVERNMENT.

THE HEAD OF SCOTLAND YARD'S ANTI-TERRORIST SQUAD SAYS IT'S "REASONABLE TO ASSUME" THE IRISH REPUBLICAN ARMY WAS RESPONSIBLE FOR A BOMB WHICH KILLED A BRITISH CONSERVATIVE PARTY MEMBER TODAY. THE BOMB WAS PLANTED UNDER THE MEMBER OF PARLIAMENT'S CAR. IAN GOW'S NAME HAD APPEARED ON A LIST OF BRITISH LAWMAKERS, JUDGES AND CIVIL SERVANTS FOUND IN AN I-R-A BOMB FACTORY IN 1988.

GUNFIRE AND EXPLOSIONS HAVE BEEN HEARD OUTSIDE A GOVERNMENT T-V STATION IN TRINIDAD THIS MORNING AS THE COUNTRY'S PRIME MINISTER AND 30 OTHERS ARE BEING HELD HOSTAGE FOR A FOURTH DAY. THICK BLACK SMOKE ROSE FROM THE BUILDING AS AUTOMATIC RIFLE AND MACHINE-GUN FIRE RANG OUT NEARBY. ONE SOURCE REPORTED FOUR BOMB-LIKE EXPLOSIONS. ONE REBEL SAYS A TENTATIVE AGREEMENT ENDING THE SIEGE HAS BEEN REACHED,

WITH PRIME MINISTER ARTHUR ROBINSON AGREEING TO STEP DOWN. THE REBELS HAVE BEEN
THREATENING TO BLOW UP THE PRIME MINISTER.

THE OFFICIAL RESULTS WON'T BE ANNOUNCED UNTIL WEDNESDAY, BUT IT APPEARS
MONGOLIA'S COMMUNIST PARTY CHAIRMAN AND SEVERAL OPPOSITION LEADERS HAVE WON
SEATS IN THE COUNTRY'S FIRST FREE ELECTIONS. OPPOSITION PARTY OFFICIALS DID NOT KNOW
THE TOTAL NUMBER OF SEATS WON BY EACH SIDE. MONGOLIA IS THE LATEST SOVIET-BLOC
COUNTRY TO TRY ITS HAND AT DEMOCRACY, FOLLOWING NEARLY SEVEN DECADES OF COMMU-
NIST POWER.

SECRETARY OF STATE BAKER WILL HEAD TO MONGOLIA TOMORROW, DESPITE A FEVER
TODAY. BAKER IS IN SINGAPORE FOR A MEETING OF PACIFIC RIM NATIONS. FROM MONGOLIA,
BAKER WILL HEAD TO SIBERIA.

THE GOVERNMENT SAYS AMERICANS TOOK TO THE STORES AND AUTO LOTS IN JUNE. THE
COMMERCE DEPARTMENT REPORTS CONSUMER SPENDING ROSE ONE PERCENT, THE LARGEST
MONTHLY INCREASE SINCE A ONE-POINT JUMP IN JANUARY. AUTO SALES ACCOUNTED FOR A
LARGE PART OF THE INCREASE. ANOTHER REPORT SHOWS PERSONAL INCOME ROSE FOUR-
TENTHS OF ONE PERCENT FOR THE SAME TIME PERIOD.

THE PEOPLE OF MONROE, NORTH CAROLINA, ARE COUNTING THEIR LOSSES AND CLEANING UP
WHAT'S LEFT OF DOWNTOWN. DAMAGE FROM A WEEKEND EXPLOSION MAY REACH A (M) MILLION
DOLLARS. AT LEAST EIGHT BUSINESSES WERE DESTROYED IN THE SMALL TOWN. OFFICIALS
THINK A NATURAL GAS LEAK CAUSED THE BLAST.

IT HAS A SLIGHTLY NEW NAME, NO ADVERTISEMENTS, AND A FOUR-DOLLAR, 50-CENT PRICE
TAG. "MS." MAGAZINE IS BACK AT NEWSSTANDS TODAY, FOLLOWING AN EIGHT-MONTH, SELF-
IMPOSED SUSPENSION. THE PERIODICAL IS NOW CALLED, "MS: THE WORLD OF WOMEN." INDUS-
TRY ANALYSTS ARE SKEPTICAL THE MAGAZINE WILL MAKE IT WITHOUT ADS.

AP-NP-07-30-90 1248EDT<+

AP-13THNEWSMINUTE 07-30 0165

HERE IS THE LATEST NEWS FROM THE ASSOCIATED PRESS:

WITNESSES IN THE WEST AFRICAN NATION OF LIBERIA SAY GOVERNMENT TROOPS BROKE INTO A REFUGEE CAMP AND MASSACRED AT LEAST 200 PEOPLE—MOST OF THEM WOMEN AND CHILDREN. MOST OF THE REFUGEES WHO WERE KILLED WERE MEMBERS OF TRIBES WHICH SUPPORT THE REBEL ARMIES BATTLING THE GOVERNMENT.

IN THE CARIBBEAN NATION OF TRINIDAD AND TOBAGO, THERE'S WORD OF A TENTATIVE DEAL FOR REBELS TO FREE THE PRIME MINISTER. THEY'VE BEEN HOLDING HIM SINCE FRIDAY. A REBEL SAYS THE PRIME MINISTER HAS AGREED TO STEP DOWN.

THERE'S STILL BEEN NO CLAIM OF RESPONSIBILITY FOR THE BOMBING DEATH THIS MORNING OF A CONSERVATIVE PARTY MEMBER OF THE BRITISH PARLIAMENT. BUT BRITISH AUTHORITIES SAY THEY THINK THE IRISH REPUBLICAN ARMY IS TO BLAME.

IT'S BEEN ANOTHER DAY WITHOUT ELECTRICITY FOR THOUSANDS OF CHICAGOANS ON THE CITY'S WEST SIDE. THE POWER HAS BEEN OUT SINCE AN EXPLOSION AT A GENERATING PLANT LATE SATURDAY. THE BLACKOUT HAS SPARKED SOME LOOTING.

AP-NP-07-30-90 1315EDT<+

AP-TRINIDAD(TOPS) 07-30 0158

(PORT-OF-SPAIN, TRINIDAD)—A DIPLOMATIC SOURCE SAYS A "MAJOR FIREFIGHT IS GOING ON" AROUND A GOVERNMENT T-V STATION AND PARLIAMENT IN PORT-OF-SPAIN, TRINIDAD.
 MOSLEM EXTREMISTS ARE HOLDING THE PRIME MINISTER AND 30 OTHER PEOPLE HOSTAGE FOR A FOURTH DAY.

THE HEAVIEST SHOOTING HAS BEEN CENTERED ON THE TELEVISION STATION, WHOSE EMPLOY-
EES WERE TAKEN HOSTAGE FRIDAY. AUTOMATIC RIFLE AND MACHINE-GUN FIRE HAS BEEN
PUNCTUATED BY WHAT SOUNDED LIKE ARTILLERY BOOMS.

THE SHOOTING AT THE T-V STATION APPEARS TO BE COMING FROM TWO DIRECTIONS, BUT IT
IS NOT CLEAR WHETHER THERE HAS BEEN AN ATTEMPT BY THE SECURITY FORCES TO STORM THE
BUILDING. HEAVY BLACK SMOKE IS RISING FROM THE STATION.

EARLY THIS MORNING, AUTOMATIC WEAPONS FIRE RANG OUT NEAR PARLIAMENT, ABOUT A
MILE AWAY, WHERE REBELS SEIZED PRIME MINISTER ARTHUR ROBINSON FRIDAY. THE REBELS
CLAIM TO HAVE WIRED HIM WITH EXPLOSIVES AND HAVE THREATENED TO BLOW HIM UP IF A
RESCUE ATTEMPT IS MADE.

AP-NP-07-30-90 1054EDT<+

AP-LIBERIA(TOPS) 07-30 0180

(MONROVIA, LIBERIA)-WITNESSES SAY LIBERIAN GOVERNMENT TROOPS HAVE KILLED AT
LEAST 200 PEOPLE AT A REFUGEE CAMP AT A LUTHERAN CHURCH COMPOUND IN MONROVIA. THE
WITNESSES SAY MOST OF THOSE KILLED WERE WOMEN AND CHILDREN.

ONE WITNESS SAYS HE SAW WOMEN LYING DEAD WITH BABIES STILL TIED TO THEIR BACKS.

HE SAYS HE ALSO SAW BODIES HANGING FROM THE WINDOW FRAMES OF THE CHURCH BUILD-
ING, APPARENTLY KILLED WHILE TRYING TO ESCAPE.

THE WITNESS—WHO DID NOT WANT TO BE IDENTIFIED—CALLS THE ATTACK "GENOCIDE."

THOUSANDS OF REFUGEES FLEEING THE CIVIL WAR BETWEEN REBEL FORCES AND THE CRUM-
BLING GOVERNMENT OF PRESIDENT SAMUEL DOE, ARE CROWDED INTO REFUGEE CAMPS IN THE
AREA.

THE WITNESSES SAY THE SOLDIERS BROKE INTO THE CHURCH COMPOUND DURING THE NIGHT
WHEN THE REFUGEES WERE ASLEEP.

MOST OF THE REFUGEES WERE MEMBERS OF THE GIO AND MANO TRIBES WHICH HAVE FORMED

THE MAIN SUPPORT FOR REBEL ARMIES. MOST OF DOE'S TROOPS ARE FROM HIS KRAHN TRIBE AND THE MANDINGO TRIBE.

THOUSANDS OF KRAHNS AND MANDINGOS HAVE BEEN FLEEING INTO NEIGHBORING COUNTRIES AFTER REPORTS REBELS HAD EXECUTED HUNDREDS OF THEIR TRIBESMEN.

AP-NP-07-30-90 0923EDT<+

AP-CHUNG-CBS 07-30 0154

(NEW YORK)-FOR CONNIE CHUNG, FAMILY COMES FIRST-BUT FIRST SHE HAS TO GET A FAMILY.

THE HOST OF THE C-B-S SHOW, "FACE TO FACE WITH CONNIE CHUNG," HAS ANNOUNCED SHE WANTS TO HAVE A BABY BEFORE IT'S TOO LATE-SO SHE HAS REMOVED HERSELF AND HER INTERVIEW SERIES FROM C-B-S' MONDAY LINEUP FOR NEXT FALL.

THE 43-YEAR-OLD CHUNG, WHO'S MARRIED TO "A CURRENT AFFAIR" ANCHORMAN MAURY POVICH, SAYS SHE WILL DO "FACE TO FACE" SPECIALS INSTEAD OF HER SERIES.

IN A STATEMENT EXPLAINING HER DECISION, SHE SAID SHE AND HER HUSBAND "HAVE REACHED AN IMPORTANT POINT IN OUR LIVES."

SHE SAYS AFTER CONSULTING HER DOCTORS, SHE BECAME CONVINCED SHE NEEDS "TO TAKE A VERY AGGRESSIVE APPROACH TO HAVING A BABY."

CHUNG, WHO REJOINED C-B-S NEWS FROM N-B-C IN APRIL 1989, AND ANCHORED LAST-SEASON'S LOW-RATED "SATURDAY NIGHT WITH CONNIE CHUNG," SCORED HIGH RATINGS IN MAY WITH HER FIRST TWO "FACE TO FACE" SPECIALS.

AP-NP-07-30-90 1322EDT<+

State news is fed in a format that includes a wrap-up of the most significant breaking stories and in stand-alone stories fed at various times in the day. Updates take place throughout the day.

Included in this section are three updates of a breaking story on a fatal fire. The three different versions show how the writers updated the story as more information became available.

State News

AP-PA-STATEREPORT 07-29 0725

(ALLENTOWN)-FOUR CONGRESSMEN FROM PENNSYLVANIA ARE ASKING ATTORNEY GENERAL DICK THORNBURGH TO INVESTIGATE THE DOWNFALL OF HILL FINANCIAL SAVINGS ASSOCIATION. HILL FINANCIAL WAS A 2-POINT-9 (B) BILLION DOLLAR SAVINGS AND LOAN INSTITUTION BASED IN RED HILL, MONTGOMERY COUNTY. ITS FAILURE WAS ONE OF THE MOST EXPENSIVE S-AND-L FAILURES IN THE NATION. THOSE WRITING TO THORNBURGH FRIDAY WERE REPRESENTATIVES DON RITTER, PAUL KANJORSKI, TOM RIDGE AND DICK SCHULZE. KANJORSKI AND RIDGE SERVE ON THE HOUSE BANKING COMMITTEE, AND SCHULZE'S DISTRICT INCLUDES RED HILL. ACCORDING TO THE CONGRESSMEN, PENNSYLVANIA RANKS THIRD AMONG STATES IN TERMS OF S-AND-L BAILOUT COSTS, BEHIND TEXAS AND CALIFORNIA.

(FORT CHAFFEE, ARKANSAS)-THE ARMY SAYS A SERGEANT FROM PENNSYLVANIA WAS AMONG THE VICTIMS OF A HELICOPTER CRASH IN ARKANSAS. SERGEANT JOHN DURYEA OF LEMOYNE, CUMBERLAND COUNTY WAS ONE OF FIVE SOLDIERS WHO DIED IN THE CRASH FRIDAY NIGHT. THE 38-YEAR-OLD SERGEANT AND MOST OF THE VICTIMS OF THE HELICOPTER CRASH WERE MEMBERS OF THE TENTH SPECIAL FORCES, BASED AT FORT DEVENS, MASSACHUSETTS. ACCORDING TO THE ARMY, A MODIFIED U-H-60 HELICOPTER, KNOWN AS A BLACKHAWK, CRASHED INTO THE NORTH SLOPE OF A RIDGE LOCALLY KNOWN AS PINNACLE MOUNTAIN. RUGGED TERRAIN AND DARKNESS HAMPERED RESCUE EFFORTS. OFFICIALS SAY THE CAUSE OF THE CRASH WAS A MYSTERY.

(READING)-OPPONENTS OF PENNSYLVANIA'S ABORTION CONTROL LAW WILL BE IN FEDERAL COURT THIS WEEK, ASKING SENIOR U-S DISTRICT JUDGE DANIEL HUYETT TO RULE

AGAINST IT. THE HEARING IS SCHEDULED TO START TOMORROW IN READING AND LAST MOST OF THE WEEK. ONE PROVISION OF THE LAW THAT IS LIKELY TO BE CHALLENGED REQUIRES A WOMAN TO INFORM HER SPOUSE IF SHE INTENDS TO HAVE AN ABORTION. OPPONENTS SAY THE REQUIREMENT WILL ESPECIALLY CREATE AN OBSTACLE TO ABORTIONS FOR WOMEN SUBJECTED TO VIOLENCE AT HOME. BOTH SIDES IN THE ABORTION DEBATE SAY THE TESTIMONY IN THE HEARING WILL FOCUS ON MEDICAL PRACTICE AND ETHICS.

(HARRISBURG)-GOVERNOR ROBERT CASEY SAYS THE STATE'S NEW AUTO INSURANCE LAW IS SAVING PEOPLE A LOT OF MONEY IN SOUTHEASTERN PENNSYLVANIA. CASEY, IN HIS WEEKLY RADIO ADDRESS YESTERDAY, SAID A TYPICAL MOTORIST IN PHILADELPHIA OR THE FIVE COUNTIES AROUND IT COULD EXPECT TO SAVE ABOUT 40 PERCENT ON THEIR CAR INSURANCE—THIS IN AN AREA THAT HAS PUT UP WITH SOME OF THE HIGHEST AUTO INSURANCE RATES IN THE NATION. THE LAW SPECIFIES ACROSS-THE-BOARD CUTS IN INSURANCE RATES, WITH ADDITIONAL RATE CUTS FOR DRIVERS WHO GIVE UP THEIR RIGHT TO SUE IN SOME SITUATIONS OR AGREE TO HIGHER DEDUCTIBLE CLAUSES. NOT ALL MOTORISTS WILL SEE THE FULL CUTS, HOWEVER, BECAUSE SOME INSURANCE COMPANIES RECEIVED COURT PERMISSION TO INCREASE RATES BEFORE ROLLING THEM BACK. ALSO, THE STATE INSURANCE DEPARTMENT PARTIALLY EXEMPTED 57 CARRIERS FOR FINANCIAL REASONS.

(KIMBERTON)-A FORTUNE TELLER HAS A DATE IN COURT THIS WEEK, TO ANSWER CHARGES THAT SHE TOLD A WOMAN SHE WAS UNDER A CURSE AND GETTING RID OF IT WOULD COST 200 DOLLARS. ROSEANNE MILLER OF BALTIMORE—WHO ALSO GOES BY THE NAME OF "VICTORIA"—WAS WORKING AT THE KIMBERTON COMMUNITY FAIR IN CHESTER COUNTY LAST WEEK WHEN POLICE ARRESTED HER. A WOMAN TOLD POLICE THAT ON TUESDAY NIGHT THE PALM READER TOLD HER THAT A PERSON WHO OPPOSED HER MARRIAGE HAD PUT A CURSE ON HER, BUT MS. MILLER SAID SHE COULD LIFT THE CURSE FOR 200 DOLLARS. POLICE SAID THEY LISTENED IN AS MRS. HEDDERICK DELIVERED THE MONEY THURSDAY, AND THEN THEY MOVED IN. CHARGING MONEY FOR FORTUNE-TELLING IS ILLEGAL IN PENNSYLVANIA AND CARRIES A MAXIMUM PENALTY OF A YEAR IN JAIL.

(PITTSBURGH)—AN ALLEGHENY COUNTY JUDGE SAYS HE WILL START A PROGRAM THIS FALL TO MOVE MINOR OFFENSES THROUGH COURT SYSTEM FASTER. JUDGE ROBERT DAUER CALLS IT THE P-D-Q, WHICH IN THIS CASE STANDS FOR PLEA DISPOSITION QUICKIE. THE PLAN CALLS FOR DEFENDANTS WHO PLAN TO PLEAD GUILTY TO SOME MINOR OFFENSES TO BE TOLD OF THE OPTION AT A SPECIAL COURT CONFERENCE. THOSE ELECTING TO TAKE P-D-Q WOULD ENTER THEIR PLEA AT A LATER DATE AND RECEIVE THEIR SENTENCE. PROSECUTORS AND DEFENSE ATTORNEYS SAID THE PROCESS WILL IDENTIFY CASES DESTINED FOR PLEAS AND MOVE THEM QUICKLY THROUGH THE SYSTEM.

(PITTSBURGH)—THE LEADER OF THE ANTI-ABORTION GROUP OPERATION RESCUE SAYS THE ORGANIZATION WILL BEGIN USING TELEPHONE CALLS, PRAYER AND PICKETING TO PRESSURE JUDGES WHEN ABORTION PROTESTERS ARE DEFENDANTS IN COURT. RANDALL TERRY SAID IN PITTSBURGH THE PHONE CALLS AND LETTERS WILL BEGIN IN A WEEK. SPEAKING TO A CROWD AT AN AREA CHURCH, TERRY ANNOUNCED THE OFFICE TELEPHONE NUMBER AND ADDRESS OF ALLEGHENY COUNTY COMMON PLEAS JUDGE ROBERT DAUER, WHO SENTENCED ABORTION PROTESTERS TO HOUSE ARREST EARLIER THIS MONTH. TERRY ALSO URGED HIS LISTENERS TO PICKET THE JUDGE'S HOME.

(PITTSBURGH)—THE BIDS ARE IN FOR RECYCLABLE MATERIALS FROM PITTSBURGH, AND THEY RANGE ALL THE WAY FROM A COMPANY OFFERING TWO DOLLARS AND 18 CENTS A TON FOR PLASTIC AND GLASS ALL THE WAY UP TO A COMPANY THAT WANTS THE CITY TO PAY 34 DOLLARS AND 65 CENTS A TON TO GET RID OF THE STUFF. CITY RECYCLING CO-ORDINATOR MARIBETH RIZZUTO SAYS SHE'S NOT SURPRISED BY THE WIDE RANGE OF THE BIDS, BECAUSE RECYCLING IS A NEW INDUSTRY. THE APPARENT LOW BID COMES FROM CHAMBERS OF PENNSYLVANIA INCORPORATED, BASED IN PENN HILLS. CHAMBERS SPOKESMAN JAMES LEONARD SAYS THE COMPANY HAS EXAMINED THE MARKET FOR THE RECYCLABLES AND IT BELIEVES IT CAN TURN A PROFIT.

AP-NP-07-29-90 1110EDT<+

309

AP-PA-HEADLINES(TAKE2) 07-30 0211

(SHARON)—SHARON STEEL CORPORATION IS COMING TO TERMS WITH A MIAMI FINANCIER
WHO ALLEGEDLY MISUSED FOUR-POINT-FOUR (M) MILLION DOLLARS IN COMPANY CASH. THE
ATTORNEY FOR SHARON STEEL'S U-S BANKRUPTCY COURT TRUSTEE SAYS THE DEAL WITH
VICTOR POSNER WAS STRUCK LAST WEEK.

(PITTSBURGH)—A JUDGE SAYS A NEW PROGRAM AT THE ALLEGHENY COUNTY COURTHOUSE
WILL SPEED UP PROCESSING OF BAD CHECKS, PROSTITUTION AND OTHER CASES. THE P-D-Q
PROGRAM IS DESIGNED FOR PEOPLE WHO INTEND TO PLEAD GUILTY.

(PITTSBURGH)—A PSYCHIATRIC PATIENT IS ALLEGING PERJURY BY THE FOREMAN OF THE
JURY THAT ABSOLVED A HOSPITAL OF GUILT IN HER CIVIL LAWSUIT IN ALLEGHENY COUNTY.
ELLA HORNICK—NOW OF WISCONSIN—SAYS PRISONER RUSSELL SALVITTI TAINTED HER TRIAL
BY LYING ABOUT HIS PROFESSION DURING JURY SELECTION. HE'S SERVING A DRUG SENTENCE,
BUT SAID HE WAS A COUNSELOR.

(LEWIS RUN)—THIRTY-SEVEN PRISONERS WHO STAGED A MEAL STRIKE AT THE MCKEAN
COUNTY FEDERAL CORRECTIONAL INSTITUTION ARE AT ANOTHER PRISON TODAY FOR
DISCIPLINE HEARINGS. MOST OF THE PRISON'S THOUSAND INMATES RETURNED TO THE
CAFETERIA LAST FRIDAY, ENDING A THREE-DAY BOYCOTT.

(PITTSBURGH)—A TEXAS TODDLER WHO RECEIVED TWO TRANSPLANTED ORGANS IS IN
BETTER CONDITION TODAY. TRACEY KAY GONZALES WAS UPGRADED FROM CRITICAL TO
SERIOUS CONDITION DURING THE WEEKEND AT CHILDREN'S HOSPITAL.

AP-NP-07-30-90 0102EDT<+

AP—FATALFIRE 07-30 0165

(LANCASTER)—AUTHORITIES SAY FIVE PEOPLE HAVE DIED IN A BLAZE THIS MORNING IN LANCASTER'S SOUTH SIDE.

STATE POLICE FIRE MARSHALS SAY THE FIRE BEGAN IN A ROW HOME AND SPREAD TO THE THREE ADJACENT HOUSES DURING THE EARLY MORNING HOURS.

FIVE PEOPLE DIED AFTER BEING TRAPPED ON THE SECOND FLOOR OF ONE OF THE HOMES.

TWO OTHERS HAVE BEEN TAKEN TO AREA HOSPITALS. ONE OF THE SURVIVORS, A CHILD, WAS THEN FLOWN TO THE CHILDREN'S HOSPITAL BURN UNIT IN PHILADELPHIA.

AUTHORITIES HAVEN'T RELEASED ANY IDENTIFICATIONS YET.

FIRE CREWS REMAIN ON THE SCENE, SEARCHING FOR A CAUSE. AUTHORITIES SAY ARSON HAS NOT BEEN RULED OUT.

ONE OF THE HOMES WAS COMPLETELY GUTTED, AND THE REMAINING THREE HOMES SUSTAINED HEAVY DAMAGE.

THE FIRE WAS SO STRONG THAT SMOKE FROM THE BLAZE SET OFF SMOKE DETECTORS IN A NEIGHBOR'S HOUSE. THAT NEIGHBOR NOTIFIED THE FIRE DEPARTMENT.

THE CORONER HAS SCHEDULED AUTOPSIES ON THE FIVE VICTIMS FOR LATER TODAY.

AP-NP—07-30-90 0522EDT<+

AP-PA—FATALFIRE(2NDTOPS) 07-30 0188

(LANCASTER)—AUTHORITIES SAY FIVE PEOPLE DIED AND TWO WERE INJURED IN A ROW-HOUSE FIRE THIS MORNING IN LANCASTER'S SOUTH SIDE. THREE OTHER HOMES WERE DAMAGED AND THE COST WAS ESTIMATED AT MORE THAN 80-THOUSAND DOLLARS.

FIRE LIEUTENANT ED KNIGHT SAYS FLAMES WERE BLOWING 15 TO 20 FEET ACROSS THE STREET WHEN FIREFIGHTERS ARRIVED ON THE SCENE SHORTLY AFTER 3 A-M.

KNIGHT SAYS THE VICTIMS WERE FOUND ON THE SECOND FLOOR OF THE FIRST HOUSE.

HE SAYS THE DEAD INCLUDED TWO TEENAGERS AND THREE CHILDREN, AND ONE OF THE TEENAGERS WAS PREGNANT.

AUTHORITIES SAY THE ONLY SURVIVORS WERE 36-YEAR-OLD CARMEN CINTRON AND AN INFANT GIRL. ANGELA GUIRLANDO, A SPOKESWOMAN AT COMMUNITY HOSPITAL OF LANCASTER, SAYS CINTRON IS IN SERIOUS CONDITION IN THE INTENSIVE CARE UNIT WITH BURNS, CUTS AND SMOKE INHALATION. KNIGHT SAYS THE INFANT IS IN CRITICAL CONDITION AND IS BEING TRANSFERRED TO ST. CHRISTOPHER'S HOSPITAL FOR CHILDREN IN PHILADELPHIA.

IDENTIFICATIONS OF THE DEAD AND THE INFANT ARE NOT YET RELEASED. A CAUSE HAS NOT BEEN DETERMINED.

. . . KNIGHT SAYS HE BELIEVES THE FIRE IS THE WORST IN LANCASTER'S HISTORY. HE SAYS A ROW-HOUSE FIRE IN 1969 KILLED FOUR PEOPLE.

AP-NP—07-30-90 0906EDT<+

AP-PA—FATALFIRE(3RDTOPS) 07-30 0163

(LANCASTER)—A ROW-HOUSE FIRE TODAY IN LANCASTER KILLED FIVE PEOPLE AND INJURED TWO. AUTHORITIES SAY THE DEAD INCLUDED TWO TEEN-AGERS AND THREE CHILDREN, AND THAT ONE OF THE TEEN-AGERS WAS PREGNANT.

ACCORDING TO AUTHORITIES, THE ONLY SURVIVORS WERE 36-YEAR-OLD CARMEN CINTRON AND A 1-YEAR-OLD GIRL, ANGELICA VASQUEZ. BOTH HAVE BEEN HOSPITALIZED.

A SPOKESWOMAN AT COMMUNITY HOSPITAL OF LANCASTER SAYS CINTRON IS IN SERIOUS CONDITION. A SPOKESWOMAN AT LANCASTER GENERAL HOSPITAL SAYS THE INFANT IS IN CRITICAL CONDITION AND WOULD BE FLOWN TO ST. CHRISTOPHER'S HOSPITAL FOR CHILDREN IN PHILADELPHIA.

IDENTIFICATIONS OF THE DEAD HAVE NOT BEEN RELEASED YET. THE CAUSE OF THE FIRE IS UNDER INVESTIGATION.

THE FIRE WAS REPORTED SHORTLY AFTER 3 A-M AFTER IT SET OFF A NEIGHBOR'S SMOKE DETECTORS. FIRE LIEUTENANT ED KNIGHT SAYS FLAMES WERE BLOWING 15 TO 20 FEET ACROSS THE STREET WHEN FIREFIGHTERS ARRIVED. THE BLAZE WAS DECLARED UNDER CONTROL ABOUT A HALF-HOUR LATER.

AP-NP-07-30-90 0951EDT<+

Local News

Local news is written by newspeople in the station. Stations that have a full-time news staff have various people who gather and write local news throughout the day. Many stations, however, have only one full-time newsperson. That can limit the capability of such stations to stay on top of local stories.

The stories included here are a sampling of stories from newscasts gathered and written by the local news staffs of public broadcasting station WITF in Harrisburg, Pennsylvania, WEEI NEWSRADIO 590 in Boston, and WHP News Talk 580 in Harrisburg, Pennsylvania.

This news copy includes examples of stories that have audio inserts. Places where audio is used are designated by using an outcue that indicates the end of the taped portion of the story. Other copy inserts the word "CART" (for tape cartridge) or "NETWORK" (to indicate a report from the state radio network). When using these stories for practice, you may want to prerecord inserts for use with the story.

PENSE 8/8 DR

STATE POLICE YESTERDAY ARRESTED WILLIAM PENSE SENIOR IN RAPHO TWP. IN LANCASTER COUNTY . . . ENDING A WEEKEND LONG MANHUNT. PENSE ALLEGEDLY SHOT HIS SON'S LANDLADY ON FRIDAY IN LEBANON CITY. PENSE WAS REPORTEDLY STAYING WITH HIS SON . . . AND SHOT 50-YEAR-OLD GENEVIEVE ODELL WITH A SHOTGUN WHEN SHE TRIED TO

COLLECT RENT. OFFICIALS SAY ODELL'S RENT BOOK MIGHT HAVE SAVED HER FROM SERIOUS INJURY, DEFLECTING PART OF THE SHOTGUN BLAST. SHE'S IN SERIOUS CONDITION AT HERSHEY MEDICAL CENTER.

AFTER THE SHOOTING, PENSE TOOK ODELL'S CAR AND FLED. THE CAR WAS FOUND NEAR THE GOV. DICK OBSERVATION TOWER NEAR MT. GRETNA . . . ON SATURDAY. ABOUT NOON YESTERDAY STATE TROOPERS SURROUNDED A HOUSE ON PINCH ROAD IN RAPHO TWP. AFTER A MAN WITH A SHOTGUN WAS SEEN BREAKING IN. PENSE, HOWEVER, WAS HIDING IN HIGH GRASS BEHIND POLICE LINES. AFTER A STATE POLICE HELICOPTER LANDED NEAR WHERE HE WAS HIDING . . . PENSE, CARRYING HIS SHOTGUN OVER HIS HEAD, SURRENDERED.

HE'S IN THE LEBANON COUNTY PRISON IN LIEU OF 50 THOUSAND DOLLARS BAIL.

AIR QUALITY 8/8 DR

THE CURRENT HEAT WAVE IS BRINGING MORE THAN JUST UNCOMFORTABLE TEMPERATURES AS JANE HOLLINGER REPORTS. . . . IT'S A MEDICAL RISK FOR SOME. . . .

CART

CORN FLAKES 8/8 DR

AS YOU SIT DOWN TO BREAKFAST. YOU MIGHT WANT TO CONSIDER THIS. . . . IF THAT'S A BOWL OF CORNFLAKES YOU'RE EATING, YOU'RE MUNCHING ON WHAT'S BECOMING A PRE-CIOUS COMMODITY. JAN THOMAS SAYS . . . THERE'S A SHORTAGE OF CORN FLAKES IN PA. . . .

CART

KLAN 8/8 DR

200 OF THE CURIOUS SHOWED UP IN VALLEY FORGE YESTERDAY TO WATCH AS 30 MEMBERS OF THE KU KLUX KLAN TRIED TO RECRUIT NEW MEMBERS. AS KIRK DORN REPORTS.... IT WASN'T AN ENTIRELY FRIENDLY MEETING

CART

HEADLINES 8/8

HOUSE MEMBERS RETURN TO THE STATEHOUSE TODAY TO BEGIN TALKING TO LEGISLA- TIVE LEADERS ABOUT BUDGET MATTERS STILL TO BE SETTLED ... INCLUDING DISTRIBUTING STATE MONEY TO SCHOOL DISTRICTS. SENATORS WON'T RE-CONVENE UNTIL TOMORROW.

THE STATE AUDITOR GENERAL'S OFFICE BEGINS LOOKING AT THE BOOKS OF THE YORK COUNTY PROBATION DEPARTMENT TODAY ... IT'S ALLEGED THAT AS MUCH AS 6 THOUSAND DOLLARS COULD BE MISSING.

POLICE SAY TWENTY-FOUR PEOPLE WERE INJURED, EIGHT CRITICALLY, OVER THE WEEKEND WHEN A RACING BOAT FLEW INTO A CROWD OF SPECTATORS IN PITTSBURGH. STEVE RUBIN HAS THE STORY.

"NETWORK"

IF THE GOVERNMENT GIVES ITS STAMP OF APPROVAL THE FRIENDLY ICE CREAM STORES WILL NO LONGER BE OWNED BY THE HERSHEY FOODS CORPORATION. HERSHEY CHIEF

RICHARD ZIMMERMAN ANNOUNCED TODAY THAT THE COMPANY IS SELLING THE FRIENDLY SUBSIDIARY TO A TENNESSEE RESTAURANT CHAIN SO THAT IT CAN CONCENTRATE ON THE BUSINESS OF CONSUMER FOOD PRODUCTS.

8-8-88 MG

A MAN WHO'S BEEN DESCRIBED AS THE MASTERMIND BEHIND A JOB SELLING SCHEME IN THE AUDITOR GENERAL'S OFFICE HAS BEGUN SERVING TIME IN PRISON. FORMER DEPUTY AUDITOR GENERAL JOHN KERR SURRENDERED TO AUTHORITIES TODAY TO START A TWO- TO FIVE-YEAR SENTENCE ON JOB SELLING CHARGES.

8-8-88 MG

A 13-YEAR-OLD LEGAL PRECEDENT HAS BEEN OVERTURNED IN PENNSYLVANIA THAT WILL BENEFIT MINISTERS, PRIESTS AND RABBIS. THE STATE SUPREME COURT HAS STRUCK DOWN THE APPLICATION OF SO-CALLED OCCUPATION TAXES TO CLERGY. THE COURT RULED IT WAS UNCONSTITUTIONAL FOR CLERGY TO BE TAXED FOR DISSEMINATING THEIR RELIGIOUS BELIEFS.

8-8-88 MG

MORE THAN 300 PENNSYLVANIA SMALL BUSINESS OWNERS ARE SUING GOVERNOR CASEY BECAUSE HIS ADMINISTRATION HAS NOT YET PAID THE UNEMPLOYMENT COMPENSATION DEBT OWED TO THE FEDERAL GOVERNMENT. NOT PAYING THE OVER ONE BILLION DOLLAR DEBT WILL RESULT IN A 272 MILLION DOLLAR PENALTY. JIM PANYARD, VICE PRESIDENT OF THE PENNSYLVANIA MANUFACTURERS ASSOCIATION, SAYS THE GOVERNOR HAS HAD PLENTY OF TIME AND MONEY TO PAY OFF THE DEBT . . .

("IN IT':13) (VOICE)

PENNSYLVANIA HAS TILL NOVEMBER TENTH TO REPAY THE MONEY IT BORROWED FROM UNCLE SAM ALMOST TEN YEARS AGO.

8-8-88 MG

A HARRISBURG MAN WHO, AS A CHILD, WAS A PRISONER IN A NAZI CONCENTRATION CAMP IN LITHUANIA, WILL SOON HAVE A LONGTIME WISH COME TRUE. SAM SHARON WILL LEAVE FOR THE SOVIET UNION TOMORROW ON A PAINFUL JOURNEY TO RETURN TO HIS HOMETOWN WHERE 47 YEARS AGO HIS FAMILY AND MOST OF THE JEWS IN THE TINY TOWN WERE KILLED AND DUMPED INTO MASS GRAVES. . .

("MASS GRAVE":11) #2 (VOICE)

AFTER YEARS OF TRYING TO OBTAIN A VISA FROM THE SOVIETS . . . HE RECEIVED ONE IN APRIL . . . HE ATTRIBUTES THAT, IN PART, TO SOVIET LEADER GORBACHEV'S EFFORTS TOWARD "GLASNOST."

08/13/90 06:58 nor 0:80 #12+1CADET

CADET 8AM 8/13 NC

HOLLY SHEPARD SAYS SHE IS "STUNNED" THAT STATE POLICE TROOPER BLAKE GILMORE HAS BEEN PARTICIPATING IN THE PARA-MILITARY TRAINING OF HIGH SCHOOL STUDENTS. THE HERALD REPORTS THAT GILMORE HELPED INSTRUCT 200 "STUDENT TROOPERS" DURING A PROGRAM AT THE STATE POLICE ACADEMY AT AGAWAM LAST MONTH. GILMORE WAS IN CHARGE OF TRAINING SHEPARD'S HUSBAND, TIMOTHY, AND OTHER CADETS AT THE ACADEMY IN 1988. TIMOTHY SHEPARD DIED AS A RESULT OF INJURIES HE SUFFERED DURING THAT TRAINING.

A SPOKESWOMAN FOR THE EXECUTIVE OFFICE OF PUBLIC SAFETY SAYS OFFICIALS SEE NOTHING WRONG WITH USING GILMORE AS AN INSTRUCTOR.

08/13/90 07:51 ncr 0:80 #12+1JUVENIL

JUVENILE/MURDER 8:30AM 8/13 NC

A DRAMATIC INCREASE IN THE NUMBER OF MURDERS COMMITTED BY TEENAGERS IS BEING LINKED TO CHILD ABUSE AND DRUG ADDICTION.

A/:03/"TOMORROW'S KILLER"

THAT'S A NEW YORK PROFESSOR WHO PRESENTED A STUDY ON THE SOARING RATE OF TEEN HOMICIDE AT THE CONVENTION OF THE AMERICAN PSYCHOLOGICAL ASSOCIATION, HERE IN BOSTON THIS WEEKEND.
AND CHARLES EWING OF THE UNIVERSITY OF BUFFALO SAYS THERE IS AN UNDENIABLE CONNECTION BETWEEN POVERTY AND THE SOARING RATE OF MURDERS COMMITTED BY AMERICAN TEENAGERS:

A-5/:21/"VERY LITTLE"

EWING PREDICTS THAT HOMICIDES BY TEENAGERS WILL REACH EPIDEMIC PROPORTIONS BY THE END OF THE DECADE IF THE UNDERLYING CAUSES OF THE PROBLEM ARE NOT ADDRESSED.

08/13/90 07:24 ncr 0:80 #12+1COP/SHO

318

COP/SHOT

AN AUXILIARY POLICEMAN FROM SOMERVILLE REMAINS IN GUARDED CONDITION THIS
MORNING AFTER A SHOOTING WHICH OCCURRED WHILE HE WAS OFF-DUTY. AUTHORITIES SAY
JOHN HANEY WAS TRYING TO BREAK UP A FIGHT BETWEEN SEVERAL WOMEN IN DORCHESTER
WHEN AN UNIDENTIFIED MAN SHOT HIM. CITY POLICE ARE INVESTIGATING.

08/13/90 06:59 ncr 0:80 #12+1BODIES

BODIES 8AM 8/13 NC

THE BRISTOL COUNTY GRAND JURY INVESTIGATING THE SERIAL KILLINGS OF NINE WOMEN
IS SCHEDULED TO RECONVENE TODAY. THE INVESTIGATION REPORTEDLY HAS FOCUSED ON A
FORMER NEW BEDFORD ATTORNEY, KENNETH PONTE. IT'S POSSIBLE THAT AN F-B-I ANALYSIS
OF HAIR AND SALIVA SAMPLES FROM PONTE COULD BE PRESENTED TO THE PANEL TODAY.

08/13/90 07:09 ncr 0:80 #12+1LOBSTER

LOBSTER 8AM 8/13 NC

MASSACHUSETTS LOBSTERMEN ARE STAGING A WORK STOPPAGE TODAY AS A PROTEST
AGAINST LOW LOBSTER PRICES. AND TOM BARTLETT OF BEVERLY SAYS THEY WILL ALSO GIVE
AWAY A TON OF LOBSTERS TO ORGANIZATIONS THAT HELP SENIOR CITIZENS:

A-3/:13/"TO THE ELDERLY"

BARTLETT SAYS AREA LOBSTERMEN PLAN TO STAY OUT OF THE WATER FOR THREE DAYS.

8-21-90 ckf 1006

TALKS CONTINUE AT THIS HOUR AS NEGOTIATORS FOR THE HARRISBURG SCHOOL DISTRICT
AND ITS TEACHERS WORK TO REACH A CONTRACT AGREEMENT PRIOR TO AUGUST 28.

THE DISCUSSIONS BEGAN THIS MORNING AT 8.

THE TEACHERS ARE SEEKING SALARIES ABOVE THE STATE MINIMUM OF 18 THOUSAND 500
DOLLARS AS WELL AS IMPROVEMENTS IN BENEFITS.

THE DISTRICT HAS BEEN LOOKING AT A TEACHERS PROPOSAL AND IS EXPECTED TO OFFER A
COUNTER TODAY.

A TEACHERS MEMBERSHIP MEETING . . . WHICH INCLUDES A CONTRACT VOTE IF TODAY'S
MEETINGS GO WELL . . . OR A STRIKE AUTHORIZATION VOTE IF THEY DON'T . . . IS SET FOR
THURSDAY.

A DELAY IN DECISION MAKING ON CONVERTING THE LEBANON JUNIOR HIGH TO A MIDDLE
SCHOOL.

CG=ROTHERMEL *

RUNS= :11

OUT Q=ALTERNATIVES

LEBANON SCHOOL BOARD VICE PRESIDENT BOB ROTHERMEL WHO SAYS THE BOARD WILL
HAVE TO DECIDE NEXT WEEK IF IT WILL BRING 6TH, 7TH AND 8TH GRADE STUDENTS TOGETHER
THIS YEAR . . . OR WAIT UNTIL NEXT.

GOOD NEWS FOR A YORK COUNTY SCHOOL.

YORK CHRISTIAN SCHOOL HAS BEEN GIVEN THE GREEN LIGHT BY THE SPRING GARDEN

TOWNSHIP ZONING BOARD TO HOLD CLASSES AT THE LIVINGWOOD CHURCH FOR THE 1990-91 SCHOOL YEAR.

YORK CHRISTIAN'S FACILITY WAS BADLY DAMAGED BY FLAMES LAST MONTH.

SCHOOL SUPERINTENDENT PETER TEAGUE SAYS THE CHURCH IS IDEAL FOR HIS STUDENTS.

CG=TEAGUE #3

RUNS= :13

OUT Q=GO

TEAGUE SAYS YORK CHRISTIAN HOPES TO HAVE ITS SCHOOL REBUILT AND READY TO GO BY JANUARY FIRST.

NATIONWIDE SAYS THE STATE ISN'T ON ITS SIDE.

SAYING THE STATE'S NEW AUTO INSURANCE LAW WILL COST IT MILLIONS EACH MONTH, THE INSURANCE GIANT HAS GONE TO COURT SEEKING TO HAVE IT EXEMPTED FROM THE 10-22 PERCENT CUTS MANDATED.

NATIONWIDE'S JEFF BOTTI SAYS HIS FIRM IS WATCHING ITS BOTTOM LINE CAREFULLY . . .

CG=BOTTI #31

RUNS= :10

OUT Q=PENNSYLVANIA

NATIONWIDE IS THE SECOND LARGEST INSURANCE FIRM IN THE STATE.

CUMBERLAND COUNTY DEMOCRATS HAVE TAPPED GEORGE MATTHIAS AS THEIR REPLACE-MENT FOR 87TH STATE HOUSE CANDIDATE DENNIS HURSH.

HURSH LEFT THE RACE EARLIER THIS MONTH BECAUSE OF THE ILL HEALTH OF HIS INFANT DAUGHTER.

MATTHIAS WILL FACE REPUBLICAN PAT VANCE IN THE RACE TO SUCCEED GOP LT. GUBER-NATORIAL CANDIDATE HAL MOWARY AS THE REPRESENTATIVE OF THE NORTHERN WEST SHORE.

8-21-90 ckf HBURG TEACHERS

HARRISBURG SCHOOLS AND ITS EDUCATORS ARE NEGOTIATING FOR A NEW CONTRACT THIS
TUESDAY.

WHP'S CHRIS FICKES HAS BACKGROUND ON THE TALKS.

CG=FICKES *

RUNS=:

OUT Q=STD.

THE TEACHERS ARE SEEKING SALARIES ABOVE THE STATE MINIMUM OF 18 THOUSAND 500
DOLLARS AS WELL AS IMPROVEMENTS IN BENEFITS.

THE DISTRICT HAS BEEN LOOKING AT A TEACHERS PROPOSAL AND IS EXPECTED TO OFFER A
COUNTER TODAY.

A TEACHERS MEMBERSHIP MEETING . . . WHICH INCLUDES A CONTRACT VOTE IF TODAY'S
MEETINGS GO WELL . . . OR A STRIKE AUTHORIZATION VOTE IF THEY DON'T . . . IS SET FOR
THURSDAY.

HARRISBURG TEACHERS HAVE STRUCK ONLY ONCE . . . IN 1976.

CHRIS FICKES, NEWS/TALK 580, WHP.

8-21-90 LEB SCHOOL

THE LEBANON SCHOOL BOARD HAS PUT OFF—FOR AT LEAST ANOTHER WEEK—
A DECISION AWARDING A CONTRACT RENOVATING THE CITY'S JUNIOR HIGH SCHOOL—AND
CONVERTING IT INTO A MIDDLE SCHOOL...

BIDS ON THE 11-MILLION DOLLAR PROJECT ARE REPORTED TO HAVE COME IN SOME 2-
MILLION DOLLARS OVER THE PROJECTED COST . . .

LEBANON SCHOOL BOARD VICE PRESIDENT BOB ROTHERMEL EXPLAINS WHY THE SCHOOL
BOARD HAS PLACED A DECISION ON HOLD FOR ANOTHER WEEK.

CG=ROTHERMEL #33
RUNS= :11
OUT Q=ALTERNATIVES

ROTHERMEL SAYS IT'S HOPED WORK ON THE PROJECT COULD START NEXT MONTH—WITH A
COMPLETION DATE IN AUGUST OF NEXT YEAR...

8-21-90 ckf ETOWN SCHOOLS

SHOULD THE ELIZABETHTOWN SCHOOL DISTRICT PURCHASE SOME LAND TO ALLOW FOR
FUTURE EXPANSION.
AS WHP'S GORDON WEISE REPORTS, THAT QUESTION WILL COME BEFORE THE SCHOOL
BOARD TONIGHT.
CG=WEISE #
RUNS= :
OUT Q=STD.

AT ISSUE ... 34 ACRES ALONG EAST HIGH STREET JUST EAST OF ELIZABETHTOWN HIGH
SCHOOL AND WEST OF ROUTE 283.
WHILE DISTRICT OFFICIALS DON'T HAVE ANY SPECIFIC PLANS FOR THE
LAND ... THEY DO SAY IT COULD BE USED FOR SCHOOL BUILDINGS OR FOR ATHLETIC FIELDS.
A RECENT LOOK AT THE DISTRICT'S FACILITIES SHOWED E-TOWN WILL NEED AN ADDI-
TIONAL 40 CLASSROOMS IN NINE YEARS—BY THE YEAR 2000.
THE REASON FOR ALL THAT EXTRA SPACE ... AN EXPECTED 40 PERCENT INCREASE IN
STUDENT ENROLLMENT AS WESTERN LANCASTER COUNTY CONTINUES TO GROW.
TONIGHT'S PUBLIC HEARING IS SET FOR 7:30 AT THE E-TOWN MIDDLE SCHOOL.
GORDON WEISE, NEWS/TALK 580, WHP.

Business News

This section includes various types of financial information fed by AP. This includes such items as stock market updates, gold prices, and business news. Radio stations often use this material in business news formats that are integrated into other programming.

AP-BUSINESSWATCH:DOLLAR/ 07-29 0053

(TOKYO)-THE DOLLAR OPENED AT 149.10 YEN ON THE TOKYO FOREIGN EXCHANGE MARKET MONDAY, DOWN FROM FRIDAY'S CLOSE OF 150.75 YEN.

AP-NP-07-29-90 2110EDT<+

AP-BUSINESSWATCH:HONGKONG 07-29 0051

(HONG KONG)-GOLD ROSE 38 CENTS AN OUNCE MONDAY, OPENING AT $367.87. IT CLOSED AT $367.49 SATURDAY.

AP-NP-07-29-90 2147EDT<+

AP-BUSINESSWATCH:LONDONM 07-30 0057
AP-BUSINESSWATCH: LONDON MORNING GOLD FIX

(LONDON)-THE MONDAY MORNING GOLD FIXING IN LONDON WAS $367.80.
THE FRIDAY AFTERNOON FIX WAS $366.75.
THE FRIDAY CLOSE WAS $367.15.

AP-NP-07-30-90 0541EDT<+

AP-BUSINESSWATCH:OPENING WALL STREET 07-30 0129

(NEW YORK)—PRICES ON THE NEW YORK STOCK EXCHANGE ARE LOWER IN LIGHT TRADING. THE DOW JONES INDUSTRIAL AVERAGE, WHICH LOST MORE THAN TEN POINTS FRIDAY, IS OFF 22 POINTS IN TODAY'S EARLY GOING. OVERALL ON THE BIG BOARD, DECLINING ISSUES HAVE A THREE-TO-ONE LEAD OVER GAINERS.

ANALYSTS LOOK FOR THE MARKET TO CONTINUE ITS SLIDE AS PLAYERS FOCUS ON THE CONCERNS SPARKED BY FRIDAY'S DISAPPOINTING REPORT ON SECOND-QUARTER ECONOMIC GROWTH. HOWEVER, THEY DON'T EXPECT TO SEE ANY MAJOR DAMAGE NOW THAT THE WAVE OF QUARTERLY EARNINGS REPORTS HAS CRESTED.

THOSE REPORTS HAVE BEEN A MAJOR SOURCE OF MARKET PESSIMISM, AND WALL STREETERS NOW THINK THAT THE LET-UP MAY ALLOW ANY BRIGHT SPOTS TO GET MORE ATTENTION.

AP-NP-07-30-90 0942EDT<+

AP-BUSINESSWATCH :WALLSTR 07-30 0076
AP-BUSINESSWATCH: WALL STREET OPENING PRICES

(NEW YORK)—HERE ARE SOME OF THE OPENING PRICES ON THE NEW YORK STOCK EXCHANGE:

A-T-AND-T	36	1-4	DOWN 1-8
GENERAL MOTORS	47	1-8	DOWN 1-4
EXXON	49	1-8	DOWN 1-8
I-B-M	111		DOWN 3-8
GENERAL ELECTRIC	71	5-8	DOWN 3-8

AP-NP-07-30-90 0943EDT<+

AP—BUSINESWATCH:NYSETRA 07-30 0050

	TODAY	PREVIOUS SESSION
9:30-10:00	20,340,000	22,400,000

AP—NP—07-30-90 1004EDT<+

AP—BUSINESSWATCH:DOWJONE 07-30 0061
AP—BUSINESSWATCH:DOWJONES 10:00 AVERAGES

30 INDUSTRIALS	2880.94	DOWN	17.57
20 TRANSPORTATIONS	1119.16	DOWN	15.51
15 UTILITIES	202.97	DOWN	0.38
65 STOCKS	1019.42	DOWN	7.86

AP—NP—07-30-90 1006EDT<+

AP—PERSONAL INCOME 07-30 0127
AP—PERSONAL INCOME

(WASHINGTON)—CONSUMER SPENDING HAS POSTED ITS LARGEST GAIN IN FIVE MONTHS
WITH A JUMP OF ONE PERCENT IN JUNE. AT THE SAME TIME, THE COMMERCE DEPARTMENT
REPORTS PERSONAL INCOMES EDGED UP JUST FOUR-TENTHS OF ONE PERCENT.

CONSUMER SPENDING IS CONSIDERED A GOOD INDICATOR OF ECONOMIC HEALTH SINCE IT
ACCOUNTS FOR ABOUT TWO-THIRDS OF THE NATION'S ECONOMIC ACTIVITY.

AMERICANS' SAVINGS RATE—SAVINGS AS A PERCENT OF DISPOSABLE INCOME—FELL TO
FOUR-POINT-NINE PERCENT. IT HAD BEEN FIVE-POINT-FOUR PERCENT IN MAY AND FIVE-

POINT-ONE PERCENT IN APRIL. A HIGHER SAVINGS RATE IS IMPORTANT BECAUSE IT MEANS LESS DEPENDENCE ON FOREIGN CAPITAL SINCE FUNDS WOULD BE AVAILABLE DOMESTICALLY FOR BUSINESS INVESTMENT.

AP-NP-07-30-90 1037EDT<+

AP-BUSINESSWATCH:DOWJONE 07-30 0061

30 INDUSTRIALS	2889.36	DOWN	9.15
20 TRANSPORTATIONS	1117.34	DOWN	17.33
15 UTILITIES	203.28	DOWN	0.07
65 STOCKS	1020.83	DOWN	6.45

AP-NP-07-30-90 1040EDT<+

AP-BUSINESSWATCH:NYSETRA 07-30 0050

	TODAY	PREVIOUS SESSION
9:30-10:00	35,560,000	37,190,000

AP-NP-07-30-90 1041EDT<+

AP-MIDDAYBUSINESSMINUTE 07-30 0175
 THE PLAN BY EMPLOYEES OF UNITED AIRLINES TO PURCHASE THE CARRIER'S PARENT FIRM MAY BE IN TROUBLE. THE "WALL STREET JOURNAL" REPORTS CHEMICAL BANKING HAS WITHDRAWN AS ONE OF FIVE LEAD BANKS FOR THE PROPOSED BUYOUT OF U-A-L. THE UNION GROUP FACES AN AUGUST NINTH DEADLINE TO ARRANGE FINANCING FOR THE FOUR-POINT-38 (B) BILLION DOLLAR DEAL. THE REPORT HAS PRODUCED A SHARP DECLINE IN U-A-L SHARES.

327

AT MID-MORNING (EASTERN TIME), THEY WERE DOWN FIVE DOLLARS AT 158 DOLLARS EACH.

THE "MIDDLE EAST ECONOMIC SURVEY" SAYS LAST WEEK'S AGREEMENT BY "OPEC" PRODUCERS WILL PUSH OIL PRICES SUBSTANTIALLY HIGHER IN THE SECOND HALF OF THIS YEAR. THE 13 MEMBERS OF THE WORLD OIL CARTEL SET AN OVERALL OUTPUT QUOTA OF NEARLY 22 1-2 (M) MILLION BARRELS A DAY, AND RAISED THE BENCHMARK PRICE TO 21 DOLLARS A BARREL. WHETHER THE PRODUCERS WILL ADHERE TO THE PRODUCTION CAP, HOWEVER, IS A MATTER OF SPECULATION.

THE PRICE OF GOLD IN LONDON AT THE AFTERNOON FIXING WAS 367 DOLLARS, 30 CENTS AN OUNCE. THAT'S DOWN 50 CENTS FROM THE MORNING FIXING, BUT UP 55 CENTS FROM FRIDAY AFTERNOON'S FIXING.

AP-NP-07-30-90 1053EDT<+

AP-BUSINESSWATCH:DOWJONE 07-30 0064

30 INDUSTRIALS	2889.11	DOWN	9.40
20 TRANSPORTATIONS	1117.88	DOWN	16.79
15 UTILITIES	203.03	DOWN	0.32
65 STOCKS	1020.73	DOWN	6.55

TRADING: LIGHT

AP-NP-07-30-90 1104EDT<+

AP-BUSINESSWATCH:LONDONS 07-30 0058

(LONDON)-PRICES ON THE LONDON STOCK EXCHANGE CLOSED LOWER TODAY. THE FINANCIAL TIMES 100 (F-T-100) INDEX WAS DOWN 13-POINT-SIX POINTS FROM THE PREVIOUS SESSION.

AP-NP-07-30-90 1134EDT<+

AP-BUSINESSWSWATCH:MIDDAYW 07-30 0194

(NEW YORK)—THE STOCK MARKET IS BROADLY LOWER TODAY IN SELLING ANALYSTS
BLAME ON WORRIES ABOUT WEAKNESS IN THE ECONOMY. THERE ARE TWICE AS MANY ISSUES
LOSING MONEY AS GAINING. AND THE DOW INDUSTRIALS ARE DOWN NEARLY 12 POINTS IN
LIGHT TRADING.

 WALL STREETERS SAY PLAYERS ARE STILL UNSETTLED BY FRIDAY'S REPORT THAT THE
GROSS NATIONAL PRODUCT GREW AT A ONE-POINT-TWO PERCENT ANNUAL RATE IN THE
SECOND QUARTER.

 THAT INCREASE WAS SMALLER THAN EXPECTED, AND REFLECTED A BUILDUP IN
INVENTORIES RATHER THAN GAINS IN FINAL DEMAND AMONG CONSUMERS AND BUSINESS
PURCHASERS. THE NUMBERS ARE SEEN AS AN INAUSPICIOUS SIGN FOR PRODUCTION AND
CORPORATE PROFITS IN THE MONTHS AHEAD.

 THAT'S PROVIDING INVESTORS LITTLE INCENTIVE TO BUY STOCKS, ESPECIALLY GIVEN THE
TENDENCY OF INDIVIDUAL ISSUES TO SELL OFF SHARPLY IN ANY INSTANCE OF DISAPPOINTING
EARNINGS.

 AT 11:30 A-M (EASTERN TIME), THE DOW JONES AVERAGE OF 30 INDUSTRIALS WAS DOWN
11.88 AT 2886.63.

 THE NEW YORK STOCK EXCHANGE ESTIMATES AN AVERAGE SHARE OF COMMON STOCK AT
11 A-M WAS DOWN 14 CENTS. THE BIG BOARD INDEX OF MORE THAN 15-HUNDRED ISSUES
WAS DOWN 0.77 AT 192.55.

 TRADING DURING THE FIRST HOUR AND A-HALF TOTALED 44,410,000 SHARES.

AP-NP-07-30-90 1139EDT<+

AP-MIDDAYWALLSTREET-TAKE 07-30 0238

 HERE ARE THE TEN MOST ACTIVE BIG BOARD ISSUES TRADED BEFORE NOON (EASTERN
TIME):

SOUTHERN COMPANY	25	1-4	UNCHANGED	
WAL-MART	30	5-8	DOWN	1
UNITED TELECOMMUNICATIONS	25		DOWN	3-8
MCDONALD'S	31	1-4	DOWN	1-2
PHILIP MORRIS	47	3-8	UP	3-4
ENTERGY	19		DOWN	3-4
I-B-M	111	1-4	DOWN	1-8
CHEVRON	77	7-8	UP	5-8
G-E	71	3-4	DOWN	1-4
BOEING	57	5-8	DOWN	1 5-8

THE FIVE VOLUME LEADERS ON THE AMERICAN STOCK EXCHANGE:

B-A-T INDUSTRIES	10	13-16	UP	1-16
ECHO BAY MINES	12	3-4	DOWN	1-8
SALOMON NIKKEI-1-93	9	3-8	DOWN	1-8
ENERGY SERVICE	4	1-2	UNCHANGED	
DENMARK NIKKEI	10	3-8	UNCHANGED	

AND THE FIVE MOST ACTIVE ISSUES IN OVER-THE-COUNTER TRADING (NASDAQ):

CETUS	16	1-4	UP	3-8
LIZ CLAIBORNE	28	1-4	DOWN	1 3-4
M-C-I	36	7-8	DOWN	3-4
INTEL	42	1-4	DOWN	1 1-4
SOFTWARE TOOLWORKS	12	5-8	DOWN	1 3-8

AP-NP-07-30-90 1141EDT<+

AP-BUSINESSWATCH:CLOSING 07-30 0064

(LONDON)-THE PRICE OF GOLD CLOSED TODAY IN LONDON AT 367 DOLLARS AND 25 CENTS
AN OUNCE-UP TEN CENTS FROM FRIDAY.

THE ZURICH CLOSE WAS 366 DOLLARS AND 75 CENTS-A LOSS OF 40 CENTS AN OUNCE.

AP-NP-07-30-90 1203EDT<+

AP-BUSINESSWATCH:DOWJONE 07-30 0064

30 INDUSTRIALS	2882.18	DOWN	16.33
20 TRANSPORTATIONS	1118.07	DOWN	16.60
15 UTILITIES	203.35	UNCHANGED	
65 STOCKS	1019.66	DOWN	7.62

TRADING: LIGHT

AP-NP-07-30-90 1206EDT<+

AP-BUSINESSWATCH:NYSETRA 07-30 0092

| | TODAY | PREVIOUS SESSION |
| 9:30-12 | 62,170,000 | 67,150,000 |

AT NOON, THE NEW YORK STOCK EXCHANGE ESTIMATES THAT AN AVERAGE SHARE OF
COMMON STOCK WAS DOWN 18 CENTS.

THE EXCHANGE'S INDEX WAS DOWN 1.03 AT 192.29.

INDUSTRIALS WERE DOWN 1.29 AT 240.79.

TRANSPORTATIONS WERE DOWN 2.35 AT 167.21.

UTILITIES WERE DOWN 0.27 AT 88.01.

AND FINANCE ISSUES WERE DOWN 0.93 AT 138.77.

AP-NP-07-30-90 1208EDT<+

AP-BUSINESSWATCH:DOWJONE 07-30 0064

30 INDUSTRIALS	2883.17	DOWN	15.34
20 TRANSPORTATIONS	1116.79	DOWN	17.88
15 UTILITIES	203.41	UP	0.06
65 STOCKS	1019.56	DOWN	7.72

TRADING:

AP-NP-07-30-90 1237EDT<+

AP-BUSINESSWATCH:NYSETRA 07-30 0051

	TODAY	PREVIOUS SESSION
9:30-12:30	69,620,000	78,380,000

AP-NP-07-30-90 1238EDT<+

AP-BUSINESSWATCH:DOWJONE 07-30 0064

30 INDUSTRIALS	2884.90	DOWN	13.61
20 TRANSPORTATIONS	1118.80	DOWN	15.87
15 UTILITIES	203.53	DOWN	0.18
65 STOCKS	1020.53	DOWN	6.75

TRADING: LIGHT

AP-NP-07-30-90 1312EDT<+

AP-BUSINESSWATCH:DOWJONE 07-30 0061

30 INDUSTRIALS	2882.92	DOWN	15.59
20 TRANSPORTATIONS	1119.53	DOWN	15.14
15 UTILITIES	203.97	UP	0.62
65 STOCKS	1020.68	DOWN	6.60

AP-NP-07-30-90 1335EDT<+

AP-BUSINESSWATCH:NYSETRA 07-30 0050

	TODAY	PREVIOUS SESSION
9:30-1:30	82,290,000	95,310,000

AP-NP-07-30-90 1339EDT<+

```
AP-BUSINESSWATCH:NYSETRA    07-30 0050

                              TODAY            PREVIOUS SESSION
      9:30-1:00           76,750,000            86,210,000

AP-NP-07-30-90  1318EDT<+
```

Sports Information

Sports information received on the AP wire includes continuous updates on games in progress, summaries of sports results, and news stories and features.

Baseball line scores give a summary of data from games in progress. Significant information about the game is given, along with the current score. Pitchers are often listed in line scores, as are the names of home run hitters and the number of the inning in which the home run was hit.

"Sportswatch" is a summary of sports stories fed over a period of time. We have presented the "Sportswatch" feature as it is fed—interrupted by line scores of ongoing baseball games and state sports stories.

```
AP-SCORECARD   07-29 0184

  HERE IS THE LATEST FROM THE BALLPARKS:

AMERICAN LEAGUE
  NY YANKEES              8     CLEVELAND     4 (TOP 9TH, 1ST GAME)
     ERIC PLUNK PTG NEW YORK 7TH
     JESSE OROSCO PTG CLEVELAND 9TH
     RUDY SEANEZ PTG CLEVELAND 9TH

  TORONTO                9     TEXAS        7 (TOP 7TH)
     JOHN CANDELARIA PTG TORONTO 6TH
```

BOSTON 10 DETROIT 3 (IN 8TH)
 JERRY DON GLEATON PTG DETROIT 6TH
 MIKE HENNEMAN PTG DETROIT 8TH

MINNESOTA 5 OAKLAND 4 (BOT. 6TH)
 TODD BURNS PTG OAKLAND 5TH
 JUAN BERENGUER PTG MINNESOTA 6TH

MILWAUKEE 3 CHICAGO 2 (BOT. 5TH)
 HR: MIKE FELDER, MILWAUKEE 5TH NONE ON, HIS 2ND

BALTIMORE 4 KANSAS CITY 1 (TOP 7TH)
 MEL STOTTLEMYRE PTG KANSAS CITY 4TH

NATIONAL LEAGUE
 FINAL CHI CUBS 2 MONTREAL 1

 FINAL PITTSBURGH 2 PHILADELPHIA 1

 SAN FRANCISCO 1 CINCINNATI 0 (TOP 3RD)

ATLANTA 0 LOS ANGELES 0 (BOT. 1ST)
 STARTERS CHARLIE LIEBRANDT, ATLANTA
 RAMON MARTINEZ, LOS ANGELES

HOUSTON 0 SAN DIEGO 0 (BOT. 1ST)
 STARTERS JIM DESHAIES, HOUSTON
 BRUCE HURST, SAN DIEGO

AP-NP-07-29-90 1626EDT<+

AP-LINESCORE:NATIONALLEA 07-29 0069

				R	H	E
CHICAGO	100	000	100 -	2	4	2
MONTREAL	000	000	100 -	1	4	1

HARKEY, WILLIAMS (8)

GROSS, SMITH (8) SAMPEN (9)

WP-HARKEY (9-5)

LP-GROSS (8-8)

SV-WILLIAMS (12)

AP-NP—07-29-90 1631EDT<+

AP-LINESCORE:NATIONALLEA 07-29 0070

				R	H	E
PHILADELPHIA	100	000	000 -	1	2	0
PITTSBURGH	000	200	00X -	2	3	0

COMBS, AKERFELDS (7)

DRABEK

WP-DRABEK (13-4)

LP-COMBS (6-8)

HRS-PHILADELPHIA, DAULTON (6)

AP-NY—07-29-90 1636EDT<+

AP-LINESCORE:AMERICANLEA 07-29 0068

```
                              R    H    E
BALTIMORE       211  000  000 - 4   12   0
KANSAS CITY     000  001  000 - 1    4   0
```

MITCHELL, BALLARD (8) OLSON (9)

GORDON, STOTTLEMYRE (4)

WP-MITCHELL (3-3)

LP-GORDON (6-7)

SV-OLSON (23)

AP-NP-07-29-90 1720EDT<+

AP-SPORTSWATCHNASCAR:DIE 07-29 0165

(TALLADEGA, ALABAMA)-DALE EARNHARDT OUTLASTED BILL ELLIOTT TO WIN THE
DIEHARD 500 NASCAR RACE AT THE TALLADEGA SUPER SPEEDWAY.

EARNHARDT CREW GAMBLED THAT HE HAD ENOUGH FUEL LEFT TO FINISH THE RACE, AND IT
PAID OFF AS HE HELD OFF ELLIOTT OVER THE LATE PORTIONS OF THE RACE. EARNHARDT
DIDN'T GIVE UP ANY GROUND ON THE FINAL LAP, AS HE FINISHED TWO CAR LENGTHS IN FRONT
OF ELLIOTT.

IT'S THE THIRD TIME THAT EARNHARDT HAS WON THE RACE AS HE BECAME ONLY THE
THIRD DRIVER TO TAKE THE CHECKERED FLAG IN THE EVENT AS THE POLE-SITTER. HE AVER-
AGED 174-POINT-430 MILES PER HOUR IN HIS CHEVY LUMINA.

STERLING MARLIN FINISHED THIRD, FOLLOWED BY ALAN KULWICKI AND RICKY RUDD.

THE RACE WAS MARRED BY A PIT ACCIDENT THAT INJURED FOUR MEMBERS OF TRACY
LESLIE'S CREW. STANLEY SMITH, DRIVING IN HIS FIRST WINSTON CUP RACE, LOST CONTROL
OF HIS CAR AND SPUN INTO LESLIE'S CAR WHICH WAS BEING SERVICED BY THE CREW. THREE
OF THE INJURED WERE TAKEN TO THE HOSPITAL FOR X-RAYS AND OBSERVATION.

AP-NP-07-29-90 1622EDT<+

AP-SPORTSWATCH:BASEBALL(07-29 0120

 N.L.

 (MONTREAL)—THE CHICAGO CUBS RODE A STRONG PERFORMANCE BY ROOKIE PITCHER
MIKE HARKEY TO A 2-TO-1 WIN OVER MONTREAL.
 HARKEY WORKED SEVEN AND A THIRD INNINGS, GIVING UP ONLY FOUR HITS ALONG THE
WAY. HE STRUCK OUT FIVE AND WALKED NONE IN RUNNING HIS RECORD TO 9-AND-5.
 MARK GRACE DROVE IN A RUN WITH A SINGLE IN THE FIRST FOR THE CUBS, WHILE SHAWN
DUNSTON PROVIDED WHAT PROVED TO BE THE GAME WINNER, WITH A SACRIFICE FLY IN THE
SEVENTH. CHICAGO HAS NOW WON ELEVEN OF ITS LAST 14 GAMES.
 KEVIN GROSS WAS A HARD LUCK LOSER FOR THE EXPOS AS HE WORKED SEVEN INNINGS AND
GAVE UP JUST THREE HITS. HIS RECORD IS NOW 8-AND-8.

AP-NP-07-29-90 1629EDT<+

AP-SPORTSWATCH:BASEBALL(07-29 0122

 A.L

 (TORONTO)—THE BLUE JAYS GOT THREE R-B-I'S EACH FROM MANNY LEE AND FRED
MCGRIFF AS THEY BEAT THE TEXAS RANGERS 10-TO-8.
 TORONTO TRAILED 7-TO-5 HEADING INTO THE FOURTH, BUT SCORED FOUR TIMES TO TAKE
THE LEAD FOR GOOD.
 MCGRIFF GOT TWO RUNS HOME WITH A SINGLE TO TIE IT, AND THE LEAD RUN SCORED ON AN
ERROR BY RAFAEL PALMEIRO. LEE HAD A THREE-RUN DOUBLE IN THE THIRD INNING.
 JIM ACKER GOT THE WIN IN RELIEF TO MAKE HIS RECORD 2-AND-2. JOHN CANDELARIA GOT
HIS FIFTH WIN OF THE SEASON AND FIRST SINCE BECOMING A BLUE JAY IN A TRADE WITH
MINNESOTA ON FRIDAY.

THE LOSS WENT TO CRAIG MCMURTRY, HIS FIRST DECISION OF THE SEASON.

AP-NP-07-29-90 1726EDT<+

AP-LINESCORE:AMERICANLEA 07-29 0074

				R	H	E
BOSTON	012	401	023 -	13	18	4
DETROIT	200	010	000 -	3	5	0

HARRIS, GRAY (9)

ROBINSON, TERRELL (4) GLEATON (6) HENNEMAN (8)

WP-HARRIS (8-4)

LP-ROBINSON (8-8)

HRS-BOSTON, RIVERA (4)

AP-NP-07-29-90 1726EDT<+

AP-PA-REDSOX-SENATORS 07-29 0106

HARRISBURG 4, NEW BRITAIN 2

(HARRISBURG)—JOHN WEHNER SCORED ON A FOURTH-INNING DOUBLE STEAL, SPARKING THE HARRISBURG SENATORS TO A 4-TO-2 WIN OVER THE NEW BRITAIN RED SOX TODAY IN THE EASTERN LEAGUE.

LATER—DOUBLES BY JEFF OSBORNE AND GREG TUBBS DROVE IN TWO MORE RUNS OFF RED SOX LOSER PAUL QUANTRILL.

THE RED SOX BROKE UP STEVE ADAMS' SHUTOUT BID IN THE SIXTH WHEN RANDY RANDLE

WALKED, STOLE SECOND AND CAME AROUND TO SCORE ON INFIELD OUTS.

ADAMS WENT SIX INNINGS TO REGISTER THE WIN. JOE AUSANIO EARNED HIS 11TH SAVE.

AP-NP-07-29-90 1751EDT<+

AP-NATIONALLEAGUE 07-29 0043

FINAL SAN FRANCISCO GIANTS 4 CINCINNATI REDS 0

AP-NY-07-29-90 1754EDT<+

AP-SPORTSWATCHADVISORY 07-29 0062

SAN FRANCISCO'S SCOTT GARRELTS LOST HIS BID FOR A NO-HITTER WITH TWO OUTS IN
THE NINTH INNING AGAINST CINCINNATI. PAUL O'NEILL SINGLED TO LEFT-CENTER FIELD TO
BREAK UP THE BID. THE GIANTS WON 4-TO-0.

AP-NP-07-29-90 1756EDT<+

AP-SPORTSWATCHGOLF:WITHL 07-29 0198

(BETHESDA, MARYLAND)-HERE ARE THE TOP FINISHERS IN THE L-P-G-A CHAMPIONSHIP,
WITH PRIZE MONEY AND FOUR ROUND SCORES. PAR IS 71.

1.	BETH DANIEL,	$150,000	71-73-70-66 – 280	4-UNDER
2.	ROSIA JONES,	$92,500	60-70-70-72 – 281	3-UNDER

3.	DAWN COE,	$67,500	73-71-68-72 — 284	EVEN
4.	SUE ERTL,	$52,500	70-67-79-69 — 285	1-OVER
5.	BETSY KING,	$33,250	72-73-72-69 — 286	2-OVER
	PATTY SHEEHAN,	$33,250	75-71-70-70 — 286	
	TAMMIE GREEN,	$33,250	72-72-70-72 — 286	
	CINDY FIGG-CURRIER,	$33,250	72-68-73-73 — 286	
9.	ANNE-MARIE PALLI,	$19,500	75-72-70-70 — 287	3-OVER
	PAT BRADLEY,	$19,500	73-71-71-72 — 287	
	AYAKO OKAMOTO,	$19,500	75-69-70-73 — 287	
	DEB RICHARD,	$19,500	71-72-70-74 — 287	
	CATHY JOHNSTON,	$19,500	70-70-71-76 — 287	
14.	MARTHA NAUSE,	$13,500	73-73-75-67 — 288	4-OVER
	AMY BENZ,	$13,500	79-75-76-68 — 288	
	NANCY LOPEZ,	$13,500	78-70-70-70 — 288	
	CINDY RARICK,	$13,500	74-71-72-71 — 288	
	DONNA AMAMACCAPANE	$13,500	73-73-68-74 — 288	
	SUSAN SANDERS,	$13,500	73-73-68-74 — 288	

AP-NP-07-29-90 1804EDT<+

AP-SPORTSWATCHADVISORY 07-29 0044

CHIP BECK IS THE WINNER OF THE BUICK OPEN GOLF TOURNAMENT.

AP-NY-07-29-90 1806EDT<+

AP-SCORECARD 07-29 0164

HERE IS THE LATEST FROM THE BALLPARKS:

AMERICAN LEAGUE

FINAL	TORONTO	10	TEXAS	8
FINAL	BOSTON	13	DETROIT	3
FINAL	BALTIMORE	4	KANSAS CITY	1
FINAL	MINNESOTA	6	OAKLAND	5 (10 INNINGS)
FINAL	1ST GAME NY YANKEES	8	CLEVELAND	5
	2ND GAME NY YANKEES	4	CLEVELAND	1 (TOP 5TH)

COLBY WARD PTG CLEVELAND 4TH

| MILWAUKEE | | 6 | CHICAGO | 6 (TOP 11TH) |

SCOTT RADINSKY PTG CHICAGO 10TH

PAUL MIRABELLA PTG MILWAUKEE 10TH

| CALIFORNIA | | 3 | SEATTLE | 1 (TOP 7TH) |

NATIONAL LEAGUE

FINAL	SAN FRANCISCO	4	CINCINNATI	0
FINAL	CHI CUBS	2	MONTREAL	1
FINAL	PITTSBURGH	2	PHILADELPHIA	1

| LOS ANGELES | | 4 | ATLANTA | 3 (TOP 9TH) |

TIM CREWS PTG LOS ANGELES 9TH

HR: TOMMY GREGG, ATLANTA 8TH NONE ON, HIS 4TH

| SAN DIEGO | | 4 | HOUSTON | 3 (TOP 9TH) |

JUAN AGOSTO PTG HOUSTON 8TH

DAVE SMITH PTG HOUSTON 8TH

CRAIG LEFFERTS PTG SAN DIEGO 9TH

HR: JACK CLARK, SAN DIEGO 8TH 1 ON, HIS 17TH

AP-NP-07-29-90 1842EDT<+

AP-SPORTSWATCHGOLF:BUICK 07-29 0124

 (GRAND BLANC, MICHIGAN)-CHIP BECK CAME CHARGING FROM EIGHT SHOTS OFF THE
PACE TO SHOOT A 7-UNDER 65 AND WIN THE BUICK OPEN BY ONE SHOT.
 BECK'S 16-UNDER TOTAL EARNED HIM THE THIRD TOURNAMENT WIN OF HIS CAREER. HE
OPENED HIS FINAL ROUND WITH THREE STRAIGHT BIRDIES AND HAD A STRING OF THREE MORE
ON HOLES 12 THROUGH 14.
 U-S OPEN CHAMP HALE IRWIN TOOK A SHOT AT FORCING A PLAYOFF IN AN ERRATIC ROUND
OF GOLF. HE WOUND UP WITH A 2-OVER PAR 74 THAT INCLUDED SIX BOGEYS. HE NEEDED TO
DROP A 20-FOOT PAR SAVING PUTT ON THE FINAL HOLE, BUT LEFT IT SHORT AND HAD TO
SETTLE FOR A SHARE OF SECOND PLACE.
 MIKE DONALD AND FUZZY ZOELLER ALSO ENDED UP ONE SHOT OFF THE PACE.

AP-NP-07-29-90 1907EDT<+

Weather Information

Weather information is another wire service staple. Forecasts, weather alerts, temperature readings, and severe weather warnings form a major component of radio's value to its listeners. Wire service copy is for most stations the primary source of weather information.

Weather information may be the material most frequently moved on the wire services. Throughout the day there is a steady stream of data and forecast information for various regions of the country and state.

In using the weather information here, keep in mind the various ways in which it is used. Try to integrate it into your ad-lib style, and learn to read the data with a sense of understanding. Much of the work is done for you by the wire service, but since it is so big a part of radio's service, be sure that you can handle it effectively.

```
AP-PA-WEATHERSUMMARYFORP    07-29 0158
AP-PA-WEATHER SUMMARY FOR PENNSYLVANIA AND THE NORTHERN PANHANDLE OF W VA

WEATHER SUMMARY FOR PENNSYLVANIA AND THE NORTHERN PANHANDLE OF W VA.
NATIONAL WEATHER SERVICE PITTSBURGH PA
345 PM SUN JUL 29 1990

      ...A FINE FINISH TO A FIRST-RATE WEEKEND...

  PENNSYLVANIANS ENJOYED YET ANOTHER PERFECT SUMMER DAY WITH PLENTY OF SUN-
SHINE AND TEMPERATURES IN THE 80S. THESE HIGHS FOLLOWED EARLY MORNING READINGS
IN THE MID 60S. WINDS THROUGHOUT THE DAY WERE FROM THE SOUTHEAST AT 5 TO 10 MPH.
TODAY IS PITTSBURGH'S FIFTH CONSECUTIVE DAY WITHOUT PRECIPITATION . . . THE LONG-
EST PERIOD IN 1990.
  A COLD FRONT WILL SLOWLY APPROACH WESTERN PENNSYLVANIA MONDAY . . . SPREADING
CLOUDS AND SCATTERED THUNDERSTORMS OVER THE AREA. EASTERN PENNSYLVANIA
SHOULD REMAIN DRY UNTIL MONDAY NIGHT. TUESDAY . . . CLOUDS AND SCATTERED SHOWERS
WILL REMAIN IN THE FORECAST FOR MOST OF THE STATE.
```

REHAK

(FILED BY THE NATIONAL WEATHER SERVICE AT 15:49 ET)

AP-NP-07-29-90 1550EDT<+

AP-PA-HARRISBURGANDVICIN 07-29 0123
AP-PA-HARRISBURG AND VICINITY FORECAST

HARRISBURG AND VICINITY FORECAST
NATIONAL WEATHER SERVICE HARRISBURG PA
400 PM EDT SUN JUL 29 1990
.THIS EVENING . . . A 30 PERCENT CHANCE OF A SHOWER.
.TONIGHT . . . MOSTLY CLEAR. PATCHY LATE NIGHT FOG POSSIBLE. LOWS 65 TO 70
. LIGHT WINDS.
.MONDAY . . . MOSTLY SUNNY . . . WARM AND HUMID. HIGHS IN THE UPPER 80S. LIGHT WINDS.
.MONDAY NIGHT . . . PARTLY CLOUDY WITH PATCHY FOG. A 30 PERCENT CHANCE OF A SHOWER
OR THUNDERSTORM AFTER MIDNIGHT. LOWS NEAR 70.
.TUESDAY . . . VARIABLE CLOUDINESS WITH A 40 PERCENT CHANCE OF SHOWERS OR THUNDER-
STORMS. HIGHS IN THE MID 80S.

(FILED BY THE NATIONAL WEATHER SERVICE AT 15:52 ET)

AP-NP-07-29-90 1553EDT<+

AP-PA-PITTSBURGHMETROPOL 07-29 0115
AP-PA-PITTSBURGH METROPOLITAN AREA FORECAST

345

PITTSBURGH METROPOLITAN AREA FORECAST
NATIONAL WEATHER SERVICE PITTSBURGH PA
348 PM EDT SUN JUL 29 1990

.TONIGHT . . . PARTLY CLOUDY. LOW IN THE UPPER 60S. WIND SOUTHWEST 10 TO 15 MPH.
.MONDAY . . . MOSTLY CLOUDY WITH A 60 PERCENT CHANCE OF SHOWERS AND THUNDER-
STORMS. HIGH NEAR 85.
.MONDAY NIGHT . . . CLOUDY WITH A 70 PERCENT CHANCE OF SHOWERS AND THUNDER-
STORMS. LOW IN THE 60S.
.TUESDAY . . . MOSTLY CLOUDY WITH A 50 PERCENT CHANCE OF SHOWERS. HIGH NEAR 80.
CHANCE OF RAIN 60 PERCENT

(FILED BY THE NATIONAL WEATHER SERVICE AT 15:52 ET)

AP-NP-07-29-90 1553EDT<+

AP-PA-CLIMATOLOGICALREPO 07-29 0242
AP-PA-CLIMATOLOGICAL REPORT (DAILY)

CSUS2 KPIT 291950
CLIMATOLOGICAL REPORT (DAILY)
NATIONAL WEATHER SERVICE PITTSBURGH, PA
349 PM EDT SUN JUL 29 1990

 FOR YESTERDAY SATURDAY JULY 28 1990

TEMPERATURE				PRECIPITATION			
HIGH	88			DAY	NONE	NORMAL	0.12
LOW	63			MONTH	6.36	NORMAL	3.47
MEAN	76	NORMAL	72	YEAR	28.35	NORMAL	22.43

DEGREE DAYS

	HEATING		COOLING	
FOR THE MONTH . . . 4 DEGREES BELOW NORMAL				
FOR THE YEAR . . . 724 DEGREES ABOVE NORMAL	DAY	0	DAY	11
	MONTH	4	MONTH	194
	SEASON	4	SEASON	407

TEMPERATURE AND PRECIPITATION FOR YESTERDAY IN THE FOLLOWING YEARS:

	HIGH	LOW	MEAN	PRECIPITATION
1989	82	62	72	NONE
1988	90	63	77	NONE

. . . PITTSBURGH AIRPORT TEMPERATURES FOR TODAY JULY 29 1990

12A	1AM	2AM	3AM	4AM	5AM	6AM	7AM	8AM
71	71	70	68	68	68	65	65	69

9AM	10A	11A	12P	1PM	2PM	3PM	4PM	5PM
73	77	78	81	83	83	85		

FROM MIDNIGHT TO	8 AM
HIGH TEMPERATURE	—
LOW TEMPERATURE	64
PRECIPITATION	NONE

. . . FOR TODAY SUNDAY JUL 29 1990 . . .

NORMAL HIGH	83	RECORD HIGH	96 IN 1901	SUNSET TONIGHT	838 PM
NORMAL LOW	62	RECORD LOW	52 IN 1982	SUNRISE TOMORROW	615 AM

END

(FILED BY THE NATIONAL WEATHER SERVICE AT 15:53 ET)

AP-NP-07-29-90 1553EDT<+

AP-PA-CLIMATOLOGICALREPO 07-29 0179
AP-PA-CLIMATOLOGICAL REPORT (DAILY)

CSUS2 KPHL 292030
CLIMATOLOGICAL REPORT (DAILY)
NATIONAL WEATHER SERVICE OBSERVATORY
PHILADELPHIA INTERNATIONAL AIRPORT PA
4:33PM EDT SUN JUL 29 1990

TODAY'S WEATHER: PARTLY SUNNY AND SEASONABLY WARM

TODAY HIGH 87 AT 2:48PM LOW 72 AT 12:01 AM
NORMAL TEMPS FOR TODAY HIGH 86 LOW 68 AVG 77

. .RECORD TEMPERATURES .
TODAY. JUL 29 HIGH 98 IN 1892 LOW 59 IN 1914
TOMORROW. JUL 30 HIGH 98 IN 1988 LOW 58 IN 1981

DATA BELOW IS THROUGH YESTERDAY. . SAT JUL 28 1990
. .DEGREE DEPARTURE .
DEPARTURE FROM NORMAL FOR THE DAY.PLUS 2
DEPARTURE FROM NORMAL FOR THE MONTH.PLUS 51
DEPARTURE FROM NORMAL FOR THE YEAR.PLUS 713

```
. . . . . . . . . . . . . . . . . . . . . . . . . . . . . . . PRECIPITATION . . . . . . . . . . . . . . . . . . . . . . . . . . . . . . .
YESTERDAY'S TOTAL . . . . . . . . . . . . . . .     TRACE
MONTH'S TOTAL . . . . . . . . . . . . . . . . . .      2.19
YEAR'S TOTAL . . . . . . . . . . . . . . . . . .     22.94
DEPARTURE DAY . . . . . . . . . . . . .  MINUS       .13
DEPARTURE MONTH . . . . . . . . . . .  MINUS      1.30
DEPARTURE YEAR . . . . . . . . . . . .  MINUS       .97

-TM-

(FILED BY THE NATIONAL WEATHER SERVICE AT 16:34 ET)

AP-NP-07-29-90   1634EDT<+

AP-PA-HTEMPS   V0000 07-29 0069

4PM EST PENNSYLVANIA THIS HOUR
```

TOWN	WEATHER	TEMP	WIND	FLSLK	VIS	HUM	BRMTR	HI	LOW	PCPN
ERIE	HAZE	83	NW 12	98	6	72%	30.02F	86	64	
WILLIAMSPORT	PTLY CLDY	85	S xz7	97	20	55%	30.05F	86	63	

```
AP-NP-07-29-90   1616EDT<+

AP-PA-WESTERNPENNSYLVANI   07-30 0460
AP-PA-WESTERN PENNSYLVANIA ZONE FORECASTS<
```

WESTERN PENNSYLVANIA ZONE FORECASTS

NATIONAL WEATHER SERVICE PITTSBURGH PA

1014 AM EDT MON JUL 30 1990

PAZ001-002-302300-

LAKE SHORE-NORTHWESTERN-

1014 AM EDT MON JUL 30 1990

.THIS AFTERNOON . . . WARM AND HUMID WITH SHOWERS AND THUNDERSTORMS LIKELY. SOME WITH HEAVY DOWNPOURS AND GUSTY WINDS. HIGH IN THE UPPER 80S. WIND SOUTHWEST 10 TO 20 MPH BUT HIGHER GUSTS IN THUNDERSTORMS. CHANCE OF RAIN 60 PERCENT.

.TONIGHT . . . WARM WITH SHOWERS . . . ALSO SOME THUNDERSTORMS THROUGH EARLY TONIGHT WITH HEAVY DOWNPOURS. LOW 65 TO 70. WIND SOUTHWEST 10 TO 20MPH BUT HIGHER GUSTS IN THUNDERSTORMS THEN WIND SHIFTING NORTHWEST 10 TO 15 MPH. CHANCE OF RAIN 80 PERCENT.

.TUESDAY . . . MOSTLY CLOUDY AND COOLER WITH A 40 PERCENT CHANCE OF SHOWERS. HIGH IN THE MID 70S.

NORTHERN MOUNTAINS-

1014 AM EDT MON JUL 30 1990

.THIS AFTERNOON . . . WARM AND HUMID WITH SHOWERS AND THUNDERSTORMS LIKELY. SOME WITH HEAVY DOWNPOURS AND GUSTY WINDS. HIGH IN THE MID 80S. WIND SOUTHWEST 10 TO 15 MPH BUT HIGHER GUSTS IN THUNDERSTORMS. CHANCE OF RAIN 60 PERCENT.

.TONIGHT . . . SHOWERS AND THUNDERSTORMS. SOME WITH HEAVY DOWNPOURS AND GUSTY WINDS. LOW IN THE MID 60S. WIND SOUTHWEST 10 TO 15MPH BUT HIGHER GUSTS IN THUN-DERSTORMS. CHANCE OF RAIN 80 PERCENT.

.TUESDAY . . . MOSTLY CLOUDY AND COOLER WITH A 50 PERCENT CHANCE OF SHOWERS. HIGH NEAR 75.

SOUTH CENTRAL MOUNTAINS-SOUTH CENTRAL-
1014 AM EDT MON JUL 30 1990

.THIS AFTERNOON . . . WARM AND HUMID WITH SCATTERED SHOWERS AND THUNDERSTORMS.
SOME WITH HEAVY DOWNPOURS. HIGH IN THE MID TO UPPER 80S. WIND SOUTHWEST 10 TO
15MPH BUT HIGHER GUSTS POSSIBLE IN THUNDERSTORMS.
.TONIGHT . . . SHOWERS AND THUNDERSTORMS. SOME WITH HEAVY DOWNPOURS AND GUSTY
WINDS. LOW NEAR 70. WIND SOUTHWEST 10 TO 15MPH BUT HIGHER GUSTS IN THUNDER-
STORMS. CHANCE OF RAIN 80 PERCENT.
.TUESDAY . . . MOSTLY CLOUDY AND COOLER WITH SHOWERS LIKELY. HIGH 75 TO 80. CHANCE
OF RAIN 60 PERCENT.

WESTERN-SOUTHWESTERN INCLUDING PITTSBURGH-
1014 AM EDT MON JUL 30 1990

.THIS AFTERNOON . . . WARM AND HUMID. SHOWERS AND THUNDERSTORMS LIKELY. SOME
WITH HEAVY DOWNPOURS AND GUSTY WINDS POSSIBLE. HIGH IN THE UPPER 80S. WIND
SOUTHWEST 10 TO 15MPH BUT HIGHER GUSTS IN THUNDERSTORMS. CHANCE OF RAIN 60
PERCENT.
.TONIGHT . . . SHOWERS AND THUNDERSTORMS. SOME WITH HEAVY DOWNPOURS AND GUSTY
WINDS. LOW 65 TO 70. WIND SOUTHWEST 10 TO 15 MPH BUT HIGHER GUSTS IN THUNDER-
STORMS. CHANCE OF RAIN 80 PERCENT.
.TUESDAY . . . MOSTLY CLOUDY AND COOLER WITH A 40 PERCENT CHANCE OF SHOWERS. HIGH
IN THE UPPER 70S.

(FILED BY THE NATIONAL WEATHER SERVICE AT 10:19 ET)

AP-NP-07-30-90 1020EDT<+

AP-PA-PITTSBURGHMETROPOL 07-30 0134
AP-PA-PITTSBURGH METROPOLITAN AREA FORECAST

PITTSBURGH METROPOLITAN AREA FORECAST
NATIONAL WEATHER SERVICE PITTSBURGH PA
1015 AM EDT MON JUL 30 1990

.THIS AFTERNOON . . . WARM AND HUMID. SHOWERS AND THUNDERSTORMS LIKELY. SOME
WITH HEAVY DOWNPOURS AND GUSTY WINDS POSSIBLE. HIGH IN THE UPPER 80S. WIND
SOUTHWEST 10 TO 15MPH BUT HIGHER GUSTS IN THUNDERSTORMS. CHANCE OF RAIN 60
PERCENT.
.TONIGHT . . . SHOWERS AND THUNDERSTORMS. SOME WITH HEAVY DOWNPOURS AND GUSTY
WINDS. LOW 65 TO 70. WIND SOUTHWEST 10 TO 15 MPH BUT HIGHER GUSTS IN THUNDER-
STORMS. CHANCE OF RAIN 80 PERCENT.
.TUESDAY . . . MOSTLY CLOUDY AND COOLER WITH A 40 PERCENT CHANCE OF SHOWERS. HIGH
IN THE UPPER 70S.

R. SMITH

(FILED BY THE NATIONAL WEATHER SERVICE AT 10:19 ET)

AP-NP-07-30-90 1020EDT<+

AP-PA-RADARSUMMARY 07-30 0107
AP-PA-RADAR SUMMARY<

RADAR SUMMARY
NATIONAL WEATHER SERVICE PITTSBURGH PA
130 PM EDT MON JUL 30 1990

DO NOT USE AFTER 3 PM . . .

AT 130 PM PITTSBURGH WEATHER SERVICE RADAR SHOWED SCATTERED THUNDERSHOW-
ERS ACROSS EASTERN OHIO FROM AURORA SOUTH TO CROOKSVILLE. THE HEAVIEST ACTIVITY
WAS FOUND 10 MILES EAST OF ZANESVILLE AND JUST NORTH OF AKRON.
 OVER THE PAST HOUR COVERAGE AND INTENSITY INCREASED RAPIDLY. MOVEMENT OF THE
THUNDERSHOWERS WAS EAST AT 20 MILES AN HOUR.

LEONARDON

(FILED BY THE NATIONAL WEATHER SERVICE AT 13:39 ET)

Subscribers receive a wide variety of material—health features, personality stories, entertainment news, and so on—from wire services. What follows is a variety of items that moved on the AP radio wire during the course of a typical day. Like the news, sports, and weather copy, this too comes in ready to read on the air. Whether the material is used to supply material for ad-libbing, or packaged into some kind of feature that runs at a specific day and time, the various information that arrives via a station's wire service can be very helpful in adding zest and vitality to the on-air product.

Celebrity, Health, and Other Wire Service Copy

AP—FEELINGGOOD 07-30 0227

PNEUMONIA ON THE RUN

 FOLKS IN NON-MEDICINE CIRCLES CALL IT "GALLOPING PNEUMONIA." IT'S A RARE FORM OF
PNEUMONIA THAT CAN HAVE DIRE CONSEQUENCES IF IT'S NOT TREATED QUICKLY.
 PNEUMONIA ON THE RUN, COMING UP—ON FEELING GOOD.

—BREAK—

 GROUP A STREPTOCOCCAL PNEUMONIA HIT THE HEADLINES RECENTLY WHEN IT TOOK THE
LIFE OF PUPPETEER JIM HENSON. ACCORDING TO THE "LAHEY CLINIC HEALTH LETTER,"
GALLOPING PNEUMONIA ACCOUNTS FOR WELL UNDER FIVE PERCENT OF ALL PNEUMONIA. BUT
THE BACTERIA THAT CAUSE IT ARE NOT UNCOMMON AT ALL. THEY ALSO CAUSE STREP
THROAT, A COMMON AILMENT AMONG CHILDREN.
 DOCTOR FERNANDO MARTINEZ WORKS AT THE LAHEY CLINIC. HE SAYS ALL TYPES OF PNEU-
MONIA RESPOND WELL TO ANTIBIOTICS. WITH GALLOPING PNEUMONIA, THE KEY IS EARLY
TREATMENT. LIKE ITS NAME SUGGESTS, THE ILLNESS PROGRESSES QUICKLY. AND IF IT
SPREADS BEFORE ANTIBIOTICS TAKE EFFECT, IT COULD BE TOO LATE.
 WITH OTHER TYPES OF PNEUMONIA, MARTINEZ SAYS TREATMENT CAN BE LESS CRITICAL,
BUT STILL IMPORTANT TO SPEEDY RECOVERY.
 MARTINEZ SAYS PEOPLE WHO THINK THEY MAY HAVE PNEUMONIA OF ANY KIND SHOULD SEE
A DOCTOR. THE WARNING SIGNS? A COUGH THAT PRODUCES SPUTUM, A FEVER AND CHEST
PAIN—ESPECIALLY THE KIND THAT INCREASES WITH COUGHING OR BREATHING.
 BUT THERE ARE NO HARD AND FAST RULES. MARTINEZ SAYS YOU DON'T HAVE TO BE EXPERI-
ENCING ALL THREE TO HAVE PNEUMONIA. SUCH PROBLEMS ARE YOUR BODY'S WAY OF TELLING
YOU SOMETHING'S WRONG. SO LISTEN TO IT, HE SAYS, AND MAKE THAT APPOINTMENT.

AP-NP-07-30-90 0529EDT<+

AP—OBIT—DAY 07-29 0215

(LOS ANGELES)—SINGER AND BANDLEADER BOBBY DAY, WHO RECORDED "ROCKIN' ROBIN,"
"LITTLE BITTY PRETTY ONE" AND OTHER "DOO-WOP" ROCK HITS, HAS DIED OF CANCER AT
AGE 60.

DAY, WHO HAD BEEN HOSPITALIZED SINCE JULY 15TH, DIED FRIDAY, ACCORDING TO A
FAMILY FRIEND.

BORN ROBERT JAMES BYRD SENIOR, THE TEXAS NATIVE FOUNDED TWO SONGWRITING
ENTERPRISES IN LOS ANGELES, BYRDLAND ATTRACTIONS AND QUILINE PUBLISHING.

HE FORMED THE HOLLYWOOD FLAMES IN THE 1950'S, WHOSE "BUZZ-BUZZ-BUZZ" AND
"CRAZY" WERE HIT SINGLES IN 1957. HE ALSO RECORDED "GEE WIZ" AS PART OF THE DUO
BOB AND EARL.

DAY WROTE "LITTLE BITTY PRETTY ONE" AND RECORDED IT IN 1958. BUT THURSTON
HARRIS, WHO RECORDED A MORE UP-TEMPO VERSION OF IT WITH DAY'S BLESSING, HAD THE
BIGGER HIT THAT SAME YEAR.

DAY WAS THE FIRST TO RECORD THE JIMMIE THOMAS SONG "ROCKIN' ROBIN," AND HIS
VERSION HIT NUMBER TWO ON THE BILLBOARD CHARTS IN 1958. THE SONG BECAME A HIT
AGAIN MANY YEARS LATER FOR THE JACKSON FIVE.

OTHER DAY RECORDINGS INCLUDED "OVER AND OVER" IN 1958 AND "THE BLUEBIRD, THE
BUZZARD AND THE ORIOLE," "GOTTA NEW GIRL" AND "THAT'S ALL I WANT" IN 1959.

DAY RECENTLY APPEARED IN THE NATIONWIDE TOUR "THIRTY YEARS OF ROCK 'N ROLL"
WITH DONNIE BROOKS AND TINY TIM.

HE IS SURVIVED BY HIS WIFE JACKIE, CHILDREN ROBERT, ROBIN, SIMONE AND ERIN, AND
EIGHT GRANDCHILDREN.

A FUNERAL IS SCHEDULED FOR NEXT SATURDAY.

AP—NP—07-29-90 2120EDT‹+

AP—SEGUE 07-30 0388
BY MARY LYON

STARWATCH: ZSA ZSA JAIL

ZSA ZSA GABOR GETS OUT OF JAIL IN EL SEGUNDO, CALIFORNIA, TODAY—AFTER SERVING A 72-HOUR SENTENCE FOR SLAPPING THAT BEVERLY HILLS COP LAST YEAR. POLICE SAY SHE DIDN'T LIKE THE FOOD, AND THEY AVERAGED 60 CALLS PER DAY ABOUT HER—OTHERWISE THE WEEKEND WAS UNEVENTFUL. GABOR'S HUSBAND SAYS SHE ALSO COMPLAINED THAT IT WAS COLD IN HER EIGHT-BY-TEN FOOT CELL—SO HE BROUGHT HER PILLOWS AND A SILK BED COVER. GABOR PAID 85-DOLLARS A DAY TO DO HER TIME IN THE EL SEGUNDO JAIL RATHER THAN HAVE L-A COUNTY PICK ACCOMMODATIONS FOR HER.

STARWATCH: PATRICK SWAYZE

PATRICK SWAYZE SAYS WHEN HE WAS FILMING THOSE STEAMY LOVE SCENES WITH DEMI (DEH-MEE') MOORE IN THE MOVIE "GHOST," HE WAS KEEPING ANOTHER ACTRESS IN MIND— HIS WIFE, LISA NIEMI. IN AN INTERVIEW IN THE AUGUST SIXTH ISSUE OF "PEOPLE" MAGA- ZINE, SWAYZE SAID HE USED HIS FEELINGS FOR HIS WIFE A LOT. AS FOR MOORE, SHE HAS RAVES FOR SWAYZE, SAYING "HE'S SENSITIVE AND HAS A VULNERABILITY THAT'S RIGHT OUT THERE." MOORE ALSO SAYS SWAYZE "LOOKS GREAT WITH HIS SHIRT OFF."

STARWATCH: EDDIE MURPHY

EDDIE MURPHY IS PUTTING THE 10-THOUSAND SQUARE FOOT BEVERLY HILLS MANSION HE BOUGHT FROM CHER ON THE MARKET—FOR NINE (M) MILLION DOLLARS. MURPHY BOUGHT THE PLACE FOR JUST OVER SIX (M) MILLION DOLLARS. IT HAS SIX BEDROOMS, EIGHT BATHS, A GYM, FORMAL DINING AREA, AN ATRIUM IN THE LIVING ROOM, A SKYLIGHT THAT OPENS AUTOMATICALLY AND A MOAT. A REAL ESTATE AGENT SAYS MURPHY WANTS SOMETHING "MORE TRADITIONAL, LIKE HIS NEW JERSEY RESIDENCE," WITH A GUEST HOUSE AND MORE ROOMS.

MUSIC TRACKS: BOBBY DAY OBIT

A FUNERAL IS SCHEDULED NEXT SATURDAY IN LOS ANGELES FOR SINGER AND BANDLEADER BOBBY DAY, WHO RECORDED SUCH OLDIES BUT GOODIES AS "ROCKIN' ROBIN," "LITTLE BITTY PRETTY ONE" AND OTHER "DOO-WOP" HITS. ACCORDING TO A FAMILY FRIEND, DAY

DIED OF CANCER ON FRIDAY AFTER BEING HOSPITALIZED FOR TWO WEEKS. HE WAS 60. DAY, WHOSE REAL NAME WAS ROBERT JAMES BYRD SENIOR, FORMED A GROUP—THE HOLLYWOOD FLAMES—IN THE 1950'S, AND ALSO RECORDED AS PART OF THE DUO BOB AND EARL.

TODAY IN MUSIC HISTORY

IN 1986, IT WAS REPORTED THAT R-C-A DROPPED JOHN DENVER FROM ITS ROSTER AFTER THE RELEASE OF HIS SINGLE, "WHAT ARE WE MAKING WEAPONS FOR." THE SONG REPORTEDLY UPSET THE COMPANY'S OWNER, GENERAL ELECTRIC, ONE OF THE LARGEST DEFENSE CONTRACTORS IN THE U-S. G-E SOLD R-C-A TWO MONTHS LATER.

IN 1954, ELVIS PRESLEY MADE HIS PROFESSIONAL DEBUT AT OVERTON PARK IN MEMPHIS.

BIRTHDAYS

ACTOR ARNOLD SCHWARZENEGGER IS 43. SINGER-SONGWRITER PAUL ANKA IS 49. ACTOR-SINGER EDD "KOOKIE" BYRNES IS 52. BLUESMAN BUDDY GUY IS 54. SAXOPHONIST DAVID SANBORN IS 45. SINGER KATE BUSH IS 32. MOVIE DIRECTOR PETER BOGDANOVICH IS 51.

AP-NP-07-30-90 0530EDT<+

AP-PEOPLEINTHENEWS 07-30 0343

IT'S A REAL-LIFE VERSION OF THE KNIGHT IN SHINING ARMOR SAVING A DAMSEL IN DISTRESS. EXCEPT THIS TIME IT'S THE KING OF SPAIN IN A RUBBER BOAT, SAVING TWO GIRLS WHOSE SAILBOAT HAD CAPSIZED. A NEWSPAPER IN SPAIN SAYS KING JUAN CARLOS JUMPED FULLY CLOTHED FROM A DINGHY HE WAS USING TO RETURN FROM HIS YACHT ALONG THE MEDITERRANEAN SHORE. HE REPORTEDLY SWAM TO THE GIRLS AND BROUGHT THEM TO SAFETY.

PRINCESS DIANA TOOK IN A CONCERT SATURDAY NIGHT ON WHAT'S SAID TO BE TINA TURNER'S FAREWELL TOUR. DIANA'S HUSBAND, PRINCE CHARLES, MISSED THE CONCERT AS

357

HE RECOVERS FROM A BROKEN ARM SUFFERED WHEN HE FELL FROM HIS POLO PONY. SOME 60-THOUSAND FANS JOINED THE PRINCESS FOR THE SHOW NEAR LONDON, INCLUDING ELTON JOHN, MARK KNOPFLER AND KATE BUSH.

THE DUCHESS OF YORK, THE FORMER SARAH FERGUSON, CALLED ON HER PARENTS YESTERDAY IN ARGENTINA—WHERE HER STEPFATHER, HECTOR BARRANTES, IS SUFFERING FROM LEUKEMIA. SHE BROUGHT BOTH HER KIDS ON THE TRIP—INCLUDING FOUR-MONTH-OLD EUGENIE. SARAH CAUGHT A PRIVATE PLANE FROM BUENOS AIRES FOR THE TRIP TO THE BARRANTES RANCH ABOUT 250 MILES SOUTHWEST OF THE CAPITAL.

KITTY DUKAKIS WILL REPORTEDLY SHED NEW LIGHT ON AN INCIDENT INVOLVING A POISONOUS DOSE OF RUBBING ALCOHOL. BOSTON NEWSPAPERS YESTERDAY QUOTE THE GOVERNOR'S WIFE AS WRITING IN HER AUTOBIOGRAPHY THAT SHE DIDN'T KNOW THE SUBSTANCE WAS POISONOUS. THE BOOK REPORTEDLY HAS MORE ON HER ALCOHOL AND DRUG ADDICTION, SAID TO BE LINKED WITH THE DISCOVERY AS A TEENAGER THAT HER MOTHER WAS BORN OUT OF WEDLOCK.

A SURVEY OF LAWYERS FINDS SKEPTICISM THERE WILL BE A CONVICTION AGAINST WASHINGTON D-C MAYOR MARION BARRY IN A COCAINE TRIAL NOW UNDERWAY. A POLL OF 200 MEMBERS IN THE TRIAL LAWYERS ASSOCIATION FOUND MORE THAN HALF PREDICTING EITHER A "NOT GUILTY" VERDICT, OR A MISTRIAL. ANOTHER 35 PERCENT BELIEVE THE ODDS ARE ALSO HIGH FOR ACQUITTAL ON THE MISDEMEANOR COUNTS. BARRY WAS BUSTED EARLIER THIS YEAR IN AN F-B-I "STING" OPERATION.

EX-MARYLAND GOVERNOR MARVIN MANDEL CANNOT BE SUED IN CIVIL COURT OVER A CONTROVERSIAL RACETRACK DECISION WHEN HE WAS STATE EXECUTIVE NEARLY 20 YEARS AGO. A MARYLAND COURT OF APPEALS RULING FRIDAY SAYS HE IS IMMUNE COURT ACTION FROM FORMER OWNERS OF A RACE TRACK, WHO CLAIMED HE UNFAIRLY DENIED THEM EXTRA RACING DAYS THAT WOULD HAVE BOLSTERED THE VALUE OF THE TRACK. MANDEL ASSOCIATES LATER BOUGHT THE TRACK AND THE EXTRA DAYS WERE GRANTED.

AP-NP—07-30-90 0530EDT<+

AP—DIVERSIONS:MUSICPOP/R 07-30 0300

A LOOK BACK AT THE WORK OF ONE OF THE "DEAD", A NEW SPRINGSTEEN IN THE WORLD
AND SANTANA HITS THE ROAD.

THOSE STORIES NEXT ON DIVERSIONS.

—BREAK—

THE GRATEFUL DEAD HAS BEEN HIT WITH A SETBACK, WITH A NATIONAL TOUR SCHEDULED
TO RESUME THIS MONTH. KEYBOARD PLAYER BRENT MYDLAND (MID'-LAND) WAS FOUND
DEAD IN HIS HOME THURSDAY EAST OF SAN FRANCISCO. HE'D JUST RETURNED HOME FROM
TOURING EARLIER IN THE WEEK.

MYDLAND HAD BEEN WITH THE BAND SINCE 1979, REPLACING KEITH GODCHAUX, WHO IN
TURN HAD REPLACED RON MCKERNAN, WHO DIED OF CIRRHOSIS OF THE LIVER IN 1973.

WHEN HE FIRST JOINED THE BAY-REA-BASED BAND, MYDLAND WAS REALLY OVER-
SHADOWED BY JERRY GARCIA AND OTHER, MORE FAMOUS MEMBERS. AS TIME PASSED BY, HE
WROTE MORE SONGS AND ADDED TO THE BAND'S HARMONIES WITH WHAT SPOKESMAN
DENNIS MCNALLY CALLED HIS "ROUGH, BLUESY, TEXTURED VOICE."

JOHN BARLOW COLLABORATED WITH MYDLAND ON MANY OF HIS SONGS. HE SAYS MYDLAND
"...WAS SO GOOD AT WHAT HE DID THAT HE WAS ABLE TO BECOME FUNDAMENTAL TO EV-
ERYTHING THAT THE BAND WAS DOING MUSICALLY WITHOUT IT BEING IMMEDIATELY
APPARENT TO THE AUDIENCE."

BRUCE SPRINGSTEEN AND HIS GIRLFRIEND HAVE A NEW SON. PATTI SCIALFA GAVE BIRTH TO
A 7-POUND, 9-OUNCE BOY AT A CALIFORNIA HOSPITAL LAST WEEK. A SPOKESMAN SAYS THE
BOY WAS BORN SOMETIME BETWEEN TUESDAY AND FRIDAY OF LAST WEEK.

THE BOY IS SPRINGSTEEN'S FIRST CHILD.

SPRINGSTEEN AND SCIALFA HAVE BEEN LINKED ROMANTICALLY SINCE HIS DIVORCE FROM
WIFE JULIANNE PHILLIPS IN 1989.

VETERAN GUITARIST CARLOS SANTANA AND HIS GROUP HAVE HIT THE ROAD, IN SUPPORT OF THEIR NEW ALBUM "SPIRITS DANCING IN THE FLESH." SANTANA, ONE OF THE REAL SURVIVORS OF THE MODERN MUSIC SCENE, HAS RELEASED 26 ALBUMS TO DATE.

THE L-P IS DEDICATED TO UNITED FARM WORKERS ORGANIZER CESAR CHAVEZ. HOWEVER, THE FIRST SINGLE IS A COVER OF CURTIS MAYFIELD'S "GYPSY WOMAN." LIVING COLOUR'S VERNON REID HELPED PRODUCE TWO TRACKS. HE PLAYED GUITAR ON ONE OF THEM.

SANTANA'S CURRENT TOUR CONTINUES THROUGH SEPTEMBER 2ND.

AP-NP-07-30-90 0531EDT<+

AP-DIVERSIONS:MUSIC-TAKE 07-30 0170

HERE'S THIS WEEK'S ROCK MUSIC QUIZ: (7/30)

WHAT IS THE HIGHEST CHARTING SONG BY THE GROUP SANTANA?

THE ANSWER IN A MOMENT. BUT FIRST WE'LL CHECK THE WEEK IN POP MUSIC HISTORY.

"TOY SOLDIERS" BY MARTIKA WAS STILL NUMBER ONE THIS WEEK IN 1989.

"SHOUT" BY TEARS FOR FEARS WAS IN THE TOP SPOT THIS WEEK IN 1985.

"MAGIC" BY OLIVIA NEWTON-JOHN WAS THE TOP TUNE THIS WEEK IN 1980.

"THE HUSTLE" BY VAN MCCOY AND THE SOUL CITY SYMPHONY WAS THE TOP SONG THIS WEEK IN 1975.

"(THEY LONG TO BE) CLOSE TO YOU" BY THE CARPENTERS WAS IN THE TOP SPOT THIS WEEK IN 1970.

"(I CAN'T GET NO) SATISFACTION" BY THE ROLLING STONES HELD THE TOP SPOT THIS WEEK IN 1965.

"I'M SORRY" BY BRENDA LEE MOVED INTO THE TOP CHART POSITION THIS WEEK IN 1960.

AND "ROCK AROUND THE CLOCK" BY BILL HALEY AND HIS COMETS WAS NUMBER ONE THIS WEEK IN 1955.

NOW HERE'S THE ANSWER TO THIS WEEK'S POP MUSIC QUIZ:

"BLACK MAGIC WOMAN" WAS NUMBER-FOUR IN "BILLBOARD" IN NOVEMBER 1970.

AP-NP-07-30-90 0531EDT<+

BC-PA-LOT-LOTTERYGLANCE 07-29 0064

 HARRISBURG (AP)-HERE ARE THE WINNING NUMBERS SELECTED SATURDAY IN THE PENNSYLVANIA STATE LOTTERY:
<
DAILY NUMBER
 7-0-9
 (SEVEN, ZERO, NINE)

BIG 4
 8-8-1-5
 (EIGHT, EIGHT, ONE, FIVE)

AP-NP-07-29-90 1133EDT<+

BC-PA-LOT-SATURDAYSPIN 07-29 0070

HARRISBURG (AP)-IN THE "PENNSYLVANIA SATURDAY SPIN" GAME, RONNIE SCHLEY OF
WILLIAMSPORT WON THE GRAND PRIZE OF $50,000.

NINE FINALISTS WON $5,000 EACH.

PLAYERS ARE ENTERED IN THE "SATURDAY SPIN" AFTER WINNING A TICKET IN THE
INSTANT LOTTERY GAME.

AP-NP-07-29-90 1133EDT<+

BC-IA-LOTTOAMERICA 07-29 0105
LOTTO AMERICA JACKPOT GROWS TO $6 MILLION<

DES MOINES, IOWA (AP)-NO TICKET MATCHED ALL SIX NUMBERS IN SATURDAY'S LOTTO
AMERICA DRAWING, AND WEDNESDAY'S JACKPOT CLIMBS TO AN ESTIMATED $6 MILLION.

SATURDAY'S JACKPOT WAS ESTIMATED AT $4 MILLION.

THE MULTI-STATE LOTTERY ASSOCIATION SAID 56 TICKETS MATCHED FIVE NUMBERS FOR
A PRIZE OF $1,240 EACH, AND 3,655 TICKETS MATCHED FOUR NUMBERS FOR A PRIZE OF
$44 EACH.

THE WINNING NUMBERS WERE 5, 11, 12, 40, 42 AND 45.
—DASH——
(FIVE-ELEVEN-TWELVE-FORTY-FORTYTWO-FORTYFIVE)

AP-NP-07-29-90 1135EDT<+

AP-WHERETHERE'SLIFE 07-30 0340

HENRY HOLCOMB HAD A HANKERING FOR A HAM SANDWICH. SO, HE WENT TO THE DELI AT A
TEXAS K-MART AND GOT HIMSELF ONE, AND ONE FOR A FRIEND WHO HAD HELPED HIM MOVE.

OR AT LEAST THAT'S WHAT HE THOUGHT HE DID. WHEN HENRY GOT HOME, HE FOUND THAT HIS HAM SANDWICH BAG CONTAINED MONEY INSTEAD OF MUNCHIES. IT TURNS OUT THE CLERK AT THE PORT ARTHUR-AREA K-MART HAD HANDED HENRY A BAG FULL OF BUCKS—MORE THAN TWO HUNDRED OF THEM. HENRY RETURNED THE CASH TO THE STORE. HE WAS REWARDED FOR HIS HONESTY WITH A TEN-DOLLAR GIFT CERTIFICATE—AND THE TWO HAM SANDWICHES.

TALK ABOUT GLASNOST. WHEN CAROL KIMBROUGH AND IGOR KUZMINICH GOT MARRIED, SHE SAID HER VOWS IN RUSSIAN AND HE SAID HIS VOWS IN ENGLISH. THE TWO MET LAST SUMMER WHEN CAROL TRAVELED TO THE SOVIET UNION ON AN EXCHANGE TRIP. HER VISIT WAS PART OF RICHMOND, INDIANA'S, SISTER CITY PROGRAM—CREATED TO FOSTER GOODWILL BETWEEN THE U-S AND THE SOVIET UNION. IGOR KNEW NOT A WORD OF ENGLISH WHEN THEY MET. BUT THAT DIDN'T STOP THE TWO WOULD-BE LOVE BIRDS. A TRANSLATOR FILLED IN THE GAP UNTIL IGOR LEARNED THE WORDS HE NEEDED TO KNOW. AND HE MUST HAVE BEEN QUITE A TALKER, BECAUSE WHEN CAROL RETURNED TO VISIT IGOR AND HIS FAMILY A FEW MONTHS LATER, THE TWO DECIDED TO TIE THE KNOT. GUESS THE SISTER CITY PROGRAM'S WORKING.

HOW'S THIS FOR ROMANTIC. DINNER FOR TWO—O-K MAKE THAT FOUR, IN AN INTIMATE SETTING—ATOP A GRAIN ELEVATOR, WITH THE BEST OF CUISINE—STEAKS GRILLED ON A TABLETOP GRILL. THAT'S HOW JIM AND KELLY WEST WILL CELEBRATE THEIR WEDDING ANNIVERSARY. THE WESTS WON THE DINNER WITH A 125-DOLLAR BID AT AN AUCTION TO BENEFIT A LEUKEMIA PATIENT. THE LA PLACE, ILLINOIS, COUPLE SAY THE MONEY WENT TO A GOOD CAUSE, AND BESIDES, IT SOUNDED INTERESTING. BUT MRS. WEST SAYS SHE HOPES IT'S NOT TOO WINDY.

JOSEPH HARDY SENIOR IS LORD OF THE MANOR. THE PITTSBURGH MAN HAS ALWAYS HAD THE MARKS OF NOBILITY, AND THE MONEY TO GO WITH IT. BUT NOW IT'S OFFICIAL. HARDY PAID 187-THOUSAND DOLLARS FOR A TITLE AT A LONDON AUCTION. YOU CAN CALL HIM LORD OF THE MANOR OF HENLEY-IN-ARDEN IN WARWICKSHIRE. THE FOUNDER OF 84-LUMBER COMPANY DOESN'T GET A SEAT IN THE HOUSE OF LORDS—IMAGINE WHAT THAT MUST COST. BUT

HE DOES GET TO PRESIDE—ALONG WITH THE MACE-BEARER, THE ALE-TESTER AND THE BUTTER-WEIGHER—AT THE ANNUAL HENLEY COURT MEET. HARDY'S WIFE SUMS IT ALL UP—VERY WEIRD.

AP-NP-07-30-90 0534EDT<+

-SEGUE
BY MICHAEL WEINFELD

MUSIC TRACKS: BON JOVI
 JON BON JOVI WANTS IT KNOWN ONCE AND FOR ALL—JUST BECAUSE HE'S MADE AN ALBUM WITHOUT HIS BAND, IT DOESN'T MEAN THEY'VE BROKEN UP. BON JOVI SAYS HE DOESN'T HAVE "ANY INTENTION" OF LEAVING THE GROUP. HE SAYS IF THE REST OF THE BAND WANTS TO QUIT, THAT'S ONE THING, BUT HE SAYS HE HOPES THAT DOESN'T HAPPEN. BON JOVI IS OUT WITH A SOUNDTRACK TO "YOUNG GUNS TWO," WHICH OPENS WEDNESDAY.

MUSIC TRACKS: TALKING HEADS
 IT'S BEEN TWO YEARS SINCE THE TALKING HEADS RELEASED AN ALBUM, BUT JERRY HARRISON SAYS THEY'RE "NOT THROUGH AS A BAND." HE TELLS "PEOPLE" MAGAZINE THEY'RE "OFFICIALLY IN HIBERNATION." HARRISON HAD HOPED THE GROUP WOULD PUT OUT AN ALBUM THIS YEAR, BUT HE DIDN'T GET HIS WAY. HARRISON IS USING THE HIATUS TO TOUR WITH HIS OTHER BAND, CASUAL GODS, ALONG WITH TOM TOM CLUB AND DEBORAH HARRY.

MUSIC TRACKS: TINA TURNER
 TINA TURNER MAY TURN UP IN A SCIENCE FICTION MOVIE AFTER SHE ENDS WHAT'S BEING BILLED AS HER FINAL CONCERT TOUR. THE TOUR ENDS IN SIX WEEKS. HER PRESS AGENT SAYS TURNER HAS SEVERAL FILM PROJECTS IN THE WORKS, BUT SHE'S ESPECIALLY INTERESTED IN A SCIENCE FICTION SCRIPT. TURNER PERFORMED BEFORE 60-THOUSAND FANS IN LONDON

OVER THE WEEKEND. PRINCESS DIANA, ELTON JOHN AND GUITARIST MARK KNOPFLER WERE AMONG THOSE WHO CAUGHT THE SHOW.

STARWATCH: DUDLEY MOORE DIVORCE

DUDLEY MOORE AND HIS THIRD WIFE BROGAN LANE ARE SPLITTING UP. DIVORCE PAPERS ARE ON FILE IN LOS ANGELES, CITING IRRECONCILABLE DIFFERENCES. MOORE AND LANE TIED THE KNOT TWO AND A HALF YEARS AGO IN LAS VEGAS. LANE IS AN ASPIRING ACTRESS.

STARWATCH: KELLY MCGILLIS

KELLY MCGILLIS SAYS ACTORS MAKE "BORING" LOVERS, WHICH IS WHY SHE SAYS SHE'S HAPPILY MARRIED TO A YACHT SALESMAN. A TABLOID ONCE DESCRIBED HER HUSBAND, FRED TILLMAN, AS A "COMPLETE NOBODY." BUT MCGILLIS SAYS SHE DOESN'T CARE WHAT HE DOES BECAUSE "HE'S GREAT." GETTING MARRIED, SHE SAYS, WAS HER FIRST STEP IN GETTING A PERSONAL LIFE, AND THE BABY SHE HAD LAST MAY IS ANOTHER.

STARWATCH: MERYL STREEP

GIVING OSCAR-WINNING PERFORMANCES IS A BREEZE FOR MERYL STREEP, COMPARED WITH HAVING TO SING IN PUBLIC. STREEP TELLS "TIME" MAGAZINE SHE WAS BESIDE HERSELF WITH FEAR WHEN SHE HAD TO SING A COUNTRY SONG IN HER LATEST MOVIE, "POSTCARDS FROM THE EDGE." SHE SAYS, "MY KNEES WERE GOING A MILE A MINUTE AND MY UPPER LIP WAS UNCONTROLLABLE." SHE SAYS SHE PRACTICED THE SONG FOR THREE DAYS UNTIL SHE AND DIRECTOR MIKE NICHOLS WERE SATISFIED.

AP-NP-07-30-90 0940EDT<+

AP-PA-REPUBLICANWONDERB 07-30 0155

(WASHINGTON, D-C)—AT ONE TIME, MARC HOLTZMAN WAS CONSIDERED A REPUBLICAN WONDER BOY IN PENNSYLVANIA. BUT HE'S LEFT BEHIND HIS NORTHEASTERN PENNSLVANIA ROOTS TO BRING ONE-HOUR PHOTO LABS, SPEEDY OPTICAL SERVICES AND OTHER BUSINESSES TO EASTERN EUROPE.

THE KINGSTON NATIVE RAN UNSUCCESSFULLY FOR CONGRESS IN 1986 AGAINST DEMOCRAT PAUL KANJORSKI. HE STILL HAS DEBTS FROM THAT RACE. IN 1980, AT AGE 20, HE DIRECTED THE PENNSYLVANIA REAGAN-BUSH CAMPAIGN.

HE HAS RENTED APARTMENTS IN BUDAPEST AND PRAGUE AND HELPED ESTABLISH A HOLD-ING COMPANY FOR HIS ENTERPRISES. HE'S ALSO TRYING TO LEARN HUNGARIAN.

ALL THIS FROM A GUY WHO JUST TURNED 30 AND LOOKS BARELY OLD ENOUGH TO BUY A BEER. HOLTZMAN SAYS HE STILL GETS CARDED WHEN HE'S NOT WEARING A COAT AND TIE.

BUT HE ENJOYS BEING A POLITICAL VETERAN. EVEN AT 30, HOLTZMAN HAS A WEALTH OF ELECTION EXPERIENCE COMPARED WITH THAT OF HIS EASTERN EUROPEAN COUNTERPARTS.

AP-NP-07-30-90 1312EDT<+

The following section contains an opening and three stories from the script for the evening television newscast of a medium-market CBS affiliate, WHP-TV in Harrisburg, Pennsylvania. Note the split between the video cues (to the left) and the audio (on the right).

Television News Script

11/23 21:36 JHE 2:20 * 15+1101 990LH-1

```
SUPT Z

TALENT-2-SHOT            (***GENE***)

                            GOOD EVENING, COMING UP NEXT ON NEWSIGHT 21...

ENG-AOA

VONAT (***VONAT***)
                          THE PRESIDENT AND CONGRESSIONAL LEADERS

                          LOOK HAPPY TONIGHT, AS A STOPGAP SPENDING

                          MEASURE IS SIGNED...

ENG-AOB

SOT (***SOT***)

RUNS-:06                  ((I'M EVAN FORRESTER...))

ENG-AOC

VONAT (***VONAT***)       (***ROXANNE ***)

                            AND A STRIKE LOOMS AT THE STROEHMAN BAKERY

                          IN HARRISBURG....

ON CAM                    (***GENE***)

                            THE TWO-LIVE CRUE OBSCENITY TRIAL HAS JURORS

                          LAUGHING....
```

11/23 21:36 JHE 2:20 * 15+1101 990LI-2

(***ROXANNE ***)

 AND JIM HAS A NICE WEEKEND WEATHER FORECAST,
AND DOUG HAS LOTS OF HIGH SCHOOL FOOTBALL
ACTION. . . .

 STAY WITH US, NEWSIGHT 21 IS NEXT!

(-0-)

BREAK-1

RUNS-1:00 (***BREAK-1***|)

COLD

TALENT-2-SHOT

ENG-A1

VONAT (***VONAT***) (***GENE ***)

 A MORE CONTENT PRESIDENT BUSH MEETS WITH
CONGRESSIONAL LEADERS AS THE ATMOSPHERE
CHANGES IN WASHINGTON.

(-0)

FEDERAL

TALENT-2-SHOT (***GENE ***)

 GOOD EVENING.

 LAWMAKERS ARE NO LONGER PRESSING TO MEET A
MIDNIGHT DEADLINE.

(***ROXANNE***)

 PRESIDENT BUSH HAS SIGNED A MEASURE TO KEEP
THE GOVERNMENT FUNDED THROUGH NEXT
WEDNESDAY.

11/23 21:36 JHE 2:20 * 15+1101 990LI-3

(***GENE***)

BUT THE FIGHT'S NOT OVER. HOUSE AND SENATE MEMBERS WILL BE TRYING TO AGREE ON A COMPROMISE BETWEEN THE TWO BUDGET PACKAGES THEY'VE APPROVED.

(***ROXANNE***)

PRESIDENT BUSH HAD SOME ADVICE FOR RANK-AND-FILE LAWMAKERS THIS AFTERNOON.

ENG-A2

SOT (***SOT***)

RUNS-:13

((I WOULD SAY TO DEMOCRATS AND REPUBLICANS . . . PLEASE HEED WHAT YOUR LEADERS ARE SAYING . . . THE LEADERS IN THE SENATE AND THE LEADERS IN THE HOUSE . . . WE SHARE THIS VIEW AND UH . . . THAT'S WHAT I SAY TO THEM.))

ON CAM

(***ROXANNE***)

FULLSCREEN

CG-SENATE VERSION

GASOLINE TAX: 49 CENTS

INCOME TAX; LIMITS

DEDUCTIONS

MEDICARE: INCREASED TAXES
THE SENATE VERSION OF THE BUDGET DEFICIT-REDUCTION BILL WOULD DOUBLE THE GASOLINE TAX . . . FROM THE PRESENT 9-CENTS A GALLON TO 18-CENTS. ON INCOME TAX, THE SENATE VERSION LIMITS

369

11/23 21:36 JHE 2:20 # 15+1101 990LI-4

DEDUCTIONS FOR PEOPLE WHO MAKE OVER 100-
THOUSAND DOLLARS A YEAR.

FULLSCREEN
CG-HOUSE VERSION
GASOLINE TAX: NO INCREASE
INCOME TAX:
WEALTHY-33%
MEDICARE:
INCREASED TAXES

THE HOUSE VERSION HAS NO INCREASE IN THE
GASOLINE TAX, BUT HITS THE WEALTHY HARD. IT
INCREASES THE TOP TAX BRACKET PAID BY THE
WEALTHIEST FROM 28 TO 33 PERCENT. BOTH VERSIONS
INCREASE MEDICARE TAXES.

ON CAM

(***ROXANNE***)
CONGRESS NOW MUST WORK OUT THE DIFFERENCES.
(-O)

11/23 00:16 JHE 2:20 #15+1 WAGNER-1

TALENT-GENE

(***GENE***)
A YORK COUNTY BABYSITTER IS STILL ON TRIAL
FOR THE MURDER OF A CHILD SHE WAS WATCHING.
TODAY, PROFESSIONAL TESTIMONY BACKS THE
STORY OF 23-YEAR-OLD THERESA WAGNER THAT THE
CHILD FELL.

THE PROSECUTION CHARGES WAGNER HIT THE CHILD
AT LEAST TWICE.

BUT A DOCTOR TESTIFIED 18-MONTH OLD CRYSTAL
SEACHRIST HAD PRIOR SKULL SURGERY
FOR A DEFORMITY, AND THAT CONTRIBUTED TO THE
SEVERITY OF INJURIES SUFFERED IN THE FALL.

THE BABY'S MOTHER DISAGREES.

ENG-A3

11/23 00:18 JHE 2:20 #15+1WAGNER-2

SOT (***SOT***)
CG-ELLEN SEACHRIST/
CHILD'S MOTHER
RUNS-:09 ((YOU KNOW IT HURTS WHEN YOU HEAR SOMEONE
 SAYING SOMETHING THAT'S NOT TRUE ABOUT YOUR
 DAUGHTER . . . SHE WAS A VERY NORMAL GIRL.))

VONAT (***VONAT***)
 WAGNER MAINTAINS WHAT HAPPENED WAS AN
 ACCIDENT.
 THE TRIAL CONTINUES TOMORROW.
 (-0)

11/23 00:17 JHE 2:20 #15+1GMRECALL-1

TALENT-ROXANNE (***ROXANNE***)
 GENERAL MOTORS SAYS IT'S RECALLING 520-
 THOUSAND 1989 AND 1990 MODEL CARS FOR

POTENTIALLY DEFECTIVE BRAKE LIGHTS.

A G-M SPOKESMAN SAYS THE CARS MAY HAVE A FAULTY ELECTRICAL SWITCH THAT COULD RESULT IN FAILURE OF THE BRAKE LIGHTS . . . BUT HE SAYS THE PROBLEM DOESN'T AFFECT THE BRAKES.

CG-FULLSCREEN
CG-GENERAL MOTORS RECALL
CG-1989 AND 1990 MODELS:
CG-GRAND PRIX
CG-CUTLASS SUPREME
CG-REGAL
CG-LUMINA

THE MODELS INVOLVED IN THE RECALL ARE THE 1989 AND 1990 PONTIAC GRAND PRIX, OLDSMOBILE CUTLASS SUPREMES, BUICK REGALS, AND 1990 CHEVROLET LUMINA CARS.

G-M SAYS IT KNOWS OF TEN ACCIDENTS IN WHICH THE LIGHT DEFECT MAY HAVE BEEN A FACTOR.

OWNERS OF THESE CARS CAN GET THE DEFECT FIXED AT NO COST FROM G-M DEALERS.

(-0)

This section of drill material gives you a variety of commercial copy, station promos, and other scripts. The material has been selected to give you practice in reading copy in several different forms requiring different approaches and techniques.

The distinguishing feature of the copy in this section is that it was written to persuade. Commercial copy is designed to get people to spend money on a product or service. Station promos are intended to get people to watch or listen to your station and not others. The AV script is intended to induce people to travel to the Caribbean. All have a message that seeks to persuade.

The best way to approach copy that is intended to persuade is to read through it several times and try to distill for yourself the central purpose intended by the copywriter. Try to identify the techniques used to make the message clear. Once you understand what the writer intends, and how copy has been structured to achieve a purpose, you will have a better idea of what techniques you as the announcer can bring to the job.

The following is commercial and promotional copy written for radio. There is material from both small- and large-market stations. (Copy courtesy of the William Cook Agency. Copyright the William Cook Agency, Inc.)

Appendix

C

Drill Material: Scripts and Commercial Copy

Radio Commercial Copy and Station Promos

THE
WILLIAM COOK
AGENCY

CLIENT: FIRST UNION FLORIDA
JOB TITLE: CUSTOMIZED BANKING RADIO - PERFORMANCE BANKING
JOB NUMBER: FUFL-R-00091-4
DATE: DECEMBER 3, 1990
COMMERCIAL #: FFLR-30CBR-00091
RUN DATES: TBD

:30

SNG: WE'RE FIRST UNION BANK...

(:22)
ANC: To get more than checking out of your checking account, First Union recommends Performance Banking. It's customized, with smart-money features. Like a no-fee credit card, lower rates on auto loans, interest on your checking balance, and service that's guaranteed. Compare First Union Performance Banking to other bank accounts, and get more for your money.

SNG: SERVICE BANKING SERVING YOU
WE'RE FIRST UNION NATIONAL BANK

ANC: Member FDIC.

(FFLR00091A)
KJ/ag

T H E
WILLIAM COOK
A G E N C Y

CLIENT: FIRST UNION FLORIDA
JOB TITLE: DODGER SPONSORSHIP RADIO (50)
JOB #: FUFL-42242
DATE: JANUARY 26, 1989
COMMERCIAL #: FUFL-60-029B (TO ROTATE WITH FUCORP-60SS-00068)
RUN DATES: AS INSTRUCTED

:60 TRACK #4 (:33.6 BED)

SNG: WE'RE FIRST UNION BANK
OUR COMMITMENT TO SERVICE
IS SOMETHING THAT WE GUARANTEE
WE DELIVER PERFORMANCE
IN A WAY NO OTHER BANK CAN BEAT

ANC: By the time you reach 50, you've made a real contribution through a lifetime of productivity. And FIRST UNION thinks you deserve some privileges. That's why we offer you the special privileges of Benefit Banking when you're only 50! Benefit Banking gives you a free interest checking account, free travelers' checks, notary service, estate planning, a bonus rate on CDs ... and so much more. So if you're 50 or over, call or visit FIRST UNION today. And let the privileges of Benefit Banking benefit you.

SNG: WE'RE FIRST UNION NATIONAL BANK.

(FLR42242B)
5/2/lmj

THE
WILLIAM COOK
AGENCY

CLIENT: FIRST UNION FLORIDA
JOB TITLE: SPORTS RADIO -- THE GAME :60
JOB #: FUFL-R-00140-5
DATE: SEPTEMBER 28, 1990
COMMERCIAL #: FUFLR-60G-00140
RUN DATES: TBD

ANC: First Union salutes Florida's athletes
Because they don't just come to play
They come to win.

SFX: (SLIGHT CROWD NOISE BUILDING)

ANC: It happens every year
In stadiums packed to capacity
Young athletes take to the field
And learn the difference between good and great
While we cheer, and cry "Go, go, go!"
Willing them onward toward the goal.

SFX: (ROAR OF CROWD PEAKS, FADES)

ANC: Because at First Union we know what it takes to win
And we give you everything we've got
The muscle to move forward
The strategies to get ahead
And the commitment to go on when the going gets tough.

SFX: (CHEER RISES AND FADES, MUSIC MAY BE UNDER)

ANC: For the game is tough and exciting
And we don't come to play.
We come to win. For you.
First Union salutes Florida's athletes.
First Union, committed to Florida
And what it takes to help you win.

FIRST UNION
SPORTS RADIO -- THE GAME :60
FUFL-R-00140-5
PAGE 2

 (PAUSE)

ANC: Service. We guarantee it.

 (PAUSE)

 First Union National Bank of Florida.
 Member FDIC.

(00140-60)
KJ/bh:lmj:bh

THE
WILLIAM COOK
AGENCY

CLIENT:	MEMORIAL MEDICAL CENTER
JOB TITLE:	HEART RADIO
JOB #:	MMC-R-10819-2
DATE:	OCTOBER 10, 1989
COMMERCIAL #:	TBD
RUN DATES:	TBD

MAN: I had the sweats. I was nauseous. I thought it was some kind of flu bug. Or something I ate. I'm only 38. Play golf whenever I can. I cut down on smoking...and I'm not that much overweight. Anyway, the chest pain, it was like someone was standing on my chest. I could hardly catch my breath. So my neighbor says, "I'm calling an ambulance." Stupid me, I'm still going, "Nah, nah, nah, I'll be all right. It's just gas pains." Only now the pain starts spreading to my shoulder and neck. Then my arm. So finally I say, "Okay, okay. Call the ambulance." I got to the hospital and they stopped the heart attack...I mean as fast as it started...with this new treatment that dissolves blood clots. Here's the real kicker: The treatment is so new, it's not available everywhere. Guess it was my lucky day.

ANC: Don't depend on a lucky day. Know the signs of a heart attack and know where to go. The Heart Emergency Network at *Emanuel County Hospital, Swainsboro, Georgia,* and Memorial Medical Center.

MAN: I still can't believe it. I was having a heart attack and didn't even know it.

ALT TAGS:

 *Evans Memorial Hospital, Claxton, Georgia,

 *Jenkins County Hospital, Millen, Georgia,

 *Liberty Memorial Hospital, Hinesville, Georgia,

 *Live Oaks Hospital, Ridgeland, South Carolina,

 *Screven County Hospital, Sylvania, Georgia

(HATTACK)

3/1mj

THE
WILLIAM COOK
AGENCY

CLIENT: JNO. H. SWISHER
JOB TITLE: HOCKEY RADIO
JOB #: SWSH-R-10029-2
DATE: OCTOBER 3, 1988
COMMERCIAL #: TBD
RUN DATES: TBD

:60 RADIO

MAN: Okay, first, pucker up.

WOMAN: (playfully suspicious) I thought you were going to teach me about hockey.

MAN: I am. I'm demonstrating a faceoff.

WOMAN: Faceoff! I think you're offsides.

MAN: Looks like I'm starting off in the penalty box.

WOMAN: So, been a Ranger fan long?

MAN: Since the ice age.

WOMAN: So why aren't we <u>at</u> the Garden?

MAN: I always listen to the game on the radio so I can sit back, relax and enjoy my cigar. You don't mind, do you?

WOMAN: No. Not at all.

MAN: Could you hand me my Rangers jersey, please?

WOMAN: Cold?

MAN: No, it's a ritual.

WOMAN: Ritual?

JNO. H. SWISHER
HOCKEY RADIO
SWSH-R-10029-2
PAGE 2

MAN: Yeah. Every time the Rangers play,
 I wear my lucky jersey and light up a Bering.

WOMAN: I understand the jersey, but why the Bering cigar?

MAN: Nowadays I can't find the time or place to smoke
 as often as I like, so when I can do it, I do it right with Bering.

WOMAN: (Playfully) You look pretty good in that jersey.

MAN: (grizzly voice) Oh yeah, well how 'bout a body check?

WOMAN: How 'bout a slap shot?

ANC: Bering long-filler cigars...made from 100% imported tobacco with
 natural leaf binder and wrapper. When you can do it, do it right.

(HOCKEY5)
GH/JS/bp

THE
WILLIAM COOK
AGENCY

CLIENT: JNO. H. SWISHER & SON
JOB TITLE: :60 SEC. BERING RADIO/ROWBOAT
JOB #: SWSH-R-10558
DATE: AUGUST 2, 1988
COMMERCIAL #: SWSHR-60RB-10558
RUN DATES:

SFX: (Ambience of Central Park by the lake.)

WOM: Ah...that's my boat.

MAN: Your boat?

WOM: I just rented it.

MAN: So did I.

WOM: This is the last one in the park.

MAN: Sorry.

WOM: What ever happened to chivalry?

MAN: Times change. Speaking of time, you're cutting into my cigar time.

WOM: Cigar time?

MAN: Nowadays, I can't smoke as often as I'd like, so when I can do it, I do it right.

WOM: You rented a boat to smoke a cigar?

MAN: A Bering cigar.

WOM: Let's split it.

MAN: My cigar?

WOM: The boat...half an hour each.

MAN: No, no. You don't rush smoking a Bering cigar.

JNO. H. SWISHER & SON
:60 BERING RADIO/ROWBOAT
SWSH-R-10558
PAGE 2

WOM: Oh, well.

MAN: What were you gonna do?

WOM: (hesitant) Work on my poetry.

MAN: I enjoy poetry.

WOM: Really? Well, you want to share my boat?

MAN: Okay. You don't mind if I smoke my cigar?

WOM: Not at all.

ANC: Bering long-filler cigars, made from 100% imported tobacco, with a natural leaf wrapper and binder.

SFX: (rowing)

MAN: Read it.

WOM: It's not finished.

MAN: Go on.

WOMAN: (Clearing throat) Alas, my true love. Though it be from afar, your perpetual passion stirs me like...like the...

MAN: (A little crass) like the aroma (pause) of a Bering cigar.

ANC: Bering Cigars. When you can do it, do it right.

(BOATMAN)
GH/bp:lmj:bp

THE
WILLIAM COOK
AGENCY

CLIENT: WINN-DIXIE HEADQUARTERS
JOB TITLE: EDLP PHASE IV :30 RADIO "YOU'LL NEED SOMETHING"
JOB #: WDH-R-10151-3
DATE: JANUARY 24, 1991
COMMERCIAL #: WDHR-30Y-10151
RUN DATES: TBD

ANC:	Sometimes it's easier to make money than to keep it. But shop at WINN-DIXIE and you'll need something to keep your savings in.
SFX:	**SOUND OF LOOSE CHANGE GOING INTO JAR**
ANC:	At WINN-DIXIE, you save a few cents on just about every item. So nearly everything you put in your cart puts a few cents back in your pocket.
SFX:	**CHANGE GOING INTO JAR**
ANC:	And those nickels and dimes will add up
SFX:	**CHANGE GOING INTO JAR**
ANC:	to a lot of dollars.
SFX:	**A LOT OF CHANGE GOING INTO JAR**
ANC:	Which is great. Because at WINN-DIXIE, what you save
SFX:	**CHANGE GOING INTO JAR**
ANC:	is what you keep.
SFX:	**CHANGE GOING INTO JAR**
ANC:	WINN-DIXIE, low prices every day.
SFX:	**CHANGE GOING INTO JAR**
ANC:	That's a promise.
SFX:	**CHANGE GOING INTO JAR**

(WDHR10151D)
KJ/ag:bh

THE
WILLIAM COOK
AGENCY

CLIENT: WINN-DIXIE HEADQUARTERS
JOB TITLE: EDLP PHASE IV - :60 RADIO "NICKELS AND DIMES"
JOB NUMBER: WDH-R-10151-3
COMMERCIAL #: WDHR-60N-10151
DATE: JANUARY 24, 1991
RUN DATES: TBD

ANC: Question: What do you do with loose change -- you know, those nickels and
 dimes that collect in your pocket or the bottom of your handbag?

SFX: **SOUND OF HANDFUL OF LOOSE CHANGE**
 JANGLING
 Right. You save them --

SFX: **CHANGE GOING INTO CONTAINER**
 in a can, in a jar -- whatever.

SFX: **MORE CHANGE GOING INTO CONTAINER**
 -- And you let them add up to dollars.

SFX: **MORE CHANGE GOING INTO CONTAINER**
 And you've noticed they can add up to a lot of dollars?

SFX: **MORE CHANGE GOING INTO CONTAINER**
 then **MORE CHANGE GOING IN**
 Good.

SFX: **MUSIC UP**
 Because it shows how saving a few cents on just about every item every day
 at WINN-DIXIE really adds up. Now, imagine doing your grocery shopping
 where just about every time you put something in your cart, it's like putting
 a few cents back in your pocket.

SFX: **LOOSE CHANGE JANGLING**
 And those nickels and dimes can add up fast.

SFX: **CHANGE GOING INTO A CONTAINER**
 So when you get home, put your WINN-DIXIE savings in a BIG jar, because
 you'll save on every aisle every time you shop.

SFX: **COIN INTO CONTAINER**
 And that adds up to a lot of dollars.
 WINN-DIXIE. Low prices every day.

SFX: **CHANGE JANGLING**
 That's a promise.

SFX: **CHANGE INTO CONTAINER**

(WDHR10151N)
KJ/ag:bh

THE
WILLIAM COOK
AGENCY

CLIENT: WINN-DIXIE STORES, INC.
COMMERCIAL #: WDAR-60V1-10769 (aka: 60ALP-10769)

:60 SARAH 6 (:12.5 BED) (RELATIVES VISIT/LOW PRICE)

BAR: Every time my relatives visit, they eat me out of house and home. There's my Uncle

Louie. Whenever we have a cookout, he has two double cheeseburgers, three helpings

of baked beans, half a dozen hot dogs and a diet soda. It's ridiculous. Oh, and talk

about "like father like son." You should see Cousin Freddie. Every time I turn around

he's got his face in the fridge. This guy doesn't just snack between meals. He snacks

between the salad and the entree. I'm sure glad I shop at WINN-DIXIE, because they

have low prices on everything in the store. Meat, produce, baked beans, everything.

Hey, it's important for me to save money on groceries. Especially when my Aunt

Sophie's idea of a light lunch is anything she can pick up with a fork. So, from the

bottom of my pocket book, WINN-DIXIE, I thank you.

(:12.5)

ANC: ?

(SARAH6)

THE
WILLIAM COOK
A G E N C Y

CLIENT:　　　WINN-DIXIE STORES, INC.
COMMERCIAL #:　WDAR-60F-10769

:60　SARAH 5　(:12.5)　(FLOWERS)

BAR: I'm kind of a hopeless romantic. My husband, he's just kind of hopeless. But I discovered

a surefire way to get him to bring me flowers. All I do is call him up at his office at

about ten o'clock in the morning and say, "Hi, Honey, do you know what today is?"

Silence. Then I say, "You (SFX: sniff) don't know?" "Uh, uh" he says. Then I go, "Well, I

don't want to talk to you until you can tell me what today is!" And I hang up. Then, just

when he's ready to go home, I call him and say, "If you don't know what today is, maybe

you can remember to pick up some potatoes at WINN-DIXIE on the way home." Potatoes

are right next to the flowers. It never fails. He walks in the door with a sack of

potatoes, a bouquet of flowers and says, "Honey, I'm sorry. I just can't remember what

today is." So I tell him, "It's Tuesday."

(:12.5)

ANC: ?

(SARAH5)

THE
WILLIAM COOK
AGENCY

CLIENT: WINN-DIXIE STORES, INC.
COMMERCIAL #: WDAR-60RV-10199

:60 SARAH 3 (:8.5 BED) (COUCH POTATO/DELI)

WIF: My husband is a couch potato. In fourteen years, he's worn out three recliners. Can't

remember our anniversary, but he's got the TV schedule memorized. One time I took

the batteries out of his remote control. He called 911. Last week he comes home from

work, plops down in his recliner, throws it into liftoff position and tells me that his boss

is giving a dinner party and we're supposed to bring dessert. So I said, "Great. What are

you gonna make?" That brought him to his feet. He goes, "Gee, honey, I thought you'd

make your famous strawberry shortcake." "Think again," I said. "He's your boss. You

cook something." He was smarter than I thought. Went to the WINN-DIXIE

Deli/Bakery and picked up a cheesecake. Well, his boss's wife raved over it. So he says,

"Thank you. I made it from scratch." Then she asked for the recipe.

(:8.5)

ANC:

(SARAH3)

387

THE
WILLIAM COOK
AGENCY

CLIENT: WINN-DIXIE STORES, INC.
COMMERCIAL #: WDAR-60LC-10199

LC :60 SARAH 2 (:8.5 BED) (3 CHILDREN/FROZEN FOOD)

MOM: I have three children. Two I gave birth to and one I married. It's hard enough keeping

them in line. The last thing I need to worry about is feeding them. By the time I get

home from work at five my two sons, Rambo and the Terminator, have been there for

an hour, rearranging the furniture. Then at 5:15 my husband arrives. This man thinks

the living room is one big laundry hamper. Anyway, by five-thirty I start to fix dinner.

Okay, sometimes I can muster the energy to make something real gourmet. But let me

tell ya, when it comes to frozen food, I'm president of the fan club. I love those little

plastic plates that come with the microwave stuff. I now have full place settings for

fifty. My trick is, whenever I have a rough day, I stop by WINN-DIXIE on the way

home. They have a great selection of frozen foods. Besides, shopping at WINN-DIXIE

is a lot less expensive than therapy.

(:8.5)

ANC: ?

(SARAH2)

THE
WILLIAM COOK
AGENCY

CLIENT: WINN-DIXIE STORES, INC.
COMMERCIAL #: WDN-60CR-10630 CS

:60 SARAH 18 (:6 BED) (STAFF MEETING/CHEESE)

BAR: Last week the boss put me in charge of food for the big staff meeting. She says, "Don't

forget Camembert and Gorgonzola." I said, "Who?" She said, "Go to the Cheese Shop at

WINN-DIXIE." So there I was, with all of those cheeses. And I wouldn't know a Swiss

from a Gouda if it yodeled. They had sharp cheese, round cheese, blue cheese, yellow

cheese, cheeses from all over the world! Switzerland, France, New Zealand, Kenosha.

Good thing they had a cheese expert to help me. She said, "How 'bout Monterey Jack?" I

said, "The name is Barbara and I've never been to California." So she says, "How about a

dip?" I said, "Nah, we've got plenty of those back at the office." Anyhow, to make a

long story short, that WINN-DIXIE cheese girl fixed me up with everything I needed.

Now the boss calls me the "Gouda Gourmet." To think that just last week I thought a

fine Muenster was Frankenstein with good table manners.

(:6)

ANC: ?

(SARAH18)

THE
WILLIAM COOK
AGENCY

CLIENT: WINN-DIXIE STORES, INC.
COMMERCIAL #: WDN-60CR-10630 P

:60 SARAH 17 (:6 BED) (EMMA'S CURE/PHARMACY - LOCATION TAG ONLY)

WOM: It never ceases to amaze me. Get sick, and everybody's got a home remedy. My Aunt Emma's cure-all is crushed garlic and Limburger cheese in a sock hung around her neck. "I never catch a cold," she says. That's because nobody gets within fifty yards of the woman. Then there's Cousin Moonbeam from California...swears by frozen tofu daiquiris. And my mother, who, every time she hears me sneeze, wants to give me an oil and vinegar rubdown. It's great if you don't mind smelling like a salad bar for a week. Me, I just go to the Pharmacy at WINN-DIXIE. Their low prices alone will make you feel better. But what I like most is the convenience. By the time I pick up some chicken soup, my prescription's ready. That's because they have a computer with my file in it. They know everything: my doctor's name, my allergies, the medicine I'm taking. And not once did they tell me to gargle with guacamole.

(:6 BED)
ANC: ?

(SARAH17)

RADIO COPY

FM 102 WHYL

Making Your Money Talk

P.O. Box WHYL
Carlisle, PA 17013

717-232-3126 or 717-249-1717

Client: **BRENNEMAN'S FURNITURE**

Length: **:30**

Today's date **5/25**

Start date **6/1-2** End date _____

Copy by: **RAY THOMAS**

Salesman: **LINCOLN**

Co-op Brand: **LANE**

Subject: **FATHER'S DAY**

1 A LANE RECLINER FROM BRENNEMAN'S FURNITURE IS A GREAT WAY TO SAY "HAPPY FATHER'S

2 DAY." THE LANE "SPOILER" FEATURES HEAD TO TOE COMFORT WITH SOFT, OVERSTUFFED

3 CUSHIONS. REGULAR $525, NOW A LOW $419. GIVE DAD THE GIFT OF COMFORT HE DESERVES

4 AND SAVE ON THE LANE RECLINER OF YOUR CHOICE. (BRING IN THE SALE CARD FROM

5 SATURDAY'S CARLISLE SENTINEL AND SAVE AN ADDITIONAL 10-PERCENT!) (HURRY, BECAUSE

6 THE NATIONAL LANE FATHER'S DAY SALE ENDS SOON!) THERE'S FREE DELIVERY AND YOUR

7 MAJOR CREDIT CARD IS WELCOME.)

·8 (JINGLE)

9 JUST OFF THE PLAINFIELD EXIT OF I-81, CARLISLE.

10

11

12

13

14

15

·16

This announcement was broadcast........ times, as entered in the station's program log. The times this announcement was broadcast were billed to this station's client on our invoice(s) numbered/datedat his earned rate of:

$.. each for announcements, for a total of $..

$.. each for announcements, for a total of $..

...
Signature of station official

...
(Notarize above)

...
Type name and title Station

391

FM 102 WHYL

Making Your Money Talk

P.O. Box WHYL
Carlisle, PA 17013

717-232-3126 or 717-249-1717

RADIO COPY

Client:	CARLISLE TRUCK PLAZA
Length:	:60
Today's date	5/31
Start date	5/31 End date 6/30
Copy by:	RAY THOMAS
Salesman:	LINCOLN ZEVE
Co-op Brand:	
Subject:	SUMMERS HEAT

1 HI FOLKS, THIS IS PAUL ROGERS OF THE CARLISLE TEXACO TRUCK PLAZA FAMILY RESTAURANT
2 WITH SOME THOUGHTS ON THE SUMMER'S HEAT. YOU KNOW THERE'S NOTHING I HATE WORSE
3 THAN SLAVING OVER A HOT STOVE IN THE HEAT OF SUMMER. AND YOU CAN BEST BELIEVE MY
4 WIFE HATES IT EVEN MORE THAN I DO. THAT'S WHY SUMMER IS THE PERFECT TIME TO GET THE
5 LITTLE LADY OUT OF THE KITCHEN AND BRING THE WHOLE FAMILY IN FOR DINNER AT THE
6 CARLISLE TEXACO TRUCK PLAZA FAMILY RESTAURANT. ENJOY ALL YOUR DINNER FAVORITES IN
7 AIR-CONDITIONED COMFORT. THERE'S SOMETHING ON THE MENU FOR EVERY TASTE . . . EVEN
8 SUMMERTIME DESSERTS LIKE OUR SCRUMPTIOUS COLOSSAL, HUGE BANANA BOATS! AND THE
9 COLDEST SOFT DRINKS IN TOWN. SO THIS SUMMER, LEAVE THE SLAVING OVER A HOT STOVE TO
10 US. COME COOL OFF WITH DINNER TONIGHT AT THE CARLISLE TEXACO TRUCK PLAZA FAMILY
11 RESTAURANT, WHERE WE ALWAYS KEEP THE GRILL HOT FOR YOU.
12 ANNOUNCER: THE CARLISLE TEXACO TRUCK PLAZA FAMILY RESTAURANT, 1 1/2 MILES NORTH OF
13 I-81 ON ROUTE 11 NEAR NEW KINGSTON. JUST LOOK FOR THE TEXACO SIGN.
14
15
16

This announcement was broadcast times, as entered in the station's program log. The times this announcement was broadcast were billed to this station's client on our invoice(s) numbered/dated at his earned rate of:

$..................................... each for announcements, for a total of $.....................................
$..................................... each for announcements, for a total of $.....................................

.....................................

Signature of station official

.....................................
(Notarize above)

.....................................
Type name and title Station

FM 102 WHYL

Making Your Money Talk

P.O. Box WHYL
Carlisle, PA 17013

717-232-3126 or 717-249-1717

RADIO COPY

Client:	FIRST BANK AND TRUST
Length:	:30
Today's date	7/1
Start date	7/1 End date 7/30
Copy by:	RAY THOMAS
Salesman:	LINCOLN
Co-op Brand:	
Subject:	SAVINGS PLANS

1 SECURING YOUR FUTURE BEGINS WITH A SMART SAVINGS PLAN FROM FIRST BANK AND TRUST!

2 FIRST BANK C.D.'S ARE THE PERFECT FINANCIAL PLANNING TOOLS. EARN HIGH RATES WITH

3 GOVERNMENT-INSURED SECURITY WITH A C.D. SAVINGS PLAN TO MEET YOUR GOALS AND

4 NEEDS . . . OR GET THE SAVINGS <u>HABIT</u> WITH A FIRST BANK STATEMENT SAVINGS ACCOUNT

5 THAT OFFERS HIGH RATES AND FREE 24 HOUR ACCESS TO ANY MAC MACHINE. FROM C.D.'S TO

6 SAVINGS TO TRUST AND ESTATE PLANNING, DEPEND ON 1ST BANK AND TRUST'S 130 YEAR

7 RECORD OF SERVICE. 5 LOCATIONS TO SERVE YOU. A PNC BANK AND MEMBER FDIC.

8

9

10

11

12

13

14

15

16

This announcement was broadcast........ times, as entered in the station's program log. The times this announcement was broadcast were billed to this station's client on our invoice(s) numbered/datedat his earned rate of:

$.. each for announcements, for a total of $...

$.. each for announcements, for a total of $...

..
Signature of station official

..
(Notarize above)

..
Type name and title Station

BARBEAU PRONOUNCED BAR-BO

ANNCR: ATTENTION HOMEOWNERS AND WOULD-BE HOMEOWNERS! ARE HOME MAINTENANCE CHORES GETTING THE BEST OF YOU? IS REPAIRING A BROKEN STEP NOW AN IMPOSSIBLE STEP? THEN LISTEN TO THESE IMPORTANT FACTS ABOUT THE RUSSELL BARBEAU COMPANY. FOR OVER 14 YEARS, THEIR EXPERIENCED CRAFTSMEN HAVE DONE IT ALL . . . REPAIRS, REPLACEMENTS, ADDITIONS . . . YOU NAME IT. NO JOB IS TOO SMALL. DO YOU NEED BROKEN SASH CORDS RE-PLACED, BROKEN PANES REPAIRED, LOCKS INSTALLED, OPEN OR ROOF DECKS ADDED, OR YOUR CELLAR CONVERTED? THE RUSSELL BARBEAU COMPANY CAN HELP. JUST CALL 1-800-826-5000 FOR A FREE CUSTOM ESTIMATE. THEY EVEN WORK EVENINGS TO FIT YOUR BUSY SCHEDULE. ANYTHING FROM CELLULOSE INSULATION ON AN EXISTING BUILDING, TO A NEW PORCH OR DECK ON YOUR EXISTING PROPERTY. THE RUSSELL BARBEAU COMPANY PROS ARE YOUR EXPERTS . . . FROM WINDOW REFURBISHMENT, DOORS, SHEET-ROCK INSULATION AND SIDING, TO FIXING DRAFTY HOLES, CRACKS AND SO MUCH MORE. RUSSELL BARBEAU IS LICENSED, BONDED AND INSURED. CALL 1-800-826-5000 FOR A FREE ESTIMATE. THEY EVEN WORK EVENING HOURS AND WEEKENDS. THAT'S 1-800-826-5000. YOU'LL BE PLEASANTLY SURPRISED AT THE AFFORD-ABLE PRICES . . . SO CALL NOW. 1-800-826-5000.

SPON ID: THIS (FEATURE) IS SPONSORED BY ACCOUNTEMPS . . .

ANNCR: HERE'S A QUESTION FOR EXECUTIVES. HOW DO YOU HANDLE A BUSINESS EMERGENCY? AN EMERGENCY THAT PUTS YOU IN IMMEDIATE NEED OF A TEMPORARY ACCOUNTANT, BOOK-KEEPER, DATA ENTRY OR CREDIT/COLLECTIONS PERSON. IF YOU'RE RUNNING AN EFFICIENT BUSINESS, NO ONE HAS THE TIME TO FILL IN FOR AN ABSENT EMPLOYEE. YOU'LL NEED A RELI-ABLE, EFFICIENT, PROFESSIONAL TEMPORARY HELP SERVICE . . . ACCOUNTEMPS. ACCOUNTEMPS ARE THE SPECIALISTS IN TEMPORARY ACCOUNTING, BOOKKEEPING, DATA ENTRY AND CREDIT/COLLECTIONS PEOPLE AND THEY ARE AVAILABLE ON A HALF DAY'S NOTICE TO WORK IN YOUR OFFICE AS LONG AS YOU WANT . . . A DAY, A WEEK, A MONTH OR MORE . . . TO

HELP YOUR ACCOUNTING, BOOKKEEPING OR CREDIT DEPARTMENT RUN SMOOTHLY. SO THE NEXT TIME YOU HAVE A PERSONNEL EMERGENCY, CALL ACCOUNTEMPS IN BOSTON, BRAINTREE, LEXINGTON AND DANVERS. THEY UNDERSTAND WHAT YOU NEED. IN FACT, YOU CAN CALL THE PRESIDENT, HERB MYERS AT 951-4000 IN BOSTON, ALSO BRAINTREE, LEXINGTON AND DANVERS. ACCOUNTEMPS IS A DIVISION OF THE ROBERT HALF ORGANIZATION—ACCOUNTEMPS.

ANNCR: DID YOU KNOW THAT WOBURN FOREIGN MOTORS NOW HAS NEW ENGLAND'S FINEST SELECTION OF QUALITY PREOWNED VEHICLES? YES, YOUR PREMIERE JAGUAR AND TOYOTA DEALERSHIP IS NOW THE LEADER FOR LATE MODEL HIGH-LINE USED CARS. CHOOSE FROM AN INCREDIBLE SELECTION OF TOYOTAS, JAGUARS, MERCEDESES, BMWS, PORSCHES, VOLVOS, SAABS, CADILLACS, LINCOLNS . . . YOU NAME IT. OVER 50 AVAILABLE FOR IMMEDIATE DELIVERY. HOW ABOUT A 1987 JAGUAR XJ6 . . . 4 DOOR SEDAN, FINISHED IN RICH REGENT GRAY COMPLE- MENTED BY A PLUSH BURGUNDY LEATHER INTERIOR, ONE OWNER, LIKE NEW, ONLY 32,000 MILES, NOW AT WOBURN FOREIGN MOTORS WITH THE REMAINDER OF THE FACTORY WARRANTY FOR ONLY $26,900. EACH AND EVERY CAR IS HAND PICKED FOR ITS QUALITY AND MUST PASS A FULL 40 POINT SERVICE FROM BUMPER TO BUMPER. LIKE A 1989 MAXIMA 4 DOOR SEDAN FULLY AP- POINTED FOR ONLY $17,900, SAVE ALMOST EIGHT THOUSAND DOLLARS. CALL 933-1100. FOR MORE DETAILS, THAT'S 933-1100. TAKE EXIT 36 ON 128 TO WOBURN FOREIGN MOTORS ONLY MINUTES FROM DOWNTOWN BOSTON. STOCK NUMBER 3548A.

ANNCR: THIS ANNIVERSARY SWEEP HER OFF HER FEET WITH A DIAMOND ANNIVERSARY RING FROM ALPHA OMEGA JEWELERS OF CAMBRIDGE. WHILE OTHER GIFTS MAY SAY, "I LOVE YOU" IT'S THE DIAMOND ANNIVERSARY RING, A SIMPLE BAND OF DIAMONDS, THAT SAYS YOU'D MARRY HER ALL OVER AGAIN. AND ISN'T THAT WHAT ANNIVERSARIES ARE ALL ABOUT? AT ALPHA OMEGA JEWELERS YOU'LL FIND DIAMONDS, EMERALDS, SAPPHIRES, AND RUBIES FROM ALL OVER THE WORLD OF THE VERY FINEST QUALITY AND PRICE. QUALITY, BECAUSE SHE DE- SERVES THE BEST. YOU'LL FIND THE LARGEST SELECTION OF DIAMOND ANNIVERSARY RINGS . . .

14 KARAT, 18 KARAT, 22 KARAT, GOLD JEWELRY AND WEDDING BANDS. YOU CAN VISIT ALPHA OMEGA AT THE GALLERIA MALL IN HARVARD SQUARE AT 57 JFK STREET OR CALL 864-1227. THAT'S 864-1227. AND THERE'S VALIDATED PARKING AT UNIVERSITY PLACE. THIS YEAR TELL HER YOU'D MARRY HER ALL OVER AGAIN WITH A DIAMOND ANNIVERSARY RING FROM ALPHA OMEGA JEWELERS.

08/14/90 14:22 MMC ?:80 *12+1 SPORTSN

SPORTSNIGHT PROMO

(M) I'M CRAIG MUSTARD

(B) AND I'M RON BARR

(M) TONIGHT AND EVERY WEEKNIGHT AT SEVEN IT'S WEEI SPORTSNIGHT,

(B) THEN AT 11, IT'S MY TURN: SPORTS BYLINE USA.

(M) TONIGHT ON SPORTSNIGHT . . . _____ AND THEN,

(B) TONIGHT ON SPORTS BYLINE USA . . . _____ .

(M) AND I'LL HAVE THE LATEST SCORES AND NEWS, PLUS YOUR CALLS AND COMMENTS. PLEASE JOIN US TONIGHT, WEEI SPORTSNIGHT AT 7 . . .

(B) AND SPORTS BYLINE USA AT 11 . . . EXCLUSIVELY ON THE NEWS STATION.

(M) NEWSRADIO 590 WEEI.

08/07/90 11:36 MMC 0:80 *12+1 WEATHER

WEATHER PROMOS

EXPERIENCE IS THE KEY INGREDIENT TO THE WEEI WEATHER WATCH FORECAST . . .
HI THIS IS WEEI METEOROLOGIST DICK ALBERT . . .

TODAY, EVERYONE HAS RADAR AND SATELLITE PICTURES TO HELP PREDICT THE WEATHER BUT OFTEN EXPERIENCE IS MISSING . . .

BOB COPELAND AND I HAVE SEEN JUST ABOUT EVERY WEATHER CONDITION NEW ENGLAND CAN THROW AT US. THAT MEANS, WHEN WE ANALYZE THE COMPUTER DATA, WE KNOW WHAT THAT MEANS FOR THE BOSTON AREA.

EXPERIENCE YOU CAN DEPEND ON . . .

THE WEATHER WATCH FORECAST, EXCLUSIVELY ON THE NEWS STATION, NEWSRADIO 590 WEEI.

WEATHER PROMO #2

EXPERIENCE CAN MAKE THE DIFFERENCE WHEN IT COMES TO FORECASTING THE WEATHER IN NEW ENGLAND . . .

HI THIS IS WEEI METEOROLOGIST BOB COPELAND . . .

DICK ALBERT AND I HAVE ALL THE MODERN TOOLS LIKE SATELLITE AND RADAR, BUT WE ALSO HAVE ONE OTHER KEY INGREDIENT, DECADES OF EXPERIENCE . . .

WHEN WE ANALYZE THE WEATHER DATA COMING OFF THE COMPUTERS, WE KNOW EXACTLY WHAT IT MEANS FOR THE BOSTON AREA, BECAUSE WE'VE SEEN IT ALL BEFORE.

EXPERIENCE YOU CAN DEPEND ON . . .

THE WEATHER WATCH FORECAST, EXCLUSIVELY ON THE NEWS STATION, NEWSRADIO 590 WEEI.

08/10/90 14:42 MMC 7:80 #12+NEWSTIP

NEWSTIP PROMO

IF YOU SEE NEWS HAPPENING CALL 241-9959 . . .

THE WEEI NEWSTIP LINE.

EVERY WEEK WEEI NEWSRADIO AWARDS 59 DOLLARS TO A LISTENER WHO CALLS THE WEEI NEWSTIP LINE WITH THE BEST NEWSTIP OF THE WEEK.

241-9959, WRITE THE NUMBER DOWN AND KEEP IT HANDY.

THE WEEI NEWSTIP LINE, FROM THE NEWS STATION, NEWSRADIO 590 WEEI

06/19/90 10:43 MMC 0:80 #12+1SUMMER

SUMMER PROMO #2

THROUGHOUT THE SUMMER OF 90 STAY WITH NEWSRADIO 5-90, BECAUSE THURSDAY THRU SUNDAY WEEI'S SUMMER CALENDAR WITH BILL LAWRENCE WILL FEATURE FESTIVALS, CON-CERTS, MOVIES, THEATER, PLUS EVENTS FOR THE WHOLE FAMILY.

AND FRIDAY THRU SUNDAY, THERE'S WEEI'S BEACH AND BOATING REPORTS WITH TOM WENDELL.

PLUS WEEI'S EXCLUSIVE WEATHER WATCH FORECAST WITH METEOROLOGIST BOB COPELAND AND DICK ALBERT.

AND WE'LL GET YOU FROM HERE TO THERE WITH WEEI'S ALL DAY TRAFFIC WATCH.

FOR THE SUMMER OF 90, IT'S NEWSRADIO 5-90, THE NEWS STATION, WEEI.

06/13/90 15:49 BOA 0:80 #12+1PROMO

PROMO

POLITICS IN MASSACHUSETTS. IT'S NOT ALWAYS PRETTY, BUT IT'S NEVER DULL.

THIS IS WEEI'S BOB OAKES. THURSDAY AFTERNOONS AT 4:50 PM AND FRIDAY MORNINGS AT 7:50 AM, CAMPAIGN JOURNAL TAKES YOU BEHIND THE HEADLINES, TO GIVE YOU A CLOSE-UP

VIEW OF CAMPAIGN 90.

THE CANDIDATES . . . THE ISSUES . . . THE MONEY, THE MOVERS AND SHAKERS. JOIN US AS WE CHRONICLE THE FIGHT FOR YOUR VOTE.

CAMPAIGN JOURNAL. THURSDAY AT 4:50 PM, FRIDAYS AT 7:50 AM. ONLY ON THE NEWSTATION, NEWSRADIO 590, WEEI.

The following TV commercials were written by advertising agency writers for several different clients. They include copy that requires a "voice-over" announcer, who reads copy off camera, and other spots that feature short dramatic situations in which the performers play a role. In some dramatic spots, the talent appears on camera. In others the performance is off the camera.

Television Commercials

THE
WILLIAM COOK
A G E N C Y

CLIENT: ORLANDO DAA
JOB TITLE: 1990 YEAR-END CLEARANCE
JOB #: DDAO-T-10241-2
DATE: DECEMBER 3, 1990
COMMERCIAL #: DDAO-30YE-10241 B
RUN DATES: TBD

:30 YEAR-END MUSIC

Open on graphic of months popping on screen.	VO:	You waited all year long for the best deal.
"December" blooms.		Now is your time to save big...
SUPER appears from top left corner of screen: NEW DODGE		on a new Dodge at your Gold Star Dodge Dealer.
75-million-dollar GRAPHIC flips up from infinity to full screen.	SFX: VO:	(POWEEE/ZOWEE) (STACK & REVERB) The seventy-five-million-dollar Dodge Clearance.
Cuts of SUPER: Up to $2500 Cash Back	VO:	Get up to $2500 cash back.
Cut to quick cuts of Dodge cars and trucks.		Plus huge year-end savings.
Cut to crash of video excitement. Special-effect graphic: $75 MILLION DODGE CLEARANCE	SFX: VO:	(POWEE/ZOWEE) (STACK & REVERB) The seventy-five-million-dollar Dodge Clearance!
Cut to Dodge Caravan.		Get $1000 cash back on Caravan.
Cut to clocks & super: Sale ends Dec. 31.		Time is running out.
Cut to quick cuts of Dodge cars, trucks and vans.		Eight thousand vehicles must be sold before the first.
Cut to crash of video excitement. Special-effect graphic: $75 MILLION DODGE CLEARANCE	SFX: VO:	(POWEE/ZOWEE) (STACK & REVERB) The seventy-five-million-dollar Dodge Clearance!
Cut to Gold Star Dodge dealer logo.		Get the biggest savings of the year right now...at your Gold Star Dodge Dealer.

(DDOT10241)
GH/Gl/ag

THE
WILLIAM COOK
A G E N C Y

CLIENT: ORLANDO DAA
JOB TITLE: 1991 DODGE ANNOUNCEMENT (RATED)
JOB #: DDAO-T-10111
DATE: NOVEMBER 29, 1990
COMMERCIAL #: DDAO-30R-10111 B
RUN DATES: TBD

Open on graphic: WARNING: The following scenes are rated "R."	**VO:** Warning: The following scenes are rated "R."

Cut to clapboard.

Cuts to series of shots of the Dodge Stealth Twin Turbo RT & SUPER: RACY	**MUS:** (Hot music track throughout) **VO:** The RACY Dodge Stealth,

Cut to series of shots of the Dodge Caravan EL & SUPER: REFINED	REFINED Caravan,

Cut to series of shots of the Dodge Shadow convertible & SUPER: REFRESHING	REFRESHING Shadow convertible,

Cut to series of shots of the Dodge Spirit RT & SUPER: RESPONSIVE	RESPONSIVE Spirit RT,

Cut to series of shots of the Dodge Viper & SUPER: RADICAL (Coming Soon)	And the RADICAL new Viper.

Cut to clapboard.

Cut to Gold Star Dodge Dealer logo.	RUN to your Gold Star Dodge Dealer and see the hot new cars RIGHT NOW.

(DAOT10111R)
GDH/MC:ag:bh

THE
WILLIAM COOK
AGENCY

CLIENT: FIRST UNION CORPORATE
JOB TITLE: "MY JOB DEPENDS ON IT" TV SPOT/VERSION B
JOB #: FUCORP-T-0070
DATE: JANUARY 24, 1991
COMMERCIAL #: FUB-30MJ-0070 B
RUN DATES: TBD

(:30)

Open on female customer service representative at computer terminal.	CSR #1:	Hello, Mrs. Jennings? This is First Union.
Quick cut of computer screen and busy office.		
Cut to male customer service representative.	CSR #2:	We'd like to ask you a few questions about service.
Quick cut to computer screen.		
Cut to Branch Manager.	BM:	We're tough on ourselves at First Union.
Pan of two male customer service representatives.	CRS #3:	Were you pleased with our service?
Cut to computer screen.	CRS #2:	Do you find our 24-hour banking machine reliable?
Cut to Branch Manager.	BM:	I'm a Branch Manager...
Quick cut to male and female customer service representatives.	CSR #2:	Did we greet you with a smile?
Cut to computer screen then female customer service representative.	CSR #4:	How long did your transaction take?
Cut to Branch Manager with "Member FDIC" in lower left corner.	BM:	...and I'm going to see to it that you get service that no other bank can equal.
Quick cuts to busy office, female customer service representative and computer screen.	CSR #4:	Did we have the information you needed?
Cut to Branch Manager.	BM:	My job depends on it.
Cut to First Union logo. Fade up: Service. We Guarantee It. Member FDIC	ANC:	First Union service. We guarantee it.

(MYJOB)
/lms

THE
WILLIAM COOK
A G E N C Y

CLIENT:	MEMORIAL MEDICAL CENTER
JOB TITLE:	HEART TV "THE ELEPHANT"
JOB #:	MMC-T-10620-4
DATE:	MAY 14, 1990
COMMERCIAL #:	MMC-30T-10620 E
RUN DATES:	TBD

(:5)

1. Open on wide shot of elephant walking into frame.

RALPH:

What does it feel like to have a massive heart attack?

(:2)

2. Diss. to MCU of same elephant stepping backwards.

Just imagine four-ton Elli here

(:4.5)

3. Diss. to elephant sitting down on stool.

sitting on your chest.

SFX: (LOUD SITTING SOUND, RUMBLE)

Everyone should know the

(:8)

4. Dip to black. Fade up on warning signals appearing on screen.
Cut to warning signals scrolling across screen.
 Uncomfortable pressure, pain or squeezing sensation in the chest.
 Pain that spreads to the shoulder, neck, arms or jaw.
 Fainting, sweating, nausea, shortness of breath.

warning signals of a heart attack, AND, at the first sign, know the best place to call: The Heart Emergency Network at Memorial Medical Center.

(:3.5)

5. Dip to black. Fade up on elephant sitting up.

VO: Don't wait until it turns into something you can't ignore.

(:2)

6. Cut to CU of elephant as she lifts trunk and roars.

SFX: (ROAR)

(:2.5)

7. Dip to black. Fade up on Heart Emergency Network logo.

Call the Network hospital in your area

(:2.5)

8. Dip to black. Fade up on elephant as she gets back on all four legs and walks away from stool.

and get it off your chest.

(HEARTTV2)
TMc/lmj:jcm:lmj

THE
WILLIAM COOK
AGENCY

CLIENT: WINN-DIXIE HEADQUARTERS
JOB TITLE: EDLP PHASE IV COMPARISON "WEEK AFTER WEEK" DEMO
JOB #: WDH-T-10141-4
DATE: JANUARY 24, 1991
COMMERCIAL #: WDH-30W2-10141
RUN DATES: TBD

:30

Open on money and cut to jar with a shopping list.	**ANC:** Okay. Say your weekly grocery budget is $50. Which you take with your list
Hand picks up list. Under jar, SUPER: PUBLIX Widen to reveal 2nd jar. SUPER: XTRA	(MUSIC UP) to any grocery store you think has low prices. You'll have $4.20 left at PUBLIX.
Hand action with coins/dollars.	At EXTRA, $6.23
Hands toss dollar bills and coins into each jar. UNDER SUPER 1, ADD: $4.20 UNDER SUPER 1, ADD: $6.23 WIDEN, see jar #3. Under jar, SUPER: WINN-DIXIE	**SFX:** (MONEY CLINKS INTO JAR) But take the same list to WINN-DIXIE, and you'll have $12.79 left from your $50 budget, because
Hand tosses coins and dollar bills into jar.	**SFX:** (MONEY CLINKS INTO JAR)
SUPER: SPINNING NUMBERS THAT SETTLE DOWN: $12.79	**ANC:** you save a few cents on nearly every item every day.
Move into WINN-DIXIE jar, diss. to hand putting in more money.	And what you save at WINN-DIXIE is what you keep, week...
SUPER: Price comparison of 20 items made in Broward and Palm Beach Counties on January 1, 1991. Prices may have changed since that date.	
Diss. to hand putting in more money.	**SFX:** (MONEY CLINKS INTO JAR)
Diss. to hand putting in more money (repeat till out). Bring up logo: WINN-DIXIE, America's Supermarket® Low Prices Every Day. That's a Promise.	**ANC:** After week... **SFX:** (MONEY CLINKS) **ANC:** After week... **SFX** (MONEY CLINKS) After(TILL OUT)

(WDHT10141U)
KJ/RM/bh

THE
WILLIAM COOK
A G E N C Y

CLIENT: WINN-DIXIE HEADQUARTERS
JOB TITLE: EDLP PHASE IV POWER BUY "TRAINLOAD"
JOB #: WDH-T-10141-4
DATE: JANUARY 24, 1991
COMMERCIAL #: XXCX-1148
RUN DATES: TBD

:30

Open on ECU of W-D shopping bag. Hand pats bag.	BVO:	When you shop, you bring groceries home in one of these.
Widen to reveal Burt walking down street with grocery bag.		But WINN-DIXIE shops for over 2 million customers every day.
	SFX:	(DISTANT SOUND OF TRAIN)
		They bring groceries home in one of these.
Freight train roars in front of camera.	SFX:	(ROAR OF FREIGHT TRAIN)
	SFX:	(TRAIN SOUNDS UNDER FOOTAGE)
Cut to existing computer footage.	BVO:	WINN-DIXIE constantly tracks down the best deals,
Cut to roaring freight train.		then uses volume buying power
Cut to printout footage.		to lower the price even more.
Cut to series of ECUs of Power Buy stickers and products on shelf. Hands pick up products.		They call them POWER BUYS. So shop WINN-DIXIE.
	SFX:	(TRAIN OUT)
Cut to Burt putting items away in his kitchen. W-D bag in frame.	BURT:	And you'll never miss the best deal.
Cut to ECU of train zooming by, revealing JAR LOGO. Hand drops dollars and coins into jar.	BVO:	Power Buys save you money on **every aisle**, every day.
SUPERS: WINN-DIXIE, America's Supermarket® Low Prices Every Day. That's a Promise.	SFX:	(TRAIN AND/OR WHISTLE)

(WDHT10141K)
KJ/RM/bh:ag:bh:ag

THE
WILLIAM COOK
AGENCY

CLIENT: WINN-DIXIE HEADQUARTERS
JOB TITLE: EDLP PHASE IV DISCOUNT "SEE RED"
JOB #: WDH-T-10141-7
DATE: JANUARY 24, 1991
COMMERCIAL #: XXCX-1149
RUN DATES: TBD

:30

Open on white screen.

ANC: You know how you feel when you pay full price
and

Screen slowly begins to turn red, by either slowly
deepening all over or with strong swashes of red.

SFX: (ANGER SOUND)
then find out everybody else paid less?

Red fades to sunny blue sky with puffy white clouds.

SFX: (MUSIC UP, BIRDS TWEET, ETC.)

ANC: Well, it won't happen at WINN-DIXIE.

Coins, dollar bills and items such as magazines,
snack packs, greeting cards, pantyhose packages,
etc., start to fall in slo-mo through sky.

Forget the package price, forget the cover
price, because you won't pay them. With
WINN-DIXIE discounts, you save 5 to 25% off
the full price of snacks, magazines, greeting
cards, pantyhose...

Start to follow one of the coins down.

And what you save

Coin lands in jar with other coins and dollar bills,
some additional money follows until out.
BRING UP LOGO:
 WINN-DIXIE, America's Supermarket®
 Low Prices Every Day
 That's A Promise

is what you keep.

(WDHT10141J)
KJ/RM/bh

THE
WILLIAM COOK
A G E N C Y

CLIENT: WINN-DIXIE HEADQUARTERS
JOB TITLE: EDLP PHASE IV - "30 POUNDS"
JOB #: WDH-T-10141-5
DATE: JANUARY 24, 1991
COMMERCIAL #: XXCX-1144
RUN DATES: TBD

:30

Open very wide on Burt walking with his puppy through a park. An overweight jogger runs by, huffing and puffing.

Cut to MCU of Burt and DOLLY with Burt, still walking, not looking directly into camera, but glancing at it as if it were a companion. (Documentary feeling.)

He pauses on his walk, slow move in to Burt.

He pats his tummy.

He resumes walking, camera stays close.

Diss. to Mason jar in limbo. Hand drops bunch of coins plus a couple of dollar bills into jar.

SUPER:
 WINN-DIXIE, America's Supermarket®
 Low Prices Every Day.
 That's A Promise.

Cut back to Burt CU. He's on park bench with dog. Puppy jumps on him, licks him.

BURT: I have a friend who once asked me, "What's the best way to lose 30 pounds?"

So I told him (GLANCES AT CAMERA, LITTLE SMILE) -- one pound at a time.

(QUIETLY, SINCERE, FATHERLY ADVICE.) A pound isn't much, but lose one every week...and it becomes a lot.

Tried and true advice.

Same at WINN-DIXIE. Saving a few cents isn't much, but save it on just about every item every day -- and it adds up to a lot.

SFX: (CLINKING OF COINS)

(WDHT10141I)
KJ/RM/bh:ag

T H E
WILLIAM COOK
A G E N C Y

CLIENT:	WINN-DIXIE HEADQUARTERS
JOB TITLE:	EDLP PHASE IV "BASEBALL GLOVE"
JOB #:	WDH-T-10141-6
DATE:	JANUARY 24, 1991
COMMERCIAL #:	XXCX-1143
RUN DATES:	TBD

:30

Open very wide on Burt walking down neighborhood street. Kids (boys and girls) are playing baseball in the street.

BURT: Years ago, my son told me he wanted to buy a baseball glove with his own money.

Cut to ECU of Burt and DOLLY with him. He strolls along, talking, not looking directly into camera, but glancing at it as if it were a companion. (Documentary feeling.)

(JOKING, MAYBE HAND TO HEART OR HEAD) When I regained consciousness, I told him

He pauses a moment to make his point.

*(THOUGHTFULLY, FATHERLY) "Start saving your pennies, and the dollars will take care of themselves."

He resumes walking, camera dollies with him.

He got the glove and the message. It's WINN-DIXIE's message, too. Save a few cents on nearly every item -- every day -- and you'll end up with a lot of dollars you wouldn't have had.

Diss. to Mason jar in limbo. Hand drops a bunch of coins and a couple of dollar bills into jar.

SFX: (CLINKING COINS)

SUPER:
 WINN-DIXIE, America's Supermarket®
 Low Prices Every Day.
 That's A Promise.

Cut back to Burt, MCU. He sits on front porch steps wearing ball glove, has ball, or tosses ball with one of the kids.

BURT: Little things add up to a lot at WINN-DIXIE.

(WDHT10141E)
KJ/RM/bh:ag

THE
WILLIAM COOK
AGENCY

CLIENT:	WINN-DIXIE HEADQUARTERS
JOB TITLE:	EDLP PHASE IV "GONNA NEED 'EM"
JOB #:	WDH-T-10141-7
DATE:	JANUARY 24, 1991
COMMERCIAL #:	XXCX-1141
RUN DATES:	TBD

:30

Open on dolly through attic. There are old family items like tricycle, hat rack, old porch rocker, doll house, etc. In background Burt rummages in an old cupboard like an antique armoire or dry sink. There is a large black leather trunk nearby. Stacked on it are some dusty Mason jars. Light streams through rafters from a high window.

SFX: AMBIENT SOUND OF RUMMAGING.

BURT: I like to save things, because -- well, I might need them.

Burt walks over to trunk, picks up Mason jar. He looks at it, glancing at camera now and again as if it were a companion.

I use these for pocket change.

He reaches into his pocket and pulls out a handful of loose change and tosses it into the jar.

Toss in a little every night, and it really adds up.

Burt moves to the stairs and starts down. Camera follows from behind.

Same thing happens at WINN-DIXIE. Save a nickel or dime on one thing, it's not much. But save it on just about everything and you come out with a fistful of savings from WINN-DIXIE every time you shop.

Diss. to Mason jar. Hands put coins and dollar bills into jar.

SFX: (CLINKING COINS.)

SUPER:
WINN-DIXIE, America's Supermarket®
Low Prices Every Day.
That's A Promise.

BURT VO:
That's a promise.

Cut to Burt in front of open cupboard. Jar full of coins is there. He places second jar (the one from the attic) next to it.

BURT: So get one of these, because,--well--you're gonna need it.

(WDHT10141A)
KJ/RM/bh:ag:bh:ag

409

Audiovisual Script

This audiovisual script is representative of the work broadcast performers are often hired to do and has several features that make it an excellent exercise for polishing your skills. The rapid change of visual elements calls for the narrator to be precise. You must be constantly aware of the changing visuals, while taking care that your attention to this concern does not cause your concentration on your presentation to lapse.

This narration is difficult because it is not one continuous thought, but rather a series of individual thoughts, most of them relating specifically to the picture being displayed at a particular moment. The challenge is to avoid a choppy style in your delivery. A trick that helps here is to identify the central message of the presentation and keep it focused in your mind as you read.

This script demands that narrators communicate both a sense of the fun of traveling to this resort and the carefree atmosphere of the unhurried lifestyle. The writing is descriptive, and the style of the narration should be evident to the listener/viewer.

Look for key words that convey images of beauty, fun, and relaxation. Take care to emphasize these key words so that they come through clearly. You might try going through the script and highlighting all the descriptive words you see.

THE
WILLIAM COOK
AGENCY

CLIENT: SANDALS
JOB TITLE: A V PRESENTATION
JOB #: SR-C-11730
DATE: JANUARY 17, 1990
COMMERCIAL #: NA
RUN DATES: NA

	FEMALE VO:
Up from black to title slide: Dear Sandals,	Dear Sandals,
Diss. to couple walking on the beach at twilight.	I think perhaps we began to come back together that very first night, while we strolled down the beach.
Diss. to closeup of couple above.	The Caribbean sky just seemed to dwarf our problems.
Diss. to aerial of the property.	But I'm getting ahead of myself.
Diss. to second shot.	I'm really writing to tell you what we liked so much about Sandals.
Diss to couple in wicker chairs.	For starters, we really liked the "couples only" idea.
Diss. to second couple.	It's not that we don't like kids. We do. But you guys devote all your energies...
Diss. to third couple.	
	to just one group - couples - and it's great.
Diss. to couple at swim-up bar.	The swim-up pool bars, for instance. They're perfect for couples.
Diss. to couple at piano bar.	And without a bunch of singles on the loose... well, you know what I mean.
Diss. to snorkeling.	I can't begin to tell you all the things we did. I think we did it all. We snorkeled.

SANDALS
A V PRESENTATION
SR-C-11730
PAGE 2

Diss to skiing.	skied...
Diss. to cabaret	danced...
Diss. to dining.	dined...
Diss. to toga dancing.	danced...
Diss. to dining.	and dined again.

Diss to chefs with beautiful food.	The restaurants were fantastic...
Diss. to snacking.	and the round-the-clock snacks filled in where the dining ended.

Diss. to couple with waiter behind them.	Most importantly, we really liked being able to order what we wanted.

Diss. to health club.	Oh, yes, and thanks for putting in a health club.

Diss. to second health-club shot.	The workouts kept me from gaining even a pound.

Diss. to entertainment.	Unlike a lot of other vacations, this wasn't a
Diss. to couple.	he or she vacation...it was a "we" vacation.

Diss. to Montego Bay.	But rather than me telling you about the other side of this story,
Diss. to interior shot.	I'll let him tell you himself.

Diss. to Royal Caribbean.	MAN:	Well, here goes. To be honest, I picked
Diss. to Negril.		Sandals because of the all-inclusive pricing.
		I was just fed up with making decisions.

Diss. to zoom in on Ocho Rios.	So I took the easy way out. Pure convenience. To begin with, that is.

SANDALS
A V PRESENTATION
SR-C-11730
PAGE 3

Diss. to pool.	It wasn't until we actually got there that I discovered the biggest benefit of all.
Diss. to couple with two waiters offering plates of food.	Not once, not even a little, did we discuss money again.
Diss. to couple in whirlpools with drinks.	For the entire vacation.
Diss. to couple in paddle boat.	We knew everything...
Diss. to couple playing tennis.	was included.
Diss. to sunfish.	So we just did...
Diss. to boat bike.	what we wanted.
Diss. to cognac after dinner.	If we wanted a cognac after dinner, we ordered it.
Diss. to midnight snack.	If we wanted a midnight snack, we had one.
Diss. to couple in canoe at twilight.	If we felt like doing something, we did it.
Diss. to couple in a hammock.	And if we didn't, well, then we didn't.
Diss. to couple in rattan swing.	I can't tell you how relaxed you can get when...
Diss. to couple having drinks with banjo player in background.	you don't have to carry your wallet or even a few bucks for tips.
Diss. to couple under a straw hut.	For once in my life, I really did smell the roses.
Diss. to drink with hibiscus.	
Diss. to couple with yellow drinks and hibiscus on the table.	I even noticed the flowers...
Diss. to couple with conch shell and waiter pouring the water.	the water....

SANDALS
A V PRESENTATION
SR-C-11730
PAGE 4

Diss. to moonlight scene.		the moon.
Diss. to man looking at his sweetheart.		But most of all, I noticed her. Again. You know, I hadn't done that for some time.
Diss. to closeup of above.		And what I saw was worth all the money in the world -- all inclusive or not.
Diss. to room with two couples.	WM:	I just wanted to say one more thing. The rooms were beautiful...
Diss. to room with view of ocean and couple looking out.		so close to the ocean and all.
Diss. to empty room with spiral staircase. Diss. to couple at white table.		And although we didn't spend...well, a whole lot of time in ours, the little niceties were really nice.
Diss. to room revealing vanity and king-size bed.		The king-sized bed...even the blow dryers in the rooms...were nice surprises.
Diss. to couple on a veranda. Diss. to couple on a pier. Diss. to peacock. Diss. to couple with palm tree in background. Diss. to couple on beach with sunfish in background.		You knew nothing could detract from the rest and relaxation of a trip to such a beautiful place.
Diss. to gazebo. Diss. to aerial of Negril.		We're already planning our next trip. We took you up on your offer... and played a little at the other three Sandals Resorts on the island.
Diss. to fronts of buildings at Negril with beach.		We can't decide if next time we'll stay at Negril with its fantastic seven-mile beach...

SANDALS
A V PRESENTATION
SR-C-11730
PAGE 5

Diss. to Royal Caribbean, front of building.	Or try Royal Caribbean. We really were taken with its British Colonial charm.
Diss. to Monetgo Bay beachfront with two-story veranda.	We liked the Jamaican style of Montego Bay, too.
Diss. to building with boat in foreground.	Then again, we might just stay at Ocho Rios again.
Diss. to Dunn's River Falls. Diss. to artist's rendering.	But who knows? We heard there's a new Sandals at Dunn's River Falls opening soon. We might just be your first guests there.
Diss. to Carlyle, front of building. Diss. to Carlyle interior. Diss. to third Carlyle amenity shot.	While we were visiting, we heard about your Carlyle Hotel on Montego Bay. Everyone says it's smaller, more intimate, and bit different that your other resorts. You know, it's hard to decide.
Diss. to Montego Bay.	But WHEREVER we stay, you can be sure of one thing...it won't be long before we come back.
Diss. to people around a piano. Diss. to couple having a candlelight dinner.	Because at Sandals we found something we were never able to find at any other resort in the world...

SANDALS
A V PRESENTATION
SR-C-11730
PAGE 6

Diss. to silhouette. each other. Sincerely, Kenny

Diss. to Sandals slide. Tricia McCauley.

 Sandals
(TONY)
GDH/bh:lmj

Acted delivery Speaking lines in the guise of a character, such as assuming the role of a tired husband in a headache-remedy commercial. Opposite of straight delivery, in which a reader delivers lines as an announcer, not as a character.

Actuality An interview segment recorded on tape for later use, sometimes in a voice actuality or voice wrap. The term *actuality* is most commonly used in radio. Television producers tend to call interview segments *sound bites* or *SOT* (sound-on-tape) *segments.*

Actuality interview An interview conducted expressly for the purpose of gathering an actuality.

Ad lib Material spoken spontaneously without being read from a script. Literally, "at pleasure."

Additions In speech, the interjection of extra sounds within a word, such as saying "ath-a-lete" instead of "athlete."

Adult contemporary A radio format that usually consists of a mix of softer rock (as compared to "hard" rock) and often includes a heavy component of news and information.

AFTRA American Federation of Television and Radio Artists, a union that represents certain on-air personnel.

Agent A businessperson who represents a performer in contract negotiations. The agent receives a percentage of the performer's salary in return for negotiating the terms of the contract.

Aircheck Audio or video recording of a performer when he or she is on air. Often used as a critiquing tool or an audition tape.

Album-oriented rock (AOR) A radio format featuring longer cuts, usually of fairly "heavy" rock, although AOR is split into several segments, including "classic" AOR.

Amplification The process of boosting a signal's strength, one function of the audio console.

Anchor In current usage, anyone who delivers news on air, in radio and television, from a studio. Generally reserved to refer to the main announcer who reads the newscast from start to finish. Also used, on occasion, to refer to "sports anchor."

Arbitron A firm that, among other types of research, is noted for its radio ratings. In informal usage, *Arbitron* is used as a noun to denote the ratings report.

Area of dominant influence (ADI) A ratings term that delineates a broadcast market by size. There are slightly over 200 ADIs in the United States.

Articulation In informal usage (usage by performers rather than speech scientists), the clarity of sound production by a person speaking.

Attribution A reference, within a story, to the source of the story or information.

Audition channel A separate channel on the audio console that lets the operator hear the output of the board without having that output go over the air. It is useful for doing production work off air and for hearing off-air sources through the main speaker.

Automation Using mechanized devices to carry out certain operations in the

broadcast or cable studio. For example, some radio stations have equipment that automatically plays back a sequence of recordings. Many television studios have preset, mechanized control of the cameras, thus eliminating the need for a camera operator.

Backtiming Timing a selection or spoken presentation so that it ends at a certain time.

Bidirectional pickup pattern A mic pattern that picks up sounds from the front or rear but rejects sounds from the side.

Cassette A plastic device that holds tape internally. Both audio and video tape come in cassette format.

Billboard A listing of audio or video cuts to be fed by a news service.

CD Compact disk.

CHR Abbreviation for *contemporary hit radio,* a format that features a rotation of a fairly small number of the most popular songs.

Cardioid A type of microphone with a one-direction, heart-shaped pattern. (Note that the root *cardi-,* as in *cardiac,* means *heart.*)

Cartridge machine A unit that plays or records cartridge tapes, which are continuous loops of tape housed in a plastic case that is usually called a *cart.* The units are called *cart machines.*

Cluttering In informal usage, the tendency of some announcers to push sounds together in a too-rapid jumble.

Compressing copy Speeding up the reading to shorten the time needed to read copy.

Console The device used by an audio operator to route, amplify, and mix audio sources.

Convention An agreed-on way of doing things; for example, pronouncing a foreign name the way respected newscasters say it.

Copy Any written material to be read on tape or over the air.

Country/country western A format featuring songs of a distinctly rural character. There are many varieties of country, some of which are quite close to rock. "Western" music often features steel guitars and cowboy-type themes; "country western" is a variety of country.

Cue channel A channel on the audio console that allows the operator to hear a source without having it go over the air. Cue is generally routed through a small speaker in the console, as opposed to *audition,* which is played back over the studio speaker.

Cutaway In video production, a segment (usually a shot of the reporter or some other image relevant to the news story) that is used to cover an edit during an interview.

Daypart In radio, a section of the day that has particular audience characteristics. Morning drive time, for example, is a daypart.

Dead air Silent time on radio, generally something announcers try to avoid at all costs.

Dialect In informal usage, a peculiarity of speech based on either region or social status. A distinctive variation of a language in which pronunciation, usage, and grammatical structure differ from the theoretical standard. Usually refers to a geographic difference (for example, a Cajun dialect) but also refers to differences caused by the social class of the speaker.

Diaphragmmatic breathing Inhalation and exhalation using the full expansion and contraction of the diaphragm, a sheet of muscle between the chest and the abdomen; the diaphragm is responsible for motion of air through the breathing apparatus and vocal tract.

Digital audio tape (DAT) An audio tape that records signals in the on-off language of computers.

Distortion In speech, the improper alteration of sound, such as saying "intertainment" instead of "entertainment" (the initial "e" sound is distorted). In broadcasting, *distortion* often refers to unacceptable deviations in the sound caused by the electronic equipment; for example, when a tape is played too loudly over a speaker.

Drive time Periods of heavy listening when many radio audience members are in their cars. Morning drive time and afternoon drive time are two important dayparts.

Dub To copy an audio or video tape.

Easy listening A radio format usually featuring orchestrated versions of popular and standard songs along with vocals.

EFP (electronic field production) The use of portable equipment to gather and/or edit material outside of the studio.

ENG (electronic news gathering) Basically the same as EFP, but applied to news operations.

Erase head The part of a tape-recording unit that eradicates any signal laid down on tape.

Fact sheet A listing of brief items from which the announcer will ad-lib a commercial.

Field producer An executive in charge of the artistic and technical elements of a program produced outside the studio.

Field report A news item filed from outside the studio.

Fluency In informal usage, the area of speech concerned with either cluttering or stuttering, or both.

Format The overall programming structure of a radio station.

Frequency response The range of frequencies that can be reproduced by a microphone or audio system.

Fricative A speech sound produced by forcing air through a narrow vocal passage, therefore producing the sound by friction (hence the term *fricative*). The sound of "f," for example, is produced by the friction of air being forced between the top lip and the bottom teeth.

General American speech The speech pattern used by an educated American, free from regional accents. A more precise and common term is *network standard.*

Hard news News that is "breaking"—that is, happening currently—and is of immediate importance. Soft news is generally considered to be "human interest" news, which is not necessarily current or breaking.

Hard sell A type of delivery that involves a very deliberate, forceful approach.

Inflection The announcer's use of tone and pitch.

International Phonetic Alphabet (IPA) A comprehensive system of symbols used to describe the full range or speech sounds, of primary use to linguists, speech clinicians, and other scholars.

Lead The opening sentence or sentences of a news story.

Libel A published ("published" means put in print or stated over the air) statement that is provably untrue and causes hardship to someone's reputation and/or finances.

Market A term indicating the locality served by a station.

Melody (in reading) The rise and fall of pitch among words in a sentence.

Microphone A device for picking up sounds and changing the motional energy of sound waves (a vibration in the air) into electrical energy.

Mixing The process of taking two or more audio outputs and blending them together.

Mobile unit A vehicle designed to transmit a signal back to the station.

Monitor An audio speaker or a studio-quality television set that is used to listen to or watch the signal in studio.

Moving coil mic A microphone using a coil that moves through a magnetic field in response to the movement of a diaphragm, which vibrates in response to sound waves. The movement of the coil produces an electrical signal.

NABET National Association of Broadcast Employees and Technicians, a union that represents some technical and certain other employees in broadcasting.

Network A linkage of organizations—in our frame of reference, primarily broadcast stations—in which a central source of programming supplies material to the individual stations that make up the system.

Network standard The unaccented (that is, lacking regional accents) speech patterns, pronunciation, and grammatical construction used by most announcers broadcasting over radio and TV networks.

News/talk A format that features listener call-in combined with heavy news programming.

News director The executive in charge of the news department.

News feed A series of reports "fed" from a network to local stations, usually by satellite or telephone line.

Omission In speech, the failure to pronounce a sound within a word, such as saying "maket" instead of "market."

Omnidirectional pickup pattern A microphone pickup pattern in which sound sources are picked up equally well in all directions regardless of their position in relation to the microphone.

Outcue The last words (or other visual or auditory cue) in a taped presentation. Knowing the outcue helps an anchor or announcer to know when the piece is ending.

Package A complete report filed by a television journalist for inclusion in a newscast. Usually the rough visual equivalent of a radio voice actuality.

Patter A word used primarily by radio staff announcers to describe their spoken delivery. Usually ad-libbed humorous material.

Phrasing The way an announcer uses timing and pitch to communicate a message clearly.

Phonation The act of producing a speech sound by vibrating vocal cords.

Playback head The electromagnetic sensor that picks up signals on an audio tape and translates them back to sound.

Plosive A speech sound produced by an explosion (a word that uses the same

420

root as the word *plosive*) from the mouth. The *p* sound, for example, is produced by building up air behind the closed lips and then allowing it to "explode."

Potentiometer The device on an audio console that controls volume, usually referred to as a "pot."

Privileged communication A certain type of statement that is immune from a libel charge. Privileged communication takes place on the floor of legislative bodies, in courts, and in most official proceedings.

Prompting device A device that projects the script on a one-way mirror in front of the television lens. The announcer can see the script, but it won't show up on the camera.

Pronouncer A written reference explaining how to say an unfamiliar word. Wire services include pronouncers in their copy.

Proximity effect The way some mics tend to boost bass frequencies when a person speaks very close to the mic's diaphragm.

Public figure (defense) The concept that someone who actively seeks public office or, to a lesser extent, public notice, has less protection against libel.

Ratings Statistical measurements of the audience viewing or listening to a particular broadcast station or network. These measurements are made by specialized ratings firms and reported to the stations. The ratings report is then often referred to as "the book."

Record head The part of a tape-recording unit that lays a signal down on the tape.

Reel-to-reel A recording unit that uses tape spooled on open reels, rather than on cassettes.

Regionalism A speech pattern characteristic of a particular geographical location, such as a New England accent or a Southern accent. Regionalisms are generally a handicap to on-air performers, even within the regions from which they derive their accents.

Résumé A document that outlines experience and education. Sometimes called a "vita" in other professions, but almost always called a résumé in broadcasting.

Reverse shot A video picture of a reporter, usually taken from the opposite angle of the shot of the newsmaker. The reverse shot serves two purposes: to show the reporter on the scene and to provide a piece of cover video to facilitate an edit. A reverse shot must never change the context of the actual questions as posed during the interview.

Ribbon mic A microphone using a thin element that vibrates in response to the velocity of sound waves. The ribbonlike element is suspended in a magnetic field that converts the sound to an electrical signal.

Rip and read The practice of allowing news coverage to become nothing more than ripping wire-service copy off the teletype machine and reading it on the air. It is becoming a rather anachronistic term because most copy comes in over the computer, but the concept remains the same.

Running the board Operating the broadcast console.

Share The percentage of the available audience tuned in to a particular radio or TV station. (A rating reflects the percentage in relation to the total of all households that have radio or TV in a given area.)

Shock jock Slang term for *disk jockey* who uses outlandish material to amuse the audience.

Slate Any method of indicating when a taped segment starts. Announcers often slate their taped news reports, for example, by saying "Bribery story, take 2, rolling in three . . . two . . ."

Social dialect A peculiarity of speech that is primarily related to one's social and/or educational background.

Soft news Nonbreaking news, such as feature news or human interest stories.

Soft sell A low-key sales approach.

Spot Colloquial term for a commercial.

Standard English The type of English spoken and written by an educated person of the upper class or upper-middle class. Applied particularly to the United States, the term "standard American English" is often used. Note that this term applies mainly to usage, vocabulary, and sentence structure. *Network standard* is the term generally applied to unaccented speech.

Standup A report done with the journalist reading straight to the camera, usually standing before some recognizable landmark or landscape that figures in the news event.

Station sound The underlying strategy of the station, the "sound" into which all elements must fit.

Stop A speech sound caused by completely shutting off the flow of air. A stop is a component of a plosive. The lips in the "p" sound come together to impede the flow of air and then come apart to release the "explosion."

Straight reading or **straight delivery** A reading in which the announcer delivers the copy as an announcer, not in the guise of a character. Opposite of acted scene or acted delivery.

Studio interview An interview conducted in studio as part of a show that has a beginning, a middle, and an end. Distinct from an actuality interview, in which only a piece of the interview is to be used.

Stuttering A complex group of speech problems stemming from a variety of causes and offering many manifestations, one of which is stammering or spasmodic repetition of a sound. Stuttering can also involve "blocking" on words, not being able to initiate pronunciation.

Style An unusual or unique way of doing things; a method of presentation that differentiates one's work from that of others.

Substitution A speech term describing a situation in which an improper sound is used in place of the proper sound, such as saying "wabbit" instead of "rabbit."

Tally light The light on a camera that shows when the camera is on air.

Tight board; running a tight board Industry jargon for adeptly operating the console and butting program elements up against each other in rapid succession with no blank time or "dead air."

Transduction Converting energy from one form to another. A microphone transduces the motional energy of sound into electrical energy; a loudspeaker transduces electrical energy into sound.

Voicer An oral report of a straight news item, spoken by a journalist who signs off with a name ("this is Ted Baxter reporting from City Hall").

Voice Actuality A report from a journalist in which an actuality (the sound of an event or recording of an interview) is included.

Voiceover Narration placed over video.

Wild sound bite A recorded piece of sound, such as the sound of fire engines, used in an edited news piece.

Wire service A service, such as the Associated Press or United Press International, that provides news from a central source to client affiliates.

Wrap or **voice wrap** A radio report in which the reporter's narration "wraps" around the actuality. Same as a voice actuality.

Some of the more traditional selections in the study of broadcasting are listed here, along with some nontraditional works that give valuable insight into the world of on-air performance. Some of the following works are now out of print but are readily available in libraries and through interlibrary loan.

Suggested Reading

Books

Stanley R. Alton. *Audio in Media.* 3d ed. Belmont, CA: Wadsworth, 1990. The definitive guide to audio; contains answers to any questions an announcer might ask about mics, audio consoles, and other equipment.

The Associated Press. *Associated Press Stylebook and Libel Manual: The Journalist's Bible.* Reading, MA: Addison-Wesley, 1987. Useful guide to practicalities of turning out news copy that will keep you on the air and out of trouble.

Eric Barnouw. *Tube of Plenty: The Evolution of American Television.* Rev. ed. New York: Oxford University Press, 1982. Readable history based on *A Tower in Babel, The Golden Web,* and *The Image Empire,* by the same author.

Cicely Berry. *Voice and the Actor.* New York: Macmillan, 1974. Although primarily intended for the stage actor, this is a valuable book for any performer.

Shirley Biagi. *Interviews That Work: A Practical Guide for Journalists.* 2d ed. Belmont, CA: Wadsworth, 1992. Leading journalists discuss the art of interviewing. Text includes a chapter on broadcast interviewing, and examples related to broadcast appear throughout.

John R. Bittner and Denise A. Bittner. *Radio Journalism.* Englewood Cliffs, NJ: Prentice-Hall, 1977. Highly detailed study of radio news, with attention paid to the process of newsgathering.

Broadcasting/Cablecasting Yearbook. Washington: Broadcasting Publications. Names, addresses, phone numbers, and other valuable information on job hunting and the industry in general. The address for the *Yearbook* and for the periodical, *Broadcasting,* is 1735 De Sales Street NW, Washington, DC 20036-4480.

Irv Broughton. *The Art of Interviewing for Television, Radio and Film.* Blue Ridge Summit, PA: TAB Books, 1981. Highly detailed study with practical advice.

Kate Carr. *How You Can Star in TV Commercials.* New York: Rawson Wade, 1982. Interesting and concise, written by leading casting director.

Dick Cavett and Christopher Porterfield. *Cavett.* New York: Harcourt Brace Jovanovich, 1974. Very valuable insight into Cavett's strategy of interviewing.

Lee J. Dudek. *Professional Broadcast Announcing.* Newton, MA: Allyn & Bacon, 1981. Overview of announcing duties and techniques.

Douglas Ehninger, Bruce E. Gronbeck, Ray E. McKerrow, and Alan H. Monroe. *Principles and Styles of Speech Communication.* 11th ed. New York: Scott, Foresman, 1990. Interesting and informative.

Eugene Ehrlich and Raymond Hand, Jr. *NBC Handbook of Pronunciation.* 4th ed. New York: Harper & Row, 1984.

Jon Eisenson. *Voice and Diction: A Program for Improvement.* 5th ed. New York: Macmillan, 1985. Useful guide.

James E. Fletcher, ed. *Handbook of Radio and TV Broadcasting: Research Procedures in Audience, Program and Revenues.* New York: Van Nostrand Reinhold, 1981. Useful for understanding ratings and the broadcast business in general.

Uta Hagen, with Haskel Frankel. *Respect for Acting.* New York: Macmillan, 1973. One of the classic acting texts.

Carl Hausman. *Crisis of Conscience: Perspectives on Journalism Ethics.* New York: Harper-Collins, 1992. Broad-based study of some of the modern problems facing the journalist.

Carl Hausman. *Crafting the News.* Belmont, CA: Wadsworth, 1992. Standard broadcast journalism text but with heavy emphasis on news judgment and what makes news.

Carl Hausman. *The Decision-Making Process in Journalism.* Chicago: Nelson-Hall, 1990. Case histories of how experienced journalists made decisions; a useful introduction to news judgment.

William Hawes. *The Performer in Mass Media: In Media Professions and in the Community.* New York: Hastings House, 1978. Well-written guide with special focus on dramatic performance.

Vangie Hayes and Gloria Hainline. *How to Get into Commercials.* New York: Harper & Row, 1983. Authoritative and detailed, with good sections on commercial delivery.

Sydney W. Head, with Christopher H. Sterling. *Broadcasting in America: A Survey of Television and Radio.* 6th ed. Boston: Houghton Mifflin, 1990. Authoritative survey work with valuable insights.

Stuart W. Hyde. *Television and Radio Announcing.* 6th ed. Boston: Houghton Mifflin, 1991. Detailed study of announcing field.

Kathleen Hall Jamieson. *Eloquence in the Electronic Age.* New York: Oxford University Press, 1990. Primarily a treatise on political speechmaking, yet contains valuable insights into what makes a message work in the mass media.

Michael C. Keith. *Radio Programming: Consultancy and Formatics.* Stoneham, MA: Focal Press, 1987. Detailed analysis of radio formats, quite useful to the announcer who needs to perform effectively in a certain genre.

Lauren Kessler and Duncan McDonald. *When Words Collide: A Journalist's Guide to Grammar and Style,* 3d ed. Belmont, CA: Wadsworth, 1992. Practical and easy-to-use guide.

Richard Labunski. *How to Find That First Broadcast News Job.* Seattle: School of Communications, University of Washington, 1985. Straightforward step-by-step guide to finding work in broadcast news.

Tim Logan. *Acting in the Million Dollar Minute: The Art and Business of Performing in TV Commercials.* Washington, DC: Communications Press, 1984. A comprehensive how-to book; good advice on performance techniques.

Barbara Matusow. *The Evening Stars: The Making of the Network News Anchor.* Boston: Houghton Mifflin, 1983. Enlightening behind-the-scenes look at the news business.

National Association of Broadcasters. *Guidelines for Radio: Copywriting.* Washington, DC: National Association of Broadcasters, 1982. A guide to producing effective radio copy for various types of spots; a valuable ancillary tool for the announcer, who will frequently be creating his or her copy. Also gives some insight as to the interpretation of copy from the writer's point of view.

National Association of Broadcasters. *Sports on Television.* Washington, DC: NAB, 1990. An expensive but highly detailed guide to sports programming. While geared toward management and programming staff, the work does offer some insights into the nature of sports programming and therefore the role the announcer plays.

Lewis B. O'Donnell, Philip Benoit, and Carl Hausman. *Modern Radio Production,* 2d ed. Belmont, CA: Wadsworth, 1990. Contains several sections on techniques of the announcer in various production duties.

Lewis B. O'Donnell, Carl Hausman, and Philip Benoit. *Radio Station Operations: Management and Employee Perspectives.* Belmont, CA: Wadsworth, 1989. Includes highly detailed information on radio formats and radio news and the announcer's role in station operations.

Dan Rather, with Mickey Herskowitz. *The Camera Never Blinks: Adventures of a TV Journalist.* New York: Morrow, 1977. Good reading for those interested in the "right stuff" of journalism.

Edd Routt, James B. McGrath, and Fredric A. Weiss. *The Radio Format Conundrum.* New York: Hastings House, 1978. Outstanding view of the announcer's role within formats; many examples.

Everett M. Schreck. *Principles and Styles of Acting.* Reading, MA: Addison-Wesley, 1970. Concise, easily digested book on basic acting techniques.

Nicolas Slonimsky, ed. *Baker's Biographical Dictionary of Musicians.* 6th ed. New York: Schirmer, 1978. One of the few works of its kind that includes pronunciations; valuable for classical music announcers.

Konstantin Stanislavski. *Building a Character.* New York: Theatre Arts Books, 1977. Translated by Elizabeth Reynolds Hapgood. Excellent study of what makes a character real to the audience.

Christopher H. Sterling and John M. Kittross. *Stay Tuned: A Concise History of American Broadcasting.* 2d ed. Belmont, CA: Wadsworth, 1990. An excellent quick-reference guide to the industry's history. Compact and accessible.

Vernon Stone. *Careers in Radio and Television News.* 6th ed. Washington, DC: Radio-Television News Directors Association, 1989. The definitive guide to what's available and what the jobs pay. Single copies are available for a modest price from the Radio-Television News Directors Association, Suite 615, 1717 K St. NW, Washington, DC 20006.

Ann Utterback. *Broadcast Voice Handbook: How to Give Meaning and Style to Each Word You Speak.* Chicago: Bonus Books, 1991. A practical voice-training manual useful to broadcasters.

Mike Wallace and Gary Paul Gates. *Close Encounters.* New York: Morrow, 1984. Actual transcripts from Wallace interviews highlight a master in action.

Periodicals

Broadcasting (1735 De Sales St. NW, Washington, DC 20036). The trade journal of the broadcast industry. For the performer, of most interest for its help-

wanted ads. Note, though, that most positions advertised are not for beginners.

College Broadcaster (Box 1955, Brown University, Providence, RI 02901). Addresses wide range of issues of interest to college TV and radio station personnel. Announcing and related areas—such as programming—receive clear and relevant treatment.

Communicator (The Magazine for the Radio-Television News Directors Association, Suite 615, 1717 K Street, Washington, DC 20006). Frequent articles on improving performance. One of the most valuable publications for the news announcer. Membership in the RTNDA (you don't have to be a news director to join) also entitles you to a twice-monthly job information service listing and a code number to access a jobs data bank.

The Quill (Society of Professional Journalists, P.O. Box 77, Greencastle, IN 46135). Geared toward print and broadcast journalists. Articles of general interest to the news announcer.